WHO RUNS THE
ARTWORLD

WHO RUNS THE ARTWORLD: MONEY, POWER AND ETHICS

Brad Buckley and John Conomos

First published in 2017 by Libri Publishing

Copyright © Libri Publishing

Authors retain copyright of individual chapters.

The right of Brad Buckley and John Conomos to be identified as the editors of this work has been asserted in accordance with the Copyright, Designs and Patents Act, 1988.

ISBN 978-1-911450-13-9

A CIP catalogue record for this book is available from The British Library

Design and cover by Carnegie Publishing

Printed by Edwards Brothers Malloy

Libri Publishing
Brunel House
Volunteer Way
Faringdon
Oxfordshire
SN7 7YR

Tel: +44 (0)845 873 3837
www.libripublishing.co.uk

Acknowledgments

THE EDITORS SINCERELY WISH to thank the following people for making this book possible. Paul Jervis and John Sivak of Libri Publishing for their unwavering professionalism and dedication in seeing our manuscript through from its conception to its realisation.

To Tracey Clement and Sarah Shrubb respectively, for their consummate copyediting of the book and to Helen Hyatt-Johnston for her professional advice, encouragement and assistance over the past two years. To Ian McLean for his suggestion that in the title we use 'artworld', rather than art world drawing on Arthur Danto's use of the word, signalling that it is a thing in its own right.

Also to Lucy Frontani of Carnegie Publishing for her strategic book and cover design.

Also, we are indebted to Amy Scaife for allowing us to use the image, which is on the front cover, and also to the other artists for their generous assistance in helping us to illustrate this book.

We are of course especially grateful to all of our contributors who gave their time and expertise in helping us to materialise our editorial intentions and objectives. Many heartfelt thanks to all of you in sharing our concern for how our society and culture are undergoing rapid and unprecedented change.

It is hoped that *Who Runs the Artworld: Money, Power and Ethics* in its own way contributes to a better ethical understanding of contemporary art's broader ecology of capital, history, power, space and spectacle.

Brad Buckley and John Conomos

For Occupy Sydney College of the Arts Students
2016

For John Clarke, in memoriam
1948–2017

For John Berger, in memoriam
1926–2017

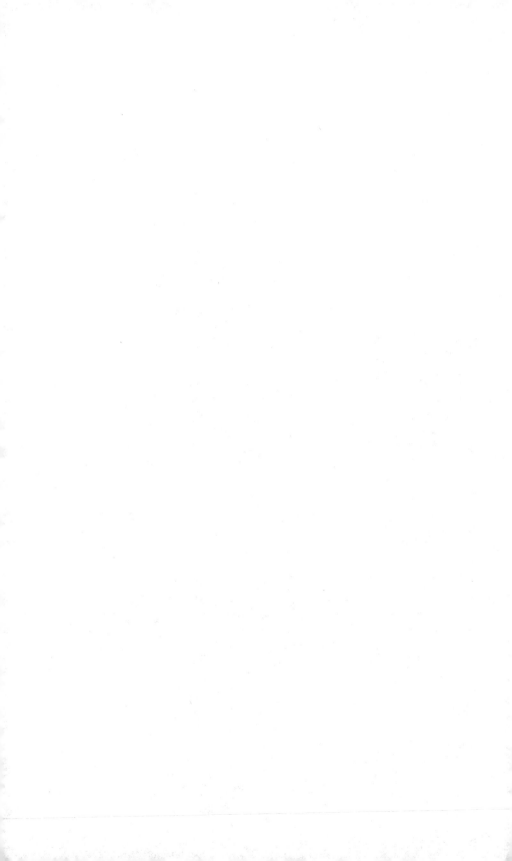

Contents

List of Illustrations

Ian McLean

Figure 4.1 Imants Tillers, *The Nine Shots* (1985), acrylic and oilstick on 91 canvas-boards (nos. 7215 – 7305), 330cm × 266cm, National Gallery of Australia. Courtesy of the artist.

Figure 4.2 Imants Tillers, *I am Aboriginal* (1988), oilstick, gouache, synthetic polymer paint on 105 canvasboards (numbers19057–19161), 124.5cm × 190.5cm. Photographer Simon Cowling, Private collection, Perth, Australia. Courtesy of the artist.

Figure 4.3 Tillers, Imants. "One Painting Cleaving (Triangle of Doubt) (1982)." In *Eureka! Artists from Australia*, edited by Sue Grayson, and Sandy Nairne, 36. London: Institute of Contemporary art and the Arts Council of Great Britain.

Figure 4.4 Michael Nelson Jagamara and Imants Tillers, *Hymn to the Night* (2011-2012), synthetic polymer on 165 canvasboards (numbers 89763 – 89927), 277cm × 532cm. Private collection. Courtesy of the artists and Fire Works Gallery, Brisbane, Australia.

Figure 4.5 Richard Bell, *Bell's Theorem* (2002), acrylic on 25 canvas boards, 173cm × 127cm. Courtesy of the artist and Milani Gallery, Brisbane, Australia.

Introduction

Brad Buckley and John Conomos

Capitalism survives by forcing the majority, whom *it exploits,* to define their own interests as narrowly *as* possible. This was once achieved by extensive deprivation. Today in the developed countries it is being achieved by imposing a false standard of what is and what is not desirable.

John Berger[1]

His hero was the Emperor of Qin, a third-century-BC despot, remembered for starting the construction of the Great Wall and the destruction of the Confucian classics. He was the first great book-burner in history.

Ian Buruma[2]

A work of art is so intensely the expression of our solitude that one wonders what strange necessity for making contact impels an artist to expose it to the light.

Jean Cocteau[3]

T HIS IS AN ERA of 'post-truth' populism, of neoliberal market economies, of globalisation, and of the rapidly increasing simulacra of a 'counterfactual' world as represented by the surreal ascendancy of Donald Trump to the White House as the 45th US President. The issues and questions we raise in this book have a particular urgency for anyone concerned with contemporary art, culture, class, gender and power in our public and private lives. *Who Runs the Artworld* attempts to delineate some of the critical and theoretical perspectives that are most germane to the

aesthetic, cultural, historical and political complexities of the global artworld. The contributors to this book are renowned scholars, artists, curators, and writers. Each address, in their chapter, some aspect of the 'Gordian Knot' of money, power and ethics that is central to our artworld.

This 'Gordian Knot' is salient to the artworld in the context of what the French Marxist theorist and filmmaker Guy Debord brilliantly calls the "society of the spectacle". It has huge metaphorical implications in the light of Trump's not unexpected victory – for those of us who have watched the decline of the US working and middle class over the past thirty years. Equally significant is Trump's general menacing psychopathic narcissism, and sheer ignorance. In a word, critic and journalist H.L. Mencken's acerbic views on US culture and democracy in the 1920s have come back to haunt us.[4] As many commentators have noted, including Sidney Blumenthal, Mark Danner, Philip Roth, and Don Watson, Trump's self-aggrandizing deviousness and mediocrity seem to have emerged straight from the core brute material of US culture itself.[5] Trump's literary forebears may be found in Sinclair Lewis' *It Can't Happen Here* or in Roth's 2004 novel, *The Plot Against America* or, earlier still, in Herman Melville's last novel, first published in 1857, *The Confidence-Man: His Masquerade*, which has a con man selling get-rich schemes to passengers on a Mississippi riverboat. For Roth, Melville's con man is Trump's most authentic archetypal precursor.

So, in terms of the nexus between money, power and ethics that characterises the artworld, we can see in bold surreal and incredulous detail the post-Fordist dynamic informing Trump's egomaniacal and laughably ill-equipped lust for the Oval Office. His 'Hail Caesar' ambition is evident in his recent 'executive order' mania: in one fell swoop Trump executed a series of orders that included: cutting federal funding to cities providing sanctuary to undocumented migrants; ensuring that funding to international organisations that provide advice to women about reproduction and at times provide abortions, is cut; eliminating environmental and financial regulations; and attempting to deny entry to the US (via airports) to people from seven select Muslim-majority nations. On the latter point, Australian social commentator Don Watson notes (as have many others) that Trump carefully selected these countries, which did not include Saudi Arabia, and various other Middle Eastern nations, so that his actions would not impact on his vast business interests in those countries. This illustrates the huge conflict of interest that characterises Trump's presidency, which, we must remember, was based not on the popular vote – Hillary Clinton received 2.8 million more votes than Trump[6] – but on the electoral college system.[7] Further, should we believe that Trump's victory was a clear resounding one without any profound resistance to it by pre-Trump Americans, let us not forget, as Watson reminds us, that Hannah Arendt's majestic 66-year-old *The Origins of Totalitarianism* recently sold out on Amazon.

Paradoxically, Trump's 'reality television' populism embodied the late Supreme Court justice Louis Brandeis' telling wisdom: we have to make a choice between democracy

and wealth concentrated in the hands of a few, for we cannot have both. Trump's self-absorption and unbridled self-aggrandizement were at the very centre of the 2016 presidential election, and now of the White House. As Lewis H. Lapham points out, the US deserved him as president because he was fabulously wealthy and therefore free to say anything: what to do to 'Make America Great Again', how to 'drain the swamp' of elitism and stupidity in Washington, and how to fix the disaster in the Middle East.[8] It has been, and remains, a spectacular 'fairground spectacle'.

Therefore, at the centre of our book is the enduring question of the dynamic and complex connections between money, power and ethics, in particular how they shape the artworld and its role in our increasingly polarised democracy. Is there a growing disconnect between the visual arts and the rising populism across the Western world? And how does Trumpism impact on American cultural life and the body politic and the world at large through social media, Fox News, reality television, the internet and so forth?

Unfortunately, as Yale University's David Bromwich noted recently, without the human faculty of moral imagination we can always be seduced by the will of the powerful and fail to recognise the nature of their actions.[9] This is emphatically the case with Trump's ascension to the White House. It is important to remind ourselves that moral imagination is crucial to the project of maintaining freedom in a society that is being trampled by the all-encompassing ideology of neoliberalism. Lamentably, this is as much the case in art and culture as it is in politics and society more generally.

Trump's attempts to dismantle Jeffersonian democracy included, of course, the elimination of four independent cultural agencies central to US art, the humanities and life: the National Endowment for the Arts, the National Endowment for the Humanities, the Institute of Museum and Library Services, and the Corporation for Public Broadcasting. All are essential to the nation's cultural infrastructure. In dollar terms, the cuts to these four cultural organisations would save only 0.006 per cent of the 2016 federal spending. But Trump's overall budget plans also included eliminating nineteen independent agencies, agencies that work in the fields of environmentalism, climate change, national indigenous affairs, abortion services, and regionalism.

His desire to scrap these major agencies appears to be predicated on the knowledge that they are critical, in terms of providing funding support, to a complex network of arts organisations, educational activities, museums, libraries and public broadcasters. Trump's wholesale destruction of these agencies is also, without any doubt, indicative of his endorsement of the 'trickle-down' supply-side economics and politics of Margaret Thatcher, Ronald Reagan and George W. Bush's administrations. Thatcher's famous mantra that "there is no such thing as society" has informed neoliberalism since the 1980s.[10]

On Australia's public broadcaster, the ABC, there is a unique television program, Q&A, where a live audience asks the panel questions around a broad theme or topic. On 13

March 2017, the theme was the 'Festival of Arts'. Film, theatre and opera director Neil Armfield and arts and media executive Kim Williams, time and again, superbly reinforced the truth that life without the arts is life not reached to its full civic, creative, democratic and political potential.

To believe that money, power and ethics are not centre stage, and thus crucial to expanding cultural and arts institutions, and the temper of our society at large, is simply, to quote Williams, "boneheaded and stupid". For as Winston Churchill famously quipped, "The arts are essential to any complete national life. The state owes it to itself to sustain and encourage them … Ill fares the race which fails to salute the arts with the reverence and delight which are their due".[11]

The present-day fetish for data-driven results and 'quantifying' the arts now extends to our art schools and more generally to higher education, particularly in the Anglosphere. As the American feminist, artist and writer A.L. Steiner has recently remarked, we must "resist technocratic educational models and analytical matrices"[12] in higher education. This neoliberal straitjacketing has created a grossly misconceived understanding of the role of the arts.

Oscar Wilde's view was that "All art is quite useless".[13] That is precisely why art matters and why it needs to be constantly supported by a cultural zeitgeist where creativity, critique, equity and experimentation are always possible for everyone. Simply put, the arts are 'useful' because they are beyond the ideological, linear, monocultural and panoptic constraints of quantification.

Tragically, contrary to this understanding of the arts, the recent wilful destruction of Sydney College of the Arts, arguably the most influential art school in Australia over the past forty years, by its host institution, the University of Sydney, serves as a case study in how neoliberalism has leached into public universities across the Anglosphere. From the first day of its forced amalgamation with the University of Sydney in 1990, as part of a 'reform' of higher education in Australia, the College came under attack from the University's neoliberal senior management. The current management (also tinted with a moralising Christianity) have engaged in a sustained attack on the College, using language that would make George Orwell blush. Inspired by the Occupy movement, a large group of principled students, who saw through the public relations smokescreen, stormed the Dean's office and administration building in late 2016, occupying them for 65 days. This led to the resignation of the Dean but ultimately the neoliberals won, leaving Sydney College of the Arts as little more than an empty husk.[14]

As US art critic and historian Hal Foster recently pointed out, theory and the role of critique have been displaced by the culture wars of the 1980s and 1990s.[15] And after 9/11, Foster argues, little attention or space has been given to critique in our universities and art museums.[16] Rarely do curators promote serious debate about the reception of what was once thought of as difficult art. The value of art is now

profoundly determined by the marketplace, and art criticism itself has consequently been, more often than not, dismissed as irrelevant. These times have thus often been described as being 'post-critical', as being too relativistic and not robustly pluralistic. 'Theory' has been deemed too rigid, passé, and rote.[17] The constraints created by our current conceptual, cultural, and historical, and political world have been welcomed and affirmed.

Our task in this book is to address, in a reflexive, informed and speculative way, the notion that our artworld is – intrinsically and extrinsically – shaped by the three-inter-connecting key forces; money, power and ethics.

We deal also with the question of aesthetic value, which is of course bound up with the political, and vice versa. As the American philosopher, Richard Shusterman has suggested:

> To understand or appreciate such value it does not seem necessary to base one's evaluation on vivid, direct experience of the artwork itself; one can instead concentrate on the work's effect and relationship in the social, political, or economic fields in which it is situated.[18]

Art has always been bound up, as the German philosopher Dieter Mersch notes, with ideas about knowledge and truth.[19] These notions were integral to Hegel's philosophy and were later explored by Theodor W. Adorno and Martin Heidegger. As Mersch rightly observes, Maurice Merleau-Ponty, discussing Cézanne, insisted that painting itself was a form of 'research' and that painters can be seen to be engaged in 'mute thinking'. Painting itself, Mersch suggests, can be seen as a kind of *theoria*, following the original definition of the word: a 'spectacle', or 'vision' that is intrinsically cerebral. In fact, art's specific mode of 'thinking' or speculating means that the viewer is grounded in art's 'worldly circumstances'[20] and anchored in the very concrete phenomena of our everyday life.

In recent times, art, as it has been taught and researched in the broader disciplinary ecology of our universities, has been provocatively defined as an essential epistemo-logical practice, a kind of aesthetic research. Critically, art always, Mersch argues, exhibits, portrays, performs and presents. What is important here is that all these practices embody the epistemic mode of *showing*.[21] And this showing becomes a continuous act of 'showing asunder' (*Zer-zeigung*). Hence 'aesthetic reflexivity' in art happens through making, and all its vital processes of *Zer-zeigung*. In other words, art's definitive capacity is to mirror, to turn back on itself, in terms of content, form, process, materiality, and mediality. It is not a question of the artist doing the reflecting, or the viewer: art's reflexivity announces itself in "leaps and bounds – passages without origin, transition or finality", manifesting as an event within the larger order of things.[22]

How is art to be experienced directly by the spectator in a society that is crowded with cultural, museological and self-interest groups all vying to produce ideas,

contexts and values for the making, exhibiting and manifestation of art? Where in this miasma does the artist stand, and how is he or she to be understood as someone who is, we hope, working in the enterprise of, to borrow George Steiner's useful expression, producing "grammars of creation"?[23] And how do artists and curators relate to each other in terms of being centre stage or in the wings (metaphorically speaking) of the artworld and its audiences? Is it the curator's job to be low-key, on the outskirts, or is it their job to be more high-key, at the centre of things? Despite the current proliferation of curatorial and museum courses, what is painfully evident is the ascendancy of corporate managerialism in determining the curator's *modus operandi* and *raison d'être*. This has had a pernicious influence on what artists produce, and on how they are curated, promoted and valued by all of us who seek and support art that is not banal or decorative, but is full of critique and curiosity about our world and everything in it.

Critique is required when examining the aesthetic, cultural and historical complexities of the contemporary art mainstream. Despite its having being (as Foster has argued recently) deployed in the last few decades with mixed and limited success, we need to not only enunciate critique but to intervene, to take it somewhere else, because the relationship of the critique to the aesthetic has become more complicated in the era of spectacular hyperreality, hubbub, climate change, globalisation, perpetual war, and massive population turbulence.[24]

Who Runs the Artworld is based on the belief that money, power and ethics are critical compass points of our artworld that need constant scrutiny if we are to continue to demystify the myths, and the class and political interests, that shape our art, culture and society. We need a continuing inter-disciplinary enterprise of critique that involves thinkers as varied as Bruno Latour, Jane Bennett and Jacques Rancière, amongst others, who illustrate a continuing self-questioning examination of their own aesthetic, epistemological and cultural baggage.[25] We hope that our book underscores the theoretical complexity of such an enterprise and reinforces the view that ours is an era of hybrid intellectual, cultural and social complexities, differences, interests and ambiguities. As Foster puts it, "now more than ever, no clear line exists between the human and the non-human, the cultural and the natural, the constructed and the given, and ... we need a language, an ethics and a politics to address this complex condition".[26]

All our eminent contributors have, in their own ways, endeavoured to discuss the many links between money, power and ethics as they are manifested in the artworld. Above all, our contributors have rigorously and imaginatively investigated their subject, taking a sceptical, self-questioning and anti-disciplinary approach and focusing on their knowledge of their topics. Essentially, all of us concerned with creating, disseminating and analysing art in and outside our professional contexts, and living in a world that is in a state of constant emergency, need to appreciate how our world is fundamentally impacted by the everyday machinations of this ubiquitous 'Gordian knot' of money, power and ethics.

This was perfectly illustrated, for example, with the protest performance *Human Cost* at the Tate Britain's Duveen Gallery in 2011, where a woman was covered in molasses (read symbolically oil), while lying in a foetal position on the museum's floor. This performance was a protest at British Petroleum's sponsorship of the museum. The image of her performance, which is on this book's front cover, is a vivid example of Victor Burgin's concept of 'guerrilla semiotics' at play and can be examined in the context of the Occupy movement, and the events of Occupy Wall Street.

The remainder of our introduction will focus on the contributors to the three parts of our book; money, power and ethics. The writers in each section have been placed in alphabetical order. All our contributors are cognisant of the importance of the topic they are discussing, and understand, as we do, that art in itself is forever situated in, to use US art critic and poet Barry Schwabsky's fitting term, "the unfinished present".[27]

Part I: Money

In the first section, there are four chapters. Each chapter highlights the importance of money's long-term impact on how artists cope, function and execute their art-making in our post-Fordist economy. It also considers how art is exhibited, distributed, funded, and received in the many public spheres of critical reception – both those with, and those without, government funding and support; and whether or not artists can sustain their art practices in their lifetime. These chapters also explore how money shapes the concerns of the various institutions and interests of the artworld: museums, galleries, art academies, art critics, and the government agencies that support the arts.

Bruce Barber's chapter is titled "Quoi ou quoi (who or what) rules the artworld? Taking care of business. The art curator as hedge fund manager to the artworld's Ponzi scheme". Barber has given us a highly incisive, detailed and perceptive critique of the curator as delinquent, and as a hedge fund manager. He traces the fundamental question of who runs the artworld to the 16th century, with Pope Leo X (Giovanni di Lorenzo de Medici, 1475–1521), a member of the powerful Medici family and a patron of the arts, particularly poetry, painting, architecture, music and design. When he was elected Pope Leo X, he is believed to have said, "Since God has given us the Papacy, let's enjoy it". Over the centuries since, the question of who runs the artworld has become complex, especially with the emergence of modernity in the 1860s, with its acknowledgement of the aesthetic, socio-cultural and political factors that connect art, capital and power.

If we accept, as Barber suggests, that the role of the curator has always been a dominant site for struggles over control and power, then perhaps the curator is no more delinquent than the artist, critic, or museum director.

Today the artworld's politico-economic structure has transformed into a huge Ponzi scheme, with artist players, payers and prayers at its base, and symbolically and economically going upwards, with the holders of the actual capital and the symbolic capital at the top of the pyramid. As there are now key art stars, gallerists, collectors, art historians and so forth, it follows that the curators have become hedge fund managers, leveraging symbolic capital in the artists and the works they curate. And by 'short selling', they minimise art market risk.

By doing this they define their own market value as artworld gatekeepers and power brokers. And before 2008, a few curators, like many of the Wall Street hedge fund managers, indeed had the (art)world at their feet. As we all know, since then they have both suffered and profited as a result of the economic downturn.

Barber explores the hypothesis that the curator may be likened to the hedge fund manager with particular emphasis on the various curatorial practices affiliated with international biennales, and proposes some challenges to certain contemporary curators whose aim seems to principally be to promote art exhibitions as sites for social criticism. Barber focuses on some of the more visible curators, such as Biljana Ciric, Travis Chamberlain and Shihoko Iida, and most closely on the curatorial team at The 2nd Roma Pavilion, 'Witness', at the 2011 Venice Biennale.

Our second chapter is "The Valorization of Art: what artists are up against", by Peter Booth and Arjo Klamer. The authors comprehensively discuss how artists and their practice are inevitably defined by the various systems of governance and the markets of their everyday life. In particular, they are concerned with the various coping mechanisms available to artists as they confront, resist and encounter the obstacles and conflicts in their trajectories as artists. Booth and Klamer deftly dissect the ways in which artists are themselves located between contexts of creativity, exhibiting, funding, and critical reception, and analyse the salient issues and questions artists face as they endeavour to cope with their own lifeworld.

The authors argue that there are five spheres of value or valorisation, with five distinct logics, that artists have to deal with. Initially, all artists start in their own homes, or what the ancient Greeks called *oikos* – this reflects the fact that artists require the emotional and financial support of their parents from the very beginning of their careers. This is most significant, in that it gives the artist a very sustainable grounding in trying to survive as an artist. The second logic is the cultural logic: what kind of genres, forms and contexts will the artist be working with. Overall, this refers to what kind of artistic conversation they will engage in with their peers, their networks, their endless clubs and groups. Critically, the authors note, it is the interaction between the social and the cultural logic that creates art. It is both an ongoing social and cultural practice; a life-long conversation, and at the same time, a creative commons that all of us can share.

Booth and Klamer then explore the market logic, which is decisive in giving the artist's practice its commodification status. This logic is paramount in relation to how artists intellectually, emotionally and ethically react in reference to compromising (or not), once their art is reduced to commodity status. Some artists, such as Damien Hirst and Jeff Koons (both examples used by the authors), take advantage of the market logic. Others, such as Ian Fairweather, the reclusive Australian artist, react quite differently to the commodification stage of artmaking. As a basic rule, most artists use all logics and spheres in the continuing process of the valorisation of their art practice. Valorisation that takes place across all spheres may also, and often does, produce anxieties, clashes, compromises – the valorisation artists seek can be very problematic in character. Booth and Klamer aptly quote the Roman philosopher Marcus Tullius Cicero's wise concept of *summum bonum,* which refers to the end that artists are ultimately looking for: to support their art through government or market spheres, as long as they are not compromised in doing so.

The next chapter, "What do Artists Want? Re-reading Carol Duncan's 1983 essay 'Who rules the artworld' in 2017", is by New York-based artist, activist and writer, Gregory Sholette. He poses several critical and challenging questions about Duncan's monumental feminist and Marxist critique of the art market in the early 1980s – and, of course, about the assumptions, concerns and methodologies of the traditional art history discipline and its capacity to be relevant to today's socio-cultural and political turmoil, oppression and deception.

For Duncan, as Sholette points out, the disconnect between academic discourse and the real-world politics was quite startling, as her academic art history peers, as well as artists and curators, simply ignored her trenchant essays for journals such as *Artforum.* Duncan's stinging, well-informed and well-researched essays, focused as they were on central issues such as patriarchy, class, fetishism, spectatorship and power, fell on deaf ears.

Along with a number of other artists, Duncan helped establish an interpretation of art history rooted in social agency first, and objecthood or iconography second. She also incorporated themes from Antonio Gramsci and Raymond Williams "Who rules the artworld", referring to a need for 'failed' artists as part of the mechanism of the art market. To put it another way, there is a proletariat of artists from whom, curators, the agents of the market, can pick and choose.

In the three decades since her essay was published, the artworld has grown in both size and economic value, while simultaneously incorporating many aspects of the institutional critique Duncan and others raised, including seeking to make art history more inclusive of social realities. Nevertheless, the fundamental question that "Who rules the artworld" asked – who is permitted to be taken seriously as an artist and under what conditions is something even considered art? – remains. Sholette's essay attempts to explain this seeming paradox by proposing the emergence of a new cultural reality, best described as 'Bare Art'.

He argues, persuasively, that we now live in a world of artistic dark matter that makes up the bulk of contemporary art, and is primarily invisible to those who claim a monopoly on the interpretation and management of culture: the critics, curators, art historians, dealers, collectors, and arts administrators. We are confronted with a unique combination of rebellion and riches in our artworld, which has, remarkably, integrated into global capital. Essentially, we have (after Giorgio Agamben's famous term, 'bare life') a new bare artworld that is at the same time claustrophobic and extremely volatile.

Sholette's 'dark matter' perspective has magnified in importance since the Occupy Wall Street events of 2011, which took place in the wake of the Arab Spring. Since then many new art activist organisations have sprouted, including Art and Labor, Working Artists and the Greater Economy (WAGE), Gulf Labor Coalition, Occupy Museums, Liberate Tate, collectively asserting a sustained moral position, as well as (often) taking direct action, and demanding that the artworld become a better all-round world citizen. For example, after years of steady protests by the environmental justice art collective Liberate Tate, the Tate Modern has vowed to no longer accept funds from British Petroleum.

John C. Welchman's chapter, "Gift Vouchers: Giving and Rebates in the Age of Appropriation", is an incisive, erudite and perceptive discussion of the latter half of the 1980s and the early 1990s, when the dominant avant-garde art discourse in New York focused on questions of appropriation, commodification, media imagery and the market, on the one hand, and on the other, on an extremely significant critique of the commercial and social institutions of that era. Welchman looks closely at the 'bookended' objects of Mike Kelley's soft animal piece *More Love Hours That Can Ever Be Repaid* (1987) and the 1993 *Art Rebate /Arte Reembolso* project by three artists living in the San Diego area at that time – David Avalos, Louis Hock and Elizabeth Sisco.

Welchman notes a significant impulse in Kelley's oeuvre that attempts to unpack the fundamental dichotomies – health, security, cleanliness and general wellbeing on one hand, and impurity, sickness, peril and suffering on the other. What Welchman observes in Kelley's work is a 'deviant meta-morality tale' that endeavours to critique and articulate past attempts to locate social morality in natural law (in the context of the work of Marcel Mauss, who advocated for a "return to the ever-present bases of law") and to deal with development narratives and their origins in the basic anthropology of the gift, or various psychological economies of children and infants. Mauss' ideas about the usefulness of the gift economy, Welchman reminds us, were a direct counterbalance to capitalism's preoccupations with money, markets and buying power, and can be seen as a serious attempt to reprocess natural law through compensatory 'social policy' or legislation of the 1950s and 1960s, when Kelley was growing up.

As the author observes, Kelley's very last major large-scale project was *Mobile Homestead* (2006–13) which was concerned with the conditions and maintenance of a healthy body and, as a corollary, a healthy citizenry. The work engaged with a

growing dramatic schizophrenic impulse, and sadly, the artist became fatally suscep-
tible to it. He became obsessed with setting up dangerous activities that were
secretive, subjective and instinctive.

Part II: Power

The role of 'power' in the contemporary artworld has increased dramatically during
the last three decades or so, with the emergence of the 'art star' – now its most
definitive and ubiquitous characteristic. Historically speaking, power in the artworld
became more evident with the rise of modernity in Europe. One of the first to observe
its significance in the visual arts was the poet Charles Baudelaire, in his *The Painter of
Modern Life: And Other Essays* (1863). By the early 20th century, power in the artworld
became even more prominent with the development of public art museums,
galleries, curators, critics and collectors. Patronage and criticism emerged at the same
time, and had a huge impact on power in art. With the international art biennales of
the last few decades, this power has become profoundly significant.

Since the late 1960s and the emergence of the curator as creator or auteur, curators
have become an integral part of the art star system: they can be artists' touts, their
mediators. But the intricate (in)visible interconnections between curators, institutions,
benefactors and artists have remained largely unexplored. The curator's hegemony
in shaping the concerns and direction of much of today's contemporary art is at least
in part the result of the dramatic increase in the numbers of exhibitions and
permanent collections on show. Finally, power is inextricably connected with money
and ethics. When we speak of power in the artworld we are often referring to many
of its synonyms: intrigue, deception, collaboration, gossip, manipulation, corruption,
and so forth.

Michael Birchall's chapter, "The Precarious Nature of Curatorial Work", is a compre-
hensive, perceptive and informative account of how curators working within and
outside the museum in the last twenty-five years have been forced, like artists, to
reconsider their role in the system of artistic production and the global knowledge
economy. Their conditions of labour and role have changed, and their professional,
social and existential worlds are now coloured by precarity.

Thus, curators associated with art museums, biennales, galleries, and independent
curators, are increasingly forming vital working alliances with artists and performing
a central role in the actual creation, mediation and dissemination of ideas. Further, the
precarious and difficult circumstances of their work as curators means that many now
need to supplement their income with teaching, publishing and other kinds of
creative work.

Relatedly, there are independent curators who also now become 'guest curators' for
museums and galleries that wish to exhibit ideas, exhibitions and events that will

bring in new audiences. This has meant, in certain situations, according to Birchall, that independent guest curators may work for cultural institutions such as the Kunst-Werke Institute for Contemporary Art in Berlin. They work without pay in the hope that they will increase their future employment prospects by being affiliated with such institutions because of their 'reaching out' exhibition programmes. Young curators, are currently under immense pressure to create innovative programmes so that they may have a successful global career. This has led to more and more curators working with artists – and they have invested as much in the artists' careers as in their own. Thus, there are now many collaborations between curators and artists: organising exhibitions and developing new ideas and practices for the artists.

However, the curator's position as a cultural producer gives them substantial authorial privileges and powers that are not given to the artists themselves. In other words, curators have become 'gatekeepers' to the artworld, and in so doing they have accumulated symbolic capital, and have created roles for themselves in defining certain elements of artistic production and mediation. According to the French artist Daniel Buren, this has meant that the artist has now been transformed into a 'meta-artist'.

The changes in contemporary curatorial practices started to emerge in the context of the neoliberal market economy, during the last three decades. Particularly, as Birchall observes, since the 1960s and early 1970s with the manifestation in Europe (especially in France and Italy) of *operaismo* or *workerism*. With the post-Fordist economy and the concomitant increase of 'immaterial labour', artistic practice and the art system changed. Artists, curators and arts administrators, were, like everyone else, influenced by the consumer-driven open networks of services, and stopped using the linear model of seeing the world as primarily grounded in industrial production.

The next contributor is Juli Carson. Her chapter, "Libidinal Economies", acutely analyses art (from a Lacanian perspective) and its changing presence in our culture since 9/11. She specifically focuses on art in successive bull markets and, especially, on how art and economics are libidinal economies that have immense aesthetic, cultural, psychic and political implications and consequences for anyone involved with them.

She begins her critique with the voices and actions of the post-2011 Wall Street Occupy group, Strike Debt. Carson considers their political intervention, which aimed to investigate and expose one substrate of financial capitalism – the secondary debt market – and how bankers, brokers, traders and investors make obscene profits from others' debts. The Strike Debt group intervened in this secondary debt market by buying bundled debt and absolving the debtors.

Strike Debt's intervention is a classic example of what Michel de Certeau calls a tactic versus a strategy. A strategy is when a bearer of will and power (such as a bank) can be isolated from an 'environment'. This strategy produces a new set of relations with external entities such as competitors, clients and, in Strike Debt's case, borrowers. A

tactic, however, is something radically different, in that it lacks a regular spatial or institutional location. Nor, as Carson says, does it have a borderline delineating it from an exterior other. Instead, the place of the tactic *is* the other. The Strike Debt group, like many other post-2011 Occupy Wall Street artist-activists, has to be flexible and seize its opportunities on the wing. This has enabled many artists, cultural producers, curators, activists to intervene in the artworld and provide it with new ideas, artistic productions, exhibitions and programmes. A further example of this is the development of 'pop up' art exhibitions curated in abandoned buildings or buildings ripe for redevelopment, in cities such as London, New York, Berlin, and Sydney.

Over the course of the 1980s bull market, the NYSE (where the selling and buying of securities, currency and commodities took place) and the artworld (where critiques of Wall Street culture were developed and scripted) two distinct economies located in two different physical locations. The former was supposed to be rational, mathematical and regulated, the latter libidinal, creative and subversive. However, that was not really true. The artworld, in fact, was just the bohemian substrate of the real deal, the bottom line, of the financial market. In gastronomic terms, the Odeon Café was the physical location – the centre of mass – where these two celestial bodies, art and finance, effortlessly orbited each other with near mathematical precision. The aesthetic and economic spheres shared a gravitational pull because they were – and still are – libidinally and inextricably connected.

Art stars such as Julian Schnabel, Robert Longo and Jeff Koons and others tango danced with star dealers and gallerists such as Mary Boone, Larry Gagosian and Tony Shafrazi in those halcyon days of postmodernism. Curators and gallerists, artists and arts administrators, all versed in European theory, were the order of the day; theorists such as Guy Debord, Jacques Derrida, Julia Kristeva and Jean Baudrillard saturated the contemporary art discourse and the zeitgeist of that ahistorical, hyperinflated, disorientated, schizophrenic, fragmented and hyperreal era. Carson boldly dissects the issues around the connections between the bull markets of Wall Street in the 1980s, 1990s and the following decade, and the debates between Jean-François Lyotard and Fredric Jameson in the mid-1980s. She also analyses the debate between Theodor Adorno and György Lukács around the very influential exhibition curated by Lyotard – *Les Immateriaux*, in May 1985, at the Centre Georges Pompidou in Paris.

Adam Geczy's chapter, "The Task of the Curator", cogently and authoritatively explores today's curators' many challenging ethical and political issues by adopting Walter Benjamin's thesis, that art ideally is never created for the viewer and the public in mind, but for its own general existence. Geczy maintains that the curator is keeping with Benjamin's argument, basically being a translator between the artwork itself and the public. This means that curators have since modernism became powerful ideological actors in the artworld, deciding who is selected, and how their art is exhibited, discussed and received in everyday life. In the last three decades in particular, curators have accumulated power. Those who work with large funded art

museums and institutions, particularly, wield enormous power in shaping taste and culture.

With the immense acceleration of biennales and art fairs since the 1990s, we have global curators, and an ethical dilemma: should one be mindful of not offending or disturbing the sponsors and benefactors who fund these art museums and biennales? Art has been transformed into a vast entertainment-industry-complex where the emphasis is on audience numbers, not critical debate. Audiences are, according to Geczy, "coddled rather than challenged". Following Benjamin's 1923 "The task of the translator", Benjamin asserts that if a curator tries hard in his or her "translation task" of attracting the public then they have made a very problematic or indifferent translation. What we have today, Geczy states, is curators lusting after huge audiences, thinking that this suggests excellent curatorship.

So, the question remains, what is the critical task or objective of the contemporary curator? Geczy does a brief genealogical reading of the history of curatorship, tracing its trajectory from its earliest beginnings in the Middle Ages to the present. Fundamentally, the curator's task shifted from being a keeper or guardian in the Middle Ages to being a custodial mediator between art collections and their major modes of display up to the 1980s. This is when we witness the explosion of global art practice and the curator, to paraphrase Geczy, becoming a mediator of artists and their publics as well as of static objects.

Finally, Geczy writes about two seminal figures of modern curating and curatorship, Kenneth Clark and Alfred Barr. The former was the director of the National Gallery in London during World War II and a highly influential television broadcaster on art and culture. Barr was the founding curator and director of the Museum of Modern Art (MOMA) in New York and responsible for developing the idea of curated programming for art museums.

Crucially, the global curator highlights the complex binary between curating as a part of traditional art history education and curating art as a form of entertainment in our era of global pluralism. In short, between curating as the dissemination of speculative critical ideas or basically as entertainment and theatricality.

Brett Levine's thoughtful account of modern curating, "Because We Can: Curatorial Intervention at the Intersections of Intention and Reception", is the result of his encountering an exhibition where a portion of its exhibits were installed in the traditional linear style of presentation and the remainder were salon-style, floor to ceiling, edge to edge. When the exhibition's curator was asked "How could you do this?" the reply was "We do it this way because we can". The exchange illustrated the role of autonomy, agency and power in the shift from artist-driven intentionality to curator-mediated interventionality.

For Levine, these two poles represent in a nutshell the two kinds of modality for exhibition-making today. At one end of the spectrum, the author states, is the overall

frame of Anglo-American and European reception theory, where the concepts of intentionality and reception are to be found. This includes the work of influential theorists such as Hans Robert Jauss, Wolfgang Iser and Roman Ingarden. And at the other end, we have something which is entirely different and difficult to define: as Levine's suggests, what it is not is the unmediated space between intention and reception, although it requires a detour through reception theory to illustrate why.

Simply put, reception theory, according to Jauss, emphasises a *lack* of shared experience between the artist and the viewer. Once the artist has executed the artwork and releases it to the public sphere of reception and withdraws, the viewer never encounters the artist. Instead, the viewer brings all his or her critical and interpretive resources and experiences to the encounter with the artwork in question. So, the viewer can never know what the artist intends, and vice versa, the artist never knows what the viewer receives. What occurs is already mediated. Although one person can occupy the two positions of an artist and viewer, they can never do it at the same time.

Reception theory can only work in the form of a duality, without the presence of the curator, and its dialectic is one of intentionality and reception. With the expanding power of the curator in the artworld in the last few decades, a new journal has emerged: *Exhibitionist*. It is devoted to a systematic analysis of these issues and the relationship of curating to reception theory. Its inaugural editor, Jens Hoffman, advances the thesis that the act of curating is one of intervention: of limiting, excluding and producing meaning by utilising codes, signs and materials.

The *Exhibitionist*'s theoretical genealogy can be traced back to the French film journal *Cahiers du Cinéma* and the theory of auteurship. The idea of curatorial authorship, which is disturbing for artists, in terms of authority and empowerment, first surfaced in 1972, with Harald Szeemann's ground-breaking documenta 5. In response to this, a number of artists signed a petition against curatorial autonomy, wishing to return the artist's intention to centre stage so that viewers' experiences would be aligned with the intentions of the exhibiting artists.

Curatorial intervention is now manifested in many different ways: curators may encourage artists to produce or reproduce different artworks; curators may alter, change, or amend the contents of artworks and their contexts; and curators may simply recontextualise artists' artworks.

Part III: Ethics

The troika of money, power and ethics that rules the contemporary artworld begs the question: 'What ethics?' This question has exponentially become increasingly significant during the last few decades for aesthetic, behavioural, cultural and economic reasons, and we hope that *Who Runs the Artworld* goes some way to

illuminating, in a nuanced, informed and critical fashion, the paradoxical character of our three interlocking themes. Most recently, ethics have been brought into sharp public relief with the election of Donald Trump as US President. His refusal to release his tax returns and his explanation (after his election) of how his business empire will be organised so that there will be no conflict of interest are examples. His plan to make his business dealings transparent and ethical were described by Walter Shaub, head of the US Office of Government Ethics, as "meaningless".[28] What does it mean when the 'leader of the free world' not only flouts the conventions of office but is being accused of violating the US Constitution? This behaviour sends a clear signal to all that it is now open season on ethics.

If we agree with Oscar Wilde's statement that "art is the most intense mode of individualism that the world has known", we need to ask ourselves exactly what role artists, curators, art historians, critics and writers have played in allowing the artworld to become a place of increasing clamour, hypocrisy, pervasive dissimulation, and unbridled neoliberal ideology?[29]

What role have careerist curators played in sustaining the 'art star' economy of exhibition, production and critical reception? In the growing, and stifling, conformity of our art museum and gallery world? Many gifted artists (both 'emerging' and 'mid-career', to use the cultural or curatorial term) choose to not engage in this world – primarily, we are told, because of the amount of energy required to be part of the 'scene and herd' crowd (to echo *Artforum*'s witticism) – and so are invisible to the public gaze.

This truth is evident to anyone who has even a passing familiarity with the curatorial, funding and ideological complexities and biases of the artworld, where to say that 'the emperor is naked' leads immediately to being categorised as 'difficult', a 'trouble-maker', a 'stirrer', a 'pariah', a 'ratbag', someone who is rocking the boat. In 2000, the Peruvian Nobel Laureate Mario Vargas Llosa captures this:

> Often the most talented artists have no way of reaching an audience, whether because they refuse to be corrupted or because they are simply no good at doing battle in the dishonest jungle where artistic successes and failures are decided.[30]

Vargas Llosa was prepared to call a spade a spade, to acknowledge the ruinous hyperbole of our times, to say that artists themselves are also gridlocked in this institutional whoredom. Those among us who are cynical and opportunistic may be oblivious to the necessity for every artist to continually question everything, and to stay with their ideals as an artist or a curator – this is a permanent struggle, and the fight takes knowledge, technique, passion, patience, curiosity and a generosity of spirit. It is certainly not achieved overnight, despite what our 'reality television' shows may say to the contrary.

Who among us appreciates that in order to succeed as a curator or as an artist, one must accept and value the need for reciprocity between tradition and

experimentation? As Vargas Llosa puts it, we who curate, create and promote art must surrender to ideals that contribute (ideally) to one's vocational calling.

Of course, it would be terribly unfair to blame only curators for this, as artists, critics, academics, gallerists and spectators are, in their own ways, just as responsible. However, in the main, it is curators who seek stardom at the expense of the artist (who, after all, is the vital base of the artworld food chain) and who should shoulder most of the blame.

This critique aims to speak of what is not said about the flourishing corporatized museum culture that is in place throughout the West and Asia, where art museums function like royal courts in which curators produce a highly visible class of 'indentured' artists, who then act like courtiers – though courtiers whose works are dependent upon these curators. This highly problematic situation not only leads to a small group of artists parading their wares, time and again, around the same circuit of exhibitions and to the same critical reception; it also produces a crushingly boring spectacle of art as entertainment. It produces art that is empty of the ideas, forms and contexts we need if we wish to ignite our imagination, question our own times, and engage in sincere, informed and reflective dialogue with the past.

Amelia Jones' "Bodies for Sale: New Prologue to 'The Contemporary Artist as Commodity Fetish'" primarily explores the intersection between artists' self-imaging strategies and the marketing of the artist as commodity through the notion of fetishism (photographic, racial, sexual and commodity). In her cogent and informed critique Jones provides numerous examples of artists who perform in ways that make it difficult to categorise them, thereby producing mutable selves that cannot be easily fetishized.

This chapter is Jones' re-examination of her 2004 article "The contemporary artist as commodity fetish" and she begins by criticising the romanticized approach of author Christian Viveros-Fauné, to artist Marina Abramović's 2010 restaging of two previous performances: her 2005 *Seven Easy Pieces* at the Guggenheim Museum in New York, and 2010's *The Artist is Present*, an exhibition and live performance at the New York's Museum of Modern Art. The article critiqued Abramović's limited view that she was 'fully' present and available to visitors. Abramović insisted that 'presence' itself signifies something spiritual and metaphysical, but in reality, Jones argues, the term itself cloaks the workings of capital, and presents an illusion: value that is meant to be inherently transcendental rather than invested in economics.

Since 2004 Jones has observed a shift in the artworld from seeing itself as the way in which artists can create and circulate their work and/or, in effect, deconstruct their identities "as creative origins", to an interest in the capacity of the *live* body to either undermine or ratify these circuits of value. Abramović's *The Artist is Present* illustrates perfectly the many ways a live performance and an artist's body can be spectacularised and commodified – paradoxically, as signifiers of authenticity. The author

posits the view that from the 1970s to the 1990s, the artists cited in her 2004 article used technologies of representation to depict the subject through the circulation of images. Not even the concept of 'subjectivity' is of any real theoretical use, according to Jones, as we have come to the realization that we have to deal more with the simulacrum quality of all embodied experience, including representations of 'live' performance. This suggests that performative artists such as the radical queer s/m performer Ron Athey and others must resist selling their bodies as an image or art, and move forward in a culture that is 'colonised by corporate capital'.

Ian McLean's lucid, comprehensive and persuasive chapter, "Lost causes and inappropriate theory: Aboriginal art it's a white thing and other tales of sovereignty", discusses the many intricacies of Aboriginal art in the context of postmodernism, globalism, the marketplace ideology of post-colonialism, and the shifting concerns, tensions and tropes of the contemporary artworld as first described by Arthur Danto, among others. The chapter details the ongoing decolonising narrative of Indigenous art in the context of the nation state, from 1945 to 2000 and onwards. At the core of the author's account is the perennial presence of the tension between the open egalitarian inclusiveness of the *demos* and the fashionable exclusiveness of fine art in everyday life. For McLean, the key question posed at the inner sanctum of the artworld is 'What is sovereign: the artworld or the demos?'

The author looks at the work of certain significant non-Indigenous artists such as Imants Tillers, and Indigenous artists including Brook Andrew, Richard Bell, Gordon Bennett, Vernon Ah Kee and Tracey Moffat. McLean discusses the differences and commonalities between African art and Indigenous Aboriginal art from the past century to the present one. He argues that the divergence between the two first started in the 1990s, when a new generation of African critics and curators – who embraced the transcultural dynamics of globalism and left behind the project to locate essentially African modernism – emerged. In contrast, Indigenous and non-Indigenous critics and curators of Indigenous art subscribed to discourses that centred around challenging issues of Aboriginality, ethnicity and sovereignty.

McLean's chapter is also predicated on the different theoretical approaches of Jean-Hubert Martin and Okwui Enwezor, in the context of four specialist Indigenous art curators: Djon Mundine, Margo Neale, Hetti Perkins and Judith Ryan. And importantly, it poses a critical question: What can these curators of Indigenous contemporary art learn from the success of Enwezor?

Jennifer McMahon and Carol Gilchrist's contribution, "The Space of Reception: Framing Autonomy and Collaboration", is a very concise, engaging and informed account of the aesthetic considerations that determine the common style of exhibition in our galleries and museums today. They argue that unless modern audiences are actually empowered to give meaning and significance to artwork through critical dialogue, the power of the audience itself is undermined and so is that of the art. The authors advance the thesis that unless indeterminacy is negotiated

and understood, then what is facilitated is the critical rather than the coercive character of art, and without the conditions for inter-subjectivity being provided, galleries and museums will determine an experience that is sadly devoid of art.

The authors make their case by relying on the major aesthetic, cultural and philosophical ideas of T.S. Eliot and – especially, in some detail – Stanley Cavell. They discuss the artworld primarily in terms of contemporary art being constructed as cultural information, as brands defined by popularism, and finally art in relation to cultural pluralism.

Certain museum traditions are based on assumptions that grew out of the humanism of the Enlightenment. The dominant idea of education was, according to the authors, part of the *raison d'être* of the museum. However, curators have now become entertainers in the artworld, simply because of the increasingly commercial nature of the museum. Many contemporary artists are striving to resist the appropriation of their artworks in these mercantile contexts by using new media, which problematizes the museum's cultural authority and power and, by and large, resists the fetishization of the artwork as a precious object.

Their chapter considers ideas that have been decisive in determining new museum practices and the resulting requirements imposed on curators, in order to illustrate the palpable tension between artists' expanding autonomy and the museum. By using examples from Australia and Germany, McMahon and Gilchrist demonstrate how artists are restructuring the space of reception so that they can have a more effective show and collaborative relationship with their audience.

Stevphen Shukaitis and Joanna Figiel's "Watermelon Politics and the Mutating Forms of Institutional Critique Today" is a polemically sharp, perceptive and illuminating examination of the changing modalities of today's critiques of institutions. Their chapter is an account of how the critique of institutions has been renewed by the rise of social media and new political formations, all of which are raising many questions about the concerns and operations of contemporary art institutions. The groups they discuss include the Precarious Workers Brigade and Working Artists and the Greater Economy, which problematize unpaid cultural and artistic labour, and Liberate Tate, with its constant questioning of the Tate Museum's sponsorship by British Petroleum.

These examples can be interpreted in terms of the ethical and political conflicts and problems that were first evident some years ago, with the rise of the critique of institutions itself, but at the same time, new concerns and emphases have manifested more recently. Crucially, Shukaitis and Figiel note how these new manifestations of the institutional critique exhibit what they call 'watermelon' politics: they deal with the more visible concerns of ecology and sustainability, but the important issues of labour and production, which exist at a much deeper level, remain.

The authors suggest that what we are seeing now is different layerings and expressions of these questions of ethics, labour, sustainability and precarity. There are even

questions about the very nature of the institution, as its parts often operate concurrently and clash with each other. All these new perspectives and issues revolve around the perennial question: who runs the artworld and for whose precise benefit?

Perhaps one of the more outstanding examples of the new expressions of institutional critique is, according to Shukaitis and Figiel, Yates McKee's recent book *Strike Art: Contemporary Art and the Post-Occupy Condition*, which asks those working in the artworld to consider the available resources strategically, for the purpose of creating political rupture. Shukaitis and Figiel suggest that critique can then be applied to art history, and connectedly to art history's canonisation of particular critiques.

John von Sturmer's chapter, "Art scene, art scene, sweet especial art scene: As the world comes to us thus we come to the world" is a far-ranging, autobiographically framed, playful meditation on the aesthetic, ethnographic, cultural and historical complexities of today's artworld. The author speculates on the multilayered interdisciplinary character of art history, anthropology, aesthetics, literature and sociology as they apply to the artworld in our public and private lives. He examines the three poles of artwork (past, modern and contemporary), the artist him or herself, and the very idea of art. He discusses art as play, art as display, art as waste and excess, and art as 'ooh-ah', the gasp that is so characteristic in the hyperbolic, simulacral, volatile artworld.

More and more, he suggests, the focus is on the artist as producer/entrepreneur. Self-promotion has become the *sine qua non* (a thing that is absolutely necessary) of art production. Therefore, we are obliged to ask, how stable, permanent, is the artworld? Von Sturmer wittily suggests that he wishes for a 'Museum of Fake Art', as the fake is emblematic of our age, especially once we recognise the availability of the image on the internet.

Von Sturmer discusses whether there is an art 'scene' at all. Who are its actors, who 'buys it', and how dependent is any kind of culture on the art scene? What is the relationship between a scene, no matter how one defines it – maybe, as he suggests, as a 'a loose confederacy of [the] interested' – and its bureaucratic parallel? And where does the academic belong in all of this?

We might also want to believe that 'being-in-art' is a particular way of engaging with the world. If art is one way of being in the world, how does any specific engagement with it speak of what we might describe as a world condition? Can we talk about a 'Great Wall of Art' where art production is as relevant to coherence, to making sense, as it is to being 'wilful and wayward'? These are some of the questions and issues Von Sturmer raises in his fascinating chapter on the artworld as it is located in our world at large.

Some Final Thoughts

Who Runs the Artworld: Money, Power and Ethics examines, using transdisciplinary concepts and methodologies, the aesthetic, economic and power mythologies and structures of today's global artworld. The main aim of the book is to unmask the interconnectedness of art, economics and power, and to delineate the implications of this. All the contributors have experience of the artworld and of the tension between economic value and the value of culture, or the cultural object. Moreover, all the contributors also share an aim – to deconstruct the artworld's underlying cherished doxas, mythologies and economic power structures.

We seek to disseminate knowledge and perspectives in the academy, in scholarship that 'speaks to power'. We hope our book underscores the ways in which cultural, economic and ethical standpoints can challenge popular views and values of the artworld, the art market and contemporary art scholarship, and illustrates how art, power and economics are intimately interwoven.

It is a complicated and challenging subject to address at this time. With the immense socio-cultural, fiscal, ecological and political upheavals in Europe, the US and elsewhere, it behoves us all, as global citizens, to find – or in fact to establish – a world that is more equitable, democratic and sustainable.

As Theodor Adorno and Max Horkheimer argued in a recently published 1956 dialogue, which took place over three weeks, the mark of authentic thought is that it "negates the immediate presence of one's own interests".[31] To do this one needs to bring out the utopian in a world which militates against doing so. All of us, regardless of who we are and what we do, need to be able to recognise and value the contradictions, tensions and fault-lines within and between our occupational lives and our private lives, to see the benefits of not separating theory from practice, life from art.

Notes

1 John Berger, *Ways of Seeing* (London: Penguin Books, 2008), 154.
2 Ian Buruma, *Theater of Cruelty: Art, Film, and the Shadows of War* (New York: New York Review of Books Inc., 2014), 410.
3 Jean Cocteau, *The Difficulty of Being*, trans. Elizabeth Sprigge (Brooklyn: Melville House Publishing, 2013), 140.
4 Don Watson, 'American Berserk', *The Monthly*, no. 131 (2017): 8.
5 See also Mark Danner, 'The Real Trump', *The New York Review of Books* 63, no. 20 (2016). www.nybooks.com/articles/2016/12/22the -real-trump (accessed 25 April 2017).
6 Michael Tomasky, 'Trump: The Gang', *The New York Review of Books* 64, no. 1 (2017): 4–8.
7 For a discussion of the US electoral system see Eric Maskin and Amartya Sen, 'The Rules of the Game: A New Electoral System', *The New York Review of Books* 66, no. 1 (2017): 8–10.
8 Lewis H. Lapham, *Age of Folly* (London: Verso, 2016), 283–86.
9 David Bromwich, 'Preface', in *Moral Imagination: Essays* (Princeton: Princeton University Press, 2014), xi–xxiv.

10 Margaret Thatcher first stated her famous words in an interview with *Women's Own* magazine, 31 October 1987. 'Epitaph for the Eighties? "There Is no such thing as society"', *The Sunday Times*, http://briandeer.com/social/thatcher-society.htm (accessed 20 April 2017).

11 Winston Churchill to the Royal Academy, London, 30 April 1938. 'Winston Speaking to the Royal Academy of Arts', winstonchurchili.org, http://www.winstonchurchill.org/resources/speeches/1930-1938-the-wilderness/to-the-royal-academy-of-arts (accessed 25 April 2017).

12 '2018 Presidential Visiting Fellow in Fine Arts: A.L. Steiner', *Art & Education*, http://www.artand-education.net/announcement/a-l-steiner-2018-presidential-visiting-fellow-in-fine-arts/ (accessed 20 April 2017).

13 Oscar Wilde, 'Preface', in *The Picture of Dorian Gray* (London: Popular Penguin, 2008), iii–iv.

14 For a wide-ranging discussion of art schools see Brad Buckley and John Conomos (eds), *Rethinking the Contemporary Art School: The Artist, the Phd and the Academy* (Halifax, Canada: NASCAD University Press, 2009).

15 Hal Foster, *Bad New Days: Art, Criticism, Emergency* (London: Verso, 2015), 115–16.

16 Ibid., 115, 182–83, note 16.

17 Ibid., 115.

18 Richard Shusterman, 'Entertainment value: intrinsic, instrumental and transactional', in Michael Hutter and David Throsby (eds), *Beyond Price: Value in Culture, Economics, and the Arts* (Cambridge: Cambridge University Press, 2008), 42.

19 Dieter Mersch, *Epistemologies of Aesthetics*, trans. Laura Radosh (Zurich: Diaphanes, 2015), 18.

20 Edward Said, *The World, the Text and the Critic* (Cambridge: Harvard University Press, 1983), 336.

21 Ibid., 15.

22 Ibid.

23 George Steiner, *Grammars of Creation* (New Haven, CT: Yale University Press, 2002).

24 Foster, *Bad New Days: Art, Criticism, Emergency*, 115–24.

25 Ibid.

26 Ibid., 121.

27 Barry Schwabsky, *The Perpetual Guest: Art in the Unfinished Present* (London: Verso, 2016).

28 David Cole, 'Trump Is violating the Constitution', *The New York Review of Books* 64, no. 3 (2017): 4.

29 Oscar Wilde, *The Soul of Man under Socialism and Selected Critical Prose* (London: Penguin Classics, 2001), 142.

30 Mario Vargas Llosa, 'Elephant dung', in *The Language of Passion: Selected Commentary* (New York: Farrar, Straus & Giroux, 2000), 170.

31 Theodor Adorno and Max Horkheimer, *Towards a New Manifesto*, trans. Rodney Livingston (London: Verso, 2011), 171.

Part I: Money

Qui ou Quoi (Who or What) Rules the Artworld? Taking Care of Business: The Art Curator as 'Hedge Fund Manager' to the Artworld's Ponzi Scheme.[1]

Bruce Barber

> The question of Being is itself always already
> divided between who and what.

Jacques Derrida[2]

THE QUESTION "WHO RUNS the artworld" would have been relatively easy to answer in 1517. A good case, for example could have been made for Pope Leo X (Giovanni di Lorenzo de' Medici) born 11 December (ironically the author's birthday) 1475, died 1 December 1521. Giovanni a younger member of the famous Medici family based in Florence became an important patron of the arts, especially poetry, painting, architecture, music, design and according to a 16th-century commentator, upon his election Leo was alleged to have said, "since God has given us the Papacy, let us enjoy it". During his Papacy, Leo's enjoyment concerned the seeking (granting indulgences) and obtaining of major capital donations to rebuild and decorate Saint Peter's Basilica.[3] He commissioned artists such as Raphaël and his studio assistants to decorate St Peter's and the Vatican rooms, subsequently commissioning Leonardo also to produce work on behalf of the Vatican. He also promoted the study of antiquities, (appointing Raphaël as Director), literature, poetry, visual art,

music, and reorganised the University of Rome. According to Pope Leo's biographers, he borrowed and spent heavily in order to satisfy his plans to cement his cultural legacy; and not unlike some major capitalist culture brokers and so-called philanthropists today, this eventually led to him receiving criticism from both within and outside of the Catholic Church and risking bankruptcy.

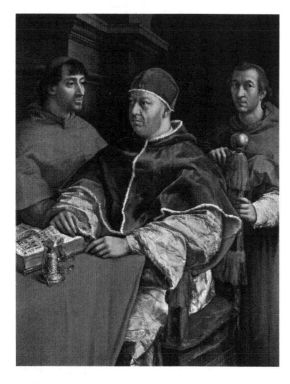

Figure 1.1 Raphaël, *Pope Leo X with Cardinals* (1518 – 1519), oil on wood, 154cm × 119cm. Uffizi Gallery, Florence.

Leo X arguably represents an important model for considering who and/or what rules the artworld as it was constituted in the early 16th century, when Neo-Platonist art theorists such as Marsilio Ficino, incidentally a former Florentine teacher of Leo, were positing the notion that artists, who often create something out of nothing, could model themselves after God *artifex deus* (the great maker),[4] and consider themselves to be *alter dei* in order to elevate their position beyond mere artisans, long time considered mimickers of reality, and to achieve the lofty status of philosophers, poets and rhetoricians.[5] Ficino's *Theologica Platonica,*1520, considered an important foundational text of Renaissance Neo-Platonist philosophy, introduced the new metaphysical requirements for change in the status of visual artists from being under the celestial patronage of Mercury (the fleet-footed messenger) to that of Saturn (the brooding melancholic intellectual):

> In paintings and building the wisdom and skill of the artist shines forth.
> Moreover, we can see in them the attitude and the image, as it were, of his

mind; for in these works the mind expresses and reflects itself not otherwise than a mirror reflects the faces of a man who looks into it.[6]

With this text and his earlier *De Triplici Vita,* 1482-89, Ficino became a major Renaissance aesthetician, tempering the long-standing Platonic antagonism towards the visual arts to endorse Aristotle's position, thus reconciling both Greek philosophers' views on the sources of creativity and genius. Giorgio Agamben suggests that Ficino himself was melancholic and indicates that as his horoscope showed Saturn ascendant in Aquarius it therefore seemed natural for him, as an exemplary Florentine intellectual, to privilege a melancholic Saturnine disposition for both himself and his cohort. He therefore contributed to a paradigm shift that had powerful ideological conse-quences throughout the following centuries.

> The rehabilitation of melancholy went hand in hand with an ennobling
> influence of Saturn which the astrological tradition associated with
> melancholic temperament as the most malignant of planets, in the intuition
> of polarized extremes where the ruinous experience of opacity and the
> ecstatic ascent to divine contemplation co-existed alongside each other.[7]

Aristotle's *pazzia* (melancholy) thus became the companion of Plato's *mania* (madness), and "the melancholy of great men became simply a metonymy for Plato's divine mania".[8] Thus 500 years ago, a powerful force was incepted in the artworld; one which combined capital with an aesthetico-political ideology that exalted the role of genius artists (Michelangelo, Leonardo, Raphaël) and their creative work as a necessity for a God-fearing society. But for the messy Protestant intervention of Martin Luther's 95 theses nailed to the door in Wittenberg, Pope Leo X's pleasure seeking drive – super ego injunction – in the name of God the Almighty, curating artists to assist him with the embellishment of important Catholic architecture, and conspiring with Ficino's Neo-Platonic critical intellectualism, set the stage for not only several centuries of art production and consumption but also consolidation of a generic 'artworld'. We could therefore propose that at this time the appropriate response to the Derridean question *qui ou quoi* – who and what was running the artworld – the answer would be the paradoxical collusion between: the wealthy patron as curator, the intellectual critic and philosopher, and the artist; thus art, money and power, not necessarily in this order. After the Reformation and the sacking of Rome 50 years later, the cultural power shifts to Bologna and the establishment of the Carracci Academy recognised as the first professional art school. Thereafter the artworld ceases to be homogeneous and becomes variegated. Asking the question of "who or what runs the artworld?" two or three centuries later would therefore have elicited tremendously varied results, depending on which conditions were estab-lished for the exploration of the question(s). If we take what was previously described as a paradoxical collusion between the wealthy patron as a curatorial force, the intel-lectual critic, philosopher and the artist, we would first have to identify a significant geographical and urban site such as the Vatican wherein this collusion/collision was

enabled to occur. Of course, a post factum analysis may not render the 'economies' as precisely as we could frame them with the earlier example; and with the Enlightenment, Empire building through colonisation, the developing importance of property, industrialisation, the exploitation of labour, and with this the creation of surplus value, the ground rules shift somewhat in favour of capital.

If we place within this field of discussion, the idea of art for the public, the 18th century renders some important dates for consideration; among these the establishment of the British Museum and public availability of the previously private Royal Library collection of paintings, sculpture, prints and manuscripts. At this time, many previously private collections were being opened throughout Europe, France, and Germany, with however many conditions to the public, including select invitations and modes of dress.[9] In 1817 there are some additional markers that provide some reinforcement to our model. An event of some significance in that year was the building and opening of Dulwich Public Art Gallery, the first in England and among the first in the world to be especially designed for viewing of a major collection by the general public and not the conventional brokers of power, the oligarchs, Royalty, Landed Gentry and the Church. And we would have to identify the Imperial family of the British Crown, in collusion with John Ruskin (8 February 1819-1900) who was the leading English art critic of the Victorian era, art patron, draughtsman, watercolourist, a prominent social thinker, a philanthropist, whose influence on both the production and critical reception of art of this period was great. His support of the Pre-Raphaelites and the painter J.M.W. Turner was especially significant.

The question who or what runs the artworld, becomes very complicated with the foundations of modernity in the 1860s but the collusion, recognising the breadth of meaning in its synonyms: collaboration, complicity, conspiracy, connivance, intrigue, plotting, secret understanding, and scheming, between capital, art and power remains. It is of course represented in critical writing, philosophy and literature, for example Charles Baudelaire's *The Painter of Modern Life*, 1863, and Émile Zola's 20-volume *Les Rougon-Macquart* series which includes *L'œuvre (Masterpiece)* a fictional account of Zola's friendship with Paul Cézanne with whom he studied in Aix en Provence, and considered a fairly accurate portrayal of the Parisian artworld in the mid-19th century; and of course visually by some iconic works: Edouard Manet's *Le Déjeuner sur l'herbe*, 1862-3, *Olympia*, 1863, Gustav Courbet's *The Painter's Studio: A real allegory summing up seven years of my artistic and moral life*. 1855, and several others during the 50-year period from 1850-1900. Roger Shattuck's *Banquet Years* discusses the formation of the French avant-garde during symbolist period of the 1880s and through to the advent of the First World War, with a compelling argument about the collusion of bohemianism, art, literature, criticism and patronage.[10] The growing art market and the institutions that collected and exhibited art for the public during this time both symbolically and actually represented capital as a determining force in the production and consumption of culture. With the triumph of art for the public as described by Elizabeth Holt, in 1984, and others, the collusion model remains intact

in various urban sites throughout Europe in the late-19th century until the First World War.[11] In 1916 the Cabaret Voltaire shared its anti-war and anti-capitalist ideologies in Zürich and other urban sites, such as Berlin, Cologne, Paris and New York. 1917 was the signal year of Marcel Duchamp's aesthetically anarchic assisted readymade (R. Mutt's) *Urinal* and with it the cultural base, critical philosophy, money, art and power moves to New York. Peggy Guggenheim (1898 -1979) wealthy socialite, cosmopolitan friend of intellectuals and artist members of the cultural avant-garde in Europe amasses a huge collection of work between 1938-1946 that subsequently forms the basis of the Peggy Guggenheim Museum and, in 1949, settled in Venice, Italy where she lived and exhibited her collection for the remainder of her life. While the Peggy Guggenheim Collection is a much-visited attraction on the Grand Canal in Venice, Italy she also sold an estimated 15,000 pieces to David Rockefeller (1915-2017) that were installed in the Museum of Modern Art in NYC of which for several years, he was Chairman.[12] Without the power of capital represented by Guggenheim and the Rockefellers, it is possible that the cultural power of New York would have been slow to develop. They assisted the entry of modernism in its various manifest guises in Europe to the New World, a move that has been characterised in several books including Serge Guilbaut's *How New York Stole the Idea of Modern Art*, as a result of a type of cultural putsch with ideological and economic foundations. Of course, this is simplifying a very complex period of several decades, with the movement of capital, art, artists, and intellectuals as the result of the war and the Great Depression. A key aspect of this history as far as New York is concerned is the founding of the Museum of Modern Art in the 1920s with initial patronage from Miss Lillie P. Bliss, Mrs., John D. Rockefeller Jr., and Mrs. Cornelius J. Sullivan who with the founding Board installed Alfred H. Barr in 1929 as the influential first Director.

Writing a decade later in 1939 the venerable modernist art critic Clement Greenberg perfectly understood the paradoxical collusion between art, capital and power, developing the project further to implicate the anti-capitalist modernist avant-gardes.

> No culture can develop without a social basis, without a source of stable income. And in the case of the avant-garde, this was provided by an elite among the ruling class of that society from which it assumed itself to be cut off, but to which it has always remained attached by an umbilical cord of gold.[13]

For Greenberg, the "umbilical cord of gold" is not simply a metaphor for Capital but a process of nurturing and sustenance without which culture would run the risk of being still born. The modernist critic would have stopped short at suggesting that Capital rules the artworld, perhaps because for a time it was he who wielded the most critical power in the artworld, orchestrating modernism as an international cultural form with winners and losers.

Figure 1.2 Bruce Barber, *Ponzi Art Scheme* (2008),
digital print, 30cm × 20cm. Courtesy of the artist.

If the artworld's political economic structure in 2007 was likened by some to a pyramidal Ponzi scheme,[14] with artist players, payers and prayers at its base, symbolically and economically paying forward and upward to the accumulators of symbolic and actual capital aggregated at the apex: the mega art stars, gallerists, collectors, publishers, art critics and art historians, then curators are perhaps implicated in the pyramid scheme as equivalent to 'hedge fund managers' leveraging symbolic capital in the artists and artworks they curate and 'short selling' to minimise art market risk and establish both symbolic (cultural capital in Bourdieu's sense), and add actual capital to their own market value as privileged artworld gate keepers and power brokers.[15] And like Wall Street's hedge fund managers, prior to the crisis of 2007- 2008, a few key curators have had the artworld(s) at their command both profiting and suffering with the economic crisis of those years. We should now briefly explore the characteristics of this artworld pyramid scheme with specific reference to contemporary curatorial practices associated with international biennales and propose some challenges to contemporary curators, my [occasional delinquent] self included, who wish to promote art exhibitions as strategic vehicles for social change.

But first a caveat: It is easy to confuse the role of curators these days, as indeed it is the roles of patrons, philosophers and artists. A Facebook statement from a curator for a major Canadian gallery recently intrigued me.

"Ugh... As someone in the biz, I hate it when someone incorrectly uses the term "curator"... Grrrr. Forget museums, maybe I should "curate" a list of spring pillows for Chatelaine (a Canadian Women's Magazine)? Hell, I'll just go and work for Apple making playlists:"

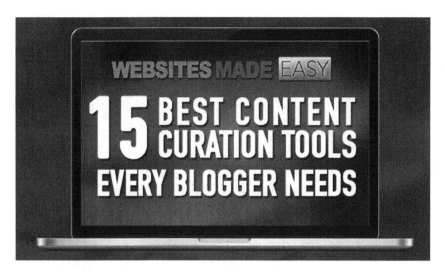

Figure 1.3 Curatorial advertisement on Facebook.

Facebook Responder 1. "I was accused of being a snob because of this very complaint. "Wanting words to mean something specific does not make me a snob!" I raged. If it does, I'll just have to accept the epithet."

Responder 2. "Irritating."

Responder 3. "I saw a sign at Starbucks about 'curated snacks' and I thought of you lol!

Responder 4. I sense you're going to be curating a beat down.

Responder 5. There are many articles about the misuse of curate/curator... https://www.google.ca/search...

Figure 1.4 Google and the Google logo are registered trademarks of Google Inc., used with permission.

word curator being misused – Google…

"This drives me bonkers. Curate is not a synonym for choose."

"A Google search about 16,400,000 results (0.67 seconds) soon turns up some interesting comments on the abuse of the term curate, for example: 'Is "Curate" The Most Abused Fashion Word of 2010?"

But we do not have to turn to Facebook to acknowledge that the keyword 'curate' in its contemporary context has both been de-professionalised through overuse and yet also accumulated much symbolic capital. A quick search on the Internet reveals curators as musicians, curators as fashionistas, curators as digital content developers, as travel planners, curators as heroic Nazi hunters. Arguably, with films like George Clooney's *The Monuments Men* based on the book *The Monuments Men: Allied Heroes, Nazi Thieves and the Greatest Treasure Hunt in History* by Robert M. Edsel, the symbolic capital of the curator has never been higher. After all, taking on the museums and collectors that have profited from the Nazis' assault on contemporary art and uncovering the vast wealth of stolen art is a heroic pursuit and although quite historically inaccurate, casts the contemporary role of curator into a powerful figure with incredible powers of detection and judiciary status affirmation of art and artists. 'The Monuments Men', were a group of approximately 345 men and women from thirteen nations who comprised the MFAA section during World War II. "Many were museum directors, curators, art historians, artists, architects, and educators".[16] Matt Damon is the archetypal curator figure in this film and plays it for all that it is worth.[17] But it is now apparent that the keyword curator has become so exploited and misused in popular discourses that it has ceased to convey its original meaning and has become a password for literally anything that has some form of authored and organised process attached to it, heroic or not, as the case may be.

We should perhaps further examine the viability of this likening of the curator with the hedge fund developer. Who or what is a "hedge fund developer" and how can this individual be compared to a curator? A quick examination of a website[18] that caters to investors reveals that the definitions for the Hedge Fund Manager/Developer are somewhat complicated. First, the all-important hedge funds? The definitions for would be investors are wide ranging from the professional, to unprofessional and even criminal. For example: "An aggressively managed portfolio of investments that uses advanced investment strategies such as leveraged, long, short and derivative positions in both domestic and international markets with the goal of generating high returns (either in an absolute sense or over a specified market benchmark)".[19] And the questionable enterprise: "Hedge funds (unlike mutual funds) are unregulated because they cater to sophisticated investors" who presumably are willing to take risks with their money, somewhat similar to gallerists, art dealers, and curators who take risks with artists whose work they exhibit and promote.

The website's authors indicate that: "In the US, laws require that the majority of investors in the fund be accredited. That is, they must earn a minimum amount of

money annually and have a net worth of more than $1 million, along with a significant amount of investment knowledge".

This somewhat arbitrary figure may remind the reader of some curators or art directors or art dealers, for example the International art collectors, culture brokers, Saatchi and Saatchi brothers; auction houses such as Sotheby's now offering an art institute "to learn the business of art", as do their following definitions: "You can think of hedge funds as mutual funds for the superrich. They are similar to mutual funds in that investments are pooled and professionally managed, but differ in that the fund has far more flexibility in its investment strategies". I'm sure that Clement Greenberg with his "umbilical cord of gold" would strongly approve of this latter estimation. If the investments are artists and the art they produce, then the rewards from hedging bets, short selling, can be many, and not necessarily shared adequately with the artists, which has been the case of many law suits over the years. Maximizing profits through the sale and resale of work without adequately compensating the producer has long been recognised within the commercial sphere as a means to increasing and thus creating surplus value to thereby realise the rewards of 'investment'.

The definitions of hedge fund management become more specific and attempt to distinguish between risky investing strategies, short-selling the market and speculation, ending with the acknowledgement that these funds can carry more risk to the investor than mutual funds and certainly government bonds.

"It is important to note that hedging is actually the practice of attempting to reduce risk, but the goal of most hedge funds is to maximise return on investment. The name is mostly historical, as the first hedge funds tried to hedge against the downside risk of a bear market by shorting the market (mutual funds generally cannot enter into short positions as one of their primary goals). Nowadays, hedge funds use dozens of different strategies, so it is not accurate to say that hedge funds just "hedge risk". In fact, because hedge fund managers make speculative investments, these funds can carry more risk than the overall market".

The final description on this investor website describes the questionable process of "hedging a bet", or a 'Bucket Shop' described as "a fraudulent brokerage firm that uses aggressive telephone sales tactics to sell securities that the brokerage owns and wants to get rid of. The securities they sell are typically poor investment opportunities, and almost always penny stocks". Phishing is often the contemporary modus operandi of bucket shops.

The Bucket Shop proprietor was incidentally the subject of Marcel Duchamp's *Wanted: $2,000 Reward (1923)* poster, which reveals that art is a risky and potential criminal business both for the artist producer and the investor. In this case Duchamp is both the perpetrator and the victim.

Figure 1.5 Marcel Duchamp, *Wanted: $2,000 Reward* (1923), 49.5cm × 34.5cm, collection of Louise Hellstrom. © ESTATE OF MARCEL DUCHAMP / SODRAC (2017).

Duchamp's ironic affirmation of investment fund delinquency in his poster, of one George W. Welch, aka Bull, aka Pickens, the operator of a Bucket Shop under the name HOOKE, LYON and CINQUER (Hook Line and Sinker) also identified as Duchamp's feminine moniker RROSE SELAVY, reveals his antipathy towards capital investment, symbolic or otherwise. The bucket shop is an offshoot of 'penny stocks' that endeavour to capitalise upon initial low value stocks that through strategic manipulation will appear attractive enough to encourage investors whose dividends encourage more attention to the Bucket Shop investment trap, now recognised to be the basis of a pyramid selling scheme, where capital accumulates at the apex for the very few, while it is diminished or non-existent for those many below who are paying forward their investments in anticipation of future rewards.

The Wall Street collapse of 2008 revealed that many capital investment firms were not only operating as bucket shop brokerages but actually pyramid selling (Ponzi schemes) defrauding their investors with unrealisable profits. The global financial meltdown of 2007- 2008, is considered by many economists to have been the worst financial crisis since the Great Depression of the 1930s.[20] It is deeply ironic that several of the world's largest Ponzi schemes were uncovered as a result of the subprime mortgage crisis. For example, Bernie Madoff's investment scam of $65 billion, one of the largest Ponzi schemes the world has witnessed, was revealed at this time. Although the SEC had been alerted as early as 1992 about Madoff's potential fraud, they could not arrest him until he came under the pressure of his investors and

then his own family members. He finally confessed and was arraigned on 11 December 2008. The following year, Madoff pleaded guilty to over ten Federal felonies: wire and securities fraud, mail fraud, money laundering and perjury. The court deliberated and subsequently sentenced him to 150 years in prison.[21]

Gregory Sholette the author of *Dark Matter: Art and Politics in the Age of Enterprise Culture* (2011) [22] has had an insider's view for over two decades of the artworld and its discontents. He employs his participant observer's experience to formulate some powerful critiques of artworld hierarchies and institutions, revealing the role of artists, described by the author as "the obscure mass of 'failed artists' and the 'dark matter' – the reserve army of surplus labour in Marx's famous thesis – who sustain and reproduce the global artworld". Throughout its eight chapters Sholette's book provides some well-argued insights into the ideological struggles and forms of resistance that have played out in various, mostly contemporary urban communities. The author explores examples of political agency manifested in artworks and group actions that have challenged the hegemony of the artworld if only to be forgotten and marginalised, a minority co-opted and absorbed by the culturally dominant institutions. Borrowing the physical sciences metaphor of "dark matter" as his unifying allegorical trope, the author conjectures that "without this obscure mass of 'failed' artists the small cadre of successful artists would find it difficult, if not impossible, to sustain the global artworld as it appears today".[23] Sholette argues further that without the "invisible mass, the ranks of the middle and lower level arts administrators would be depleted, [and] there would be no one left to fabricate the work of art stars or to manage their studios and careers". "And who", he asks rhetorically, "would educate the next generation of artists, disciplining their growing numbers into a system that mechanically reproduces prolific failure?" [24]

This observation would be depressing enough if the avant-garde did not have the concept of failure directly inscribed within its fabric. Capitalist society's conventional indicators of artistic success are readily indicated by the accumulation of both material and symbolic capital, awards, certificates, diplomas, prizes, profitable sales, goods and property. The artist and his/her/their work become the subject/object of critical legitimation and valorisation in newspapers, magazine reviews, journal essays, catalogues and books. S/he may also be offered honorary appointments and awards. But these evaluations are intrinsic to success. The *succès de scandale* that coupled with *épater le bourgeois* was a key social objective of the historical avant-gardes may be the only example of a success that includes in its very definition a measure of failure (scandal) that is ipso facto also perceived as success, hence Clement Greenberg's assessment of the avant-garde being attached to capital by an umbilical cord of gold. The value of success however, like the value of beauty, the sublime and pleasure, which we know from Kant, is necessarily a question of judgment, about which Jacques Derrida has posted a signal warning.

> Where is it to be found? This then, appears to be a/the question. Where indeed, is it to be found? Where is the limit between the inside and outside of failure?[25]

Reading Sholette's book awry, dark matter may simply be an acknowledgement that to reiterate, the artworld is a Ponzi-like pyramid scheme with artist players, payers and prayers at its base, symbolically and economically paying forward and upward to the accumulators of symbolic and actual capital aggregated at the apex: the mega art stars, gallerists, collectors, publishers, art critics and art historians. Sholette, however, is supremely aware of the political nuances in his prognoses, offering less a symptomology of a degraded artworld than culturally strategic vehicles for critiquing capitalism that could be used as political models by the Occupy movements, and world party pundits of today.[26] As Sholette opines, "What is described in these pages as 'dark matter' therefore, is not intrinsically progressive, not in the typical liberal or radical senses of that term". Instead, he argues, "It possesses at best a potential for progressive resistance, as well as for reactionary anger". [27]

Sholette's Marxist critique describes the artist agents and collaborators of Dark Matter as engaging in "hidden social production, missing mass, shadow archive", a reserve "army of labour" without which the artworld would simply collapse under the weight of its own contradictions.[28] The author however infers critical agency to this dark mass of invisible, surplus, yet essential artists who provide the shadow glue for the reproduction of the global artworld. They are, he writes, "a presence/absence of a vast zone of cultural activity that can no longer be ignored". Sholette argues that although "the artists within this shadow mass may be practically and perhaps therefore tactically invisible, "no amount of uncertainty relieves us of the responsibility to engage with them politically, as an essential element in a long-standing promise of liberation yet to be fulfilled".[29]

Increasingly the media informs us of the top ten artists, curators, and patrons that we should know. For example, the Louise Blouin Foundation based in London, UK recently listed ten curators we should know, but in truth if you are an artist everyone has ten curators you should know. [30] We are also informed that so and so is "King (or Queen) of the Artworld". Senior curators become principle administrative hires for international biennales, festivals, and art fairs. Curators have been recognised as increasingly powerful individuals in local, regional, national and in the international sphere often in the articulation of exhibition themes and invitations to artists and well as fundraising through national agencies, with gallerists and other patrons. Artists have also become their own curators, essentially attempting to bypass and even critically undermine one sector of the collusion between art, money and power. Group Material's Doug Ashford and Julie Ault [31] were very active in the 1980s bypassing the usual curatorial structures to organise their own thematic exhibitions, with collaborating artists and institutions. And Sholette's book discuses many other artist collaborations, for example the YES Men who attempt to mitigate the institutional forces of artworld capital.

Occasionally curatorial ventures fail and the artists are left to essentially fend for themselves often becoming an ethical dilemma for patrons, critics, curators and

artists within this collusion model of the artworld. For example, when the curator of the Call the Witness Roma exhibition for the 2011 Venice Biennale suddenly and inexplicably resigned from the curatorial post, the artists stepped in to work collaboratively and produce their own exhibition and archive, pooling money and resources to ensure the exhibition did not fold.

The timing was critical: In early 2010, the curatorial team of The 2nd Roma Pavilion – Call the Witness announced its open call for artists, researchers and media archive. It was described that "This project that will be presented in Venice in 2011 is conceptualized and curated by the interdisciplinary collaborative curatorial team: The 2nd Roma Pavilion – Call the Witness was an interdisciplinary collaboration that aimed to foster, the production and presentation of contemporary and new media art by Roma artists from different regions and cultures. In the core of the project lies the concept of contemporary artist as an instantaneous witness of his/her time who is not a passive viewer but rather acts as an active participant in solidarity with the events and people that provoked his/her artwork. Such a phenomenon wherein art becomes a potential agency for social makeover acquires a completely new prospect in the period of digitalization and globalization and may largely affect Roma communities".[32]

Welcome to the Media Archives "Call the Witness"!

After the review of many applications, letters of invitation were sent out to the selected exhibition artists:

The letter read:

Dear future participant,

"We are pleased and excited that we are in a position to offer you official participation in our long-term project Call the Witness – 2nd Roma Pavilion in the form of contribution to the Media Archives. Hereby we want to inform you that after the long and careful process of review and consideration of the enormous and heterogeneous visual and research materials that we've received in different formats and through different methods (research, application, recommendation, etc.) we decided to create the Media Archives respectfully of your artistic interest, even though in certain aspects it does not necessarily coincide with the curatorial concept of the main exhibition or some of the pre-established criteria were not completely met. We are interested in your participation particularly because of the general artistic and research merits of your work and its relevance for the Roma communities as a kind of transnational and transversal index and resource of references, communication and knowledge production".[33]

Several weeks later, the exhibiting artists received another letter announcing the sudden cancellation of the exhibit:

"Dear artists who were invited to participate in the Media Archive (curators, ex-curators and organizers of the Roma Pavilion are excluded from this mail), as all

of us, <u>we have just been informed about the cancellation of the Media Archive in Venice Biennial</u> and we are simply speechless about such a massive lack of professionalism and responsibility from the side of the [organization] and the new curator (name withheld) (we don't believe that (name withheld) the curator who invited us and invested so much in the project, suddenly decided to cancel it)".[34]

The letter went on to conclude that:

"Through the way those players have been acting they did not only express their disrespect for our work but also they humiliate us as artists, theorists and activists engaging and fighting against racism and anti-Romanism". (Emphasis added)

And further,

"We think that the way it was dealt with us within the last months and especially the cancellation we have just been informed about, is simply not acceptable and we want to propose that we think COLLECTIVELY, all of us who are affected by this crazy turn, how to organize an adequate reaction". (Emphasis added)

Please let us know what you think!

Very shocked, [Artist names withheld]

On Thu, Feb 24, 2011 at 4:08 PM, another group email was circulated:

Dear All,

"We are very sorry for our belated feedback to you regarding the fate of the media archives thathas started to build as part of the Roma Pavilion project that [name withheld] has been the curator of until last fall. As you all know, due to repeated complications with the former implementing organization, [name withheld] we had to take charge of the project and find an alternative way for its implementation going forward. It took a while for us to identify the new curator, and then to sort out the various details, and only now have [name withheld] and the new curator, [name withheld] concluded a final decision regarding the media archives".

"In accordance with the agreement between the two curators, the media archives that you have submitted your work to, and which has provided a critical contribution to the research of the project, will not be part of the Roma Pavilion coming up at the 54th Venice Biennale in June. It has been difficult enough to make sure that the project doesn't fail overall, and although we have tried our best to save it along with all its parts, the media archives was considered to be in its initial phase for the time being, and its development and completion would have required much more effort, time and money than what's available at this point. We regret this outcome along with both curators, but this is a consequence of the evolution of the project implementation, which took an unexpected turn halfway through the process".

I am cc'ing (names withheld) on this message since the above reflects a consensus between them.

We apologize for any inconvenience caused to you, and are hopeful that we'll find ways to collaborate with you in the future.

Thank you for your understanding, and best regards,

Roma Virtual Network

Subject: ROMA PAVILION: WEB LAUNCH AND EXHIBITION PROGRAM at the Venice Biennale

Date: June 1, 2011 4:15:13 PM GMT+02:00

ROMA PAVILION

WEB LAUNCH AND EXHIBITION PROGRAM at the Venice Biennale

Roma and non-Roma artists were selected by the curator (name withheld), for the Roma Pavilion at the Venice Biennale 2011. The Roma Media Archive is a collateral platform supporting 'Call the Witness' at the Roma Pavilion. [35]

Artists work can be seen at:

http://www.romamediaarchive.net[36]

Presentation at Roma Pavilion 3rd June 2011 Web Launch of the Roma Media Archive www.romamediaarchive.net UNESCO, Palazzo Zorzi, Castello 4930 – Venezia. 3rd June 2011 at 13:00

Presented by participating artists of the Roma Media Archive:

In the context of: Call the Witness, Roma Pavilion Collateral Event, Live Testimonies 54th International Art Exhibition – La Biennale di Venezia,

Roma Media Archive @ Venetian Navigator Exhibition

PS: we just saw that the Media Archive, that had been online now for months, was taken offline. (Emphasis added)

As one of the exhibiting artists affected by these events, one who has also been a curator of exhibitions where ethical struggles over artist inclusion, exclusion, gallery controls, contracts, inadequate capital investment, artist payments, misunderstandings, angry letters, have all been implicated and objects of negotiation. I was proud to be among those artists who resisted the top down decision to cancel the event. Although I was unable to attend the archive web site launch party that was subsequently held in Venice during the opening of the 2011 Biennale and its many collateral events, I was pleased that contributions from the exhibiting artists had made the construction and launch of the website possible and that the original

curatorial team were not disparaged, either for their withdrawal or motion to cancel, which in any event seemed to be a decision that originated higher up the Biennale food chain.

This is but one example of many curatorial misadventures that I am aware of through over 40 years of working as an artist, curator and historian in the field. Actually, one comes to expect and anticipate them. And the agents who run the artworld are not, as a noted critic and curator once informed me many years ago: "actually a very small number of people worldwide"; it's only that small number of players if one is at the apex, and not a member of the subaltern classes paying and praying from the sides and base of the pyramid. And if we take the role of curator to be more than the simple reproduction of the political and socioeconomic character of the artworld which has been a site for struggles over capital, control and power for centuries, then the curator is perhaps no more nor less delinquent than the artist, critic, art collector, gallery director or patron. All can be ethically compromised. Qui ou quoi reste la question.

Notes

1 A version of this paper was first written for the CAA Panel: The Delinquent Curator: Has the Curator Failed Contemporary Art? Los Angeles Co-Chaired by Brad Buckley and John Conomos, University of Sydney. Bruce Barber, "Taking Care of Business: The Art Curator as 'Hedge Fund Manager' to the Art World's Ponzi Scheme," in CAA Conference (Los Angeles, 2014).

2 American documentary film: Kirby Dick and Amy Ziering Kofman, "Derrida," (2002). directed by Kirby Dick and Amy Ziering Kofman. (2002).

3 R.A. Scotti, Basilica: The Splendor and the Scandal: Building St. Peter's Basilica (London: Penguin Books, 2007).

4 Deus artifex synonyms: skilled, artistic, expert, artful, cunning, creative.

5 Klemens Löffler, "Pope Leo X," vol. 9, The Catholic Encyclopedia (New York: Robert Appleton Company, 1910), http://www.newadvent.org/cathen/09162a.htm.

6 Rudolf Wittkower and Margot Wittkower, Born under Saturn, the Character and Conduct of Artists. A Documented History from Antiquity to the French Revolution (New York: WW Norton, 1963), 98.

7 Giorgio Agamben, Stanzas: Word and Phantasm in Western Culture, trans. Ronald L. Martinez, vol. 69, Theory and History of Literature (Minneapolis: University of Minnesota Press, 1993), 12.

8 Ibid., 4.

9 Elizabeth Gilmore Holt, The Triumph of Art for the Public, 1785-1848: The Emerging Role of Exhibitions and Critics (Princeton: Princeton University Press, 1984).

10 Roger Shattuck, The Banquet Years: The Origins of the Avant-Garde in France 1885- World War I (New York: Vintage Books, 1968).

11 Henri Lefebvre, The Production of Space, trans. Donald Nicholson-Smith (Oxford: Blackwell, 1991); Richard Dennis, Cities in Modernity: Representations and Productions of Metropolitan Space, 1840-1930 (Cambridge: Cambridge University Press, 2008).

12 "In 2006, he bequeathed $225 million to the Rockefeller Brothers Fund, which he and his brothers established in 1940 to promote social change worldwide." Heather Burke and Mark Schoifet, "David Rockefeller, Banker, Philanthropist, Heir, Dies at 101," Boomberg, https://www.bloomberg.com/news/articles/2017-03-20/

david-rockefeller-banker-philanthropist-heir-dies-at-101.

13 Clement Greenberg, "Avant-Garde and Kitsch," 6, no. 5 (1939): 34-49.

14 Marion Maneker, "Is This the Art World's Own Ponzi Scheme?," Art Market Monitor, http://www.artmarketmonitor.com/2009/01/12/is-this-the-art-worlds-own-ponzi-scheme/.

15 Mitchell Zuckoff, *Ponzi's Scheme: The True Story of a Financial Legend* (New York: Random House, 2006).

16 Official website: "The Monuments Men," http://www.monumentsmen.com/the-monuments-men/monuments-men-roster.

17 Ibid.

18 "Hedge Fund," Investopedia, http://www.investopedia.com/terms/h/hedgefund.asp.

19 Ibid.

20 Kathy Phelps Bazoian and Steven Rhodes, *The Ponzi Book: A Legal Resource for Unraveling Ponzi Schemes* (New Providence: Matthew Bender LexisNexis, 2012).

21 Diana Henriques, *The Wizard of Lies: Bernie Madoff and the Death of Trust* (New York: Times Books, 2011).

22 Gregory Sholette, *Dark Matter: Art and Politics in the Age of Enterprise Culture* (London: Pluto Press, 2011).

23 Ibid.

24 Ibid.

25 Jacques Derrida, *The Truth in Painting*, trans. Geoff Bennington and Ian Mcleod (Chicago: Chicago University Press, 1987), 45.

26 Micah White, one of the lead organizers of the Occupy Wall Street movement has recently established a World Party platform. Micah White, "World Party," https://www.micahmwhite.com/worldparty.

27 Sholette, *Dark Matter: Art and Politics in the Age of Enterprise Culture*, 44.

28 Ibid., 45.

29 Ibid.

30 The top 5 Curators:
 1. Anna Colin: Open School East, London, as curator and co-founder, independent curator. Notable projects: *Disclosures*, 2008-12, co-curated with Mia Jankowicz; *Witches: Hunted, Appropriated, Empowered, Queered*, la Maison Populaire, 2012.
 2. Travis Chamberlain: The New Museum, New York, as associate curator of performance. Notable shows: *NEA 4 in Residence + Performing Beyond Funding Limits*, May-June 2013; *Movement Research in Residence: Rethinking the Imprint of Judson Dance Theatre Fifty Years Later*, September-December 2012; *Green Eyes*, at P.S. 122, January 2011; *Them and Now: Ishmael Houston-Jones with Chris Cochrane and Dennis Cooper*, September – October 2010; *Replica*, a collaborative performance piece by Daniel Arsham, Jonah Bokaer, and Judith Sanchez Ruiz, December 2009.
 3. Bassam El Baroni: international art festivals and biennials, as independent curator. Notable shows: *Cleotronica 08*, Festival for Media, Art, and Socio-Culture, Alexandria, Egypt, 2008; *Overscore*, Manifesta 8, 2010; *When it Stops Dripping from the Ceiling (An Exhibition That Thinks About Edification)*, Kadist Art Foundation, Paris, 2012.
 4. Biljana Ciric: works with leading art institutions across China, as independent curator. Notable shows: *Fly*, a Yoko Ono retrospective at Ke Center for Contemporary Art and Guangdong Museum of Art, 2007; *History in Making: Shanghai 1979-2009*, 2009, a 30-year retrospective on art in Shanghai; and *Alternatives to Ritual*, 2012-2013, wherein Chinese artists expressed their attitudes to institutions.
 5. Shihoko Iida: works with, Aichi Triennale 2013, Nagoya, co-curator, independent curator. Notable shows: *Omnilogue: Journey to the West*, a series of co-curatorial

projects organised by the Japan Foundation, Lalit Kala Akademi Gallery No.1 & No.2, New Delhi, 2012; *Trace Elements: Spirit and Memory in Japanese and Australian Photomedia*, co-curated with Bec Dean, Associate Director at Performance Space, Sydney, Tokyo Opera City Art Gallery, 2008, and Performance Space, Sydney, 2009; *Rapt! 20 contemporary artists from Japan*, co-curated exhibition organised by The Japan Foundation, held across multiple cities in Australia in 2005-2006; and *Wolfgang Tillmans: Freischwimmer*. Tokyo Opera City Art Gallery, 2004.

But how do we get from the notion of the Curator as heroic figure and to the curator as hedge fund manager and this delinquent figure whom we all revere?

31 Julie Ault, ed. *Show and Tell: A Chronicle of Group Material* (London: Four Corners Books, 2010). See also: Doug Ashford, Julie Ault, and Group Material, *Aids Timeline*, dOCUMENTA (13) (Berlin: Hatje Cantz).

32 Email correspondence, 2010.

33 Email Correspondence, 2010.

34 Email correspondence, 2011.

35 Email correspondence, 2011.

36 Participating artists include in alphabetical order; Bruce Barber Sasa Barbul, Katalin Barsony, Cristiano Berti, Bodvalenke Fresco Project, Tina Carr, Edouard Chiline, Hannah Collins, Leone Contini, Nigel Dickinson, Konstantina Drakopoulou, EU-Roma, Eduard Freudmann, Zoran Kubura, Haris Kulenovic, Alexandra Gulea, Maria Kjartans, Marta Kotlarska, Ivana Marjanovic, Dusko Miljanic, Malgorzata Mirga-Tas, Tanja Ostojic, Nihad Nino Pusija Claudia Radulescu, Eva Sajovic, Marika Schmiedt, Annemarie Schöne Hedina Tahirović Sijerčić, Manuela Zanotti.

The Valorisation of Art: What Artists Are up Against

Peter Booth and Arjo Klamer

A RTISTS ARE ABOUT MAKING art. In the execution of their art virtually all of them will have to cope with systems of governance and markets. Some are able to embrace those systems; many experience them as conflicting with their artistic practice, overpowering it even, and resist or avoid them in whatever way they can. In this chapter, we want to show artists what they are dealing with, why the tensions that they may experience make sense, and point out various coping mechanisms. In the process, we bring to bear a range of texts that highlight academic discussions pertaining to the subject.

We, the authors, are a banker who became an artist who is becoming a cultural economist with a PhD, and a cultural economist who combines his professorship with a political position. Accordingly, we bring a range of contrasting experiences to this joint project.

What Are the Issues? What Are the Questions?

This book links the themes of power and politics with the world of the arts. The academic custom would be to seek a distant perspective in order to chart the world of the arts and to get a good overview. We will do so, at least to some extent, but our point of departure is the life of artists. We attempt to reason from their point of view. It is a matter of the type of questions we start with.

A question that pops up every now and then among artists is: "What am I doing 'it' for?" Especially when the income is low, and disappointments are great, these questions at times become urgent. Even when you are clear about the purpose, you may have questions about the ways in which you can get your art recognised, appreciated, discussed and financed. Can you really find a way to sustain yourself and those dependent on you?

Of course, the answers will vary depending on whether you practise art in a country with a tradition of governmental support or one that lacks a cultural policy and a cultural infrastructure. In many Western countries, you may have to deal not only with governmental institutions but also with an art market for 'big money' next to a world of artists who barely subsist. Then there are the walls that museums put up, the art academies with their limited access, selective and commercial galleries, and art critics. All these institutions will mark and fill the context in which you do your thing. And then there are all those non-artists who are sometimes interested in the work of artists but most often are not. Indeed, what is your art good for?

Faced with governmental institutions (including foundations) you may find the pressure to 'professionalise' as 'they' tell you. First and foremost, this pressure is exerted through educational networks and filtering that result in a growing necessity to attend a 'high status' art institution.[1] In addition, you need to be organised, initiate and maintain relationships with a great variety of people, employ an accountant, have a good website, operate in social media, and carefully plan your calendar with appointments, visits to openings, meetings and the like. In that way, you work on your 'branding'.

Even if you are not inclined to wonder what your art is good for, people in your environment will pose the question. Policy makers have recently been keen on the economic impact of art, that is its potential to generate income and jobs. In the wake of Richard Florida's popularised research that links a city's pool of creative workers to economic growth, there is a presumption that art can (or should) have a positive economic impact.[2] In that logic, your art has to be good for the economy. Particularly from the 1990s onwards, interest shifted to the public or 'instrumental' value of art, that is its societal and social relevance.[3] Accordingly, your art has to be good for involving immigrants and minorities, for example, or for the restoration of local neighbourhoods, for political awareness, or for schools. Engaged artists point to the political relevance of their work. Others claim the cognitive and emotional relevance of art: it can make you see the world differently, and it can generate shocks, disturbances, excitement, delight and other emotionally charged responses. Is it possible that art is also good for its own sake, as 'autonomous' artists may insist?

Especially the latter group, together with their supporters, often resist and protest the grip that governmental and market systems have on the world of the arts. The influence of big money is too big, they say, and they question the procedures that governmental institutions follow.

The Value of Art: a Thing, a Conversation, or Something Else?

In order to pave the way for our discussion and to clarify a few things to practising artists, we present a picture and several concepts that correspond to the idea of value in the arts.

We start with the presumption that you, the artist, are doing something that is important for you. Otherwise you would not have initiated the daunting process of getting into an academy or art school, put up with the endless exercises, critical sessions, tuition fees, and the uncertainties that characterise an artistic life, such as insecurities about the quality of your work, its reception and your finances. In spite of everything, you are determined to work as an artist. There must be something of importance in that work for you.

In our value-based approach that we bring to the discussion, we would say that you have values – for that is what you call whatever is important to you. The value could be 'understanding your world', 'doing something with your creative urge', 'expressing yourself', 'freedom', 'independence', 'making a difference,' or 'creating beautiful, surprising, or just strange things'. Being aware of the relevant values appears to be a good start.

The subsequent question is how artists realise their values. They do so, obviously, by engaging in the practice that is called art. As we are economists, the expectation could be that we propose to think in terms of artists producing works of art that then become products or commodities for sale in the market. Rather than take this approach, we follow Bakhtin[4] and Klamer[5] in postulating that art is a practice, or a conversation to which artists contribute with their work, activities and performances, and in which all kinds of other people and organisations, including art critics, galleries, museums, curators, art historians, and art lovers participate. Borrowing a concept from economics, we can also call that conversation a commons. A commons is something (a space, a field, or a conversation) that has value, is shared by the members without ownership being clearly defined, and which excludes non-members. Shared pastoral land is an often-cited example of a commons.[6] When understood as a conversation, art practice is also a type of commons, a creative commons.[7]

It follows that art is not a product that you can sell or buy. You can buy a physical object, a canvas with paint on it, but you need to do something in order to make the object into art. It is like this book. You can purchase it for a price, but when you have done so, you just have the physical book. In order to gain the knowledge that it contains, you have to read it, think about its offerings, decide on what is important or useful to you, and what is nonsense, useless, rubbish or whatever. That is the labour of reading, interpretation that is required in order to make the book your own. Art, therefore, is a practice, with art works functioning as incidents that you need to negotiate in order to have access to that practice.

When you, the artist, realise your values and know the practice of which you want to be part, you need to figure out how you are going to make true on your values. Acting on your values nearly always requires an interaction with someone else, and this is particularly true in the case of shared goods. As we would say, you need to valorise yourself as an artist and your work as art. You will face all kinds of opportunities but also daunting forces of resistance and opposition. As is all too well known, the life of an artist is none too easy.

Different Spheres, Different Logics

The recognition of different types of value, or valorisation, occurs in different spheres where each has its own logic. We are going to distinguish five spheres of logics that artists have to deal with.

It all starts at home, in the sphere of the *oikos* (the Greek term for home). Artists usually begin their art practice at home, with the support of their parents, or at least with their acquiescence. The support is usually financial. When the budding artists leave the home, they will need to convince the members of their new home, or just themselves when they live by themselves, that they should have the life of an artist and all involved will bear the burdens, suffer the disappointments, and enjoy the fruits together. A partner may need to work to pay the bills. In these ways artists valorise the life of an artist in accordance with the logic of the *oikos*.

The next logic that comes into play is the cultural logic, or the logic of the artistic conversation. In order to be an artist, artists need to be part of one artistic conversation or another, to give artistic meaning to their work. It may be the genre in which they work, or the work of others to which they relate. The cultural logic prescribes ways of working and ways of talking about the work. It is all about making sense and being made sense of. The artistic logic is enabling but also may be a formidable power.

The social logic encompasses all the social interactions in which artists engage to be artists, to gain approval and appreciate the work of others, the networking they do, the relations they maintain, the endless social interactions, the participation in clubs and groups and so on. It is the logic of inclusion and exclusion, of reputation, and of recognition. It is the social logic that impels artists to go to openings, to attend events, and so on. The socialising begins for most artists at an art academy. There they learn what is expected from artists, how to engage with the work of others and how to bring their own work into the conversation.

It is in the combination of the social and cultural logic that art comes about. Socially speaking art is a shared practice, or, as we noted earlier, a conversation. By seeing art as a conversation, we stress the social reality of engagement in a common practice. By contributing to the conversation, artists are part of it. The same applies to other

artists: they, too, need to contribute in order to be part of the conversation. Art is an ongoing practice both in a social and in a cultural sense.

In the market logic, art comes in the form of products with a price attached. Subjecting art to this logic is a strange move in a way, as it reduces a practice to a product. One piece gets singled out as if it were just on its own, whereas in reality it is a contribution to a social and cultural practice that is called art. Yet, the reduction to a product or commodity is the most practical and instrumental way to generate the means, usually in the form of a monetary amount, that enables the purchase of goods and services that are important to artists and their families, such as food, a house, and materials.

The problematic character of the reduction of art to a commodity status shows in the visceral reactions that many artists have against it. Other artists such as Damien Hirst and Jeff Koons take advantage of it, and are successful playing with the market logic. Anyhow, the market logic enables artists to valorise their work in exchange for means of purchase.

Another logic that artists use to generate financial means is that of governance. Governmental logic operates whenever artists deal with organizations, governments and foundations in particular. When they try to valorise their work by soliciting a subsidy, they have to deal with this logic. It comes in the form of procedures, check-lists, forms, selection committees, accounts, bookkeeping rules and the like. Some artists are good at the governmental games; others loathe them. For the latter, it may feel that governments and foundations overpower them.

As a rule, artists will use all spheres to valorise their work. Distinguishing them allows for all kinds of observations. The following examples will demonstrate how artists make use of these spheres, and how the valorising in one sphere can conflict with existing values in another. By understanding the process of valorisation, we begin to see how power comes about in each of these spheres, and how it is distributed across the art field more generally.

Valorisation, Value Conflict and Power Often Starts at Home

Due to their positive and negative impacts on artistic practice, commentators are quick to point out the significance of valorisation in the market and governmental spheres. What all too often gets overlooked is the importance of valorisation that follows the logic of the *oikos* and social spheres. We'd like to begin by discussing how art becomes valorised in the artist's *oikos* or home, and how this logic links art's valuation to other spheres.

The often unstable and isolated nature of an artist's work means valorisation in the *oikos* becomes a critical way for an artist's values to be realised. Artists have a long tradition of being financially, creatively, and psychologically supported by partners,

parents and family. Importantly, art's valorisation in the *oikos* can reduce the necessity to valorise in the market or governmental spheres, and so can be a boon for artistic innovation. On the other hand, artists that embrace an *oikos* logic often experience a fall in art's relative value, and a corresponding conflict with art's valorisation in other spheres results.

In a 2014 interview, the British artist Tracey Emin reignited debate about a particular form of conflict that arises from oikos-based valorisation of art. Emin stated, "There are good artists that have children. Of course, there are. They are called men".[8] Emin's comment mirrors Cyril Connolly's famous phrase on creativity and parenthood: "There is no more sombre enemy of good art than the pram in the hall".[9] This can of course be applied equally to male and female artists. But Emin's comment also reflects a commonly held view that female artists pay a greater price as parents than their male counterparts.

Both issues – the impact of parenthood on the creative process and the allocation of domestic roles – often have a much more significant impact on artists and their work than how the artist engages with the market or governmental spheres. Like Tracey Emin, many artists view parenthood or other values associated with the *oikos* sphere as having too great a negative impact on the creative process and so do their best to minimise valorisation in this sphere. Artists may choose to live in their studio as a way to restrict the size and reach of the *oikos* logic, or they use other strategies to resist the notion of settling down. Most choose to engage in the *oikos* on some level, but understand that it may come at the cost of diminished artistic quality and output.

In an interview on the career challenges of being an artist, the Norway-based artist Camille Norment acknowledges the compromise involved in being an artist, parent and partner. After commenting on the range of artistic and administrative tasks she has to do in her daily routine, she adds, "All of this [must be done] before 3:00pm when I have to collect my kids. And very few understand how this hangs together, so I have begun to say it straight out: I am a mother – this is my other fulltime job, and yes I take it seriously".[10] In Norway, kindergartens are heavily subsidised and parents receive some childrearing assistance, so one may wonder whether parenthood demands significant artistic compromise. Or in Tracey Emin's case, commercial success means she has had the financial means to pay for help in raising a child. Both artists allude to the fact that the real cost of parenthood is not economic, but instead the time and emotional commitment required. There is by no means universal agreement on the issue, but it can be argued that children impede the kind of mental and emotional detachment that is sometimes required to make good art.

Obstacles to the valorisation of art in the *oikos* sphere are not limited to parenthood. Particularly when artists form domestic relationships with non-artists, there is potential that an artist's lack of income or income stability becomes a source of tension or even resentment in the relationship. Some relationships do not survive, but in many cases the low relative value that emerges from valorising art in the *oikos*

sphere means artists choose to take on an amount of stable work outside of art. Coupled with children or the desire to own a physical building to base the 'home', valorisation of art in the *oikos* has the potential to alter artistic practice in a profound way. Artists are often forced to choose between reducing time devoted to art, increasing market valorisation of their work, or increasing governmental valorisation where subsidies are available.

What does valorisation and evidence of artistic compromise have to do with the distribution of power in the arts? Power has two sides. On one side, power is the ability to realise one's values. On the other, it is what stands in the way of, or obstructs, the realising of one's values. When artists value an artistic life, the practice of art, they are empowered when their *oikos* supports them in achieving such an end and face obstruction when their situation at home stands in their way (because of children, an unsupportive partner, the necessity to earn the monetary means by way of a boring job). When artists are able to generate a means by way of the market logic, and thus free themselves from obstacles at home, we might say that the market has empowered them in the sphere of the *oikos*. The point is that actual power is dependent on one's standpoint, on the sphere in which one operates and on the values, that this person seeks to realise. (If parenthood is the more relevant value the *oikos* will be less likely experienced as an obstacle than if an artistic life is the most relevant value.) Importantly, this says there is no single power structure of the arts, but a different one for each artist.

As someone who has been very clear about not letting her art be encumbered by an *oikos* logic, Tracey Emin's perspective of the power structure of the arts is presumably dominated by the elements of the cultural, social, market and governmental spheres. A 40-year old male artist with limited commercial success and a second child on the way is likely to view the power structure of the arts somewhat differently.

Valorisation, Compromise, and Power in the Governmental Sphere

In 2008, an artwork proposed by the Norwegian artist, Lars Ø Ramberg, was selected by the Oslo Municipality to be realised as part of the redevelopment of the harbourside Bjørvika area in Oslo. The work, *Yersenia pestis*, involved decorating two large concrete towers with light diodes arranged in a pattern that matched the genetic code of the black plague bacteria. The work would have particular resonance for the area given the plague's historic role in shifting Oslo's centre away from Bjørvika towards its current more western position, not to mention the plague's significance in forcing Norway into a 400-year union with Denmark, which effectively meant the end of political and cultural self-determination over that period.

Shortly after the commission was awarded, the State-owned road authority responsible for the project, Vegvesenet, announced they did not have the funding needed to build and maintain the artwork. The artist conducted a series of interviews to try

to put public pressure on Vegvesenet, and in 2010 the artist was asked to a new meeting where it was proposed he present an alternative project that could be realised for less money. The meeting took place, but since neither side could come to an agreed compromise, plans to decorate the concrete towers were dropped. Partly because of this project, Ramberg is associated with the notion of the "uncompromising artist".[11]

The case of Lars Ø Ramberg illustrates the importance of art's valorisation in the governmental sphere, and the obstacle that arises when an artist rebels against and within this sphere. Like in the *oikos*, the governmental sphere is empowering for those who are able to handle it and take advantage of its sources, yet becomes a serious obstruction to those unwilling to compromise with its logic. Even those who actively seek to resist governmental valorisation, such as the artist who is willing to walk away from a significant commission because it denigrates his or her artistic vision, find it very difficult to truly deny its power and influence. This makes sense if we look at Ramberg's unrealised tower artwork in the broader context of his career.

The same artist is in fact better known for another work that was also not realised. To mark the 100-year anniversary of Norway's independence from its union with Sweden, the Norwegian government, through its public art agency, launched a competition for an artwork that would be positioned on the site where the country's original constitution was signed. The winning submission, a proposal by Lars Ø Ramberg, consisted of installing three functional JCDecaux toilets that had been removed from Paris' streets and painted red, white and blue. The work, which came to be known as *Liberté*, was intended as a reflection on the various influences to the Norwegian constitution, and the egalitarian principles that both the constitution and a public toilet symbolise. After the work was announced as the winner, the public art agency reversed its decision. Officially, this was due to the problem of having a commercial agent sponsoring a public monument. But the reality is that it was belatedly deemed inappropriate to have a row of toilets as a monument to Norwegian independence.

In both instances Ramberg may have had grounds to pursue legal action. That none was taken (as far as has been made public), and that Ramberg moderated his criticism of the involved parties, alludes to Ramberg's recognition of values that originate in the governmental sphere, and the power the governmental asserts over artists.

A closer look at Ramberg's career reveals how deeply he, like most other professional artists, is immersed in government values. Although based in Berlin, he studied at the Oslo National Academy of the Arts and he continues his engagement with the institution through teaching. He has previously been a member of the committee that awards national arts stipends, and he is himself a recipient of a stipend that, if necessary, provides him with a minimum income until his retirement. Despite his public criticism of the cancellation of *Liberté*, Ramberg agreed to present the work as part of the Nordic Pavilion in the 2006 Venice Biennale, and later-on was willing to

have it installed in front of the National Museum. In both instances, the work was installed at locations quite removed from the site-specific constitutional reference the work was intended to have. After further controversy, and behind the scenes work, *Liberté* now stands in a public space in front of the Norwegian parliament. Despite little indication his tower work will ever be realised, he was recently awarded a major public art commission for the new city library in the same redevelopment area where the concrete towers stand.

Figure 2.1 Lars Ø Ramberg's *Liberté*, installed at Eidsvolls Plass in central Oslo, Norway. Courtesy of Studio Ramberg.

Although this brief overview of Ramberg's valorisation in the governmental sphere certainly glosses over many of the subtler details of the two projects, Ramberg's critical restraint and subsequent flexibility illustrates the reality that artists are required to make in trade-offs and compromise once they seek valorisation in the governmental sphere.

When artists recognise and take on values that originate in the governmental sphere, arts-related behaviours, processes and thinking change in line with those values. This by no means implies negative artistic consequences. By freeing up the financial or reputational resources needed to realise otherwise unrealisable projects, following arts-based structures and procedures can have a positive impact on artistic outcomes.

However, there are also many ways that art can be negatively affected by the recognition of government values. The acceptance of an anti-market logic in educational institutions places an early limit on the type of work artists make, and who they make it for. The possibility for stipends and grants tends to direct art-making toward the

vision of those on the selection committees, and means a considerable amount of studio time is directed towards writing applications. Recognising governmental values means bookkeeping, completing tax returns, working with professional arts organisations, and political engagement – all of which encourage a type of social responsibility that can be destructive to artistic irresponsibility that is sometimes needed for innovation.

How then does valorisation in the governmental sphere impact the power structure of the arts from Ramberg's perspective? By placing limits on how he allows his work to be valued in the governmental sphere, the artist demonstrates his acknowledgement of the power of the cultural and social spheres. By regularly returning to the governmental sphere to seek artistic valorisation, he also recognises and accords power to the governmental sphere. While the governmental sphere empowers his artistic work by providing the means and recognition that he needs to realise himself as an artist, it appears as an obstructive power as it shows in the compromises that he has to make.

No Man or Woman Is an Island

Tracey Emin and Lars Ø Ramberg represent the 'professional' artist in the sense that they not only make a living from their art, but they actively engage with the notion that the artist has a particular role to play *in* society. This relates to the thematic concerns of their art, but it also relates to their active embrace of valorisation according to many of the social, cultural, *oikos*, market and governmental logics. This raises the question: What about the hermetic artist, the loner who shuns society and who makes art purely for art's sake? Does not he or she avoid valorisation complications and simply make art? Art's history is sprinkled with artists that reject certain artworld structures – Van Gogh, Paul Gauguin, Cady Noland, the list goes on. In order to consider what happens to valorisation in each of the five spheres when artistic isolation is pushed to its limit, we will consider valorisation in the context of the Scottish-born artist Ian Fairweather.

When Ian Fairweather died in 1974, aged 82, he had spent the final 20 years of his life living in squalid conditions resulting from self-imposed isolation on Bribie Island in Queensland, Australia. Even in the broader context of art history, his personal story is quite remarkable. In 1952, aged 60, living in the cabin of an abandoned ship in Darwin harbour, and in a general state of despair, the classically trained painter set off from Darwin on a raft built from three aircraft fuel tanks scrounged from the local tip. The *Kon-Tiki*-inspired raft was meant to carry Fairweather to Timor, and miraculously Fairweather ended up reaching the island of Roti, Indonesia, 16 days later. Rather than finding paradise, he was incarcerated and eventually deported to the UK. By the time Fairweather managed to return to Australia in 1953, he was more or less a penniless artist who had nevertheless built strong local reputation for his post-impressionist

painting. Fairweather travelled to the then isolated and sparsely populated Bribie Island, built himself a hut from sticks and bark, and made it his home and studio. It would be the most artistically productive period of his life.

In many regards, Fairweather was an artist who sought to disengage with valorisation in social, market and governmental spheres. The isolation he sought on Bribie Island follows a long trajectory of acts towards social disengagement and an apparent disinterest in valorising his art in the social sphere. Fairweather, who had become estranged from his family at 37, had a lifetime fascination with islands and the isolation they offer. In his late 30s he spent a winter in complete isolation on Canada's Prevost Island; and it became a lost ideal for the remainder of his life.[12] While renting a studio in Melbourne, he is said to have nailed his door closed and crawled out of the window to avoid being disturbed.[13] For all his artistic success in Australia, Fairweather shunned openings of his exhibitions, only ever attending one.[14]

Figure 2.2 The artist Ian Fairweather outside his studio and living quarters on Bribie Island, Australia (1972). Photo by Bob Barnes/Newspix.

Throughout his life, Fairweather demonstrated a general disinterest in money and material possessions. Although he was able to finance his travels throughout East-Asia by sending work to London's Redfern Gallery and having a former class mate at the Slade School, Jim Ede, wire him the proceeds, Fairweather's only interest in money appear to be its ability to fulfil the basic functions of food, shelter, and art materials. Referring to his experience as a soldier in the First World War, he reflects, "Perhaps, those years I spent as a prisoner of war were some of the happiest of my life – no

responsibility for practical things like money, food, and shelter".[15] When Fairweather began to be represented by Sydney's Macquarie Gallery, Fairweather made the unusual request that the gallery handle his money and send him regular payments that were no more than that necessary to sustain life.[16]

Fairweather also displayed a general disinterest in valorising his art and life via governmental logic. When Fairweather arrived on Bribie Island, he simply found a piece of isolated land and built his hut. No local government permission was requested and none was granted, and it was perhaps only because of his fame that the local council later granted him a lease over the land he was using. The raft journey which ended in his incarceration in Indonesia and Singapore was the outcome of being oblivious to the issue of a visa. In the years that Macquarie Gallery acted as his banker, excess money was paid into a bank account on which Fairweather failed to pay tax. And perhaps his most significant infringement of procedure was the manner in which he made art. For an artist trained at London's Slade School, Fairweather's attitude to materials and their longevity continues to infuriate art historians. A great many of his works are said to have literally disintegrated on transportation due to inappropriate materials and poor packing.[17]

To be sure, there are few artists who take the notion of detachment as far as Ian Fairweather. Nevertheless, how do we make sense of an artist who apparently denies the logic of valorisation in so many spheres? Like the other artists considered in this chapter, one must consider Fairweather's artistic practice in a broader perspective to reveal the various logics of valorisation that occur. Fairweather clearly sought to valorise his art practice in the cultural sphere, but closer analysis of his practice suggests he also pursued valorisation in the social and market spheres.

The social isolation sought on Bribie Island and other places belies Fairweather's desire to remain engaged in a broader artistic conversation. On his return to Melbourne at the end of the Second World War, Fairweather spent two years living with an enclave of artists, and he maintained long-term relationships with fellow Slade student Jim Ede and Melbourne artists Jock Frater and Lina Bryans.[18] Although these artistic relationships were often based on Fairweather's financial and artistic needs, they nevertheless demanded a mutual valorisation of his art according to a social logic.

Although his monetary needs were very modest, there are several indicators that Fairweather placed importance on market valorisation of his art, and showed respect for the meaning of money more generally. Two acts in Fairweather's life illustrate this point. In 1947, Fairweather sent 130 rolled paintings from Melbourne to Redfern Gallery in London. The paint had not dried properly and the paintings arrived ruined. Because sales proceeds never arrived, Fairweather suspected he was being cheated and he later made several comments about missing money in his unpublished manuscript, *Amoreles*.[19] Secondly, letters between Fairweather and Ede indicate that Fairweather kept very precise records of money he borrowed from different people.[20]

Rather than having an ambivalent attitude towards market valorisation, this suggests Fairweather placed high value on self-sufficiency and he recognised money played a role in both enabling and undermining this.

The power structure of the art from Ian Fairweather's perspective was undoubtedly very different to that perceived by Emin, Ramberg, and probably you the reader. By repeatedly acting to assert the value of self-sufficiency, Fairweather's artistic practice must have represented a site of personal conflict. On one hand, he was aware of the need for his practice to be valorised in cultural and social terms in order to be part of the ongoing art conversation. On the other, this led to a form of dependence on others that he otherwise sought to avoid. In the end, not even the extreme isolation Fairweather sought was able to prevent a need to valorise and accord power through structures in the market and social spheres.

Conclusion

Valorisation is an essential process of realising the things we hold dear, and as such we are continually obliged to play by the rules of one or more spheres of valorisation. Clashes across spheres of valorisation mean artistic practice, much like the practice of other professions, ends up being the outcome of compromise on some level. Spheres can empower artists but they can also be experienced as opposing powers, as obstructions in the realising of their art. As we've outlined in this chapter, any compromise that artists make reflects their own perspective of the power structures that they face. Even though compromise seems a certain outcome, the meaning of compromise varies vastly.

In contrast to many other professions, artistic compromise can be particularly problematic in that it may cut away at the very thing the artist is aiming for. The Roman philosopher Marcus Tullius Cicero coined the term *summum bonum* to designate the end good that we ultimately seek to realise.[21] The distinction between means and *summum bonum* is important because, when understood as a means, there is less hindrance to trading one good for another so long as realisation of *summum bonum* is not compromised. An artist may be unconcerned about whether their work is valorised in the market or government spheres as long as doing so allows them to continue with their art making, to support a family, and so on. In this regard, art practice geared towards market or governmental valorisation of art functions as a means.

A practice that is directed towards the realisation of *summum bonum*, a practice where the ideal that is strived for is inherent to the practice itself, can be referred to as a *praxis*.[22] For example, instead of just being the tool to realise the ultimate goals of aesthetics or freedom, the practice of art can be a realisation of those very things. Where art is a *praxis*, the necessity to valorise work in multiple spheres can be the very thing that hinders achievement of art as an end in itself.

The solution seems easy, and in a way, it is. If you perceive valorising art in the *oikos* or another sphere will limit realisation of the *summum bonum* of art, you may consider avoiding the valorisation of art in that sphere. Both Tracey Emin and Ian Fairweather tried just that. But if you hold other personal goals directly linked to the sphere you're otherwise seeking to avoid, then compromise on some level is unavoidable. Perhaps the main difference of comprise where art is a praxis is that the stakes of poor choices are higher.

Notes

1 Marita Flisbäck and Anna Lund, "Artists' Autonomy and Professionalization in a New Cultural Policy Landscape," *Professions & Professionalism* 5, no. 2 (2015): 867.

2 Richard Florida, *The Rise of the Creative Class: And How It's Transforming Work, Leisure and Everyday Life* (New York: Basic Books, 2002).

3 Kevin F. McCarthy et al., *Gifts of the Muse: Reframing the Debate About the Benefits of the Arts* (Santa Monica: Rand Corporation, 2004).

4 Michael Holquist and Vadim Liapunov, eds., *Art and Answerability: Early Philosophical Essays by M.M. Bakhtin* (Austin: University of Texas, 1990).

5 Arjo Klamer, *Doing the Right Thing: A Value Based Economy* (Hilversum, NL: SEC, 2016).

6 Elinor Ostrom, *Governing the Commons: The Evolution of Institutions for Collective Action* (Cambridge: Cambridge University Press, 1990).

7 Arjo Klamer, "Art as a Common Good" (paper presented at the bi-annual conference of the Association of Cultural Economics, Chicago, 3-5 June 2004).

8 Viv Groskop, "Tracey Emin Talks About Sexism in the Art World," *Red*, http://www.redonline. co.uk/red-women/interviews/tracey-emin-interview.

9 Cyril Connolly, *Enemies of Promise* (Chicago: Chicago University Press, 2008), 116.

10 Camille Norment, "Balanse I Regnskapet, Balanse I Kunstnerskapet," *Billedkunst*, no. 7 (2016): 24.

11 Dag Weirsholm, "Lars Rambergs Kunstprosjekter I Et Perspektiv Av Kunstneriske Kompromisser," *ArtsceneTrondheim*, http://trondheimkunsthall.com/news/ lars-rambergs-kunstprosjekter-i-et-perspektiv-av-kunstneriske-kompromisser.

12 Dael Allison, "Isolation and Creativity: Ian Fairweather's 1952 Raft Journey" (Masters dissertation, University of Technology, 2012).

13 Aviva Ziegler, "Margaret Olley, Fairweather Man," (Brisbane: Fury Productions, 2009).

14 Allison, "Isolation and Creativity: Ian Fairweather's 1952 Raft Journey."

15 Nourma Abbott-Smith, *Ian Fairweather: Profile of a Painter* (St Lucia, Qld: University of Queensland Press, 1978), 19.

16 Allison, "Isolation and Creativity: Ian Fairweather's 1952 Raft Journey."

17 Ibid.

18 Ibid.

19 Ibid.

20 Ibid.

21 Marcus Tullius Cicero, *Speeches*, trans. Robert Gardner (Cambridge, Mass: Harvard University Press, 1965). Klamer, *Doing the Right Thing: A Value Based Economy.*

22 Klamer, *Doing the Right Thing: A Value Based Economy.*

What Do Artists Want? Re-reading Carol Duncan's 1983 Essay "Who Rules the Art World?" In 2017

Gregory Sholette

Figure 3.1 Malcolm Morley, *Beach Scene* (1968), acrylic on canvas, 279.4cm × 228.6cm. Courtesy the artist and Sperone Westwater, New York, US.

I. Art After Death

WING FLAPS FLAIL, DUST-CHOKED engines sputter, petrol-laden steel barrels loosen from restraints, bombarding passengers, and all the while credits flash over the mayhem as we watch the disabled twin-engine cargo plane crash-land into the Libyan Desert. Even before the movie titles have finished several listed actors are injured or killed off, their performances already completed. And still, the film goes on. Robert Aldrich's otherwise textbook Hollywood adventure movie *The Flight of the Phoenix* has always struck me as owing something to the unorthodox experiments of avant-garde cinema.[1] For one thing, Aldrich's 1965 movie was completed the same year as the late experimental filmmaker Tony Conrad previewed his first version of *The Flicker*, an infamous thirty-minute movie consisting of only black and white still frames that pulse hypnotically, generating psychedelic-like phosphene afterimages in front of viewer's eyes.

Granted, the two film projects appear entirely different at first. One movie boasts a traditional narrative script, box office star James Stewart, and five million dollars in studio resources that helped it garner two Academy Award nominations. By contrast, Conrad's experiment was made on a shoestring budget using several rolls of 16mm film gifted to him by fellow underground filmmaker Jonas Mekas. What then might link the two productions? It's surely not the way Aldrich graphically depicts the effects of air turbulence on human bodies or the fact that Conrad's experiment is rumoured to have produced bouts of nausea in audiences.[2] Rather, it is the curious way one movie appears to finish even before it starts, while the other compulsively repeats a series of visual patterns with no beginning middle or end in sight. In other words, the narrative of these works – if we can use that term here – appears to insist on the unthinkable: that once set in motion art is capable of continuing on without us, just as if it were an apparatus running without an operator at its helm. A bit like a phoenix in fact, and it is as if we are getting a glimpse of art after death.

II. Who ~~Runs~~ Rules the Artworld?

When contemplating who runs, or who rules, the artworld, let me suggest a pair of contrasting interpretive models or narratives. The first assumes high art to be an institutional structure that is indirectly ruled over by powerful elites whose objectives are ultimately driven less by a love of art or culture, than by the need to maintain their own class interests. This is a project that is accomplished through a combination of covert, as well as sometimes overt, ideological signals involving the direct economic control of museum boards, the ownership of gatekeeper galleries, but also a more roundabout mode of academic policing directed at the disciplines of art practice, history, criticism, theory, curating, and management. The second, and seemingly opposite interpretation of who controls the artworld also approaches high culture as an institutional structure. But rather than being ruled-over by the agenda of a specific

class, state, or business interests embodied in specific individuals, governments or corporations, it is instead a self-replicating program, or set of instructions, that operates across a broad bandwidth of formal and informal, networks, and increasingly within both high and low, or mass culture. And while this repetitive structure may have been built upon centuries of ruling class power, the latter's authority is now incorporated into the artworld narrative as a symbolic economy operating with the twin currencies of prestige and cultural capital, two forms of artworld booty that one hopes to harvest for the purposes of career advancement.[3]

While both of these interpretive models in the previous paragraph are schematic and admittedly overstated, it is important to note that neither forecloses on the possibility that confrontations might break out over who gets to control, or who benefits from, the broader artworld narrative. However, the first explanation has the advantage of clarity when it comes to the cause and effect and motivation that determines artworld operations, and thus also makes visible who is to blame for the direction art takes. In contrast the second reflects more accurately the way we actually experience the artworld in all its apparent miscellany, especially today, under an increasingly financialised and intangible form of global capitalism. But then there is another significant difference at play here. The first model hinges on the belief that high culture's narrative is also manifest within its specific content. By closely scrutinising particular works of art one can read traces of ideology at work, if not actual depictions of, or references to, class domination. This, after all, is the type of critical work certain art historians have performed for the past several decades, as we shall see. Conversely, the second, competing model of high culture typically bypasses the reading of specific art works in order to focus on the artworld as a discursive structure, which is the level where, according to this approach, real ideological power resides. In other words, a meta narrative.

Thus, we arrive at an apparent standoff between what might be termed a modernist, and a post-modernist interpretive paradigm regarding who rules, or who runs, the artworld. Before this essay concludes my aim is to present not so much a distinct, third interpretation, but an expanded version of artworld control and reproducibility that draws upon both of these models while re-focusing on the negative potency of what these narratives must logically exclude. With this aim in mind, I also need to point out that there are three distinct time frames at work in this essay. One is of course the present day, a point more than mid-way through the second decade of the 21st century in which, so I will argue, the demystification of high culture has been achieved, though the ecstatic liberation this disclosure was supposed to usher in appears distorted, even unrecognisable. The second time frame invoked in this essay is some thirty-five years prior to today when the noted art historian Carol Duncan pens "Who Rules the Art World?" It is upon her essay that my essay pivots.[4] In addition, Duncan's text is itself predicated on a still earlier event in the 1960s that involved an incident she was unable to forget (although it took her a decade to finally unpack and write about). Therefore, the late 1960s constitutes the third-time frame of my text.

What follows therefore, is my re-reading of Carol Duncan's "Who Rules the Art World?", a treatise that has inspired my research into high culture, as well as directly influenced a concept I label the "dark matter" of the artworld about which I will provide more details below.

III. 1968

"A little over a decade ago", Duncan writes in 1983 with reference to the late 1960s, "the art press announced a new trend in modern painting, photorealism".[5] This new style was sometimes branded hyper realism, or super realism, but the term Duncan adopts and that I will also subscribe to hereafter is photorealism. It is a school of contemporary art in which artists meticulously rendered photographic imagery with an affectless, machine-like precision typically using the vivid colour made possible with acrylic paints.[6] For Duncan, photorealism came as a surprise. "At the time, most high-art galleries were showing totally abstract or conceptual works", she writes. One canvas in particular draws her attention. In it a white family of four are depicted as they self-consciously pose for a snapshot posing on a sunny shoreline. The father, Duncan comments, is "a Dick Nixon look-alike" who "grins too much as he plays with his son's toy car, while his wife over indicates her amusement".[7] Rendered in a restrained and dispassionate manner the painting appeared to her as an acerbic commentary on the all-American nuclear family's false normalcy. "The work's cool, detached surface, clean-edged forms, and bright colours magnified the emptiness of the family cliché that the figures act out". But it was the art historian's encounter with the author of the painting that ultimately initiates a detailed investigation into the ideological underpinnings of high culture.

Duncan never names either the painting, or the painter in "Who Rules the Art World?", though the work in question is appropriately entitled *Beach Scene*.[8] It is a large canvas painted in 1968 by the British abstract expressionist turned pioneering photorealist Malcolm Morley. The piece now hangs in the permanent collection of the Hirshhorn Museum and Sculpture Garden in Washington DC.[9] But, exactly what was so startling about this painting's icy critique of family life, or with photorealism in general? After all, derisive, even sneering criticism of mainstream, white America was copious in the 1960s, including within academia, but also in best-selling novels, mainstream movies, rock and folk music songs, and sit-com television programmes. For many, the US middle class had come to symbolise sexual repression (Charles Webb's novel *The Graduate* or Philip Roth's *Portnoy's Complaint*), political hypocrisy (Bob Dylan's *Like a Rolling Stone*), and the malevolence of American patriarchy (Robert Duvall's 1979 tyrant *The Great Santini*, or Peter Boyle's unhinged father in the 1970 film *Joe*). Add to this the ludic parodies of the American dream staged by Chicago's Second City improvisational troupe, a forerunner to *Saturday Night Live*. Within this broader context, Morley's apparently sardonic painting hardly seemed shocking.[10]

What initially startled the art historian was not the presumed content of *Beach Scene*, it was instead the way the painting, and other photorealist pieces "thrust upon us highly resolved images of the modern world".[11] Recall that throughout the 1960s, and most of the 1970s, figurative and representational art was an anomaly in the high artworld, a cultural landscape saturated with ultra-flat geometric canvases, cube-shaped sculptures, and other formalist works favoured by museums, galleries and art critics.[12] Meanwhile, Duncan's art historical training focused on 18th and 19th-century European painting, a background that quite likely fuelled her initial enthusiasm for the realistic approach of photorealism regardless of its self-conscious and ironic perspective. After all, it appeared to represent a renegade group of heretical, living artists who had unexpectedly asserted their right to depict everyday reality. And at a time of intense political, social and cultural crisis such as the 1960s, virtually any figurative imagery, as opposed to abstraction or design, whether it be presented as art or entertainment or advertising, was inevitably decoded as an implicit critique, or confirmation, of the status quo. Nevertheless, the art historian was due for another surprise. And it was this second shock that ultimately led her to write "Who Rules the Art World?"

Duncan finally meets the painter Morley a year or two later. She compliments him on his craft and critical acumen. She shares her interpretive reading of his painting *Beach Scene*. At which point the art historian is rewarded with chagrin as the painter condescendingly informs her that his work has nothing to do with this or that clichéd imagery or social critique, in fact the painting has nothing to do with imagery or society at all. Instead, *Beach Scene*, he insists, is solely about "the painted surface as an arrangement of color and form".[13] Doubting his frankness, she nonetheless "did not argue with him". And yet clearly the banality of the image was brimming with uncomfortable innuendo. Was it possible that the vociferousness of the artist's response signalled another, deeper level of discomfort, if not outright suppression? Reflecting on that plausible concealment came a decade and a half later, and when it arrives Duncan takes no prisoners.

IV. 1983

"Who Rules the Art World?" starts off mercifully enough. Duncan even offers allowances for the unspoken obligation artists believe they have to frame their work within institutionally recognised critical language (despite the fact that the manifest appearance of their work typically reveals little or no obvious connection to these same conceptual intricacies to which the artist lays claim). This does not prevent her from becoming increasingly exasperated with the intentional blindness artist, and the artworld display towards their own mythologies as the essay progresses. She muses over Morley's scorching response to her reading of his work. This leads Duncan to consider that by accident she had exposed the artist's anxious fixation about issues of control and subjugation within the artworld. "Whether or not they like it or want to

admit it, most professional artists are forced to keep an eye on the market".[14] Which is to say, the value of one's work is always dependent on a combination of visibility within the artworld's key institutional venues, as well as favourable evaluations by critics who guard "the door to all available high-art spaces, sets the terms for entry, scouts the fringe spaces of new talent, and tirelessly readjusts current criteria to emergent art modes". [15] And the critic's power is vested in the artist's hope that he or she will guarantee that his or her work holds "some transcendent meaning". It is this collateral that in turn makes the art work marketable.[16]

By suggesting that Morley actually took interest in the everyday social content that he depicted, even if this subject matter was initially captured in the photograph the painter reproduced, Duncan unintentionally bounced *Beach Scene* right out of its high artworld status and sent it packing to the provinces where pictures and their meanings remain available to any viewer without the need for critical mediation. [17] The artist's vexed response to this demotion ultimately becomes the starting point for Duncan's systematic demystification of high culture. In general, "Who Rules the Art World?" makes two things absolutely clear. No matter how intensely artists may wish things to be otherwise, they do not determine how the artworld functions. Their ideas, artistic products, and even their careers are seldom determining forces within the artworld. More than that, the artist must also learn to surrender their autonomy to the demands of the artworld, even as the artworld's self-narrative promises that making art is the freest form of human labour. But above all else, the essay is a meditation not so much about Morley, or his painting, but about what any contemporary artist imagines that they get in return for invoking the immaterial discourse of art criticism. "Most people get along with art or something they consider art on their own terms without the slightest help from high art criticism", Duncan points out.[18] In stark contrast, the artworld has a costly tripartite system of admission that is premised on the systematic abandonment of such commonplace cultural innocence.

First, the professional artist must find the means to be present – either physically or through gallery representation – in what Duncan terms the "summit art community in the Western world", New York.[19] Second, the artist is required to signal to other high art professionals that he is aware of, as well as fluent in, the type of serious, critical conversation generated within this network of producers and buyers, critics, historians and administrators. "In order to become visible in this world [of privileged culture], an artist must make work that in some way addresses the high-art community or some segment of it". [20] These are two of three essential steps needed if one hopes to achieve some level of artworld success, and both require a combination of sacrifice and surrender. For example, New York between the late 1960s and early 1980s was hardly the swanky 1 per cent city it is today. Though far more affordable, most low-cost neighbourhoods where artists tended to gather including especially SoHo, the Lower East Side or Hell's Kitchen were plagued by substandard living conditions, poor or non-existent city services, as well as crime, drugs, and arson.[21]

But "Who Rules the Art World?" goes on to argue that there is a third important element necessary for art access and it has to do with the nostalgic, naïve, and non-ironic romantic sentiments most people experience when they encounter a work of art. All of these commonplace joys must be systematically and diligently detached from the professional artist's worldview. Duncan describes this self-inflicted process of dispossession as not only a sacrifice demanded by the artworld, but a forfeiture that promises to smuggle back to the acolyte a far purer form of insight.

> His unconventional art bears witness to both his heroic renunciation of the world, and his manly opposition to it…[his] work negates the world and its emotional, moral, and political possibilities with inspired convictions.[22]

Furthermore, this "triumph of the spirit" is clearly gendered male.[23] More than that, this masculine striving for individual freedom underpins the entire ideology of bourgeois culture, reaching all the way back to such representational artists as David, Géricault, and Delacroix in the 18th and 19th centuries, then moving forward through modernist experimentation with Cézanne, Picasso, Kandinsky, on up through Pollock and de Kooning, and later lays the ideological foundations for the art of the 1960s, 1970s, and the 1980s whereby its apogee is Minimalist asceticism in which all remaining vestiges of representational art are expunged. "Little by little," Duncan writes, this ever-accelerating alienation from the world rids art

> of narrative illusionism, representation, and, finally, of the picture frame itself. Modern art celebrates alienation from the world and idealizes this [detachment] as Freedom. [24]

At which point Duncan reminds us that this high art project of withdrawing from common life experience was first launched in the later eighteenth century, precisely when "the bourgeoisie was ready to make a decisive bid for state power". [25] It was also the historical moment when the art critic first appears, who would evolve into a profession later in the next century with the rise of independent art dealers and the demise of the French art academy.

> In all of these struggles criticism has fought not against high art but for control over it [but] for now as in the past, high art exists largely at the will and for the use of wealth and power–and I would add that it exists for he most part as a means of keeping that power in its place.[26]

Granted, up until the late 1980s the contemporary artworld was, like so many professions, marked by a sharp division of labour separating the activities of the artist from the critic, the critic from the art historian, and perhaps most decisively the critic from the curator. But the familiar compartmentalised artworld was about to implode. Sometime in the late 1980s the dominant role of the art critic Duncan scrupulously details began to be usurped by that of the curator, who takes over the indispensable task of sorting, labelling, and ranking art and artists in "relation to

each other within one of the ever-shifting trends that waft through the market". [27] In 1989 *New York Times* art critic Michael Brenson asserted that "the era of the curator has begun". [28]

One year after Duncan's essay appeared in print, Morley becomes the first recipient of the coveted Turner Prize, beating out British artists Gilbert & George and Richard Long among others. But the award is granted after the painter's photorealist canvases are abandoned. In 1984 he is producing large, lush images of tropical forests and beach scenes rendered in a neo-expressionist style with imagery alluding to the figurative work of Picasso and Gauguin. In retrospect, this is perhaps not all that surprising. Looking back on the 1980s we recognise that it is the decade in which the modernist paradigm that Duncan ardently denounces finally breaks down in toto.

Modernism's post-war supremacy over the artworld may have started its decline years earlier. Possibly it began with the mocking antics of Fluxus, Happenings, and other Neo-Dadaist practitioners who hoped to subvert high culture and its link to capitalist markets. But in 1968, the same year Morley paints *Beach Scene*, the artistic avant-garde moves from theory to direct action when the Situationist International joined the student and worker occupation of Paris. And yet, the power of Greenbergian criticism, with its professed Kantian philosophical foundation, was only completely toppled when a wave of young artists primarily from middle-class, rather than upper-class backgrounds, shamelessly embraced the American culture that they had grown up with: animated cartoons, advertising art, comic books and graffiti. In the 1980s the high-minded, detached and formalist artworld was suddenly confronted by a barrage of flippant and flamboyant, day-glo coloured canvases and campy performances created by artists who celebrated, even as they parodied, the all-American, white suburban life-experience. Centred in New York's East Village this bevy of fluorescent Valkyries rejected conceptual art, critical theory and institutional critique. They came riding into the citadel of high culture like puerile barbarians only to discover that the artworld was a fake fortress all along. Before the decade was over a similar "insurrection" had taken place across the pond in London as the so-called Young British Artists memorialised the profane, ephemeral, and frequently smutty facets of non-elite mass culture. The privileged worldview of serious art was forever ruptured.

Unlike previous anti-art, anti-high cultural uprisings including Dada or the Situationists, these middle-class rebels actually wanted in, not out of the artworld. Accordingly, they continued, rather than interrupted, the imaginary cultural dissent of the post-war, neo-avant-garde, which for Duncan was epitomised by Minimalism. "While Dada set out to beat the system by not producing commodities, Minimal and other trends like it admitted impotence from the start and mutely handed over the goods". [29] But something peculiar takes place with the pseudo-insurgency of the East Village Art Scene. Their lowbrow blitzkrieg of high art aesthetics was so successful that subordination to restrained upper-class taste has never been reinstated. At the same time, the disorderly and pluralistic culture that was ushered in by the 1980s also befit the

emerging economic paradigm of individualistic entrepreneurship associated with hyper-deregulated capitalism, or what we today call neoliberalism. Welcome to the new artworld, same as, or almost the same as, the old one.

Duncan was probably unaware of such events as the Times Square Show – the raucous overture that rang in the insouciant insurrection of the 1980s artworld – as well as other subterranean stirrings of high cultural dissent.[30] Focused primarily on critiquing the ideology and rituals of high museum culture she nevertheless acknowledges that there is space for rebellion when she affirms that "the high artworld monopolizes high-art prestige, but it does not organize all creative labor".[31] Unfortunately, the creative mutiny then underway was, by-and-large, neither a Left-wing Trojan Horse of the type activist critic Lucy R. Lippard anticipated, any more than it was a feminist subversion of masculinist art's "renunciation of the world" critiqued by Duncan.[32] And in an uncanny foreshadowing of the 2016 US presidential elections, the progeny of Nixon's so-called silent majority came back to roost in the derelict, post-white flight inner-cities of the 1980s. As they gained purchase within the expanding real estate and finance economies and helped pave the way for a new type of 20th-century urban gentry. Unwittingly, or complicity, artists who participated in this transformation helped set the stage for the blighted working-class enclaves of New York City and London to be reborn as neo-Bohemian havens for the 21st-century ultra-rich. For at the end of the day, these fun-loving, Warhol-inspired, art pranksters became the true scions of President Ronald Reagan and Prime Minister Margaret Thatcher's ideological reformation of capital. For despite, what they may have professed politically, and no matter how much they may have despised their own parentage, this was a crop of artists who by and large drew upon the trickle down doctrinal discharge of neo-Conservative ideologues in both the US and UK.

Still, within the world of high culture there was suddenly room to manoeuvre in ways not previously available to professional artists in the past. Previously, if one held strong, politically dissident views there were three options: suppression (be active politically, but do not reveal your politics in your art); career marginalisation (make political art, but do not expect to prosper in the artworld); or simply "drop-out" (leave the artworld altogether and go to work within actual social movements).[33] Therefore significantly, along with this explosion of frivolous, politically apathetic, anti-modernist, or post-modernist art buffoonery, arose a new wave of socially engaged art activism primarily centred within an array of 1980s collectives. Some of these groups explicitly honoured the legacy of such 1960s organisations as Art Workers' Coalition (AWC), who called upon the Museum of Modern Art and other artworld institutions to treat artistic labour fairly, diversify their collections by including women and people of colour, and made the demand that museum trustees take a public stance against the US war in Southeast Asia. Duncan participated in the AWC's protests, (and even recalls that it was at one of these actions where she had the fated encounter with Malcolm Morley).[34]

Which is to say Duncan's text did not take place in a vacuum. Instead it joined a gathering body of art objects, installation works, performances, research and writings that would come to be associated with the practice of institutional critique in which the field of art is approached as a sphere of industrial production, rather than as a vocation transcending capitalist markets and business interests. The same year "Who Rules the Art World?" appeared in print artist Hans Haacke pens a frequently cited essay entitled "Museums, Managers of Consciousness". Borrowing the term "consciousness industry" from the frequently sardonic writing of German intellectual Hans Magnus Enzenseberger, Haacke, much like Duncan, uses this phrase to cut "through the romantic clouds that envelop the often misleading and mythical notions widely held about the production, distribution, and consumption of art". [35] Haacke – whose own art had been censored on more than one occasion due to its unflinching effort to link high culture with unsavoury corporate practices – goes on to describe this process of artworld industrialisation as a procedure that those who participate in the artworld including "galleries, museums, and journalists (not excluding art historians)" are "hesitate to discuss". That is because in order to acknowledge these raw, economic connections, the artworld would have to supplant "the traditional bohemian image of the artworld with that of a business operation". This revelation would in turn negatively impact the "marketability of artworld producers and interfere with fundraising efforts". Three years prior in 1980 Lippard had co-founded Political Art Documentation/Distribution (PAD/D), a collective that actively sought to align artists with third-world liberation struggles including the Sandinista National Liberation Front in Nicaragua that President Reagan was actively seeking to overthrow.

What is crucial to note here is that figures such as Duncan, Lippard, Haacke, and other non-conformist artists and critics, played a critical role in humbling the privileged discourse of high culture, setting the stage for the successive efforts at overturning the paradigm of artworld control. The transmission of their critique was made possible through the very same artworld circuits that they challenged, including art journals, academic institutions, museums and galleries. In a sense, we could say the power of criticism met with, and also reshaped, the aesthetics of power. Which makes the enfeebling of this very same institutional critique today so unfortunate. "Now, when we need it most, institutional critique is dead", laments Andrea Fraser, one of the movement's exemplary practitioners. It has become "a victim of its success or failure, swallowed up by the Institution it stood against". [36]

V. 2017

We can measure the waste not only in the thousands of "failed" artists – artists whose market failure is necessary for the success of the few– but also in the millions whose creative potential is never touched. Let us also count the labor of the mediators who conscientiously police high-art space and maintain its order. [37]

Almost twenty years ago I read these words by Carol Duncan and realised that they resonated deeply with my own experience as an artist, but also as someone coming to the artworld from a particular class background that offered no practical knowledge about how the high artworld worked, including who gets to participate in it, and how one must behave to advance within its ranks. Furthermore, Duncan's assertion (which borrows from the writings of Marxist intellectual Antonio Gramsci)[38] that most people have the capacity to make art, but are nonetheless prevented from doing so. In fact, her words made me confront the uncomfortable reality that my own movement away from the fairly immobile social position of my upbringing was based less on talent than it was on the generosity of teachers and mentors who acted on my behalf precisely because, far better than me at the time, they understood what the invisible costs and obstacles entry into the high artworld demanded, especially from certain social enclaves.[39] Nonetheless, what has never completely receded is first the feeling of being an imposter who is trespassing into alien terrain, and second a lingering undercurrent of *ressentiment* towards those who believe art and culture are their privileged birthright.

"Vast amounts of imaginative labor" are organised by the art market Duncan writes, only so it can "spill most of it down the drain in order to get a little of it to show in a few places for the benefit of a few people". [40] But, as an artist lodged within this process, Duncan's boldly stated metaphor did not ring entirely quite right. I knew many professionally trained artists who were still actively engaged in art, despite receiving only a small amount, or zero recognition from gatekeeper galleries, museums, journals, curators or critics. Their continued involvement with the artworld was typically financed by part-time employment as a studio assistant, art fabricator, adjunct art teacher, museum or art gallery installer, or art handler among other industry-supportive functions. There was, in other words, a strange, Limbo-like zone suspended between the artworld's successful 1 per cent, and the darkness of Duncan's deep drain. And this is where most artists find themselves, neither here nor there. Which is to say, most of the artworld's imaginative labour is never simply disposed of, it is instead organised and deployed on a continuous basis to become the essential reproductive substrate for the world of high culture. The metaphor I apply to this condition is that of artistic dark matter.

Cosmologists describe dark matter, and more recently dark energy, as a necessary gravitational force that while invisible, nevertheless serves to prevent the universe from dissipating into a cold, state of homogeneity. In order to achieve this slow-down of post-big-bang cosmic expansion some 96 per cent of the universe must be made up of dark matter. This estimate, together with is inscrutable invisibility is why the theory of dark matter is also described as the "missing mass problem". [41] Like its astronomical cousin, creative dark matter also makes up the bulk of contemporary artistic activity. However, artistic dark matter is invisible primarily to those who lay claim to the management and interpretation of culture; the critics, art historians, collectors, dealers, curators and arts administrators. In this way, artistic dark matter became my

shorthand label for Duncan's vast, invisible surplus of productivity, which I further broke down into three broad species of missing creative mass:

- The many professionally trained, yet failed artists, and also pre-failed art students
- The excluded armies of amateur and non-professional artists
- And a small number of art hackers, tactical media pirates, and peripheral artists' collectives who by and large excluded themselves from this world for political reasons

By flipping Duncan's insight, the other way around the question now becomes not why is there all of this waste of talent, but what does this vast pool of seemingly excess creativity actually and materially provide to the artworld? The short answer is that the high artworld needs this shadow activity as much as some developing countries furtively depend on their dark or informal economies.[42] Not only does artistic dark matter form the opaque backdrop of mass "failure" necessary for disclosing the luminosity of a relatively few art stars, but within its sphere of excess activity are the managers, builders, installers, journal subscribers, museum paying members and art supply purchasers who literally anchor the world of high art. Except, even as I developed this elaboration of Duncan's analysis, something was happening to this zone of obligatory invisibility. Dark matter creativity was getting brighter.

A clear example of this illumination was emerging within the then, newly emergent Internet where digital networks so essential for linking together the "just in time" production of deregulated, global capitalism, also made it possible for Duncan's "millions whose creative potential is never touched" to represent themselves to each other, to share images, swap music, images, information and artistic projects, and therefore to gradually develop into online communities. This was happening at the same time neoliberal enterprise culture sought to squeeze surplus value out of every nook and cranny of life, taking advantage of non-stop precarious working conditions, and the over-indebted consumerism of the "click here economy".[43] Combine this online self-discovery process with the extreme disparity in wealth distribution and the increasing reoccurrence of capitalist economic crisis – the 1980s savings and loan scandal, the 1990s Dot.Com bubble, and the 2008 real-estate and banking collapse – and not only has artistic dark matter gotten much brighter, it now glows with resentment as the UK Brexit vote and 2016 US election outcomes indicate. In Duncan's terms then, the drain is now quite clogged, and both the artworld and democratic society are facing a spillover, some of which is progressive, though much of it is the opposite. And for the moment the latter species of dark matter is in ascendancy.

The positive effect of this brightening is that the business-as-usual artworld is now facing a mutiny. Post-Occupy artists have generated a bevy of new organisations including Working Artists and the Greater Economy (WAGE), BFAMFAPHD, ArtLeaks, Gulf Labor Coalition, Occupy Museums, Debtfair, Liberate Tate, Art & Labor. Collectively they assert a moral, as well as often direct activist and/or legal demand that the

artworld become an all-around better citizen. The group Debtfair points to the 52,035 average dollars of debt owed by art school graduates (in the US) and insists this is untenable, while Gulf Labor and its offshoot Global Ultra Luxury Faction (GULF) and Decolonize This Place stage museum interventions protesting artworld hierarchies, complicity with the new US President, and unfair labour practices including the exploitation of migrant labourers in the United Arab Emirates where the Guggenheim is developing a new museum, despite condemnation from human rights groups. And there are some concrete outcomes. The Guggenheim gave up plans to build a museum in Helsinki, Finland thanks to organising by local groups, plus some strategic assistance from members of Gulf Labor Coalition. And after years of steady protests by the environmental justice art collective Liberate Tate, the Tate Modern has vowed to no longer accept funding from British Petroleum.

All in all, the situation today is very different from what it was in the late 1960s or early the 1980s, and Duncan already hinted at its possibility when she acknowledges as a caveat to her mostly bleak analysis that it does "not organize all creative labor".[44] Yet, at the same time that we witness this surprisingly robust pushback against hierarchical artworld hegemony, the art market has undergone almost a decade of unprecedented market expansion, even outperforming the stock market, if some investment reports are to be believed.[45] Rebellion and riches seem to make up the 2017 artworld, which has become so obviously integrated into global capital that it deserves a new moniker: the bare artworld, riffing off of Georgio Agamben's term "bare life".[46] Claustrophobic, tautological, our bare artworld is our bare artworld is our bare artworld. It emerges in successive and accelerating states of shadowless economic exposure following capital's ever-quickening swerves from crisis to crisis.

VI. Conclusion: Who ~~Rules~~ Runs the Art World?

> Everyone feels caught up in a "system" whose controlling power is everywhere but in no one in particular.
>
> Carol Duncan [47]

> The reason I'm painting this way is that I want to be a machine, and I feel that whatever I do and do machine-like is what I want to do.
>
> Andy Warhol [48]

The "secret" or "mystery" of artistic production, including its purported autonomy from the capitalist market, but also its heroic "male" struggle to achieve a transcendent state of true freedom which is made concrete by the work of art itself, this seemingly enigmatic phenomenon is revealed today to be merely another type of social production, no more, no less. The struggle of artistic will power over the world now transmuted into a Warholian artist-automaton. And what Duncan, Lippard,

Haacke and a handful of other artworld practitioners laboured to expose, is now an all-too obvious elephant in the museum where corporate sponsorship is no longer camouflaged, but nakedly celebrated. Virtually everyone engaged in the artworld – from artists, critics and curators, to installers, fabricators and administrators – are fluent in the vernacular of institutional critique, thanks in large part to the critical work of the 1960s and 1970s, but also as a consequence of capitalism's ongoing economic crisis, especially following the 2008 financial collapse.

What then of photorealist art and Malcolm Morley's *Beach Scene*? Obviously neither this essay, nor Carol Duncan's "Who Rules the Art World?", turn explicitly on the subject of photorealist painting, a trend that in fact had already crested in artworld terms when she penned her essay in 1983. And yet, photorealism seems to loiter nearby both texts. Though no longer fashionable, it loiters like a petulant outcast, murmuring something about art having become, like so many other things today, an unambiguously mechanical operation. Who then rules (or runs) the artworld? Certainly, the art establishment is still a sphere of class privilege, in fact, we see today a return to virtually pre-market monarchical control of high culture whereby oligarchical Russian art collectors flush with copious petro-dollars and equally wealthy sheiks in the United Arab Emirates, now gobble-up Western art works and cultural brands including the Louvre, Guggenheim and British Museum. But we also see just as clearly that the credits have already finished, and that the artworld's raw relationship with money and power are fully divulged, once and for all. And what is also visibly present onstage is another cultural force, just as naked, and ceaselessly persistent, a vibrant, no longer dark, Golem-like agency that, despite market failure, refuses to mutely serve the success of the few.

VII. Coda

While researching this essay I came across a remarkable contention made by someone who claims to be the young boy riding on the back of the "Dick Nixon look-alike" father in Malcolm Morley's *Beach Scene*.[49] Today he identifies himself as Chairman and CEO of a global technology and counter-terrorism holding corporation. This information is available on the man's website. The now fully-grown lad asserts that Morley was hired to paint the photorealist canvas by Joseph Hirshhorn, future founder of the Hirshhorn Smithsonian Museum and Sculpture Garden, where in fact the painting now hangs. In addition, this same individual insists that Hirshhorn commissioned Morley to utilise his precise, photo-realist technique in order to reproduce a promotional poster, first printed by The Daytona Beach Chamber of Commerce a decade earlier in the late 1950s. The image on the poster is a photo of this man, his mother, father and sister that he still possesses today. While this contention is certainly fantastic, I have only substantiated to my own satisfaction that the individual and his family are indeed the people in the photograph that Morley reproduced, but I have seen no evidence that the Hirshhorn, or anyone else, commissioned the painting.

However, even if all of these claims proved false, it is genuinely ironic, as well as perhaps telling, that many years after the fact, an art work which was not supposed to have nothing to do with imagery or content, has been re-appropriated by a private individual as their own personal nugget of cultural capital. More than that, contrary to the irate Morley, but also to the analytical Duncan, it is the representational subject matter of the painting that generates the man's sentimental attachment to this work.

Notes

1 The plot of 1965 20th Century Fox movie *The Flight of the Phoenix* involves an oil-company owned twin-engine cargo plane in flight over Libya, which encounters a desert storm causing fatalities amongst the crew before crashing in a remote part of the Sahara and stranding a small group of ill-tempered survivors whose cantankerous pilot, played by James Stewart, attempts to keep them alive by forcing them to collaborate on the resurrection of a new aircraft from the wreckage of the old. The film was remade in 2004 with far less critical or box-office success.

2 Conrad even included an on-screen warning at the start of his film cautioning people that The Flicker might induce epileptic seizures.

3 According to Timothy Van Laar and Leonard Diepeveen the distinction between Pierre Bourdieu's concept of cultural capital and art world prestige is that the latter cannot be purchased, but can only be conferred upon one from others because it comes to you from "a multitude of sources, in thousands of mysterious, obvious, or banal acts of deferral. Indeed, prestige can surface only in terms of the social, from a larger group to a smaller." Leonard Diepeveen and Timothy Van Laar, *Artworld Prestige: Arguing Cultural Value* (Oxford: Oxford University Press, 2013), 15-21.

4 Initially published in the journal Socialist Review (1988-2001), which was itself heir to Marxist Perspectives (1978-1980), the pagination and version of "Who Rules the Art World?" I am referencing in my essay is taken from: Carol Duncan, "Who Rules the Art World?" in *The Aesthetics of Power: Essays in Critical Art History*, ed. Carol Duncan (Cambridge: Cambridge University Press, 1993), 169-88.

5 Ibid., 169.

6 Developed in the early 20th century, although only widely commercially available starting in the 1950s, pigmented acrylic polymer paint was made popular in part by pop art and photorealist artists. Wendy Clouse, *Acrylics* (London: Hamlyn Press, 2002), 14.

7 Duncan, "Who Rules the Art World?" 169.

8 Carol Duncan expressed this in an email. 19 February 19, 2017. Subject line: RE: a few questions for you re: Who Rules the Art World?

9 *Beach Scene*, 1968, by Malcolm Morley is a 110 X 89 7/8 in (279.4 X 228.2 cm) acrylic painting in the permanent collection of the Hirshhorn Museum since 1972. Morley's image also appears as a smaller, limited edition screen print poster edition.

10 For a time, Duncan was married to the actor and *Second City* troupe member Andrew Duncan.

11 Duncan, "Who Rules the Art World?" 169.

12 What distinguishes photorealist painting from Pop Art painting is precisely the former's capitulation to the visual attributes of photography, even as the final work remains a singular, hand-made object and therefore not a photograph.

13 Duncan, "Who Rules the Art World?" 169.

14 Ibid.

15 Ibid., 174.
16 Ibid., 173.
17 One could even go so far as to describe the intensity of the artist's indignation towards the critic as an example of reaction formation, a defence mechanism postulated by Freudian psychoanalytic theory in which a troubling emotion or traumatic memory generates an exaggerated and opposite behavioural response. In this instance, the artist truly desired critical approval and interest, but Duncan's interpretation of his work exposed an underlying conflict he could not confront directly, which then produced an angry retort, rather than a deferential or solicitous response towards someone in a position of art world power.
18 Duncan, "Who Rules the Art World?," 170.
19 Ibid. Duncan describes New York City as being at the centre of the art world with a series of satellite cities radiating outwards from it including "Paris, London, Milan, Tokyo, and other great centers of capitalism." And indeed, she is correct because New York City in 1983 was still *the* address most coveted by major gatekeeper art galleries and museums. However, this primacy was already beginning to be challenged by both the ongoing global museum boom and such phenomena as the Young British Artists who came to prominence in London in 1988.
20 Duncan, 172.
21 "When I first moved to SoHo, I could convince my mother, living a few blocks north of Houston Street, that my new neighbourhood with its trucks and trash-filled streets was too dangerous for her. Believing me, she never knocked on my door, thankfully," recalls artist Richard Kostelanetz in his memoir: Richard Kostelanetz, *Soho: The Rise and Fall of an Artist's Colony* (London: Routledge, 2003), 33.
22 Duncan, "Who Rules the Art World?," 179.
23 Ibid.
24 Ibid.
25 Ibid., 186.
26 Ibid., 187.
27 Ibid., 173.
28 Michael Brenson, "The Curator's Moment," *Art Journal* 57, no. 4 (1998): 16-27.
29 Duncan, "Who Rules the Art World?," 185.
30 Unquestionably the signature event of the decade's anti-modernist rebellion was the jam-packed, 1980 summer exhibition known as the *Times Square Show* in which a massage parlour on 41st Street was temporarily turned into a sprawling installation by Collaborative Projects that included works by Jean Michel Basquiat, Kiki Smith, and John Ahearn. Critic Kim Levin described it as a modern version of Dadaist Kurt Schwitter's Merzbau, and Robert Pincus-Witten called it a modern day *Salon des Refusés*. Levin is cited in: Margo Thompson, "The Times Square Show," *Streetnotes*, no. 20 (2010), http://people.lib.ucdavis.edu/~davidm/xcpUrbanFeel/thompson.html.; Robert Pincus-Witten, "The Times Square Show Revisited," *Artforum International* 51, no. 4 (2012).
31 Duncan, "Who Rules the Art World?," 187.
32 Ibid., 179. See also Lucy Lippard's comments about the *Times Square Show* in which she describes much of its artistic content as consisting of "pictures of guns, pictures of sex (actually pictures of women, since women and sex are interchangeable, right?) [which] constitute a statement in themselves." Thompson, "The Times Square Show". note 26.
33 This was one path artists in the 1960s chose when confronted with making art during what many on the Left perceived to be a state of war with US imperialism. Art was a seemingly frivolous pursuit under such circumstances, leading some to become union leaders or community activists. I discuss this in: Gregory Sholette, "A Collectography of Pad/D, Political Art

Documentation and Distribution: A 1980's Activist Art and Networking," (2003), http://www. darkmatterarchives.net/wp-content/uploads/2011/01/2.2.Collectography.pdf.

34 Carol Duncan, email, 19 February 2017.

35 Hans Haacke, "Museums, Managers of Consciousness," *Art in America*, no. 72 (1984). Cited here from: Kristine Stiles and Peter Howard Selz, *Theories and Documents of Contemporary Art: A Sourcebook of Artist's Writings* (Berkeley: University of California Press, 1995), 874.

36 Andrea Fraser, "From the Critique of Institutions to an Institution of Critique," *Artforum International* 44, no. 1 (2005): 279.

37 Duncan, "Who Rules the Art World?," 180.

38 "All men are intellectuals, one could therefore say: but not all men have in society the function of intellectuals," Antonio Gramsci, *The Prison Notebooks (1891-1937)*, cited from: Roger S. Gottleib, ed. *An Anthology of Western Marxism: From Lukács and Gramsci to Socialist-Feminism* (Oxford: Oxford University Press, 1989), 115.

39 Although I moved to New York City to attend higher education, my parents and other three siblings did not attend college and remained within a few miles of where I was raised in suburban Philadelphia.

40 Duncan, "Who Rules the Art World?," 180.

41 See: "The Mystery of the Missing Mass," National Aeronautics and Space Administration (NASA), https://history.nasa.gov/SP-466/ch22.htm.

42 According to the *International Labor Organization*, 80 per cent of new jobs created between 1990-94 in Latin America were in the informal sector. Furthermore, as many as half of all jobs in Italy are also part of an informal economy that is defined as economic activity taking place outside of government accounting and also goes by the name shadow, informal, hidden, black, underground, grey, clandestine, illegal and parallel economy. Matthew H. Fleming, John Roman, and Graham Farrell, "The Shadow Economy," *The Journal of International Affairs* 53, no. 2 (2000): 387-409.

43 Robert D. Hof, Gary McWilliams, and Gabrielle Saveri, "The Click Here Economy," *Business Week*, 22 June 1998, 122.

44 Duncan, "Who Rules the Art World?," 187.

45 See art market reporting by the Mei Moses art asset index that was acquired in 2016 by Sotheby's auction house. "Sotheby's Acquires the Mei Moses Art Indices," http://www.sothebys.com/en/news-video/blogs/all-blogs/sotheby-s-at-large/2016/10/sothebys-acquires-mei-moses-indices.html.

46 Giorgio Agamben, *Homo Sacer: Sovereign Power and Bare Life* (Palo Alto: Stanford University Press, 1998).

47 Duncan, "Who Rules the Art World?," 175.

48 G. R. Swenson, "What Is Pop Art? Answers from 8 Painters: Part 1," *Art News*, no. 62 (1963). Cited from: Kenneth Goldsmith, ed. *I'll Be Your Mirror: The Selected Andy Warhol Interviews* (New York: Da Capo Press, 2009), 18.

49 The site in question is MRX.com. It is managed by Neil Gerardo who is listed as the Holding Corporation's Chairman and CEO, but also as "the boy in Malcolm Morley's painting of Daytona Beach entitled "Beach Scene." See: "Neil Gerardo Is the Boy in Malcolm Morley's Painting of Daytona Beach Entitled "Beach Scene"," The MRX Group, http://www.mrx.com/neilgerardobeachscene.html.

Gift Vouchers: Giving and Rebates in the Age of Appropriation

John C. Welchman

THE DISCUSSION THAT FOLLOWS focuses on the half decade between the later 1980s and the early 1990s, a moment in which the prevailing discourse on avant-garde art in New York was oriented to, even fixated by, questions of appropriation, media imagery, commodification and the market – on the one hand – and by an organised critique of institutions and commercial (and to a more limited extent, social) structures on the other. Bookended by Mike Kelley's signature soft animal piece *More Love Hours Than Can Ever Be Repaid* (1987) and the *Art Rebate/ Arte Reembolso* project undertaken by three artists – David Avalos, Louis Hock, Elizabeth Sisco – living in the San Diego area in 1993, I want to outline some of the terms and conditions that informed a very different mode of intervention originating in Southern California. While clearly aware of the theories and claims that underwrote the commodity and institutionally oriented practices dominant on the East coast, this line of work was predicated on ideas and practices of giving and donating rather than taking or buying, and on repair and reparation rather than critique or decon-struction. So while the three teddy bears that feature in Haim Steinbach's *basic* (1986) – made at much the same moment that Kelley took up with stuffed animals – have been identified as the "gifts" they probably were purposed to be, they function in a landscape of shelved objects oriented predominantly to questions of possession, collection, and display veined with a variant of post-Surrealist object poetics and the then-current discourse on commodities.[1] The turn I identify here anticipates the somewhat more formulaic and self-conscious shift identified in a number of projects

and publications in the early and mid-2000s, including *Il Dono/The Gift* (2001) and *What We Want Is Free: Generosity and Exchange in Recent Art* (2005), that reflected on the conversion of artworks into "generosity projects" arising from "a literal transfer of goods and services from the artist to the audience".[2]

Introducing his signature appropriation-based work with craft objects commenced in the later 1980s, Kelley's *More Love Hours Than Can Ever Be Repaid* offered a dramatic intervention directed by what were at the time rather unfashionable questions about giving, receiving and reparation. The accumulation of stuffed toy animals, dolls and rugs in *More Love Hours*, was prompted by the artist's reflection on the enormous investments of time in the production and then use of these profuse but singular objects. The result was a blaring, cornucopic assemblage of handmade stuffed animals and afghans hashed together furry cheek to stringy jowl in a giant fractal mosaic of gaudy, second-hand fabrics. Organised as an exploration of the psychological binds of the gift, the piece is also focused by Kelley's retort to 1980s debates on commodification and the redemptive value argued for appropriation, which sometimes saw its preliminary "taking" as the mere disguise of a "gift":

> This is what initially led to my interest in homemade craft items, these being the objects already existing in popular usage that are constructed solely to be given away. Not to say that I believe that craft gifts themselves harbour utopian sentiments; all things have a price. The hidden burden of the gift is that it calls for pay-back but the price is unspecified, repressed. The uncanny aura of the craft item is linked to time.[3]

Writing specifically of the address in *More Love Hours* to the "false innocence . . . of the gift," Kelley elaborates on its giving routines:

> In this piece, which is composed of a large number of handmade stuffed animals and fibreglass items, the toy is seen in the context of a system of exchange. Each gift given to a child carries with it the unspoken expectation of repayment. Nothing material can be given back since nothing is owned by the child. What must be given in repayment is itself 'love'. Love, however, has no fixed worth so the rate of exchange can never be set. Thus the child is put in the position of being a perpetual indentured servant, forever unable to pay back its debt.[4]

In the absence of craft's formal location, stranded outside a "normative" exchange system, Kelley here opens up the signifying terrain of the craft object onto a psychological economy predicated on "mysterious worth," intractable "guilt," and "emotional usury".[5] In a thought that helps us understand his career-long commitment to both intensive and extensive reckoning with agendas that postmodernism often entertained on the surface, or in the social flatness of one dimensional politics, Kelley explores the discrepancy between emotional and monetary value by separating "junk" art from craft production. The former "could be said to have value IN SPITE of its material; while the craft item could be said, like

an icon, to have value BEYOND its material".[6] The values of this "beyond" were drawn out and recalibrated in other aspects of the three-part Chicago exhibition where *More Love Hours* was shown – notably in *Pay For Your Pleasure* which evaluated the conjunction of criminality, art-making and educational knowledge and in each iteration included the art work of a local mass-murderer and a collection box for donations to a victim's-rights organisation. "Since no pleasure is for free – a little 'guilt money' is in order," Kelley suggested. It followed that "a small donation to a victim's rights organization seems a proper penance to pay".[7] Having pursued the psychology of the gift into the laboriously repressed time of the craft object, Kelley offered it a socially extensive reconfiguration as a reparational payment by the art-going public for its voyeuristic pleasures.

"Three projects" and *More Love Hours* marked neither the first nor the last time Kelley reflected on the bio-social and psychological economies of the gift. Conceived within the associatively expansive paradigms of Kelley's often exorbitant meditations on structures, relations, chaos and the sublime in his early performances, "giving" was caught up in figures of creating, issuing, giving-off . . . and giving-out. In *Pond Gift* (1982–83), one of the acrylic drawings related to Kelley's collaboration with Bruce and Norman Yonemoto on the video *Kappa* (1983), for example, the pond stands-in for the primordial mush from which life-forms evolve – and are thus given-up – or into which they entropically decay – and are finally given back as undifferentiated matter, shifting ground that the artist explored in a cascade of analogues for the formless (trash, dirt, lint, light, colour). This strand of Kelley's thought is woven from interests that overlay evolutionary biology (figured by the amphibians and frogs in *Confusion*, 1982) with different aspects of the discourses that organise shape-shifting in general – metamorphoses, formal permutation, repetition and sets; but also alchemy, geomorphology, Rorschach tests and a flurry of speculative anthropomorphisms.

Imaginatively appropriated from children's programming in the early years of television, the figure of the Banana Man and his capacious accessories bear witness to another mode of giving, activated by the deep, proffering pockets of the personified fruit that makes a pair with *More Love Hours*.[8] In one of his studies (1981–82) for *The Banana Man* (1983) Kelley described the multiform repositories let into the character's costume as nothing more than dispensaries for "cheap trash" driven by the unstinting "want, want, want" of the kids gathered around him during his eponymous TV show. The chorus of unfocused needs to which they give vent is prompted by a mindless, crowd-sourced proto-consumerism, which is skewered, in turn, by the tart sarcasm of Kelley's conclusion in which the ironic humour of the set-up is augmented by parodic moral reflection: "What a Good Joke!. . . . What a Good Man!" Voluntarily dispossessed of the baubles and trinkets that line his pockets, the Banana Man is shaken-down – both literally and symbolically – by the children's contagiously insistent desire.

The main elements of the gift-giving economy that Kelley italicised so dramatically in *More Love Hours* are already present here, though in somewhat scrambled form. Both

works depart from the predicate of adult givers who function as the agents or sources of gifts directed to children. In *More Love Hours* this is an aggregate of many anonymous makers; in *The Banana Man* it is a single allegorical figure whose sole purpose is to provide entertainment. The nature of the gift is in each case similar in that it is comprised of multiple, low-value elements – wool, yarn or other craft materials knitted or sewn into soft animals or blankets and re-sewn into a complex aggregate in *More Love Hours*, and knick-knacks and sundry favours stashed in the pockets of the Banana Man. But there are also differences between the two works, notably in the constitution of what is gifted: in the later piece, it is the accumulated weight of time that makes up the true value of the gift; while the Banana Man readily metes out his giving in accordance with the role-playing imperatives that underwrite his character. The situation, of course, is more layered in *The Banana Man* as Kelley cross-identifies with the performer, though, having never seen the children's TV show on which he appeared, does so on the basis of solicited third party reports of his actions and demeanour. The gift-giving that ensues is thus doubly performed, first by the actor playing the Banana Man and then by Kelley playing out a projective version of his media persona. Further, Kelley's incarnation of the Banana Man engages with a stream of allusions, themes and subtexts – wry commentaries on maternal relations and group dynamics, pantomimic re-stagings of vaudeville antics – none of which is exclusively dependent on the gift-giving paradigm.

While Kelley inhabits the personality of the Banana Man he does so fitfully, absorbing some aspects of the figure's appearance and actions while extrapolating or wildly over-coding and reinventing many others. If, therefore, the dispensation of gifts can fairly be described as the focal attribute of the Banana Man, it follows, first, that actions staged as it were on his behalf might develop or annotate this founding orientation; and, secondly, that Kelley has in this sense trained the role of the gift-giver onto himself. Yet because this transfer is neither precise nor complete, nor, again, the sole thematic orientation of *The Banana Man*, the gift-giving regimen and the panoply of effects to which it gives rise are implicated in a host of other discourses which italicise, confront and sometimes confound them. Insofar as Kelley reverts, at times, to the position of a child subject (or otherwise) to the governance of his mother, for example, the structure of the gift economy is reversed with Kelley, putatively at least, becoming a gift recipient rather than a donor. The cascade of dependencies and imbrications that courses through *The Banana Man* – as through most of Kelley's performance pieces – mitigates against the closed logic of the gift system by opening it onto questions of education, abuse, volition, responsibility, pathology, chance and religion – among others.

Reinforcing the self-directed point of origin of the video, Kelley uses a hand-written "title" card loosely derived from classroom pedagogy and the inter-titles of silent film, to label the events that transpire in the opening scenes of *The Banana Man* as "my actions". They include the adoption of various emblematic positions: of supplication, interaction and muteness (underlined by a close-up of the artist's tightly shut mouth),

culminating in a pose of allegorical sightlessness in which a blindfolded Kelley clutching a lit candle takes on the attributes of "Justice" whose scales are formed by two buckets slung across his shoulders. The shifting motifs of cause and consequence – both abstract and apparently undirected, and performed or embodied – that furnish the paradigmatic organisation of the video turn on a key moment in which Kelley reaches into the pockets of his Banana Man suit and pulls out a yellow "business" card marked in handwritten capital letters "The Banana Man" followed by a drawing of a bunch of bananas and the ironic disavowal: "I'm not responsible". Sensorial deprivation – muteness and blindness, the latter also delivered by a box with a dollar sign and eye holes that Kelley dons later in the video – joins with randomness and contingency under the auspices of a general refusal to take responsibility. The act of finding and displaying the card and the implications of the message it bears remit to the act of giving a thoroughgoing uncertainty that precipitates a moral and epistemological crisis. For if the point of origin of the gift is not associated with secure motivation, purposeful largesse or even indiscriminate love its economy faces onto necessary ruin.

At the end of his 1925 essay on the gift, Marcel Mauss offered a number of conclusions organised under the headings of morality, politics and economics, and sociology and ethics in which he refers to the general diminishment, but also to the occasional perseverance and reformatting, of gift-giving counter-economies in early twentieth-century Western cultures. Noting the "rigours, abstractions and inhumanities" according to which the "codes" of the capitalist system have been articulated, Mauss suggests that "the whole field of industrial and commercial law is in conflict with morality".[9] At the same time he identifies a social space in which these juridical amoralities might be ameliorated. "French legislation on 'social insurance' and accomplished state socialism," he writes, "are inspired by the principle that the worker gives his life and labour partly to the community and partly to his bosses". Mauss explains further: "If the worker has to collaborate in the business of insurance then those who benefit from his services are not square with him simply by paying him a wage. The State, representing the community, owes him and his management and fellow-workers a certain security in his life against unemployment, sickness, old age and death".[10]

I want to suggest that an important impulse in Kelley's work unfolds as a confounding response to the already uncertain social dialectic that attempts to account for fundamental dichotomies between security, health, cleanliness and general well-being, on the one hand, and peril, sickness, impurity and suffering on the other. What results is a deviant meta-morality tale that takes off from attempts to found social morality in natural law (Mauss advocates for a "return to the ever-present bases of law")[11] and various origin and development narratives drawn from the anthropology of the gift or the psychological economies of infants and children. At stake in Mauss' reflections on the usefulness of the gift economy as a counterweight to a capitalist system directed by money, markets and purchasing power, is an attempt to reprocess natural

law through reparative modern social legislation, or "social policy" as it was later termed in the 1950s and 60s when Kelley was growing up.

It turns out that one of the chief architects of the welfare state and social policy in Europe during these years, Richard Morris Titmuss – who held the founding chair in Social Administration at the London School of Economics from 1950 until his death in 1973[12] – expanded on the correlation between gift-giving and health care briefly sketched by Mauss. In a noted case study published in 1970, *The Gift Relationship: From Human Blood to Social Policy*,[13] Titmuss staged an eloquent defence of social justice predicated on altruistic commitments activated by an ethics founded in what he termed – in a policy- inflected variant of the thinking of his contemporary, Emmanuel Levinas – "other-regarding". Examining the social and medical efficacies of blood donation, voluntary in the UK but compensated in a blood market in the United States, he outlined what has been described as one of the few successful demonstrations of the social wastefulness of capitalism.[14]

As attested most starkly, perhaps, by his final large-scale project, *Mobile Homestead* (2006–13), one of Kelley's abiding wider preoccupations was with the conditions, defaults and disappointments that attend the production and maintenance of a healthful body – and a healthy citizenry. In *Mobile Homestead* this was played out in a schizophrenic split that Kelley felt was inevitable – or to which he willingly and wearily succumbed – between creatively dangerous activities that were subjective, libidinal, instinctive and secretive played out in the basement and sub-basement spaces burrowed under the homestead, on one level, and the designation of the ground floor rooms of the house itself as arenas for both community projects (book swaps, exhibitions) and the provision of social services (Kelley mentioned a blood bank, needle exchange and meal services) that would be linked to the excursions of the "mobile" component, on the other.

One of the artist's working documents or "raw notes" on *Mobile Homestead* grants us access to some of the ways that the ricochet of associations – methodically developed in his early performance practice – that so often animated Kelley's thinking shifts through the gears of a poetic leverage funded by clichés, puns and semantic run-ons. In the note, Kelley assembled a series of sixteen or so common phrases and descriptions arranged in three groups that begins by relaying different aspects of the experience of homecoming or "return". Headed by "Coming Home to Roost" (the last three words are repeated four lines later), these formulae include "Homing Pidgeon [sic], "Home Delivery" and "Prodigal Son" which link animal instinct and the dispatch of goods or services with biblical allegory to provide a complex force-field of differently predicated returns. Typically, Kelley interferes with the abstraction and potentially false innocence of these locutions by annotating "Homeward Bound" with "(& Gagged) . . . (Gagging)," before shifting the grounds of his notes in the middle of the page to a series of mediations on "circulation". "Circular Breathing," supplied with the parenthesis "(Leaving)", presumably alluding to the coming and going of inhalation

and exhalation, is followed by "Blood Circulation" and "Circular Route". "Route" then gives rise through punning association to "Roots," annotated with "(Putting Down)" and accompanied by a mark in the left margin that indicates another section shift. The final four lines inflect the notion of returning in a more social dimension so that "Giving Back to the Community" is associated with "Going Back" and "Going Mobile" runs into the final annotation: "(Meals?) on Wheels".

It was as if Kelley sought parenthetically to acknowledge and then filter out all the "bad blood" with which he had trafficked over some three and a half decades. The four bracketed qualifiers offer commentaries that in three cases open up the compliant signification of the simple stock phrases to darker implications: "Homeward Bound (& Gagged) . . . (Gagging)" uses double entendre to upend the anodyne connotations of the first two words by converting "Bound" into bondage and intro- ducing ideas of captivity, hostage-taking or torture. Similarly, Kelley displaces the organic security of "Roots" with a play that overlays their natural descent into the soil (literal or metaphorical) with notions of condescension (a circumstance where someone is "put down" or belittled by someone else), which – in a final gesture of literalist multiplicity – also hints at the underneath or underground of the basement spaces in *Mobile Homestead* and other works. "Blood Circulation" and "Circular Breathing" occupy centre-stage, then, in this theatre of exchanges, mediating between various formations of generalised mobility and implied points of origin and modes of return ("going" and "giving back"). Vital circulation joins with Kelley's longstanding disquisition on circular figures – zeros, noughts, spheres – such as those conjured by the frog-bee dialogue in *Heidi: Midlife Crisis Trauma Center and Negative Media-Engram Abreaction Release Zone* (with Paul McCarthy, 1992); the swirling vortices and outsized Mexican sombrero in *The Banana Man*; and the facialised Os in the drawing for "OH" from *Oh The Pain of It All* (1980). Blood is mobilised as a privileged referent within the cipher of circulation standing, simultaneously, for genealogical fate (for better or worse) and for violence and conflict as well as mediating the very nature of healthfulness though its ceaseless movement and life-giving oxygenation.

The second moment in the rehabilitation of giving I am briefly sketching here can also be situated in relation to multiple histories, including its own contexts in a new wave of art practices made in the vicinity – and addressing the effects of – the US-Mexican border; in the debates about public funding for the arts in the US during the Culture Wars that reignited in the early 1990s;[15] and the long shadow cast by the socio-cultural comparatives posited by Mauss as an afterword to his theories of the gift.[16] Beginning in July 1993, and continuing intermittently for several weeks, an untitled group of artists, comprising filmmaker Louis Hock, photographer Elizabeth Sisco, and Chicano artist David Avalos,[17] distributed some 450 pencil-signed $10 bills to undocumented immigrant workers in Encinitas and other sites in the North County vicinity of San Diego, California. The bills were photocopied and a receipt form handed out to each recipient, who signed for a serially precise note. The money derived from a $5,000 commission awarded to the group by the Centro Cultural de la

Raza and the Museum of Contemporary Art, San Diego, for the creation of a public art project as part of the exhibition "La Frontera/The Border" – which was also partly underwritten by National Endowment for the Arts and Rockefeller Foundation grant monies.

Like Kelley's *More Love Hours*, the point of commencement for *Art Rebate* is located in the nature and experience of work and the expenditure of time; and as with the temporal investments with which the stuffed toys were produced, the labour addressed by *Art Rebate* is not well-recognised or properly compensated. Both works are predicated, then, on the operation of invisible economies mostly situated outside the purview of the official and sanctioned "economy". The press release for *Art Rebate* along with interviews, editorials and statements made by participants, draw on several core claims and assumptions: working immigrants pay considerably more taxes than they consume in public services and welfare; the fact of their labour poses little or no threat to the job security of other local workers; and the immigrants take jobs and accept standards that are below the expectation threshold of citizen-workers. It follows that they are unjustly scapegoated for the economic fallibility of the state.

As with Kelley, again, the effects of *Art Rebate* come into focus only when the legacy of Mauss' theory of the gift has been worked through. But for *Art Rebate* we need to approach Mauss from a different direction; and investigate a rather wider field of signification which includes the philosophy of giving and how it relates to the nature and understanding of money. The Italian "counter-culture" psychoanalyst, Elvio Fachinelli, can steer us in the right direction with a commentary on the theory of the gift: "The author [Mauss] speaks of the thing given or exchanged, which is not inert, but always part of the giver ('to give something to somebody is always equivalent to giving something of one's own person'); he describes the gift as one element in a total system of obligations which are rigorously necessary and may cause war if disregarded, and which also contain a play or 'sportive' element; he mentions the 'guarantee' or token inherent in the object given, identified with the object itself and such as to constitute obligation 'in all possible societies.'"[18] To these seemingly summary suggestions must be added a philosophical statement on the function of money by Aristotle: "So money acts as a measure which, by making things commensurable, renders it possible to make them equal. Without exchange there could be no association, without equality there could be no exchange, without commensurability there could be no equality".[19]

If there were once gifts, as Fachinelli remarks, with their threat of war and thread of play, and then money, with its posture of Aristotelian equality and guarantee of social exchange, could it be that in the mid-1990s we entered into an era of the rebate? With the giving systems of non-Western cultures in mind, it is clear that such a possibility cuts through the fiscal moralities on which Western liberalism is founded, moving into the domain of post-capitalist circulation, with its spectacular inversions and invisible flows. The theory and performance of the *Rebate* imagines a new nexus

of social relationships predicated on the negative increments of capitalism's public record. As we track the implications of these citations, the rebate emerges as both a critique and a renegotiation of the social "commensurability" reckoned by Aristotle to arrive with the exchange system of money.

In the *Nicomachean Ethics*, Aristotle defines "magnificence in spending" not as some kind of profligacy or inappropriate "liberality," but as the "suitable expenditure of wealth in large amounts". Such expense should be properly relative to the conditions of the spender and the circumstances and objects of the expense, and without "any fixed measure of quantity". When there is propriety in these alignments, the magnificent subject becomes, says Aristotle, a "connoisseur" with respect to his own social environment. Whether "directed towards the equipping and dispatch of a religious-state embassy, dressing a chorus, fitting out a warship, or furnishing a banquet", the giver will have performed his giving correctly, and at the same time successfully "reveal[ed] his character", if he spends "not upon himself but on public objects" so that "his gifts are a sort of dedication".[20]

What we encounter in the parameters unfurled in the media statements of the Art Rebate artists is an almost perfect negative – or shadow economy – of Aristotle's model of public munificence, which has endured through the patronage systems of the West with remarkably few inflections for well over two millennia (several horizons of technological recalibration notwithstanding). Every term or indicator in the Aristotelian formulation has been inverted by *Art Rebate*. The project can thus be defined as the (officially) unsuitable redistribution of negative wealth – taken from the state, not bestowed upon it – in small amounts (and multiple instances) according to fixed measures of quantity (the $10 bills). The measure and propriety thought by Aristotle to extend between the contexts of the spender and the circumstances and objects of the expense is likewise collapsed by the groups' pantomime of fiscal recirculation, so that the spending is not on public objects but on illegal subjects, and results not in a monument or dedication, but rather in an ephemeral fold in an immodestly outsized economic system and a relay of media-driven misinterpretations within whose logical aporias the piece finally dwells.

The scope of these negatives extends even to the sanctioned types of social magnificence itemised by Aristotle. In *Art Rebate* we witness not the clothing of a theatrical group but the undressing of the choric apparatus of the state mythology by offstage, extra-civic figures, vivid only in their everyday appearance. We see not the augmentation of the instruments of sea-borne warfare, for example, but rather a gesture that chips a plank – or a splinter – out of tax-borne military spending (in the largest navel *entrepôt* in the world). We find not a sumptuous religious mission, but a tentative token of secular reparation; not a spectacular feast, but a diverted promissory note, whose chief utility, as several critics noted, was to assist in basic provisioning.[21]

It follows that the agents of this inversion cannot be imagined as the splendid social "connoisseurs" of Aristotle's reckoning, but rather as anti-object-makers who smuggle

issues and innuendoes into the dark corners of public policy and force them as insinuations through the organs of social commentary. The group played the role of critic-artists not patron-connoisseurs. Yet their performance is subject to another form of inversion that should introduce a note of caution – or, at least, irregularity – into the symmetrical figures of the quasi-anonymous *Art Rebate* set against the manifestly honorific Public Gift. Aristotle writes that the act of public giving has a corollary in a revelation of good character that is confirmed by the decision to spend outside, not on, the self. Suggesting a last reversal here might imply that the *Art Rebate* group acts as surrogate social workers distributing someone else's money in a trade that, while it buys their own celebrity, at the same time renders the subjects of the rebate – the undocumented workers – inert or transparent at the centre of a swirl of exchanges, real and virtual.[22]

The subtle but incisive recalibration of Western understandings of the gift mobilised by the two inventions discussed here, Kelley's operating outside of standardised economic time and *Art Rebate* addressing an invisible and misrepresented para-economy, were, of course, not the first attempts in the artworld to reflect on ideas of giving and reparation in relation to work, expenditure and time. A few earlier pieces were organised in explicit association with – or homage to – non-Western gifting routines, including *Gift Event 3* put on at the Judson Church in New York in March 1967, "a kind of communal performance adapted from the Seneca Eagle Dance by Jerry Rothenberg, that combined poetry reading, music and dance in a collaboration of experimental musicians".[23] As part of his turn between the late 1960s and mid-1970s from investigations of the labour economy to more "postindustrial" interests in service and associated industries ("nurses, orderlies, housekeepers, janitors, and mothers"), Allan Kaprow made several works, including *Homemovies* (1969), which were dedicated as gifts to his friends or family in a bid to accommodate routines of intimacy and personal inter-connection – concerns that took centre stage in the 1980s with *Piece for Coryl's Birthday* (1985) and other works.[24] Other examples were organised around sharing food and conversation in updated variants of the symposium model that range from Gordon Matta-Clark's *Food* (1971) through Rirkrit Tiravanija's preparation of meals which commenced with the temporary kitchen he installed in the office space of the 303 Gallery, New York, in *Untitled (Free)* in 1992 and subsequent iterations.

What separates the work of Kelley and the Art Rebate group from most of the gift-oriented practices that preceded or followed them is their scrupulous but also ironic – and sometimes remorseless – problematisation of the issues raised by various scenarios of giving. Both take no refuge in the personal affirmations and/or modest quotients of social amelioration attendant on most work that has associated itself explicitly with giving. While for Kelley personal investment of time and love in the materials he assembled was a crucial aspect of *More Love Hours*, the givers of all this freely bestowed labour were anonymous parents and grandparents, relatives and friends who are connected by the artist in a kind of social abstraction predicated on assumptions built into a common culture. Indeed, it was the absence of Kelley's personal

relation to his materials – coupled with various conjectures or projections about his own familial circumstances or whether or not he may have been unhappy or even subject to abuse – that supplied much of the debate about what the piece "meant" or was trying to "say". So that in addition to drawing attention to the disparities and usurious defaults in economies of giving predicated on an altruistic quotient of the "family romance", Kelley produces the grounds for a sedimentation of popular assumptions and allows the speculative investments they represent to play themselves out in a tangle of causes and contradictions brokered – and fomented – by the work itself. To put it another way, Kelley points to a meta-critique of the conditions of giving with an artistic gesture that has camouflaged itself in the allure of false immediacies – in order to question the very nature of what is immediate, intimate and unquestioning.

Fired-up by social predicates that are almost the inverse of Kelley's, *Art Rebate* staged a similar form of meta-critique arising through the extraordinary proliferation of media responses that supply the afterlife of the piece. In fact, the *Art Rebate* group, their critical and correspondence column supporters and the fiercest of their art-world and media antagonists share one notable convergence: all claim that the project has had the effect of turning things upside down. This attitude is surely one of many satellites fixed by the gravity of the avant-garde. Yet no longer are we confronted here by the kind of territorial expansionism according to which the artist or movement takes its gesture of practice a little further into the unknown. Instead, as we saw in the logical relationship between Aristotelian liberalism and the defaults of the rebate, inversion is the order of the day: the other is the subject; the recto is glimpsed when looking at the verso. A good example can be found in an editorial in the *San Diego Union-Tribune* – a railing conjugation of war, domestic economics and art that denounces *Art Rebate* as "the artists' version of the Pentagon's $600 toilet seat and the $7,000 coffeepot". The antipathy rehearsed here is predicated on a reversal of newspaper values occasioned by what its writer designates as the palpable absurdity that the action should be "front-page instead of art-page".[25] It is unusual for the print media to produce a reflexive critique of its spatial proprieties. But here an editorial from the sanctioned place of opinion in the middle of the paper takes on the task of controlling its precincts, adjudicating first between "news" and "art", front and back, top and bottom, and then between the relative value of "real" and "surplus" news. This reversal, acknowledged by the institution of the press that actually registers it, is one among many. As the group put it in the *Los Angeles Times*, "the politicians are acting like performance artists and we're trying to be political". "The art", they continue, "will ride these $10 bills through the circuits of a failed economy, entering a space where politics is fiction and conceptual art is attacked for being politically real".[26] The chain of these inversions is crucial to the intervention in public art represented by *Art Rebate* and built, in turn, on the symbolic functions of money, on the one hand and giving (back), on the other.

Notes

1 Celant suggests that the teddy bear form appropriated for *basic* is used by Steinbach as "a toy, a gift, as an icon and vehicle of emotional exchange" that represents one side of the artist's wider concern "with both the exterior reality of his culture and its interior dream, in work that examines both the public and the private realms . . . " Germano Celant, "Haim Steinbach's Wild, Wild, Wild West," *Artforum International* (1987): 78.

2 Ted Purves, ed. *What We Want Is Free: Generosity and Exchange in Recent Art* (Binghamton: SUNY Press, 2005), x.

3 Mike Kelley, "In the Image of Man," (1991), 1.

4 "Three Projects by Mike Kelley at the Renaissance Society at the University of Chicago: Half a Man; from My Institution to Yours; Pay for Your Pleasure," *Whitewalls*, no. 20 (1988): 9-10. In "Mike Kelley's Line," an essay in the catalogue for the "Three Projects" exhibition (4 May – 30 June 1988), Howard Singerman underlines the emotional bind of the home-crafted gift: "What is asked for in exchange for this excessive value is appreciation, devotion, love." Howard Singerman, "Mike Kelley's Line," in *Mike Kelley: Three Projects Catalog* (1988), 10.

5 Kelley, "In the Image of Man," 1.

6 Ibid.

7 "Three Projects by Mike Kelley at the Renaissance Society at the University of Chicago: Half a Man; from My Institution to Yours; Pay for Your Pleasure," 12.

8 For more on these questions, see: John C. Welchman, "Mike Kelley and the Comedic," in *Mike Kelley* (New York: Prestel, 2013).

9 Marcel Mauss, *The Gift: Forms and Functions of Exchange in Archaic Societies* [Essai sur le don: forme et raison de l'échange dans les sociétés archaïques], trans. Ian Gunnison (London: Cohen & West, 1966), 64. Originally published in *L'Année Sociologique* in 1925.

10 Ibid., 66.

11 Ibid., 67. In a note on p. 128, Mauss modifies his apparent commitment to the principles of natural law: "Yet the moralist and legislator should not be bound in by so-called principles of natural law. The distinction between real and personal law should be considered as a theoretical abstraction derived from some of our laws. It should be allowed to exist, but kept in its proper place."

12 See: Richard Morris Titmuss, "What Is Social Policy?" in *Social Policy: An Introduction*, ed. Brian Abel-Smith and Kay Titmuss (London: Allen & Unwin, 1974), 28.

13 *The Gift Relationship: From Human Blood to Social Policy* (London: Allen & Unwin, 1970).

14 For a discussion of these issues, see: Iain McLean and Jo Poulton, "Good Blood, Bad Blood, and the Market: The Gift Relationship Revisited," *Journal of Public Policy* 6, no. 4 (1986).

15 See: James Davison Hunter, *Culture Wars: The Struggle to Define America* (New York: Basic Books, 1992).

16 For more on Art Rebate, see: John C. Welchman, "Public Art and the Spectacle of Money: On Art Rebate/Arte Reembolso," in *Art after Appropriation: Essays on Art in the 1990s* (London: Routledge, 2000).

17 For a useful account of previous public art collaborations by this group and a number of other San Diego artists, see: Robert L. Pincus, "The Invisible Town Square: Artists' Collaborations and Media Dramas in America's Biggest Border Town," in *But Is It Art?: The Spirit of Art as Activism*, ed. Nina Felshin (Seattle: Washington Bay Press, 1995).

18 Elvio Fachinelli, "Anal Money-Time," in *The Psychology of Gambling*, ed. Jon Halliday and Peter Fuller (New York: Harper and Row, 1974), 293.

19 Aristotle, *The Ethics of Aristotle: The Nicomachean Ethics*, trans. J. A. K. Thomson (New York: Barnes and Noble, 1953), Book 5: 134.

20 Ibid., Book 4: 99-102.

21 Critics – hostile and supportive – noted the immediate use-value of the rebated bills. Disparaging what he terms the "arts-babble" of the project description, George F. Will, for example, writes: "It was also lunch, as some recipients rushed to a food truck to buy tacos with their windfalls." George F. Will, "The Interaction of Space and Tacos," *San Diego Union-Tribune*, 22 August 1993.

22 Several commentators underlined the perceived neglect by the *Art Rebate* group of the kind of community preparation, involvement and follow-up that would have allowed the project to function as something more than a momentary interlude of surprise – or shock – and minor good fortune for the undocumented workers themselves. Michael Kimmelman finds in this lack the grounds for a sweeping dismissal: "By all accounts, that publicity stunt had nothing to do with serious collaboration between the artists and the workers; both as social service and as a mediation on the problems at the Mexican-American border it was laughably meager. Its real audience was the art world and its critics, among whom the gesture of giving away public money for the arts had precisely the intended incendiary effect. Had it not provoked a response from that group, the whole gesture would have been, on the face of it, empty." Michael Kimmelman, "Of Candy Bars, Parades and Public Art," *New York Times*, 26 September 1993.

23 Charles Burnstein, *A Conversation with David Antin* (New York: Granary Books, 2002), 114. See also: Jerome Rothenberg, ed. *Technicians of the Sacred: A Range of Poetries from Africa, America, Asia, Europe & Oceania* (Berkeley: University of California Press, 1985), 378-82.

24 See: Allan Kaprow, *Art as Life* (Los Angeles: Getty Publications, 2008), 45-46, 51. *Drag* (1984) was described in the associated statement as "an end-of-term gift to students in a performance class at U.C. San Diego" (292). Meiling Cheng notes of Kaprow's "redressive performances, which comprise his work as an artist, a critic, and a teacher" that "the best artistic gift for one who has no basis for un-arting might be the gift of art-making itself." Meiling Cheng, *Other Los Angeleses: Multicentric Performance Art* (Berkeley: University of California Press, 2002), 35-36.

25 "Editorial," *San Diego Union-Tribune*, 5 August 1993.

26 Elizabeth Sisco, Louis Hock, and David Avalos, "Art Rebate: Between a Rock and Hard Cash," *Los Angeles Times*, 23 August 1993. This "Counterpunch" article was a response to the *Los Angeles Times* editorial, "Bad Show," (6 August 1993). The same point is made by David Avalos in: Robert L. Pincus, "'Rebate' Gives Good Return for a Minor Investment," *San Diego Union-Tribune*, 22 August 1993. In a different context, Guillermo Gómez-Peña suggests a similar reciprosity: "Joseph Beuys prophesied it in the seventies: art will become politics and politics will be become art. And so it happened in the second half of the eighties. Amid abrupt changes in the political cartography, a mysterious convergence of performance art and politics began to occur. Politicians and activists borrowed performance techniques, while performance artists began to mix experimental art with direct political action." Guillermo Gómez-Peña, "From Art-Mageddon to Gringostroka: A Manifesto against Censorship," in *Mapping the Terrain: New Genre Public Art*, ed. Suzanne Lacy (Seattle: Washington: Bay Press, 1995), 99. For further examples of these "reversals" in the social and artistic choreography of street protests in Eastern Europe, see: John C. Welchman, "Apropos: Tune in, Take Off," *Art/Text*, no. 57 (1997). "The Rainbow Net 1999."

Part II: Power

The Precarious Nature of Curatorial Work

Michael Birchall

T HE EXPANSION OF CURATING as a profession in the last 25 years has seen an increasing amount of literature on both curating as an organising task and its place within exhibition histories. However, the labour associated with curatorial practice and its close relationship with artistic praxis remains up for debate, especially as post-Fordist labour conditions have forced both curators and artists to re-consider their role in the system of artistic production. This essay considers the precarity associated with curating and the position the curator occupies in this economic model of creative work; as a result of advanced capitalism, curators have started to enter into a working alliance with artists, and play a major role in the creation, mediation and dissemination of ideas. Beyond the museum spectrum in cities across Europe, vast numbers of curators are working as independent producers of art, and supplementing their income with other creative work, writing, teaching and publishing.

The nature of curatorial work combines artistic research, managerial roles, delegation, and academic research. Like other artistic-related professions, the curator must assume a variety of roles in his or her job. Here, it is crucial to differentiate the role of the contemporary art curator, although other curators in other disciplines may share the same roles. The skills of the curator have links with a variety of professions: managerial responsibilities, scholars, public relations, fundraisers, crowd-sourcing experts, educators, mediators, and moderators. Kitty Scott reflects on her role as a curator at The National Gallery of Canada, as an institutional curator with a full-time contract (her typical working week, extended beyond the "9–5" regular working

time). Her tasks were extensive and could include any number of activities, such as: the research and development of an exhibition proposal, making judgements on acquisitions, devising and managing group exhibitions and solo presentations, advising patrons on acquisitions, visiting artist studios, writing texts, overseeing publications of catalogues and other related publications, delivering lectures to students, travelling to speak on panels and exhibitions, and meeting with artists, curators, critics and collectors.[1] In addition, Scott reflects on her time as being largely involved in collection acquisitions above the curating of exhibitions. Her focus on collecting the contemporary represents a concern with capturing the ephemeral, rather than "presenting a range of exhibitions on the contemporary".[2]

However, this is not the only reflection of curatorial practice. Due to an expansion of the profession of curating, a large number of independent curators now work within art institutions as freelance contractors. This can be seen in institutions in the form of 'guest-curated' projects, who are reliant on the abilities of guest curators to bring in new programmes, audiences, and more importantly artists. The Kunst-Werke Institute for Contemporary Art in Berlin has been 'reaching out' to project spaces in the form of the 'One Night Stand'[3] series organised by The Network of Berlin Independent Project Spaces and Initiatives in cooperation with KW Institute for Contemporary Art. Project spaces and curators are invited to participate in this project, although they are unpaid. Independent curators are willing to work for free, as it presents an opportunity to be part of the programme at KW.

Consequently, independent curators must adopt a range of skills that are not too dissimilar from that of artists, and, crucially, networking plays a major role in this array of skills. Without affiliations in the artworld it would not be possible for curators to find exhibiting and publishing opportunities. Curators are dependent on the artworld, as much as the artworld is dependent on the labour and content that curators produce in the form of context around exhibitions, such as publications, reviews and symposia. From independent project spaces to museums, they are all reliant on the skills of the curator to produce content and to maintain international networks. Artists may curate their own exhibitions, but in reality, it is the curators who hold the power for an artist's major international success, as this is largely driven through complex networks of power-relations. Curatorial careers can be tracked through the 'blockbuster exhibitions' curators have developed and as such led to an increase in power. The gatekeeping function of the curator is linked to the promotion of artists through galleries, writing, and other curators.

Independent curators may possess the additional skills, which are more expansive than Kitty Scott's understanding of the system, as she is working within an institutional framework. Although one could argue that, even for institutionally based curators, they are still working in a similar way due to the competitive nature of the profession. These skills and activities would include: applying for residencies, writing for art magazines, catalogues, and journals, writing monographs (and any other

publications that offer the chance for a published text), visiting artist studios, going to openings, travelling to exhibitions and conferences (where this is possible), constantly building new networks, updating websites, publishing independently (online via blogs or through self-printing companies), organising festivals with other independent curators, writing exhibition proposals (to solicit work from other institutions), teaching and lecturing curating students, and meeting with artists, curators, and museum directors. What becomes apparent from this list is the need to constantly remain aware of other opportunities, as an independent curator must procure their own projects. This is paramount in the field, as another curator may seize an opportunity.

The system of art utilises the network of curators and critics to write about exhibitions for international art journals as a way of sustaining their popularity and influence. This was very much the case for early independent curators in the 1970s, such as Lucy Lippard and Seth Siegelaub.[4] Thus, the independent curator is, more than ever, reliant on a network of contacts in order to earn a reputation to continue working in the artworld and to maintain a decent standard of living. Crucially, curators must engage in work that exists outside of producing exhibitions: writing, teaching, editing, translating, and organising symposia and public programs.[5] While these tasks may inherently be part of the artworld, they have become part of what are considered to be part of the curator's function; for many though, some activities have become about surviving in the artworld. Ultimately it is expected that curators are working on several projects all at once.

As a consequence of the shifts in artistic practice, the artist is not bound by a closed relationship with his or her material, or the conventions of artistic tradition. The artist has his or her own critical role within an extended vision of technical and intellectual labour.[6] Thus, if the artist operates as a producer in contemporary art production – acting as a 'conceptual manager' of an exhibition or concept – then where does this leave the role of the curator? As we have seen, the role of the curator has shifted considerably in the last twenty years; the curator is no longer a scholar and mediator of artists' works but an active part of the exhibition making process. The curator has become overwhelmingly a collaborator (and producer) in the process of art making.

Curators must have the opportunity to realise exhibitions at desirable major institutions in order to gain further exhibition opportunities in the future. This is only made possible via an established network of peers and influential figures in the artworld. Furthermore, this opportunistic trait is in part connected to the rules of labour in a post-Fordist economy. The 'globally operating' curator must respond to local concerns, while maintaining a certain level of 'artworld' connections for the 'international' part of their audience. Sociologist Pascal Gielen notes that, "The profusion of biennales cannot be explained without the enthusiasm with which politicians, managers and other sponsors have embraced them. And it is precisely this heterogeneous interest that makes the biennale suspect".[7] With specific reference to the

curator, he comments on how, "The internationally operating curator – and indeed every globally operating artistic actor – thus enjoys the pleasures afforded by today's widespread neoliberal market economy".[8]

Curatorial work is part of a system taking place in different places, and working conditions in local temporary stations. As such, curators mostly adopt flexible working hours associated with post-Fordism in order to complete their tasks. These tasks may include devising exhibition concepts, writing funding applications, delivering presentations, writing essays for catalogues, and lecturing. The variety of tasks and the dependency on short-term contracts means that curators work constantly. Curators are directly involved in art production, from deciding the conceptual basis for an exhibition (or curatorial statements), to taking care of the logistics of the exhibition. Curatorial work is a process that is inherently based on the division of labour and may reach beyond organising and implementing an exhibition.[9] For young curators working in the field this is widely accepted as standard practice, having undergone specialist training in one of the many degree programmes around the world, available at The Royal College of Art (London), Zürich Hochschule für Kunst (Zürich) and California College of the Arts (California). These training programmes reflect the professionalization of curating, and the managerial element of curating to control and 'be equal' to new forms of production. [10] However, I see the curator's role in the production of art as being in part due to the conditions to which young curators are subject. They are under pressure to create new innovative concepts and to have a globally successful career. The desire to do this means they must be involved in producing new works of art – with artists whose careers they are deeply invested in – as well as their own. Curators often work with the same artists over a period of time, both in organising an exhibition and in contributing to discourse about the artist's practices. This long-term investment leads to collaboratively authored works between both the curator and the artist; both can profit from this symbiotic collaboration.

The curator's position as a producer affords the curator the authorial privileges that are otherwise conceded to artists. As the ideal embodiment of post-Fordist competences and procedures, the curator accumulates symbolic capital. Curators are seen as the 'gate-keepers' to the artworld, and seek to control certain parts of arts production and mediation. As Daniel Buren has argued, "Selection has replaced creation, and (…) curators are taking on the role of co-authors, if not sole authors, in relation to the artists becoming meta-artists". [11] While Buren's attack is targeted towards the symbolic capital attributed to curators, it confirms precisely what other artists take into account: the social dynamism inherent in the artworld. Curators have positioned themselves within the professional and institutional changes of post-Fordism in the past 20 years. This has been made possible by the abolition of pre-determined roles and the increase in the number of curators involved in a collective curatorial process.

Operaismo

The model of post-Fordism first expanded in the 1970s when the economy was shifting from a 'Fordist' economy to a post-Fordist system, one in which workers no longer generated material goods and instead worked to supply the demand driven by consumers. Post-Fordist production has created a new life of 'open networks' and has buried linear or structured views of seeing the world, connected to industrial production".[12] However, it must be noted that not all forms of production have moved away into a service-based model; products are still produced in factories in the West, yet the notion of workerism and the rights of the worker have changed in these contexts. Post-Fordism acknowledges the changes in the factory system, in France and Italy, and made it difficult to maintain models of management and production. The shifts in the economy and the increase of 'immaterial labour' generate a new economy and division of labour that continues to "recompose and devalue their existing skills".[13] In the context of the art system, post-Fordism and immaterial labour are used interchangeably to represent the shifts in the wider economy and their impact on artistic practice. The artworld is not exempt from these conditions, but at the same time it causes problems for itself. As Hito *Steyerl* asserts:

> Contemporary art's workforce consists largely of people who, despite working constantly, do not correspond to any image of labour. They resist settling into any entity recognizable enough to be identified as a class. While the easy way out, could be to classify this constituency as a multitude or a crowd, it might be less romantic to ask whether they are not global lumpenfreelancers, deterritorialized and ideologically free-floating.[14]

It is important to note that the first industries to be captivated by these new working conditions would include health, welfare, and education – and not finance and insurance services, as David Harvey has argued.[15] From the late 1960s onwards, art production partook in a capitalisation of service. Indeed, the emerging artworld in the 1970s, or arguably in the 1980s, did not represent an alternative production system, according to the German theorist Kerstin Stakemeier, but rather "acted highly contemporaneously in relation to the development of post-war capitalism".[16] In this sense, the shifts in the wider economy in the 1970s were being felt in the artworld at the time, as was the use of new technologies in artistic production.

Arguably, Harald Szeemann is the first 'post-Fordist curator'; his Agentur für Geistige Gastarbeit/Agency for Intellectual Migrant Work (1969) allowed him to curate projects independently, yet with the institutional strength of an agency. The name 'migrant' here – in the title of his agency – is suggestive of a travelling migrant or transitory curator who is always on the lookout for the next opportunity. As the power has shifted to the curator as a cultural producer, it has come with an increased demand placed on their intellectual abilities. Cultural work has responded to advanced capitalism, and in return it has also been shaped forever by these alterations. As Paulo Virno asserts:

Only in today's world in the post-Fordist era, is the reality of labour power fully up to the task of realizing itself. Only in today's world, that is to say, can the notion of labour-power not be reduced (as it was in the time of Gramsci) to an aggregate of physical and mechanical attributes, now, instead it encompasses within itself, and rightfully so, the 'life of the mind'.[17]

Virno's text challenges the hierarchies associated with manual and intellectual labour, but it does not replace historical divisions of class. If we consider the post-industrial economy as being comprised of entrepreneurs, and driven by the start-up working culture, then artists and curators fit into this system of production. The value is produced by labour power, and this can be both material and immaterial. As a contemporary of Virno, Maurizio Lazzarato[18] recognises that immaterial labour and the commodity are reconfigured to become more adaptable to the social and economic activities of a post-Fordist economy. Immaterial labour extends beyond the factory into other forms of society, and especially into the service-driven sectors of the workforce. The historic notions of labour, worker, and workforce, which were once understood by a distinction between manual and intellectual class positions, are now rendered obsolete in a dematerialised, globalised, cybernetic, information society weighed toward cultural production, especially fashion, software, and advertising.[19] In this reformulated workforce, the creative work undertaken by the creative class and producers are producing knowledge and surplus value for the post-Fordist economy.

The post-Fordist worker is currently being fostered in many sectors of the economy, and especially in the creative industries where large numbers of workers are needed to perform creative tasks, such as computing, drawing, and developing creative strategies.[20] The exploitation of highly paid creative workers and immaterial (or knowledge) workers has opened up a set of possibilities for re-defining the petty-bourgeois category of the creative class. Therefore, unlike other immaterial workers, the aspirations of many young people who wish to work in the arts, design, fashion, music, and so on, are very high, and partly driven by the lifestyle associations that come with this. Although the immaterial workers who are 'employed' on short-term contracts at major museums may not receive large salaries, their position is elevated in society as this is seen to be an attractive working place.

Michael Hardt and Antonio Negri argue that capitalism can only be reactive against the proletariat, which "actually invents the social and the productive forms that capital will be forced to adopt in the future".[21] Therefore, it was the Fordist rationalisation of work, and not the mere technological innovation that forced capital to make a leap into the post-Fordist era of immaterial work. As a consequence, the new industrial working class did not replace the old industrial working class, but extended it to all those whose labour is being exploited by capital.

As a consequence of this shift, artists and curators have become experts at balancing intermittent bouts of barely profitable creative work with additional routine jobs in the creative and service industries. Gregory Sholette notes that, "Artists who are engaged in

this existence build up complex networks made up of other semi-employed artists as well as family members. These networks circulate material support, as well as a great deal of intangible, informational assistance in the form of opportunities for auctions, residencies, exhibitions, publications, and technical solutions".[22] Independent curators share the same level of precarity and have similar networks of support, without this, survival would be difficult. Curators are able to generate income from curating, writing, organising conferences, teaching part-time, and editing publications. Although most of this labour is connected to the artworld, it is considered acceptable for the freelance curator to assimilate a variety of roles into one. The precarity associated with being 'independent' affords the curator the possibility to have intellectual freedom when they are producing exhibitions. He or she is not tied to the institution and can take bigger risks, which institutional curators cannot. However, this does still not justify the precarious existence adopted by career-driven curators. The work of the independent curator is limited to short-term contracts on exhibitions or biennials. Although this gives a fair degree of creative autonomy, it does not provide job security. In most cases these curators are searching for full-time employment.

Cognitive workers are expected to work all the time, and must be 'creative' wherever possible. The division of time between work time and free time has now been eroded through the use of electronic machinery, which requires them to be working all the time. Indeed, this can also be said of the immaterial workers who produce content for social media, 24/7 without any payment. The shift in the labour market has seen the transformation of creative workers into 'workers' – a hybrid of employer and employee – revoking their own worker's rights, but giving them the sense they are in complete control of their own working habits. Furthermore, workers' rights and power have become 'human capital', contributing to a new cultural market.

Curatorial Knowledge

It is important to note the rise in the so-called 'knowledge economy', or indeed what may be known as Curatorial knowledge. As creative workers, curators are required to constantly work, as they must always produce new content to be seen as being productive in the cultural field. Their work contributes to knowledge production, which is central to a contemporary society. This 'knowledge labour' is labour that "produces and distributes information, communication, social relationships, affects and infor-mation and communication technologies".[23] The 'knowledge labour' is an indirect aspect of the accumulation of capital and information capitalism. The knowledge curators produce may be used for future art projects, although most of this can also be outsourced to other 'knowledge workers', usually undertaken by assistant curators and artists who work on a freelance basis. As Christian Fuchs notes, this knowledge work may be sold as commodities on the market (such as consultancy, films, and music) and also exchanged by indirect knowledge workers that produce and reproduce the social conditions of the existence of capital and wage labour, such as education and common

knowledge in everyday life.[24] Although this labour may be necessary for the existence of society, most of this labour is performed through immaterial labour. In the arts, this can be any number of creative workers who require recognition by the artworld in order to maintain a certain level of practice.

Capital exploits unpaid labourers at the same time it is reliant on this work for a certain level of services to be performed. The production of art requires vast numbers of workers to produce knowledge and content for exhibitions and other outlets. In many ways, the curator embodies the traits of this immaterial labour, whether they are employed or not by an institution. They are required to work constantly on additional projects that may enhance their career and prosperity in the arts. This new level of immaterial labour is indeed advocated by the US urbanist Richard Florida as new 'creative labour'; he identifies the breaking down of boundaries between productive and non-productive labour as being a good thing.[25] For curators this makes working conditions increasingly difficult, as not enough opportunities exist for curators in the field. It is possible for one to exist as a creative worker, but often this labour must be supplemented by other sources of income.

Creative Labour

Richard Florida's writing on the Creative Class focuses on locations around the world that try to attract creative workers to maintain their creative edge. Florida argues that, "Human beings have limitless potential, and that the key to economic growth is to enable and unleash that potential".[26] He defines the creative class through the following four principles:

> The Creative Class is moving away from traditional corporate communicates, working class centres and even sunbelt regions to a set of places I call *Creative Centres*.

> The Creative Centres tend to be the economic winners of our age. Not only do they have high concentrations of Creative Class people, but they boast high concentrations of creative economic outcomes, in the form of innovations and high-tech industry growth.

> The Creative Centres ... are succeeding largely because creative people want to live there. Creative people are not moving to these areas for traditional reasons.

> The physical attractions that most cities focus on buildings – sports stadiums, freeways, urban malls, and tourism-and-entertainment districts that resemble them – are irrelevant, insufficient, or actually unattractive to many Creative Class people. What they look for in communities are abundant high-quality experiences, an openness to diversity of all kinds, and above all else the opportunity to validate their identities as creative people.[27]

Florida's observations concentrate on the high-status worker with marketable skills, without commenting on how these power relationships works in real working relationships. His hypothesis that everyone should be able to do creative work has a huge flaw, as 70% of the US would therefore be involved in creative labour. Florida's vision of the new economy concludes that the ideal non-alienated creative labour has moved into the workplace, and is no longer a utopian hope.[28] The neoliberal ideology present in Florida's writing is not without serious flaws, and is more in touch with the lifestyle associations of the creative and cognitive workers who work mostly in developed countries. As Marc James Léger has noted, the irony in his work is that most artists would not qualify for inclusion in his 'Creative Class' category, as members of this class earn an average above $55,000.[29]

The emergence of the so-called cultural industries, creative class, and creative industries seems to obliterate the thought that there were any industrialised countries in the nineteenth century. The creative industries include a wide sector from online platforms, mobile device application developments to creative agencies; and yet, the arts are a good model for how creative industries have been conditioned to work. As the philosopher and art theorist Gerald Raunig notes that this shift has occurred in Europe as a way to 'de-politicize' state-funded art production, and to essentially "do away with the remainders of cultural production as dissent, as controversy, and as the creation of public spaces; to promote creative industries as a pure and affirmative function of economy and state apparatus".[30]

The labour of the creative worker and the precarious worker are deeply connected to one other, as creative work promotes precarious work. As Guy Standing has noted, there was a creative tension between the precariat as heroes, and the precariat as enemies of the state.[31] In the artworld the creative freedoms given to the worker are highly praised, even as it has become an accepted reality that working in the artworld will automatically mean low pay.

This is based on a system in which art institutions operate using a capitalistic social space, meaning that rewards of "the powerful few come at the expanse of the weak; a structural fact not amenable to moral pressure".[32] The professionals who are at the lowest end of the system are unpaid so that institutions can balance budgets, artists rarely receive fees, to ensure that the system can manage to sustain itself and keep administrators in jobs. As Karen van den Berg and Ursula Passer have noted, one of the distinguishing features of art production is that it – by and large – it is not organised through the same structures, nor accessible to the same forms of measure, as other kinds of labour; it is then difficult to see how the political forms of labour organisation can play more than a metaphorical role in pointing out certain social injustices of this kind within the institution of art.[33]

Obviously, a culture-led economy needs a range of creative types to provide the relevant trends and hype, which can then be fed back in to the perceptions of the 'creative industry'.[34] If indeed this is a large industry, as governments might have us

believe, then art production is part of this process of cultural gentrification. As Europe recovers from the 2008 economic crisis into an advanced form of neo-liberalism, the desire to be creative and live in a creative hub is ever more present for the creative workers of Europe. Berlin has become a very attractive place to live and work, due to the low rents and office spaces, making it ideal for a 'start-up' culture to flourish. It is worth noting that any sort of investment in Berlin is encouraged, as since the fall of the wall in 1989, the city remains heavily in debt. Creative people from all of Europe (and beyond) are drawn to the creative energy of the city, to work in low-paid creative positions, that add to the hype of the city. It remains a "precipitous transition from self-exploitation as a cultural entrepreneur to extreme precarization".[35]

Artistic production is able to make use of new models of production to develop artworks that can be sold, but this is still separate from the industrial production of consumer goods. Gerald Raunig observes that this remains integral for the practice of art, as the rules of the "art field and especially of the art market, still circle just as resistantly around the distinct potentials of an anti-industrial imperative".[36] However, there is a strong association with the creative industries, which is evident in how studios (production spaces) for artists are often used in cooperation with small entrepreneurial models. The two models go hand in hand and have a symbiotic relationship.

Cultural production requires contemporary artists and curators to consider the demands that are made by neoliberal market capitalism for the creative production of new symbols. The work by most artists and curators (here there is little distinction) is sustained, according to Léger, by "the desire for social mobility, economic reward and cultural consecration".[37] Indeed, the labour of the curator is inherently tied to his or her career ambitions, but, I would argue it is more acute, and extending beyond the desire for 'cultural consecration'; curators have to be particularly resourceful if they are willing to survive in the artworld. More so than the artists – who are producing symbolic capital for the art market – the curator has to contextualise and produce a range of activities that interest a wider public, as well as the art-going public. Artists may indeed work under precarious labour conditions, as the Berlin based artist Anton Vidokle notes, as they have always been "independent producers, mostly without stipends, salaries, pensions, unemployment protection, or contracts".[38] However, now the very same conditions can be observed for all other creative workers, as well as in and around the artworld.

In the visual arts, self-determinacy is an integral part of the industry. For all creative workers, education provides an initial basis from which workers are able to build. Postgraduate degrees from well-known universities and with ample networking opportunities provide a platform, from which artists and curators can move to other opportunities. Under the difficult working conditions, curators must succeed wherever possible, and this includes the need to constantly learn and be aware of contemporary trends. As with other creative work, reputation and managing one's own critical reception must be maintained, and that is very much the case for the

curator. As independent curators must maintain a living, their labour is often exploited, as Christian Fuchs notes: "The multitude, the contemporary proletariat, as the class of who produce material or knowledge good and services directly or indirectly for capital and are deprived and expropriated of resources by capital".[39]

Most of this work may go on unnoticed behind the scenes via informal alliances with other curators and artists. Yet it remains an important part of the system of art, on which it is reliant. For a small minority – the artistic directors, chief curators, and biennial directors – it remains within their power to produce, as Roberts notes, "the ideational content, which is then applied and performed by others".[40] In this context, content is performed by the assistant curator and interns. Franco Berardi refers to this as the 'cognitariat'[41], and Ursula Huws uses the term 'cybertariat'[42], in reference to the amount of cyber or 'telework' that is performed in today's workplace, and inherent in the artworld. The amount of work needed to produce a range of tasks necessary for artistic production is in line with Isobell Lorey's argument on precarious work:

> The precarious cannot be unified or represented, their interests are so disparate that classical forms of corporate organizing are not effective. The many precarious are dispersed both in relations of production and through diverse modes of production, which absorb and engender subjectivities, extend their economic exploitation, and multiply identities and work places. It is not only work that is precarious and dispersed, but life itself. In all their differences, the precarious tend to be isolated and individualized, because they do short-term jobs, get by from project to project, and often fall through collective social-security systems. There are no lobbies or forms of representation for the diverse precarious.[43]

The cognitariat workforce is now endemic in many aspects of work, especially in the creative industries where large number of workers are needed to perform creative tasks, such as computing, drawing, designing, providing technical assistance, and developing creative strategies.[44]

Institutional curators, who hold positions in museums, usually hold 'safe' positions and do not risk losing their job. Although increasingly museums hire curators and assistant curators on short-term contracts to ensure a high turnover of ideas; however, this is largely the case in smaller contemporary art centres. Museum curators operate under strict procedures: fixed working and opening hours; fixed appointments; a rigid differentiation between functional units (artistic staff, educational department, public relations, and management); and a strong focus on the material (the artworks).[45] This essentially impedes the post-Fordist requirements of flexibility within a globally operating artworld. The biennial fills this role and as such shares some of the charac-teristics with the new creative industries, as they both require temporary workers to generate ideas, which are then turned over quickly in the form of technological services or customer services. The biennial offers a periodic and event based model, which makes it easier to work with temporary curators – much in the same way

start-up culture uses temporary staff (or interns)[46] to provide shot-term solutions. The contemporary artworld is thus involved in a creating a circuit of temporary workers who live a nomadic existence within a system that is constantly being renewed.[47]

However, curatorial practice is still able to retain a degree of autonomy and critical distance in the scholarly sense, even though the working patterns of the profession may reflect some of the changes in the creative economy. Unlike other traditional practices, this economy must be constantly under renewal and change, and this is in part why the practice continues to evolve. For the independent curator who forms alliances with other curators and produces work in a semi-autonomous manner, their practice is likened to that of the artist. Both practitioners find mechanisms that allow them to exist in the art system, even if not all artists and independent curators are able to earn a living entirely in the artworld. For a new generation of independent curators who have emerged out of curatorial training programmes it is vital that they gain recognition from their artistic peers; this social mechanism has a lot to do with the academic system, where young scholars gain respect via an international peer group.[48]

Under post-Fordism the labour of the artist and the curator are distinctly similar. Both embody the familiar traits associated with immaterial labour: flexible working hours, being poorly paid, and little job security.

The consequences of this immaterial labour have allowed for the expansion of museums and biennials internationally, and may have contributed to the exponential growth of the artworld. As John Roberts writes, "immateriality is the highest sphere of creativity under the post-Fordist economy".[49] While creative work may be regarded as an attractive model for art workers, it does not automatically guarantee the possibility that one day these workers will be in full-time employment in an institution. On the contrary, what remains remarkable about the system of art is the number of workers who are willing to continue this cycle without any willingness to secure better conditions for themselves.[50]

In conclusion, creative work comes at a heavy cost: longer hours in pursuit of creativity, self-exploration and autonomy and dispensability always in favour of flexibility.[51] Yet, the precarious labour of the freelance creative worker is now seen as a good model for high-skill and high-reward employment by the service industry, in the new 'creative cities' mentioned earlier.[52] The young creative worker is often identified with the slogan: 'the precarious generation'. Which further extends the understanding that the precariat is the post-Fordist successor to the proletariat, both in theory and practice.[53] If this were indeed plausible we would need to imagine a global class-coalition comprised of the precarious workers associated with post-Fordism. Would this group be capable of developing global actions on an industrial scale? Is it possible to imagine that this has already taken place; as the global occupy movement? Many artists and curators took part in these protests, because their flexible hours meant they had free time to participate in the protests.

Notes

1 Kitty Scott, *On Curatorial Intelligence, Power Talks* (Toronto: Power Plant Contemporary Art Gallery, 2011), Video recording of lecture.

2 Ibid.

3 "One Night Stand," Kunst-Werke Institute for Contemporary Art http://www.projektraeume-berlin.net/projekte/one-night-stand/.

4 Paul O'Neill, *The Culture of Curating and the Curating of Culture(S)* (Cambridge, MA: MIT Press, 2012).

5 Paula Marincola, ed. *Curating Now: Imaginative Practice, Public Responsibility* (Philadelphia: Philadelphia Exhibitions Initiative, 2001).

6 John Roberts, "The Curator as Producer'," *Manifesta Journal*, no. 10 (2009).

7 Pascal Gielen, *The Murmuring of the Artistic Multitude: Global Art, Memory and Post-Fordism* (Amsterdam: Valiz, 2010), 35-37.

8 Ibid., 37.

9 Beatrice Bismarck, "Curating Curators," *Texte zur Kunst*, no. 86 (2012): 52.

10 Ibid.

11 Anton Vidokle, "Art without Artists," *e-flux journal*, no. 16 (2000), http://www.e-flux.com/journal/16/61285/art-without-artists/).

12 "Keep on Smiling – Questions on Immaterial Labour," *Aufhaben* no. 14 (2006), http://libcom.org/library/aufheben/aufheben-14-2006/keep-on-smiling-questions-on-immaterial-labour.

13 John Roberts, "Art and the Problem of Immaterial Labour: Reflections on Its Recent History," in *Economy: Art, Production and the Subject of the 21st Century*, ed. Angela Dimitrakaki and Kirsten Lloyd (Liverpool: Liverpool University Press, 2014).

14 Hito Steyerl, "Politics of Art: Contemporary Art and the Transition to Post-Democracy," in *Are You Working Too Much?: Post-Fordism, Precarity, and the Labor of Art*, ed. Julieta Aranda, Brian Kuan Wood, and Anton Vidokle (Berlin: Sternberg Press, 2011), 30-39.

15 David Harvey, *The Condition of Postmodernity: An Enquiry into the Origins of Cultural Change* (Oxford: Blackwell, 1990).

16 Kerstin Stakemeier, "Art as Capital - Art as Service - Art as Industry: Timing Art in Capitalism," in *Timing: On the Temporal Dimension of Exhibiting*, ed. Beatrice von Bismarck (2014), 15-38.

17 Paolo Virno, *A Grammar of the Multitude: For an Analysis of Contemporary Forms of Life* (Los Angeles: Semiotext(e), 2003), 81.

18 Maurizio Lazzarato, "Immaterial Labour," in *Radical Thought in Italy: A Potential Politics*, ed. Paolo Virno and Michael Hardt (Minneapolis: University of Minnesota Press, 1996), 133-51.

19 Mary Lou Lobsinger, "Immaterial Labour," in *Labour Work Action*, ed. Michael Corris, Jasper Joseph-Lester, and Sharon Kivland (London: Artwords Press, 2014), 139.

20 Michael A. Peters and Ergin Bulut, eds., *Cognitive Capitalism, Education, and Digital Labor* (New York: Peter Lang, 2011), 99.

21 Michael Hardt and Antonio Negri, *Empire* (Cambridge, MA: Harvard University Press, 2000), 286.

22 Gregory Sholette, *Dark Matter: Art and Politics in the Age of Enterprise Culture, Marxism and Culture* (London: Pluto Press, 2011), 125.

23 Peters and Bulut, *Cognitive Capitalism, Education, and Digital Labor*, 98.

24 Ibid., 99.

25 Richard L. Florida, *The Rise of the Creative Class: And How It's Transforming Work, Leisure and Everyday Life* (New York: Basic Books, 2002).

26 *Cities and the Creative Class* (London: Routledge, 2005), 35.

27 Ibid., 36.

28 Roberts, "Art and the Problem of Immaterial Labour: Reflections on Its Recent History."

29 Marc James Léger, "The Non-Productive Role of the Artist: The Creative Industries in Canada," *Third Text* 24, no. 5 (2010): 557-70.

30 Gerald Raunig, *Factories of Knowledge, Industries of Creativity* (Los Angeles: Semiotext(e), 2013), 112-13.

31 Guy Standing, *The Precariat: The New Dangerous Class* (London: Bloomsbury, 2014), 13.

32 Marina Vischmidt, "The Aesthetic Subject and the Politics of Speculative Labor," in *The Routledge Companion to Art and Politics*, ed. Randy Martin (London: Routledge, 2015), 25-37.

33 Karen van den Berg and Ursula Pasero, "Large-Scale Art Fabrication and the Currency of Attention," in *Contemporary Art and Its Commercial Markets: A Report on Current Conditions and Future Scenarios*, ed. Maria Lind and Olav Velthuis (Berlin: Sternberg Press, 2012), 153-81.

34 Angela McRobbie, "'Everyone Is Creative': Artists as New Economy Pioneers," *OpenDemocracy* (2001), http://www.opendemocracy.net/node/652.

35 Raunig, *Factories of Knowledge, Industries of Creativity*, 116.

36 Ibid., 115.

37 Marc James Léger, *The Neoliberal Undead: Essays on Contemporary Art and Politics* (Lanham, PA: Zero Books, 2013), 96.

38 Vidokle, "Art without Artists".

39 Peters and Bulut, *Cognitive Capitalism, Education, and Digital Labor*, 99.

40 Roberts, "Art and the Problem of Immaterial Labour: Reflections on Its Recent History."

41 Franco Berardi, *The Soul at Work: From Alienation to Autonomy* (Los Angeles: Semiotext(e), 2009).

42 Ursula Huws, *The Making of a Cybertariat: Virtual Work in a Real World* (New York: Monthly Review Press, 2003).

43 Isabell Lorey, *State of Insecurity: Government of the Precarious*, trans. Aileen Derieg (London: Verso, 2015), 9.

44 Peters and Bulut, *Cognitive Capitalism, Education, and Digital Labor*, 99.

45 Gielen, *The Murmuring of the Artistic Multitude: Global Art, Memory and Post-Fordism*, 43.

46 Ross Perlin, *Intern Nation: How to Earn Nothing and Learn Little in the Brave New Economy* (Brooklyn: Verso Books, 2011).

47 Gielen, *The Murmuring of the Artistic Multitude: Global Art, Memory and Post-Fordism*, 44.

48 Ibid., 182.

49 Roberts, "Art and the Problem of Immaterial Labour: Reflections on Its Recent History."

50 There is some sense of resistance against this process through the, "Assembly for Art Workers" who have organized events aimed at transforming the current working conditions for artists. See: "Assembly for Art Workers and Opening in Berlin," Art Leaks, https://art-leaks. org/2014/09/02/art-workers-assembly-and-opening-in-berlin/.

51 Andrew Ross, "The Geography of Work. Power to the Precarious?," *On Curating*, no. 16 (2013): 11.

52 Publications include: Keith Sawyer, *Group Genius: The Creative Power of Collaboration* (New York: Basic Books, 2008); Peter A. Gloor, *Swarm Creativity: Competitive Advantage through Collaborative Innovation Networks* (Oxford: Oxford University Press, 2006); Evan Rosen, *The Culture of Collaboration* (San Francisco: Red Ape Publishing, 2009).

53 Gerald Raunig, "Anti-Precarious Activism and Mayday Parades," *EICP* (2004), http://eipcp.net/ transversal/0704/raunig/en.

Libidinal Economies

Juli Carson

> The entire history of Wall Street [is] the story of [arbitrage] scandals…linked
> together tail to trunk like circus elephants. Every systemic market injustice
> arose from some loophole in a regulation created to correct some prior
> injustice…Whatever [regulators] did to solve the problem would create yet
> another opportunity for financial intermediaries to make money at the
> expense of investors. [1]
>
> Michael Lewis, *Flash Boys*

> What we have in the discovery of psychoanalysis is an encounter, an
> essential encounter, an appointment to which we are always summoned
> with a real that eludes us…Consider the importance of appointments,
> meetings, and dates in the realm of love; there can be no love story with the
> real because you try to make a date, and repeatedly reschedule the date, but
> something else appears. [2]
>
> Jacques Alain-Miller, *Reading Seminar XI*

Part I

Art in the Age of Bull Markets

THE AUSTRIAN ARTIST AND activist Oliver Ressler's video *In the Red* opens with a shot of the Manhattan skyline at dusk viewed from the Queens shoreline. The Empire State Building – the post 9/11 signifier for the city – establishes

our point of view and location. By way of a voiceover we hear activists collectively composing a statement: "It turns out these debts we are drowning in are someone else's dollars...someone else's profit". Cutting to the collective itself, we then see the players continue on with their statement: "We broke the silence. We realised we're in the red. We're fed up. We're done hiding. We're over it. So, what are we going to do about it?" The group is Strike Debt, an offshoot of Occupy Wall Street. Aimed at exposing the concealed substrate of financial capitalism, their target is the secondary debt market, whereby a bank sells a defaulted debt – from credit cards, loans or medical insurance – to a third party for pennies on the dollar owed. The third party, in turn, collects the debt at full price, plus interest, hence the logic: "One person's debt is another person's profit". As a means of intervention, the Strike Debt collective buys these bundled debts, only to turn around and absolve them.

Strike Debt's intervention within the secondary debt market is a classic example of what the French Jesuit scholar Michel de Certeau calls a tactic versus a strategy. A strategy becomes possible when a subject of will and power – an enterprise, institution or bank – can be isolated from an "environment". As such, it assumes a place that can be circumscribed as "proper". A strategy thus generates relations with entities external to it; competitors, clients or, in Strike Debt's case, borrowers. A tactic, on the other hand, lacks a "proper" spatial or institutional location. Nor does it have a borderline delineating it to an exterior other. Rather, the place of the tactic *is* the other. Because tactics do not have a place, as de Certeau explains, they depend on time: "It is always on the watch for opportunities that must be seized 'on the wing'".[3] *In the Red* showcases the trajectory of such tacticians in the field of financial strategists, the former of which analogously seize their opportunity *on the wing*. To understand these protagonists fully – to understand the stakes and claims of their actions – we must first consider Wall Street itself as that circumscribed place of capitalist will and power *par excellence*. For it is here, on Wall Street, that an encounter – a rendezvous with a fair market – is endlessly eluded. Hence Strike Debt's tactical, interventionist approach of dealing with financial reform *off the grid*, in the space of the other.

I'll begin anecdotally. My memory of Wall Street begins *in medias res*, in 1987. It was a crazy moment in time, around which a key number of events converged. Most spectacularly, on Monday 19 October the Stock Market experienced the largest one-day crash in history, ending a bull market that had been driven by a cavalcade of leveraged buyouts, hostile takeovers, insider trading and merger mania since 1982. The numbers were astounding, hence the moniker "Black Monday", which will forever denote that day. The Dow Jones Industrial Average plummeted 508.32 points, losing 22.6% of its total value, while the S&P 500 dropped 20.4%, falling 282.7 to 225.06. Remarkably, the crash had to do with the failed interplay between stock markets and index options and futures markets. Once the fall started, there was an exponential run on the Stock Market to cash out, not unlike the run on the banks that occurred in 1929. As a result, $500 billion in Market capitalisation instantly vanished from the Dow Jones Stock index.

Meanwhile, Ivan Boesky – the notorious mergers and acquisitions trader upon whom the iconic film character Gordon Gekko is based – was sentenced to 3 years in prison for insider trading. This is the same moment that the Federal Savings and Loan Insurance Corporation (FSLIC) was declared insolvent – the result of a decade-long Ponzi scheme in the Savings and Loan industry that cost taxpayers a total of $25.75 billion to recapitalise it – before the Financial Institutions Reform, Recovery, and Enforcement Act of 1989 finally abolished the FSLIC. For a moment, 1987 was a financial race to the bottom; the cocaine driven bacchanal was over. Until, of course, it was not. Closing the door on one financial scandal merely opened the door for other instances of opportunist corruption. And there you have it, and there it is. On Wall Street, it's always a matter of *rinse and repeat*. For the Stock Market is a libidinal economy that must be regulated; however, in so doing, fair exchange is paradoxically eluded. In Lacanese, this is the nature of an intangibly Real fair market; it's an appointment to which fair trade investors are called although it always eludes them.

This failed rendezvous redirects us to a tangential libidinal economy. Seven years prior, in 1980, the famed Odeon Café opened its doors in Tribeca at the corner of West Broadway and Thomas Street, just four subway stops from the New York Stock Exchange (NYSE). Launched at the precipice of the bull market that would eventually culminate in Black Monday, the Odeon's clientele was a cross section of big business and counter-culture. As Frank DiGiacomo put it, "The Odeon was soon serving as the de facto commissary for the close-knit group of actors and directors – led by Robert De Niro and Martin Scorsese – who came to define the New York school of filmmaking. And in their midst, were the remnants of another close-knit group that had helped revive the city's cultural relevance in the mid-70s: the original cast and crew of NBC's *Saturday Night Live*" (SNL).[4] Born in the suspended moment between Studio 54's closing and the AIDS epidemic, the Odeon was a clubhouse where – as James Signorelli, a filmmaker from SNL recalls – hardly anybody spent an entire meal at one table. They just "passed from place to place and freely exchanged friends and lovers and other things".[5] As such, it was a site for inebriated encounters – be it sex in the storage closet beneath the stairs, cocaine in the loo, or fistfights at the bar – as well as the epicentre of the bull driven art market. It was there that art stars like Julian Schnabel, Robert Longo, Keith Haring and Jean-Michel Basquiat, would hook up with star dealers like Mary Boone, Tony Shafrazi and Larry Gagosian, all of whom were wheeling and dealing in the bacchanalian atmosphere. As Boone recalls it: "Keith [McNally] yelled at me because, at my birthday party, Julian and I think it was Jeff Koons or maybe Jean-Michel were throwing toilet-paper wet balls. You know how if you take a roll of toilet paper and put it into the toilet, it absorbs all the water and it becomes like a water balloon? They were throwing them at each other at my birthday party...And Keith kicked us out before we got to have birthday cake".[6]

Over the course of the 80s bull market, the New York Stock Exchange (NYSE) (where the selling and buying of securities, currency and commodities took place) and the artworld (where the critique of Wall Street culture was derived and scripted)

constituted two distinct psychic economies located in two different, physical locations. The former was supposed to be rational, mathematical and regulated, the latter libidinal, creative and subversive. However, that was not really true. The artworld, in fact, was just the bohemian substrate of the real deal, the bottom line, of the financial market. In astronomic terms the Odeon was thus the physical location – the centre of mass – where these two celestial bodies, art and finance, effortlessly orbited each other with near mathematical precision. In this way, the aesthetic and economic spheres shared a gravitational pull because they were – and still are – libidinally and inextricably connected.

Consider the following. In 1982, the bull market – deregulated and awash in liquidity and low interest rates – allowed investors to refinance and remortgage endlessly at lower rates. Without saving or lowering debt, investors bought larger houses, vehicles, vacation properties and commodities. In essence they were throwing their money at a bull market to feed a consumption binge that was really just accumulating massive debt. More was more, even though investors were saving less and less. On the art side of it, the market billionaires would spend millions on a single painting, simultaneously fuelled by Wall Street, the strong Japanese yen and aggressive marketing by the auction houses. The auction houses, in turn, constituted a secondary market dominated by speculators, as opposed to the primary market of artists, galleries and collectors. Philip Guston's *Summer* sold for $1.1 million and Willem de Kooning's *July* for $8.8 million, while the sales for 19th-century masterpieces were through the roof: Van Gogh's *Portrait of Dr. Gachet* sold for $82.5 million to a Japanese collector and Renoir's *Moulin de la Galette* for $78 million.[7] In another part of the New York artworld – the Schnabel free zone – critics and curators were consuming post-modern continental theory at the same pace that investors were consuming securities and commodities. In lower Manhattan, you could not pick up a press release for any given thematic exhibition without the cursory mention of Guy Debord's "Society of the Spectacle", Jean Baudrillard's "Procession of the Simulacrum", Walter Benjamin's "Art in the Age of Mechanical Reproduction", or Jacques Lacan's "The Mirror Stage as Formative of the Function of the I". In the mid to late 80s theory was a form of currency in the artworld on both sides of the fence: for artists who sought to interrogate the terms of status quo contemporary art discourse – witness Hans Haacke, Sherrie Levine, Cindy Sherman and Mary Kelly – as well as collectors who sought to monetise artists and artworks through Wall Street tactics of arbitrage and "pump and dump" – Charles and Maurice Saatchi being the most spectacular on that front. Among the post-structuralist texts being translated at the time, one in particular was notably absent; although in retrospect it's highly relevant to this little *mise-en-scène*. Enter the French philosopher Jean-François Lyotard's *Libidinal Economy*, written during the 1974 bear market, when prices of securities fell so low that a widespread pessimism persisted, one that ultimately elected Ronald Reagan president and set off the deregulated 1980s bull market.

The main precept of *Libidinal Economy* – a post-Marxist critique of capital – was to forge an association between what Lyotard saw as the repressive (militaristic) ethos of

classic Kantian critique and the deployment of the super-ego within the classic psychoanalytic Oedipal scenario. Lyotard's proposal was a critique of ego psychology – not Lacanian psychoanalysis – that discourse wherein the "superego is given the arduous task of keeping the id in order, a task it accomplishes, writes Freud by 'install[ing] a garrison [cathexis or investment] in the place where insurrection threatens".[8] Under separate cover, in his essay "Dérives," of 1972, Lyotard argued that Kantian critique "is deeply rational, deeply consistent with the system. Deeply reformist: the critic remains in the sphere of the criticised, he belongs to it, goes beyond one term of the position but does not alter the position of the terms".[9] As such, Kantian critique and normative psychoanalysis maintain the static conventional forms of the universal subject, proletariat, labour and exploitation. Lyotard instead called for what was a libidinal model of 'acritical' writing about the conjoined economies of the subject and capital that would *drift*, in the Situationist sense of the *derive*. In which case, "the shores [would be] disfigured and identities wrecked in this post-critical torrent which engulfs Kant's safe seat as much as the garrisons of the psychoanalytic superego".[10] However, by 1988 Lyotard had denounced the text as an "evil book". Could it be that the crash of 1987 – the result of the libidinous frenzy that occurred across politics, aesthetics and economics – gave him pause? Could it be that he realised the unbridled libido, inherently, is non-ideological and can thus drive both the left *and* the right into the same ditch?[11]

Back to the frenzied floor of the NYSE, 1987. A 2007 *New York Times* report described it this way:

> When individual investors heard that a massive stock market crash was in effect, they scrambled to call their brokers. This was unsuccessful because each broker had many clients. Many people lost millions instantly. Some unstable individuals, who had lost fortunes, went to their broker's office and started shooting. Several brokers were killed, despite the fact they had no control over the market action. The majority of investors who were selling, didn't even know why they were selling, except that they 'saw everyone else selling'.[12]

In 1987, the NYSE was still very much an analogue scenario. Meaning, the largest single crash in stock market history occurred when brokers – actual *human beings* – still picked up landlines and penned their orders on paper. There were no hand-held micro devices such as blackberries and iPhones or programmes trading to handle the overwhelming volume of shares being traded. To be clear, the total NYSE volume for the week of 19 October was 2.4 billion shares, valued at $75 trillion. That is approximately the total amount of business done in all of 1967.[13] This crash, this libidinal torrent that broke the dam and flooded Wall Street's shores, was the culmination of another libidinal drive: the longest bull run in stock market history. A new levee was therefore needed – analogously a new super-ego – tasked with the arduous chore of regulating this volume, keeping it flowing, while simultaneously acting as 'circuit breaker' that would halt trading if the Dow declined a certain number of points in a

given amount of time. Such a levee system was to be found in the complete computerisation of Wall Street, replacing people entirely.

Fast forward to the present, when the market is a pure abstraction, as Michael Lewis notes in *Flash Boys*. Market experts still report from the floor of the NYSE on CNN, but nothing is actually happening there. It's just a stage set. The reality is something quite virtual:

> For a market expert truly to get inside the New York Stock Exchange, he'd need to climb inside a tall black stack of computer servers locked inside a cage locked inside a fortress guarded by a small army of heavily armed men and touchy German shepherds in Mahwah, New Jersey. If he wanted an overview of the entire stock market…he'd need to inspect the computer printouts from twelve other public exchanges scattered across northern New Jersey, plus records of the private dealings that occurred inside the growing number of dark pools. If he tried to do this, he'd soon learn that there actually was no computer printout. At least no reliable one. [14]

Not only are the exchanges virtual now, they are actually a collection of small markets located throughout New Jersey and lower Manhattan.[15] And on Wall Street "remote" and "virtual" make a dubious combination, one ushering in more nefarious activity.

A case in point. In 2007, the Securities and Exchange Commission issued Regulation NMS, whereby the routing of orders for stock would henceforth be based upon a security information processor (SIP), a consolidated feed that directs each exchange to the best price among the markets. However, most of the exchanges do not use the SIP. Rather, they are engaged in High Frequency Trading (HFT) – a type of algorithmic trading carried out entirely by computers – to create direct connections to the markets in micro or nanoseconds. Speed is thus the new commodity for investors engaged in HFT; a direct feed to the market from a single exchange costing upwards of $60,000 a month. Without this feed, an investor cannot *see* the market because by the time he's placed an order in "real time" an HFT broker, with a direct feed, has been tipped off to the order based upon his algorithms, thus beating the slower investor to the punch. In essence, by way of HFT, the broker has *front-run* the average real-time investor. This means that the US Stock market, as Lewis argues, "was now a class system, rooted in speed, of haves and have-nots. The haves paid for nanoseconds; the have-nots had no idea that a nanosecond had value. The haves enjoyed a perfect view of the market; the have-nots never saw the market at all".[16] In other words, as Eric Scott Hunsader concludes: "When Michael Lewis used the word 'rigged,' [to describe the Stock Market] he's right. It's rigged because all of these gains depend on receiving the information faster from an alternative source, which is… forbidden by Reg NMS".[17] The arrival of the slower prey, as Lewis put it, thus awakened the HFT predator "who deployed his [usual] strategies – rebate arbitrage, latency arbitrage and slow market arbitrage" to his own advantage.

Welcome to the new bull market, where it's déjà vu all over again. Since bottoming out in 2009, after the Stock Market crashed on 15 September, 2008 – when the Dow

Jones fell 1,874 points or 18.1%, taking almost $1.2 trillion in market value – the S&P 500 has gained 200% on a total return basis. And just like the 80s, the secondary art market is a reflection of Wall Street's libidinal economy: the US artist, Paul McCarthy's *Tomato Head (Green)* (1994) sold for $4,562,500 in 2011; Charlie Ray's *Table* (1990) sold for $3,106,500 in 2011; and Ed Mark Grotjahn's *untitled (Standard Lotus No. 11, Bird of Paradise, Tiger Mouth Face 44.01)*, (2012), sold for $6,510,000 in 2013.[18] Not to mention Jeff Koon's total auction sales of $177 million for 2012. However, since the bull market is driven primarily by algorithm trading, the volume of trade reflects market manipulation more than it does economic contribution. As Max Ehrenfreund notes, "All of a sudden, what happens – and we see this in the market every day – it will take the price up 5 percent in a second, on hundreds of trades. The machines are just feeding off themselves".[19] Hence the remarkable difference in volume if we compare trade on 19 October, 1987 – when the market received 585,000 orders – and twenty years later, on a given day in 2007 *before* the current bull market, when there were 155 million orders processed due to algo-trading.[20]

And so, we have our two "celestial bodies" – Wall Street and the secondary art market – again in mutual (frenzied) orbit. This time the barycentre between the two is a location – both real *and* virtual – where interventions and interrogations are made off the grid. Enter Stike Debt – tacticians of mimesis, *par excellence*. As de Certeau instructs, the tactician "must play on and with a terrain imposed on it and organized by the law of a foreign power. It does not have the means to *keep to itself*, at a distance, in a position of withdrawal, foresight, and self-collection: it is a maneuver within enemy territory...".[21] In this case, the secondary debt market is occupied and detoured in favour of the other – *one person's debt is another person's profit* – with the surplus-value being the reversal of fortune by literally *front-running* the collection agencies in buying up bundled debt from the banks. It is, in essence, the conversion of corrupt strategies, regularly employed by the financially empowered, into a tactic in the hands of the radical other. And in Strike Debt's hands the aforementioned rendezvous with a fair market momentarily and provisionally occurs *within* the very constellation of financial capitalism it seeks to expose, a rendezvous necessarily mobilised from the edge of the targeted circumscribed space: Wall Street.

As for Oliver Ressler's video representation of this act – *In the Red* – his approach is equally and necessarily tactical, re-presenting the group's conversation *about* the action. In his way, the macro-event – the actual purchasing of bundled debt – is anecdotally made present by its micro-reenactment within Ressler's filmic *mise-en-scène*. This re-enactment, in turn, is disseminated by Ressler – or detoured – into the art field, where it is seen in various exhibitions, as well as in the financial world, and made available to activists. The reality that Lewis recalled in *Flash Boys* – *the haves enjoyed a perfect view of the market; the have-nots never saw the market at all* – is thus reversed because, in Ressler's hands, the striptease nature of the financial market is laid bare.[22] Moreover, by taking the performative rather than the descriptive route, *In the Red* plays the double role of interrogating the picturesque, toothless nature of

so-called "political art", sold for millions on the secondary art market, as well as providing a didactic template for action among Situationist minded artists and activists looking to intervene in the secondary debt market. That said, if we *were* to look at Ressler's films within the genre of documentary filmmaking, what is "documented" turns out to be what Guy Debord called the psycho-geographical engagement with a given location. Always libidinal by nature, psycho-geography demands that we discard our conventional use of space – the exhibition, the town square, the financial market – in order to create a contingent unimagined sense of *place*. In this case, it is a sense of place that deconstructs the hegemonic parameters of a financial market defined by an interior circle populated by players in back rooms and dark pools and an exterior margin populated by wandering debtors. What his films thus capture are the *means* by which a diverse group of protagonists – agents of change in the field – *go to work* on the fiscal train wreck caused by the endless Wall Street arbitrage scandals described in this essay.

Returning to Lyotard's theorisation of the river levee as a metaphor for the super-ego's regulation of libidinal flood, we could, in turn, conceive of the secondary debt market as surrounded by levees – the capitalist rules of the game – that keep the monetary juices flowing behind closed doors. What Strike Debt does, in effect, is trench those levees, allowing the uncollected debt to flow outside the market and eventually evaporate altogether. It is a perfectly inverted mimesis of what the market does all the time through *quantitative easing*: the policy by which a central bank creates money out of thin air by buying securities – such as government bonds – from banks with electronic cash that did not exist before.[23] Hence the real-time political nature of Strike Debt's libidinal declaration: "We broke the silence. We realised we're in the red. We're fed up. We're done hiding. We're over it. So, what are we going to do about it?" The answer? More tactical moves on behalf of the protagonists in the field – be they activist collectives or artist filmmakers – as a pro-active response to the century old question of the Left: *What is to be done?* And yet another question remains, one provoked by the Hungarian Marxist philosopher, Georg (György) Lukács' formulation that: "when capitalism functions in a so-called normal manner, and its various processes appear autonomous, people living within capitalist society think and experience it as a unity, whereas in periods of crisis, when the autonomous elements are drawn together into unity, they experience it as disintegration".[24] How, in other words, do we represent this unity if we experience as disintegration? Is it a choice between the artist representing the totality of capital or the fragmented experience of the consumer? That was the polemical debate between the philosophers of the Frankfurt School, between the realists and the modernists in general and between Lukács and Adorno more specifically. But in a contemporary sense we might further consider how *both* the totality *and* the experience of capitalism might be represented. Lyotard and Thierry Chaput set out to do just that when they organized *Les Immatériaux* in 1985, an experimental exhibition that took Jorge Luis Borges' essay "The Library of Babel" as its conceptual template.

Part II

Secondary Market Sublime

> ...the Library is 'total'...its bookshelves contain all...that is able to be
> expressed, in every language...Infidels claim that the rule in the Library is
> not 'sense' but 'non-sense,' and that 'rationality' (even humble, pure
> coherence) is an almost miraculous exception. They speak, I know, of 'the
> feverish Library', whose random volumes constantly threaten to transmogrify
> into others, so that they affirm all things, deny all things, and confound and
> confuse all things, like some mad and hallucinating deity.[25]

> Jorge Luis Borges, "The Library of Babel"

The question for Lyotard – in his role as curator of *Les Immatériaux* – was the following. How do you organise into representation that which is unrepresentable because it has the characteristic of the unconscious and the pulsatile nature of the Real? On this subject-the artist's aesthetic response to the sublime nature of capitalism's representation – the debate between Lukács and Adorno of 1958 returned between Fredric Jameson and Lyotard in 1985 over the subject of postmodernity.[26] Both concurred that to be a subject within capitalism in the 1980s was to be in a constant state of disorientation. So, on Lukács' point of experiencing the totality of capitalism as disintegration they agreed. Their disagreement was over what role postmodern art, architecture and criticism would play in the face of this. Simply, was postmodernism's main traits – depthlessness, simulation, ahistoricity, schizophrenia – inextricably bound up with 'late capitalism'[27] as Jameson argued in his 1984 essay "Postmodernism or, The Cultural Logic of Late Capitalism?" If so, "this whole global, yet American, postmodern culture is the internal and superstructural expression of a whole new wave of American military and economic domination throughout the world: in this sense throughout class history, the underside of culture is blood, torture, death, and terror".[28] Neither moralising nor celebrating this condition, the postmodernist's critical task, according to Jameson, would then be to craft a *cognitive map* that would "enable a stituational representation on part of the individual subject to that vaster and properly unrepresentable totality which is the ensemble of society's structures as a whole".[29] Taking recourse to Louis Althusser's post-Marxist interpretation of Lacan, this cognitive map would correspond to the Symbolic register of the subject's conscious, i.e. the world of language and culture. Ostensibly this would fill in the gap left by what uncritical postmodernism stressed: the subject's Imaginary relation to his real condition of experience, i.e. the subject's unconscious internalisation of state ideology in his or her daily life. The crucial problem with Jameson's formulation is that it was based upon a fundamental misreading of Althusser. For the "real" of which Althusser speaks is *not* a Lacanian "Real" – that which is unrepresentable because it falls out of language – but a Marxist real (with a lower case 'r') that refers to the manner in which the subject experiences his or her reality.[30] Either way, Jameson's argument for Symbolic representation – a cognitive map – of the unrepresentable is ultimately a

neo-realist position because of his utter rejection of modernist tactics of *enacting* the subject's encounter with the sublime *as* an abstract representation of his real lived condition.

The latter position, Adorno's position, is the one explicitly evoked by Lyotard's *Les Immatériaux*, an exhibition that sought to spatialise performatively the subject's sublime experience of late stage capitalism at the very pinnacle of the 80s bull run on Wall Street. The exhibition thus pivoted off his *The Postmodern Condition: A Report on Knowledge*, the target of which was Jürgen Habermas' claim that modernity has failed by "allowing the totality of life to be splintered into independent specialties which are left to the narrow competence of experts, while the concrete individual experiences 'desublimated meaning' and 'destructured form,' not as a liberation but in the mode of that immense *ennui* which Baudelaire described over a century ago".[31] Habermas instead argued that art must bridge "the gap between cognitive, ethical, and political discourses, thus opening the way to a unity of experience", what Lyotard called meta-narrative.[32] Against both Habermas and Jameson, Lyotard held out for a postmodernity that was not the *bottom line* of late capitalism but rather a return to the modernist, avant-garde tactics of disruption and negation *as* a form of critical distance from the system with which postmodernism was inextricably bound. As such, postmodernism is conceived here as modernism represented by *deferred action*. This is what Lyotard meant to invoke when he said: "…a work can become modern if at first it is postmodern. Postmodern thus understood is not modernism at its end but in the nascent state, and this state is constant".[33] Moreover, by taking up modernism's disruptive tactics, Lyotard intentionally recuperated Kant's notion of the sublime – the contradiction that develops as a conflict between the subject's ability to conceive of something and his or her ability to represent it mentally as a picture. The sublime, as Lyotard explains, thus takes place…

> …when the imagination fails to present an object which might, if only in principle, come to match a concept. We have the Idea of the world (the totality of what it is), but we do not have the capacity to show an example of it. We have the Idea of the simple (that which cannot be broken down, decomposed), but we cannot illustrate it with a sensible object which would be a 'case' of it. We can conceive the infinitely great, the infinitely powerful, but every presentation of an object destined to "make visible" this absolute greatness or power appears to us painfully inadequate.[34]

Which is to say, we may be able to conceive of late capitalism – its multinational corporations, globalised markets and labour, mass consumption and liquid multinational flows of capital – but how do we picture this mentally? How do we wrap our heads around it? According to Lyotard it's the impasse of this contradiction between our faculties that needs to be presented, not dialectically resolved. Meaning, for Lyotard, it's better to grasp capitalism as the sublime– present it through this impasse – than to cognitively map it through the positivist language of Symbolic unity. The ideology of capital already (falsely) provides this unity. Taking recourse to Lukács

again – his theoretical observation, not his aesthetic solution – under capitalism when things appear to hold together, what you really have is a sublime paradox: unity experienced as disintegration (capitalism as crisis) and vice versa. From this philosophical vantage point, capitalism thus presents us with an unrepresentable Real with which there are no successful rendezvous, even though the subject is continually driven to engage it as some sort of representation. For one cannot hold these two thoughts at once in one's mind: unity-as-disintegration. It is sublime.

Drawing upon an old modernist metaphor – the world as an infinite library – Lyotard set out to *perform* this sublime in place of 'representing' it, transforming the fifth floor of the Centre Pompidou into a massive metallic maze, divided by grey gauze screens into 61 zones that were, in turn, arranged consecutively along five adjacent pathways. As the US philosopher John Rajchman describes it, these zones consisted of "small installations of various cultural artefacts, technological representations and electronic devices, and were titled by the ideas or conditions that they were intended to represent or demonstrate".[35] Upon entering, the viewer was also provided headphones – synchronised with these zones – that played a selection of French theory (Blanchot, Baudrillard, Barthes) and modern writing (Beckett, Artaud, Mallarmé, Proust, Zola, Kleist).[36] Again, as Rajchman describes it:

> There were video, film, slides and photographs – commercial and artistic, anonymous and signed, old and recent. There were robots, an elaborate photocopier, the first display of a holographic movie, and, of course, computers – lots of them. There were examples of rugosymmetric reproduction, electromicroscopy, spectrography, holography, Doppler effects and Fourier series; displays of astrophysics, genetics and statistics. There were even a Japanese Sleeping Cell from the Kotobuki Co…At several computer consoles positioned throughout the show one could read the meditations of 30 illustrious Parisian intellectuals and writers on 50 alphabetized and cross-referenced words such as Author, Desire, Meaning, Mutation, Simulation, Voice and Speed.[37]

At the cost of 8 million francs, *Les Immatériaux's mise-en-scène* was also the work of stage designer Françoise Michel who theatrically gave the zones a 'chiaroscuro' effect by alternately spotlighting them or plunging them into near total darkness. In Caput's words: "Decked in demanding grey, illuminated by improbable lighting, with unpredictable ideas allowed to hover, this hour, this day, in this year, suspended, rigorously ordered yet without system, 'The Immaterials' exhibit themselves between seeing, feeling and hearing".[38] The aim was to induce a state of perpetual uncertainty, of the ineffable: "That we know not how to name what awaits us is the sure sign that it awaits us" as Lyotard put it.[39]

But if the subject was plunged into an ineffable state of the sublime, he or she was simultaneously plunged into a discursive pool that was structured along the lines of the unconscious, characterised by an infinite combination of contradictory associations and references, recalling the spatial and conceptual labyrinth of Borges' *Library*

of *Babel*. Ambulating through *Les Immatériaux's* maze of zones was thus akin to walking through a surrealist book, as Rajchman recalls it, producing in the viewer a kind of "postmodern reader-*flâneur*" who infused the electronic world with modernist meaning: albeit an atemporal one in that "the 'book' on one of our postmodern electronic condition is in fact a modernist one". Here, again, Lyotard performatively employed his "acritical" perspective from *Libidinal Economy*, extended to curatorial practice; hence the libidinal *drift* through the variant political and aesthetic economies. And, along the way, the shores of clean curatorial practice – one based upon chronology, historicism and categorisation – were flooded through the refusal of segregating art and technology, modernity and postmodernity, museum installation and theatrical production. However, in doing so, the exhibition shared the problematic ambivalence of *Libidinal Economy*. At the cost of 8 million francs, *Les Immatériaux* was at once a celebration of capital in as much as it denied and thus *defied* the museum's usual rotation around Wall Street, the centre of gravity for the artworld's secondary market. This produced a libidinal *jouissance* – a pleasure/pain – in the viewer that echoed the many technical failures of the exhibition so widely complained about at the time.[40]

In Seminar XI, Lacan reminds us that the libido – the source of the subject's *jouissance* – is "to be conceived as an organ, in both senses of the term, as organ-part of the organism and as organ-instrument". Such, that the source of the libido – the unconscious – is more like a bladder than a subterranean cave (as it is conventionally conceived) in that the unconscious can be filled up and emptied out with quotidian regularity. In the process, this act of *emptying out* – this depletion – enacts the return of something repressed in the subject. Analogously, what returned for many of the viewers drifting through *Les Immatériaux's* complex maze was a desire for what museums regularly make their living upon, but diligently repress: the secondary art market's connection to the financial secondary market. It is usually a fact that hides in plain view in conventional curatorial practice, where upon artworks happily shine as commodities from their pedestals or walls, piquing the viewer's desire no differently than high-end 911 Porsches do when parked in a dealership's show room floor. At base in *Les Immatériaux* was a denial of any such aesthetic engagement, commodity or otherwise – that part of modernity drops out – in that a philosopher-curator was intent on making what could arguably be seen as a single artwork *made out* of various artworks, texts, technologies and temporal modalities. Was the exhibition therefore sublime or was it merely a compost heap of culture? Should we conclude the latter to be the case, this would bring us to Deep River, an experimental exhibition space in Los Angeles that took the opposite approach in defying the secondary market.

The Ethics of Negation

Ethics requires us to risk ourselves precisely at moments of unknowingness, when what forms us diverges from what lies before us, when our willingness

to become undone in relation to others constitutes our chance of becoming human. To be undone by another is a primary necessity, an anguish, to be sure, but also a chance--to be addressed, claimed, bound to what is not me, but also to be moved, to be prompted to act, to address myself elsewhere, and so to vacate the self-sufficient 'I' as a kind of possession.[41]

Judith Butler, *Giving an Account of Oneself*

Founded in 1997 by Daniel Joseph Martinez, Rolo Castillo, Glenn Kaino and Tracey Shiffman with the firm commitment to keeping the space open for only for 5 years Deep River – a 350 square foot space on 712 Traction Avenue in Downtown LA – was the artists' response to a general malaise in the art market. Martinez explains what made it happen at that particular moment in time: "For just five years, it was a place where all that we had known as reality was discarded and replaced, without permission or apology, by the belief that anything was possible....We believed in the possibility of creating Deep River as a proposal born of optimism, a project to counter the confusion and pessimism of the artworld of the late 1990s".[42] Unlike Lyotard's *Libidinal Economy* text and *Les Immatériaux* show the Deep River project had no ambivalence in their position towards the dual secondary markets of art and finance. The door of this small storefront, in fact, was emblazoned with the manifesto: "no art critics allowed." The intention behind this negation was that art critics are concerned primarily with magazine reviews – descriptive short accounts of artworks-as-commodities – although this intention was vastly misunderstood as being anti-writer, the latter of which the founders firmly supported. To the contrary of public opinion at the time, the no-critics-allowed moniker was a conscious *act* of turning away from the market place – the domain of a chosen few – in order *to address themselves elsewhere*, as Butler notes of the ethical act, in the field of the other: emerging minority artists that had fallen through the cracks of the art market. This simple gesture of pure negation was incendiary, prompting such notes as this from one critic: "Don't worry – I won't bother you by mentioning your space in *S.F. Guardian, Art/Text, Art Issues, etc*".[43] This was to completely miss the point. As Firstenberg points out, "Martinez described this strategic, not sardonic gesture as an admonition at the front door to consider and participate in alternate modes of dialogue, critique, and reception".[44]

The scene needs to be better set to fully grasp Martinez's provocation. In some ways, Los Angeles is a traumatic city. Not in the literal sense put forth over the last 25 years by local contemporary museums that have fostered regional clichés about Charles Manson, earthquakes and mudslides.[45] To the contrary, this is trauma in the classical Freudian sense of an event from which we cannot advance. Simply, for a select but vocal few, *it's as if the last thirty years never happened*. Take, for instance, Andrew Hultkrans' 1998 *Artforum* article on LA art schools, "Surf and Turf," in which Dennis Cooper is described as "praising [his own UCLA protégés] as much for their wacky behavior – psychedelic drug use, zany costume parties, wrestling in a kiddie pool filled with fake blood – as for their art, which he describes with characteristic faux-naif

bemusement as 'crazy, large-scale, incredibly ambitious, and very sincere'". Aside from the obvious evocation of modernism's now-faded trope of the "bad boy" artist, Hultkrans makes a polemical return to the word *sincerity*. Taking his lead from Cooper's analogy of the UCLA art scene to "Seattle, right after *Nevermind* went platinum," Hultkrans asks, "Can fine art capture the instant accessibility and popular appeal of indie rock?"[46] For it was a work's presumed "lack of irony, and cynicism", associated with the *tragic* sincerity of Kurt Cobain, that these critics associated with a handful of students (following the lead of such UCLA art stars as the now late Jason Rhoades). Upon the publication of Hultkrans' article, it was obvious to many that his melancholic return to a tropic notion of sincerity was, in fact, a return of two modernist polemics: (1) a branch of early Conceptualism that dismissed any explicit political proposition, and (2) Conceptualism's more general ignorance of psychoanalytic theory. Concomitant with this melancholic return was a nervous anxiety as to how long such an anti-intellectual buzz could be maintained at UCLA. Might theory rear its "insincere" head again – as it did in the 1980s at the California Institute for the Arts – killing off unadulterated playfulness of the Hultkrans moment in the favour of a politicised neo-conceptualist practice?

Meanwhile, on the other side of town from Bel Air – the wealthy suburb where UCLA is situated – the collective behind Deep River was adamant in their *situational* negation of the art market, positioning themselves instead in a part of downtown that had yet to be gentrified with high rise condos and sprawling hipster eateries, as it is today. The crowd attending their openings – ones that always spilled into the street – was constituted primarily of east and south side Angelinos. On one side of town, you thus had a predominately white art scene characterised by the "popular appeal" of "zany costume parties" thrown by college students who kowtowed to the art market by flirtatiously soliciting the attention of local art critics, and on the other you had a group of artists who were just as committed to the neo-avant-garde strategies of 1960s and 1970s conceptual art – from Joseph Beuys to Michael Asher and Douglas Huebler – as they were to resurrecting the political content of the recently failed cultural wars in defiance of the both the local critic and the larger art market. As the US management academic, Iris Firstenberg, again, put it: "In the face of a pervasive cultural temperament guided by vernacular spectacular, biennialist burnout, multi-culturalist backlash, museum blockbusters, a muting of the culture wars, and a turn to globalism as the curatorial conceit of a generation, Deep River marked a turn toward modest and local concerns, and it operated with the luxury of irreverence and the desire for anarchy".[47]

This gesture of tenacious return – to both the laws of aesthetic form *and* the politics of identity – deconstructed the well-known historical debate between Adorno and Sartre on the subject of "committed" art. On the one hand, Sartre called for artists to make a social choice in their art production, to make *situations*. This is the position from which a person engages with the world, according to Sartre, the place where one is presented with a set of conditions that he or she can passively accept or

actively interrogate. The active position entails recognising that the quotidian choices we make – between this or that action – is an affirmation of a given "image" of humanity as a whole. As Sartre put it, in making a choice, "I am creating a certain image of man as I would have him to be. In fashioning, myself I fashion man".[48] As a means of interrogation, the committed artist might repeat these situations. In so doing, the artist would visualise the conventional choices subjects make in life, ones that could be made differently through art *as* a critique of life, or what Lacan would call the Symbolic register of our consciousness. The problem with Sartre's formulation was that his aesthetic solution – realism, basically – was so conventional that such situations redoubled the world it was staged to critique. Such art, according to Adorno, *validated* the world in the affirmative due to its inherently mimetic nature. Adorno countered that "a successful work…is not one which resolves objective contradictions in a spurious harmony, but one which expresses the idea of harmony negatively by embodying the contradictions, pure and uncompromised, in its innermost structure".[49] Hence the need for an artwork to occupy a position of *aesthetic distance* in order for it to constitute a *negative knowledge* of the actual world because, again, as Adorno puts it: "Art does not provide knowledge of reality by reflecting it photographically or 'from a particular perspective', but by revealing whatever is veiled by the empirical form assumed by reality, and this is possible only by virtue of art's own autonomous status".[50] This negation of a negation – the contradiction of a veiled contradictory world – is what he meant by the term *negative dialectics*, one that would produce a new art that antithetically opposed to the empirical reality it encapsulated.

A deconstructed model of Adorno's negative dialectics – a negation positioned *as* a Sartrean situation – is what distinguished Deep River's curatorial program, working as they did locally while thinking globally. It was a tactical response – in the most militant sense of the word – to the 90s artworld, a means of acting ethically at the margins, in the position of the other in the best de Certeauean sense. While across town at UCLA – the centre of the art market at the time – deeply racialised politics were being ideologically inscribed in favour of the primary and secondary art markets, driven by a core of senior art faculty that had been canonical figures of first generation Conceptualism. In the face of this, as a means of ethical negation, Deep River set out to produce something in the affirmative *as* a contradiction of the world in general and the art market percolating across town in specific. That was the *jouissance* of Deep River's programme. A few people putting a hole into the Symbolic, while they passed through a rather brief period of time, in the Debordian sense. It was a hole that was naturalised or indexed by the multiple rocks thrown through the spaces front glass door with alarming regularity. But by 2002, when President George W. Bush had already begun the war drums, post 9/11, and Deep River closed its doors, the corporatist bladder was ready to be filled up again bringing us to the epic crash of 2008 and the subsequent bull run currently poised to lap the last one in the 80s. A global rinse and repeat return to Imaginary politics and conventional identification

with a world of hidden contradiction would ensue in the artworld. Enter dOCUMENTA 13 as that epic instance of aesthetic mimesis against which Adorno vehemently directed his entire corpus of writing.

Watercolour in the Brain

The artwork, an ambiguous entity, a quasi-object whose attributes are to provide both grounding and relation, performs the task of the transitional object, a prop for an exercise, a gymnastics of being-without, without another, but also becoming-with, unwired, in one place and not in another place, in one time and not in another time, just here, in this place, with this food, these animals, these people, poorer, and richer too.[51]

Carolyn Christov-Bakargiev

In the words of its curator, dOCUMENTA (13) was a vast stage upon which 200 artists and art collectives, from some 50 countries, present hundreds of "transitional objects" for our "fascination". Stating that she "had no concept" – her intention was to present a "state of mind" – Christov-Bakargiev paradoxically conceptualised the exhibition on the psychoanalytic theory of object relations, predicated on her observation that documenta sprung from the trauma of WWII rather than the world's fairs of the 19th century. Apropos of this we have an installation in the Fridericianum called the "Brain" conceived as a "miniature puzzle" for the entire exhibition, of which Christov-Bakargiev states: "There are eccentric, precarious, and fragile objects, ancient and contemporary objects, innocent objects and objects that have lost something; destroyed objects, damaged objects and indestructible objects, stolen objects, hidden or disguised objects, objects on retreat, objects in refuge, traumatised objects, transitional objects".[52] And yet, despite the psychoanalytic truth claims aimed at giving transitional object status to the individual artworks, not only did dOCUMENTA (13) *feel* like a world's fair, it would be more accurate to describe the entire exhibition as the curator's *own* transitional object – one caught *between* history and art or, better yet, the concrete and the conceptual.

Coined by D.W. Winnicott, "transitional object" is a material thing – such as a doll or a blanket – that a child imbues with special value to ease his/her transition from the pre-symbolic world of the mother-child dyad (focused around the object of the breast) to the symbolic world of true object-relationships (focused around real persons). The task of today's festival curator – bridging the gap between the art fair (perceived as marginal) and the world's fair (perceived as a populist) – could analogously mandate a transitional object. And this is precisely what we are given: a documenta that reads as a symptom of the curator's unconscious desire to collapse art and life (nostalgically), even though this charge was vehemently protested by her in the exhibition's press conference.[53] That's not to say there was not any art in dOCUMENTA (13) or that it was *in fact* a world's fair. But it does *lean* into the world's

fair model by way of an exhibition platform giving us one last gasp of Nicolas Bourriaud's relational aesthetics model, most egregiously with Occupy Kassel invited to camp on the Friderichsplatz, Michael Portnoy's live game show played inside a mountain of mud, Lori Waxman's *60/wrd minute art critic* and Pedro Reyes' *SANATORIUM* where viewers check themselves in as a patient to be interviewed and diagnosed in short order. These participatory tactics make dOCUMENTA (13) more popular than its predecessors in that it catered to the viewer's readymade fascination with social networks and the global 24-hour digital news cycle, but it did not challenge or inter-rogate this spectacle *through* individual artworks. Rather, by way of its non-concept concept, dOCUMENTA (13) "reperformed" our social media spectacle *as* an art exhibition.[54]

That said, it's *because* dOCUMENTA (13) so seamlessly mimed social media, that the exhibition did have a serious side – meaning it was not just pictures of cats. In place of the national pavilions that characterise the aforementioned world's fairs, Christov-Bakargiev structured the installations around four states of mind – both mental and real – that in turn accorded with four cities in the world, two of which dominated the news cycle at the time: *under siege (Kabul), on retreat (Banff), in a state of hope (Cairo),* and *on stage (Kassel).* Again, it is in the fourth site, Kassel, that the objects related to the first three sites were *reperformed* through the lens of art. But this is problematic since this *lens* was allegorically perceived as an all-seeing internet gaze through which a subject could maintain a safe (hegemonic) distance from the object he/she grasped. As the US art historian and curator Christov-Bakargiev herself put it: "The violent, aggressive gaze seems ever more that of the person looking at a photograph at a later moment, the moment of its upload onto the Internet, and in another place, in front of their laptop far away. Power is the power to browse YouTube on the Web and to 'google' images from the detached and safe vantage point of one's laptop".[55]

It is hard to imagine an exhibition so effortlessly reconciling Adorno and Benjamin's respective (polemical) positions on political content in art, but there it was – presented on Kassel's world stage. Benjamin famously criticised "modish" documentary photography for making "the struggle against poverty an *object* of consumption, [transforming] the political struggle from a compulsion to decide to an *object* of contemplative enjoyment"[56] [emphasis mine], while Adorno warned that "the so-called artistic representations of sheer physical pain of people beaten to the ground by rifle butts contains, however remotely, the power to elicit enjoyment out of it".[57] It's important to note that an artwork does not have to *literally* depict poverty or a given atrocity when it is simply evoked in the "mental space" that we harbour such images – ones culled from YouTube and/or Google searches. This is important to emphasise because the responsibility for facilitating the public's consumption of atrocity – from Hitler's Germany to the decades of war in Afghanistan – was not, in this case, the fault of the artists themselves, many of whom offer up compelling work both aesthetically *and* politically (evidenced by works of Christian Phillip Müller, Maria Martins, Wael Shawky and Hassan Khan). Rather it was the capricious *framing* of

artwork around these four stations that afforded dOCUMENTA (13) its relentlessly spectacular culture, one that threw the overall consideration of aesthetics – and its historical imbrication with politics – under the bus. Witness, again, the curatorial directive that dOCUMENTA (13) was "not organized around any attempt to read historical conditions through art, or the ways in which art's languages and materials might represent these historical conditions".[58] In the end, the subject of art was repressed – if not aggressively *dismissed* – by dOCUMENTA (13).

A final case in point. In the aforementioned Brain sits an object described in the catalogue as "a small landscape painting by Mohammad Yusuf Asefi, who in the late 1990s and early 2000s pretended to restore figurative paintings by covering the figures of animals and humans in the National Gallery of Kabul with watercolour and was able to save about eighty paintings from destruction".[59] The original artwork – buried beneath a watercolour's pleasing veneer – remains an unnamed *object* eclipsed by the very stain that purports to present it. This watercolour in the Brain is thus an ironic, but apt, metaphor for the problematic of Carolyn Christov-Bakargiev's *own* "brain child" – dOCUMENTA (13).

Notes

1 Michael Lewis, *Flash Boys* (New York: W.W. Norton & Co., 2014), 101.

2 Jacques Alain-Miller, "Context and Concepts," in *Reading Seminar Xi*, ed. Richard Feldstein, Bruce Fink, and Maire Jaanus (New York: SUNY Press, 1995), 14.

3 Michel De Certeau, *The Practice of Everyday Life* (Berkeley: University of California Press, 1984), xix.

4 Frank DiGiacomo, "Live, from Tribeca!," *Vanity Fair*, http://www.vanityfair.com/style/2005/11/odeon200511.

5 Ibid.

6 Ibid.

7 Peter C.T. Elsworth, "The Art Boom: Is It over or Is This Just a Correction?," *New York Times*, 16 December 1990.

8 Jean-François Lyotard, *Libidinal Economy*, trans. Iain Hamilton Grant (London: The Athlone Press, 1993), xxv.

9 Ibid., xxvii.

10 Ibid., xxix.

11 Or perhaps *Libidinal Economy* was a melancholic reaction-formation against Lyotard's prior Marxist position, melancholic due to the failure of the 1968 general strike. For the tone of the book is deeply ambivalent about the materialist dialectical approach the Left had previously held with regards to capitalism. As Peter King notes in his 1993 review of *Libidinal Economy's* English translation: "A further important theme of the book is Lyotard's portrayal of capitalism as allowing for the liberation of anew libidinal intensities (hence the pleasure of the industrial accident). *Libidinal Economy* appears to be almost a celebration of capitalism in its untrammelled form as an engine of positive and masochistic desire…Capitalism allows things to happen – for desire to be fulfilled. Lyotard appears to suggest that any happening is justified by its occurrence and this is reason enough. Hence the anti-critical, anti-theoretical style of the book which attempts itself to create a happening with the reader. However, it is this uncriticality that is the main problem with the book. Lyotard just does not discriminate, either

practically or morally. After the immediacy of desire (or perhaps even before) one needs to eat; after a happening one may be bemused as well as thrilled. Indeed, a book that seeks not to discriminate between the pleasure of sexual intercourse and the 'pleasure' of deafness through industrial injury me be flawed." See: Peter King, "Postmodernist Porn," *Philosophy Now*, no. 8 (1993/4), http://philosophynow. org/issues/8/Postmodernist_Porn.

12 "New York Times Report: October 19, 1987 – Black Monday, 20 Years Later," http://graphics8. nytimes.com/packages/pdf/nyregion/city_room/20071019_CITYROOM.pdf.

13 Ibid.

14 Lewis, *Flash Boys*, 53.

15 The "market" consists of 13 public markets – 13 stock exchanges spread out over four sites run by the New York Stock Exchange, Nasdaq, BATS and Direct Edge. In addition, there are upwards of 20 "dark pools," where investors buy and sell securities without being listed to the public as in the traditional exchanges.

16 Lewis, *Flash Boys*, 69.

17 Max Ehrenfreund, "A Veteran Programmer Explains How the Stock Market Became 'Rigged'," http://www.washingtonpost.com/blogs/wonkblog/ wp/2014/04/04/a-veteran-programmer-explains-how-the-stock-market-became- rigged//?print=1.

18 Rozalia Jovanovic, "Artnet News' Top 10 Most Expensive West Coast Artists," artnet, https:// news.artnet.com/market/artnet-news-top-10-most-expensive-living-west-coast-artists-54746.

19 Ehrenfreund, "A Veteran Programmer Explains How the Stock Market Became 'Rigged'". 4.

20 "New York Times Report: October 19, 1987 – Black Monday, 20 Years Later".

21 De Certeau, *The Practice of Everyday Life*, 37.

22 While my claim that Ressler's *In the Red* exposes Wall Street's "strip tease," this operation is a continuum throughout all this film work, particularly *The Bull Laid Bear*, (with Zanny Begg) 2012, on the subprime mortgage crash and more recently *The Visible and the Invisible*, 2014, which exposes the virtual nature of global commodity trading cantered in Switzerland.

23 R.A., "What Is Quantitative Easing?," http://www.economist.com/blogs/economist- explains/2015/03/economist-explains-5.

24 Georg Lukacs, "Realism in the Balance," in *Aesthetics and Politics: The Key Texts of the Classic Debate within German Marxism* (New York: Verso, 1995), 32.

25 Jorge Luis Borges, "The Library of Babel," in *Collected Fictions* (New York Penguin Books, 1998), 115.

26 See Theodor Adorno, "Reconciliation under Duress," in *Aesthetics and Politics*.

27 "Late Capitalism" is Ernest Mandel's term and the title of his book. It refers to an epoch of capitalism that emerged in the 1950s post-war period, one in which multinational corpora- tions, globalised markets and labour, mass consumption and liquid multinational flows of capital are dominant.

28 Fredric Jameson, *Postmodernism, or, the Cultural Logic of Late Capitalism* (Durham, NC: Duke University Press, 1991), 57.

29 Ibid., 88.

30 Althusser states: "…it is not their real conditions of existence, their real world, that 'men' 'rep- resent to themselves' in ideology, but above all it is their relation to those conditions of existence which is represented to them there. It is this relation which is at the centre of every ideological, i.e. imaginary representation of the real world." Louis Althusser, *Lenin and Philosophy and Other Essays* (New York: Monthly Review Press, 1971), 164.

31 Jean-François Lyotard, *The Postmodern Condition: A Report on Knowledge* (Minneapolis: University of Minnesota Press, 1984), 72. Written in 1979, it is notable that the book was trans- lated into English in 1984, when Lyotard was curating *Les Immatériaux*.

32 Ibid.

33 Ibid., 79.

34 Ibid., 78.

35 John Rajchman, "The Postmodern Museum," *Art in America* (1985): 111.

36 Ibid., 112.

37 Ibid.

38 Anthony Hudek, "From over – to Sub-Exposure: The Anamnesis of Les Immatéiaux," *Tate Papers*, no. 12 (2009): 1.

39 Jean-François Lyotard, *Vogue*, June-July 1985, 476; Rajchman, "The Postmodern Museum".

40 As Antony Hudek relays: "[A] particularly scathing critique, by Michel Cournot and published in *Le Monde*, took the exhibition to task for assaulting the visitor with incomprehensible stimuli, from the magazine handed out before entering – impossible to read in the darkened exhibition space – to the unidentified voices streaming through h the headsets," the latter of which were constantly breaking.

41 Judith Butler, *Giving an Account of Oneself* (New York: Fordham, 2005), 88.

42 Michael Brenson et al., *Daniel Joseph Martinez: A Life of Disobedience* (Berlin: Hatje Cantz, 2009), 186.

43 Ibid., 178.

44 Ibid.

45 MOCA's "Helter Skelter" of 1992 and the Hammer's "Sunshine/Noir" of 1999 are distinguished exhibitions on this account. Dated as these examples may seem by 2015 standards, in a post 9/11 climate the mass cultural understanding of Los Angeles as a potential "disaster" has expanded to include threats of dirty bombs, terrorist attacks on LAX, or even various flu and Ebola pandemics. Given that Los Angeles is fodder for doomsday narratives by the film industry, the continuation of these themes in both mass culture and so called "fine" art seems more naturalised today than ever.

46 Andrew Hultkrans, "Surf and Turf," *Artforum International* 36, no. 10 (1998).

47 Brenson et al., *Daniel Joseph Martinez: A Life of Disobedience*, 178.

48 Jean-Paul Sartre, "Existentialism and Humanism," in *Art in Theory: 1900–1990*, ed. Charles Harrison (New York: Blackwell Press, 1995), 589.

49 Theodor Adorno, *Prisms* (London: Neville Spearman, 1967), 32.

50 "Reconciliation under Duress," 162.

51 Carolyn Christov-Bakargiev, Press Release, 15.

52 Carolyn Christov-Bakargiev, *Documenta (13): Das Begleitbuch/the Guidebook* (Berlin: Hatje Cantz, 2012), 24.

53 See: http://www.youtube.com/watch?v=MiFf7eFhfMs&feature=related

54 "Reperformed" was the curator's term. From the press release, p. 7: "The condition of being on stage, of *reperformativity* and virtuosity, concerns the question of the display of art, the relations with an audience, and therefore the status of dOCUMENTA (13) as an exhibition but also the modalities and apparatuses, whether digital or not, through which people stage themselves, continually reperforming subjectivity in inter-subjectivity.

55 Carolyn Christov-Bakargiev, Press Release, 11.

56 Walter Benjamin, "The Author as Producer," in *Reflections* (New York: Harcourt Brace Jovanovich, 1978), 230.

57 Theodor Adorno, "Commitment," in *Aesthetics and Politics* (New York: Verso, 1995), 52.

58 Carolyn Christov-Bakargiev, Press Release, 4.

59 Christov-Bakargiev, *Documenta (13): Das Begleitbuch/the Guidebook*, 25.

The Task of the Curator

Adam Geczy

In the appreciation of a work of art or an art form, consideration of the receiver never proves fruitful. Not only is any reference to a particular public or its representatives misleading, but even the concept of an 'ideal' receiver is detrimental in the theoretical consideration of art, since all it posits is the existence and nature of man as such. Art, in the same way, posits man's physical and spiritual existence, but in none of its works is it concerned with its attentiveness. No poem is intended for the reader, no picture for the beholder, no symphony for the audience.

Walter Benjamin, "The Task of the Translator"[1]

WHEN WE TAKE POSSESSION of some property that is not ours, particularly symbolic capital, we are faced with ethical choices if we wish to deploy it in some way. When it comes to art, these issues are not confined to copyright, they extend to the very places and contexts in which the work of art is viewed, and even more acute for the artist, the very decisions that are made as to what will be viewed. Curators have a great deal of power, and curators of large well-serviced and funded institutions, have more power still in cultivating taste and in the fashioning of culture. Together with the rise of international biennials and art fairs, the entry of the so-called global curator in the last thirty or so years has amplified a large cultural dilemma. Namely that institutions, compliant to sponsors and benefactors, must go out of their way not to offend the hands that feed them. Art, as numerous commentators since the 1990s have lamented, has become a vast entertainment industry in which audience visitation numbers eclipse critical reflection, where audiences are

coddled rather than challenged.² Curators have evolved into ringmasters whose task is create a pageant that will attract the public. In the beginning of his essay from 1921, "The Task of the Translator", Walter Benjamin makes the ostensibly unfathomable claim that "no picture is for the beholder, no symphony for the audience".³ But this is true: good and lasting artworks are created with only themselves in mind. Curators are in many senses translators: they mediate between the abstract and historical materials of art and the public. But as Benjamin avers, a translator who tries too hard for the audience will result in a bad or indifferent translation. The task of translation, then, is to match the radical incommensurability of the work of art. Yet contemporary curatorship makes a virtue of the opposite. Will undue responsiveness to the audience ultimately result in poor "curations"? What then is the task of the contemporary curator, especially in managing the often, divergent expectations of artist, audience, institution and sponsor? Before some answers to these questions can be ventured at all, it is first necessary to trace briefly the origins of curatorship in order to chart its evolution, and to gauge its present incarnation (and predicament).

Origins of Curatorship

"Curator" derives from the Latin, *curare*, to "care" or "take care". From *curare* we also get cure. And in what will also emerge as a darkly ironic twist to our argument, 'curator' is also used in Scotland for someone who is the guardian of a child. Conventionally curators exist anywhere there are collections of objects or documents that require order and preservation. Collections require keepers and minders who, it is hoped, understand their scope and have created an order to safeguard them and to ensure ease of access. In antiquity, this task would have fallen to servants, who were tasked with ensuring that collections of weaponry, or items like sculptural carvings, and related religious artefacts, were kept safe and in serviceable condition. Aside from weaponry, the earliest big collections were books, which before the invention of movable type, were scarce and valuable. The most celebrated library of the ancient world was the Royal Library of Alexandria which is identified as have been established during the reign of Ptolemy (285–246 BC). It was known as the "Shrine of the Muses" or "Museum" and constituted the greatest concentration of learning of antiquity.

The early example of the Ptolemaic Museum also serves to illustrate the extent to which such collections were not a mere matter of the dumb massing of items (in this case books), but also served the function of policing, vetting and therefore a form of surveillance of knowledge. As Daniel Heller-Roazen explains, the men of learning housed in the museum were devoted to scholarship that

> took the form of a massive project aimed at the conservation and, more
> radically, the "emendation" and "rectification" of the works of the classical
> Greek authors: it is here that the many forms of textual criticism still
> employed by the modern library and historical scholarship, from the

purification of diction to the practice of marginal annotation and the division and ordering of metrical sequences, are invented and refined.[4]

These scholars were the first curators, not only caring for the contents, but putting them to some logical use in the expansion and purification of knowledge. What is instructive are the words "invented" and "refined". Translated in modern terms, the curator of art refines a collection through ensuring correct provenance, providing justified chronological attribution (whence the catalogue raisonné), and by supporting the acquisition of works that would help to enlarge the depth of the collection and to widen the contexts of the holdings. In the process of this refinement, the curator is inevitably confronted with decisions, since an overly proliferating set of relationships would have the negative effect of diluting meaning. Whether faced with impoverishment of resources or of plenty, the kinds of structures that the curator puts in place are perforce inventions (hence translations), for they almost always involve gaps, be it in the work of individual artists or an artist's historical milieu. When it comes to providing larger orderings, such as projecting a particular movement, interest of sensibility, the curator's responsibilities are greater still, as what is put next to what, what is included and omitted, can have a sizeable effect on how works are read. There will inevitably be value decisions based on particular theories of art. A curator of yesteryear under the influence of the formalist art history of Heinrich Wölfflin for instance may demonstrate the purported decadence of the Baroque style, and so on.[5] As in any osmotic relationship, curators who have had a powerful mentor will reflect that style, its preservation or by a radical break.

The first collections that emerged out of the late Renaissance were not so encumbered by morality or dogma. As the name suggests, the 'cabinet of curiosities' or *Wunderkammern* to appear in the early 17th century, consisted of a random variety of objects and images that reflected the fascination of the collector. It could range from the lurid such as a double-headed foetus to works of art that had been commissioned, acquired, plundered or traded. It is a phenomenon that is historically accountable due first to the age of trade, exploration and imperial conquest, and second to the burgeoning of science as typified by Copernicus, Kepler, Galileo and Descartes. They are representative of a much larger number of thinkers who helped to move away from the Aristotelian worldview to usher in modern rational thinking. While collections of natural history are unable to relinquish their many connections to science, it is a connection that in art museums is conveniently forgotten, since it introduces elements such as method and philosophy that would vitiate or certainly complicate the creative and intuitive dimension of a curator's work. Not only did the earliest collections reflect the need to account for the anomalies and the exceptions of the world, they also served as convenient magnets for social discourse: men of like mind and with 'curiosity' would gravitate to these collections expressly or on their travels.[6] These associations would grow to fraternities that would become the 'societies' of the 18th century that would eventuate into university faculties. What is to

be highlighted here is the role of what would later become known as critical discourse. The early museums, ad hoc as they were, were *sites for discussion*: meeting, exchange, learning and, indeed, friendship.

Instigated by colonisation and trade, the wealth that grew in the 17th century, created the early incarnations of today's notion of conspicuous consumption, to which art was central. Seen together, art and architecture were crucial for the assertion of a grandee's wealth. What was commissioned and collected followed choices, which were in the best interests of the patron, to reflect his or her taste and wealth. Pictures could be symbolic representations of the patron through history or mythology, or have some bearing on past events relating to family, or have bearing on the princely lands. In the words of Andrew McClellan in his history of the Louvre,

> Modeled on the late Renaissance *kunstkammer* [sic],[7] early 18th-century
> cabinets (the term often used to describe rooms set aside for the
> presentation of valued objects) signified princely rule through an abundant
> and harmonious arrangement of paintings. At Mannheim, for example, we
> find pictures densely and symmetrically arranged around a central vertical
> axis like pieces of a puzzle.[8]

This carried through in the first museum for the public, the Luxembourg palace, which displayed the royal collection. Opening in 1750, visiting hours were exceedingly limited to Wednesdays and Saturdays for three hours. One purpose of making the collection available was not so much broader social edification but for artistic instruction. Reflecting the most influential writer on art of the day, Roger de Piles, the arrangements of pictures of "the Luxembourg encouraged a comparative mode of viewing that revealed the strengths and weaknesses of chosen artists and the schools to which they belonged through calculated juxtaposition of paintings".[9] Thus from the very outset, those responsible for the choice and arrangement of art followed some kind of theoretical agenda, more recently we call it ideology, and it is the very crisis in contemporary socio-political ideology that accounts for the crisis plaguing contemporary curating. But before turning to this it is necessary to discuss the birth of the modern exhibition and curator.

Modern Exhibitions and Curating

Before the birth of the pseudo-celebrity global curator in the 1980s, curators were intermediaries between scholars and the public on one hand, and the benefactors, government and institutions on the other. They largely begin with two incarnations. The first was a cataloguer and decipherer, the other was the hanger of paintings. Both were invested with highly ethical imperatives, either explicitly or by default.

The Paris Salon began in 1674 as part of the official academy of art and sculpture, and by 1725 it was the most important site for exhibiting works of art. Artists vied for medals, purportedly awarded by distinguished peers, which would then result in

further state and private commissions, which would ensure an artist's livelihood. In the same manner as the private princely collections, and to cope with the volume of submissions, paintings were exhibited cheek by jowl, in an elaborate patchwork arrangement that would leave only the smallest glimpses of wall space. These arrangements would be determined by a small group of artists selected by the academy, with one leading them. These positions were immensely coveted and prone to corruption, since the positioning of a painting at eye height presumed superiority over those placed far higher, which reflected a level of quality of lesser interest. The 18th-century painter Jean-Baptiste-Siméon Chardin, the great painter of still life is a notable figure in this regard, since he practised a genre that was consider the most inferior in the academic hierarchy (history and religious painting was at the top), yet was held in such regard, both morally and aesthetically, as to occupy the most esteemed post. Indeed, the serenity and quality of his painting, which so enraptured the first great art critic, Denis Diderot, together with his personality, was considered genuine reflections of a post with such responsibility. In Émile Zola's novel L'Œuvre (1886, translated as The Masterpiece), which was a veiled fictional commentary on his estranged younger friend Paul Cézanne, the hapless protagonist Claude Lantier's submission to the Salon is placed at such a remote height as to make it almost invisible. To make matters worse, the entry had only been put into effect after a good deal of wrangling, and its weak positioning only exacerbates the obloquy it receives.

The first notable curators are as cataloguers and keepers are Alexandre Lenoir and Dominique-Vivant Denon. Following the opening of the Louvre in the summer of 1793, Lenoir was the chief facilitator of the Museum of French Monuments two years after. This was very much a product of the Revolution, in which the emphasis on public access and public knowledge was at a premium (at least in theory). As opposed to sculptures from antiquity, the monuments museum was confined strictly to works relating to French history, including those salvaged from buildings ruined or demolished. What is notable is the tendentious nature of Lenoir's arrangement of objects, designed to promote the reign of Louis XIV as, in McClellan's words "one of four high points of civilisation alongside Periclean Athens, Augustan Rome, and Renaissance Italy".[10] In effect, Lenoir was instrumental in revising the belief instilled by the Revolution that Louis' reign marked the decline of culture that had been restored only by the sober and social-minded classicism of Jacques-Louis David. His is one of the first signal cases that demonstrate curatorial power. For unlike a critic or thinker who espouses beliefs in words, the curator was able to make a case through the assembly of objects. It is a kind of theory by stealth, since the concreteness of things has the power to convey the a priori completeness of the idea, despite the idea being a posteriori and perhaps incomplete and possibly mendacious.

It was one of Napoleon's many insights to see this. More than any other ruler since Augustus Octavian, Napoleon used art in all its manifestations to the benefit of his own power and image. Once the Musée Française, then Musée Central des Arts, the

national museum was renamed in 1803 as the Musée Napoleon, intended by the Emperor as a 'universal museum', a shrine of world culture so to speak. At its helm was Denon, who had accompanied Napoleon in the militarily botched but culturally highly successful Egyptian campaign of 1799. Denon published two volumes of drawings from this experience, which played some part in the Egyptian Revival ('Egyptomania') that subsequently occurred in architecture, design and fashion. As a devotee of the Emperor, Denon zealously looted sundry treasures that were the spoils of Napoleon's successful campaigns. In this period artists of the early Renaissance were not as esteemed as they are today. However, as a man of diverse and astute tastes, Denon showed an interest in the "primitives" of Italy (generally understood as painters before Raphael) which he acquired in a plundering spree in 1812, and which form the basis of the Louvre's collection of Italian masters that remains to this day. A highly significant precedent for such enthusiasm occurred only six weeks into Denon's appointment wherein he installed a series of works of Raphael in the Grande Galerie, to show the greatness of the artist. Also by including two works of the artist's teacher, Perugino, Denon's effort was conceivably, as Karsten Schubert states, "the first time that pedagogic aims and art historical methodology had played such a central role in the display of works of art".[11] And in one fell swoop it also shifted the "museum's agenda from the political-ideological to the historical-documentary".[12] Moral instruction had always been at the forefront of French cultural institutions, which accounted for the way paintings were hierarchised – according to their capacity to educate and edify. While this continued to be a standard of judgment at this time, it is noteworthy that it also extended to the ways in which works of art were shown, which reflected a growing interest in historical purpose.

While this discussion has much wider parameters, including the genesis of the British Museum at roughly the same period with its controversy over the Elgin marbles, these examples are sufficient evidence that from the very start curatorship lay rooted in responsibility with respect to the objects 'themselves' and to the power with which certain messages could be made to the audience – how symbolic objects are, to use our opening conceit, translated into overarching signification – which in turn had the potential to effect the way in which they understood the very organisation of their own culture and those relating to them (and in the case of remote and so-called primitive cultures, relation through non-relation).

The Modern Museum

By the 20th century the museum was an essential dimension of the expression of nation, culture, history and belonging. Even if from a country whose devotion to democracy was tenuous or non-existent, the museum was nonetheless born from democracy, emanating from individual rights and national ownership. Since Denon, the curator was the keeper of national treasures who would make them available to the public, and place them in some order so that the lay public could see them in the

most favourable light. Curators were therefore a new hybrid of scholars, cataloguers and inventors (more recent developments have caused them to be called on par with installation artists). Yet it is important to recall that even as late as the 1920s, art history was only beginning to form into an established discipline, existing somewhere between archivists, anthropologists, historians and connoisseurs. Indeed, curatorship was central to the development of the discipline as we know it today, and many of the foremost scholars, act as curators within specialist collections. For the specialist curator scholar, the "raw" collection is the equivalent of a laboratory. His or her role is to assign provenance, advise on further purchases and to confirm knowledge or offer insights through both written research and in the way that the art objects are distributed for display. For the purposes of our discussion, two figures remain salient in the development of curatorship and for highlighting its ethical purpose with respect to its responsibilities to society and state: Kenneth Clark who was the director of the National Gallery, London during World War II, and Alfred Barr who founded the Museum of Modern Art (MoMA) in New York.

The first of its kind for the Tate, in 2014 it staged a major exhibition devoted to Kenneth Clark's career as a critic and writer, patron and museum director. His incomprehension of some modern art notwithstanding, Clark's books on the Nude in Western art and *Civilization* continue to have traction and influence. What is of concern here however was his sizeable contribution to British culture while holding the influential seat of director of the National Gallery, a post he held in the same time span as Hitler's hold on power (1933–1945). In earlier years, he was a staunch defender of British modernists such as Henry Moore at a time when public taste for modern art was not much in vogue. At the outbreak of war, he also advocated that artists not be conscripted, for the sake of maintaining British art and culture. But Clark's role in such safeguarding was significant and material. During the Blitz, he managed to have the museum's collection stored for safe-keeping, but not at the expense of a dispiriting vacuum: Clark would choose one notable painting which was housed in the museum while it remained open. There were also regular musical concerts and other performances. Although modest, Clark's initiatives reflected a deep understanding of the stabilising and rejuvenating power of cultural artefacts and gestures, and the role of art in community – an abstract notion that is erratic and to some extent eroded by governmental rationalisation in numerous developed countries since the 1980s.

Alfred Barr was just as aware of the intangible necessities of art, and also witnessed its negative manipulation as a political tool by the Nazis while on leave from the MoMA in Stuttgart during the year of their take-over of power in 1933. The story of Barr and the genesis of MoMA has been told in detail[13] but several points need to be highlighted to emphasise the ethical role of the curator as acquirer, preserver and translator. Prior to assuming the position as the museum's inaugural director, Barr began as an art historian and ran what was perhaps the first university course in modern art, "Tradition and Revolt in Modern Painting", while a junior professor at Wellesley College in 1926. When he became the museum's direct three years later, the

culture of museums in the US still followed a European model, its focus on antiquities and the 'classic' paintings from the Renaissance to neoclassicism. Collections of modern art were confined to private enthusiasts. As a city New York was hardly alone in its ambivalence to a public collection of modern art as there were many who had no understanding of it or were openly antagonistic to it. Notwithstanding, Barr as director quickly amassed what is now one of the greatest collections of postimpressionist, cubist and other avant-garde art of the early 20th century. One of his many achievements was the Picasso retrospective in 1939–40, which at the time was another audacious move given that war in Europe was underway and that the artist was then still relatively young.

Barr's personal duty of offering the public the best and most up-to-date art was all-encompassing and visionary. He anticipated the collections of the contemporary museum and its acceptance of media not formerly considered art, including film and photography. Barr famously stated that the museum would be "a laboratory; in its experiments, [where] the public is invited to participate".[14] This was not intended in the more contemporary, insipidly literal sense of the term 'interactive' in which touch overtakes thought (more of this later), rather "participation" was intended as critical and educational (the more fashionable term today to integrate digital media is "interactive"). Thus, Barr also inaugurated the concept of public programs, which is today part of the basic make-up of any major museum. In effect, he maintained the idea of the museum as a site for discussion, investigation research and reflection, as was incipient in the *Wunderkammer*, and institutionally formalised it, giving it sophistication, breadth and intellectual mobility. He encouraged lectures and other forms of activities intended to provide an open discourse for art, which also had the salutary effect of enabling contemporary artists to reflect on their own practices. Barr was also very advanced in taking photography and film seriously as media, establishing departments for these in the museum in the early 1930s.[15] In the words of Sybil Kantor, "innovation was of primary importance in Barr's lexicon, overshadowing any other reason for art's coming to being",[16] effectively foreshadowing the later bias of conceptual art's emphasis on process and experimentation, or later the contentious debate of whether art is a form of research. His notion of the laboratory opened up the museum, as concept and physical entity, to be more than a mausoleum of precious objects for veneration. Rather the premium that Barr placed on innovation, discovery and discourse helped to ensure that the work of art maintained its relationship to process and reflection, making the site of the museum a fertile testing ground for ideas. Barr's vision of the new modern museum was to provide the place and the critical context for the positive critical exchanges between works of art, curators and audience.[17]

In their detailed study of the contemporary museum in the digital age, Beryl Graham and Sarah Cook explain that

> Art galleries, musical venues, and theatres have all used the word *laboratory* to indicate an alternative approach that can deal with process rather than

object, with participant rather than audience, or with production rather than exhibition. Even in high modernist times, Alfred Barr was describing MoMA as a laboratory. Since then, curators, including Hans Ulrich Obrist (2000), have also been using the term to stress the importance of research and to imply that the gallery can be a place of experimental methods of display, perhaps with a more active audience, whereas others have used the term *factory* to emphasise production beyond traditional art and authorship.[18]

Words and phrases like "process", "participation", "research" and "active audience" are all worth drawing attention to here, and comprise some of the linchpins on what the contemporary museum is based and what the curator is expected to instigate. Unfortunately, however, as we will see, the ethic of inclusion, with its undertones of community and togetherness, has begun to eclipse intellectual accountability, where audience/participants are 'users' and curators are increasingly "providers", much as a film house will expect its producers to have certain films made to comply with seasonal tastes (Christmas holiday blockbuster, the summer teen flick, etc.).

In an interview, Hans Ulrich Obrist commented that William Sandberg, former curator of the Stedelijk Museum in Amsterdam, that "For him ideas and information counted more than the experience of the object".[19] For the last two decades at least, it would seem that the "experience" has triumphed. To pause to think about the term is quickly to arrive at how broad and redundant it is, since one experiences the weather as much as an apple or a work of art. Sadly the experiential of the critically reflective brings art into a realm of banal equivalences. It also appears that the artist infiltrating the gallery to make it his or her studio has become its own convention whose semantics of social subversion are acted out as pantomime. If an audience is to be challenged, it is in a game-oriented way, if ideologically, it must be in the realm of "already know", that is, I know that we should do something about world hunger, I know we should do something about the plight of first nation peoples in this or that country, etc. But to call attention to the mendacity and impotence at the heart of the complicity of art and entertainment is to shake the entire contemporary curatorial edifice.

Global Curating and (Displaced) Ethics

So far, I have established the notion that, the traditional curator identified himself with the institution to which he was both ambassador and guardian. The birth of global curator originates partly in the freelance curator who was associated with the experimental practices that emerged since the 1960s. Working more frequently with artistic frameworks that were unconventional and ephemeral, there was a necessity for artists to act also as organisers, impresarios and intermediaries. Moreover, the rise in the art market meant that both dealers and consumers required more detailed knowledge of what they were purchasing. This was especially acute in the period after the war when historical works required detailed proof of their provenance, as

certification that they were not acquired in immoral circumstances. This is in no way to imply that the market was free from foul play, for it is by far the opposite, rather that a diverse and increasingly complex art market required educated, savvy intermediaries to make sense of what was before them, and to at least present a semblance of order and continuity.

Thus, the freelance curator was from a twin birth out of the commercial and non-commercial spheres. While it is a phenomenon that begins to appear in the 1980s, as with globalisation, its visibility comes with the changes of social, political and financial economies as a result of the digital age. Described in the most graphic and perhaps most lurid terms, the global curator is like a circus ring man but with a virtual troupe. He or she will either begin as a member of an institution or from art school, organising and facilitating exhibition opportunities for him or herself and for peers. Success comes out of the ability to make choices of exhibition themes and their attendant artists that incite curiosity and, at best, debate. In the absence of conventional exhibition opportunity, which is the norm for the emerging artist (now a stock term), the artist-cum-curator will seek out a shop front for a gallery space for the shorter or longer term (known as 'artist run initiatives' or ARIs for short or more recently the pop-up gallery), or create opportunities by drumming up interest from foundations, corporations or government. In short, the contemporary curator in this mould is not only a creator of opportunity but is also a purveyor of ideas, ones that might make the artists contained therein more accessible, more easily consumable, or at best more intellectually solid. What is most desirable to the curator, popularity and pervasiveness on one hand or criticality and profundity on the other, is the fundamental question that from an ethical standpoint haunts curatorship to this day.

Globalisation in art is not easy to define, but can easily begin with mirroring globalisation itself: the mobility and exchange of information, global markets, mass marketing and digitally mediated exchanges, from capital to imagery. This is by now all fairly stock stuff. But there is an important ethical integer that comes into it, namely what is being said and in whose name. The age of "post-democracy" is defined by the infiltration (or vitiation) of corporate interests in the democratic process in the most diverse, subtle and deep ways as to make them homologous.[20] To put this another way, a contemporary understanding of government without consideration of the diversity of corporate interests is naïve and inconceivable. This also means that every major museum that is accountable to its benefactors and sponsors, whether state or private, is liable to be answerable to corporate interests. It is censorship of the most covert kind, but is a condition that in the last twenty years comes into dramatic relief with the rise of large-scale exhibitions. Let us leave aside the art fairs, which are transparent about their commercial trajectory and focus on international Biennales.

Although La Biennale di Venezia or the Venice Biennale first opened its doors in 1895, the biennale phenomenon only takes root with the Bienal de São Paulo in 1951, Documenta in Kassel in 1955, the Whitney Biennial and the Biennale of Sydney both

in 1973. In the 1970s, the Biennale could still claim to be a snapshot of what art at the time was like. It was also a good way of bringing a diffuse and broad range of art under one roof. With the changes that occurred in Eastern Europe, Russia and China after 1989, the Biennale model appeared to be a measure by which countries could reclaim a sense of their own violability and traction within a cultural atmosphere that was becoming increasingly global, and globally competitive, in its approach and outlook. By the mid-90s the biennial had gone viral, from the Shanghai Biennale in 1996, to the Liverpool Biennale in 1999, and more recently still, the Singapore Biennale in 2006. Biennales also exist in Istanbul (1987), Berlin (1998), Gwangju (1995) and Vladivostok (1998). Clearly the biennale had become more and more mandatory for the stamp of cultural capital that, in a way, consummated an art museum. Art museums themselves were big architectural business: the hypermuseum, introduced by Frank Lloyd Wright's New York Guggenheim in 1959, only came into full effect at the same time when the Biennale industry, if it can be called that, flourished globally by the 1990s. Virtuoso architectural performances from the Guggenheim Bilbao by Frank Gehry (1997) to Daniel Libeskind's Jewish History Museum in Berlin (1999), continued in the tradition of Wright's critics who feared that the architecture overshadowed the art within. Indeed, Libeskind was open to paying customers for the first two years of its life with nothing in it. People were happy just to see the building. Many still hold to the belief that the now filled structure is a betrayal of its best potential.

The comingled birth of the great opera houses for art and the biennale industry serve to suggest that the whole is perhaps bigger than the parts, that what is at a premium is the residual idea of magnitude over any lasting, or indeed measurable, cultural effect. A trawl though the websites of the many biennales will reveal one striking common denominator, namely that they calculate their success according to visitation numbers. Here the spectacle is in full force, drained of adjective or anecdote and reduced to plain numbers. This is where sustainability in the traditional sense might be written into the debate, to the extent that cities are expected to cope with the influx of larger and larger numbers of people. The influx of visitors was a windfall for the formerly obscure city of Bilbao, so much so that the attraction of the architecture gave birth to the term "Bilbao effect". But the amount of biennales and the numbers expected to visit them begs the question whether there can be so much decent art, and what is the experience of these pageants after all? One answer is that of "net effect": one had a 'cultural experience' from which we extract one or two works that we "liked" (where "liking", thanks to social media and YouTube also becomes a vapidly universalist gesture). This like – together with the "likes" some of us are expected to make in a world where everything is expected to be rated – forms the basis of some anecdotal conversation, that is, if you still converse, given that it is much easier to 'chat' through truncated, written text. But the culture of 'liking' can only lead to the admission that the exponential profusion of liking and disliking is only to conceal the more sinister truth that reasoned opinion is rare. But the obsession

with visitation numbers reveals imperturbably that reasoned opinion is not what is valued or is even desirable.

Since Julian Stallabrass' coinage of the phrase "High Art Lite" 1999, a topic of critical debate has been the way art is in the service of entertainment and, with it, the demise of critical debate. Public museums and art festivals like biennales are made possible by the support of public funds, donors and corporate sponsors. While public institutions are subject to questions of propriety, donors and sponsors are steeped in vested interests. Few are the sponsors who will give money to the kinds of commentary that actively undermine the interests and procedures which the wealth came from in the first place. However, sponsors, individual and corporate *are* eager to subsidise work that looks and smells edgy, lest they disclose the dubious contradictoriness of the entire dynamic. To be too cloying is to give the game away. This meretricious and disingenuous double-play is described by Slavoj Žižek as follows:

> If you accuse a big corporation of particular financial crimes, you expose yourself to risks that can go even as far as murder attempts; if you ask the same corporation to finance a research project on the link between global capitalism and the emergence of hybrid postcolonial identities, you stand to get a good chance of getting hundreds of thousands of dollars.[21]

The bleakness of this state of affairs lies in the manner in which the corporate sponsor stands as gatekeeper to ensure that the commentary is "not much". But what is so dangerous is that critical commentary is allowed to exist, but always in a diluted form. This is the quandary of the so-called post-democratic age that contemporary art finds itself in is more sinister than the culture of totalitarianism. For the socialist realism of totalitarian art is so unerringly predictable and monotonous that it all but spells out that it is the false patina, the scrim behind which lurks a more vibrant, more courageous and more authentic vision of things. Public contemporary art, the art funded by government grants and sponsors, is given a pre-ordained limit: it is decaffeinated and pasteurised (an apt metaphor as we may note that it is impossible under lawful circumstances to get in countries with strict quarantine rules the delicious unpasteurised cheeses available in Europe). Can we imagine a biennale staging a work such as Chris Burden's *Shoot* (1974, in which he had a friend shoot at him) or Carolee Schneeman's *Interior Scroll* (where she slowly unravelled a long paper text from her vagina while reading from it 1975)?

The laboratory ethic, in which viewers were encouraged to become active participants, that was so revolutionary in Barr's age has now devolved into *passive* participation. While this might at first seem an oxymoron, it places activity at a premium and criticality as a remote second. Invented and retooled words such as "relationality" and interactivity are important ways in which the curator shows that he or she is deploying the work for public involvement, however the cerebral aspect of participation, which had been important to Barr is now no longer desirable.

Related to audience inclusivity, is a way in which curators have to negotiate gender and race. It is today an unspoken mandate, if not a routine reflex, that large exhibitions have a creditable cross-section of races and creeds, and balance of gender that would not court too much criticism. And to curators themselves: a signal example of the global phenomenon of curating is the figure of the Nigerian born Okwui Enwezor. Now something of a cultural celebrity – in 2011 *ArtReview* named him on the top 100 list of the most powerful people in the artworld – Enwezor's height of fame arrived when he curated Documenta 11 (1998–2002) – which was intended to represent an alternate perspective to contemporary art. Before I turn to the quality of the exhibition, which was high, what it amply showed was the extent to which the culture of correctness of global curating has made such a perspective impossible, simply for the fact that every such exhibition is billed as providing a new vision of something. There remains the most delicate of questions: does Enwezor's professional and cultural valency rest largely on the fact that he was born in Nigeria? To what extent are we presented with the bad faith lurking inside the conflicted heart of political correctness? We might ask yet more cryptic questions: what does the curator set out to present and express when the status quo is organised to act as if 'it' is already being presented and expressed with due good faith and authenticity? And if the culture of contemporary art is about reflecting cultural pluralism in whose name and for whom does the curator speak? Whom does he in fact serve?

These are questions with more than one answer, for they reflect the instability and the protean nature of global pluralism itself. What Enwezor's Documenta opened up, arguably for the first time, was a level of cultural diversity on the level of representation but also of approach. While the question had already begun to loom large as to how a multiplicity of critical standards – the standards that had challenged and all but replaced Euro-American modernism – could productively be deployed curatorially to make something coherent, as opposed to a curatorial equivalent of chocolate all-sorts. Or to put this in terms established at the beginning of this essay, what does the curator choose to translate and into what language and who judges the quality according to what terms? One of Enwezor's strategies was to start out as a group, nominating six other curators to assist in shaping the exhibition.[22] As Enwezor's explains,

> I wanted to emphatically make it clear in the context of *Dokumenta 11* that there was no single author but a group of collaborators very much in tune with each other's strengths and weaknesses. This was by far one of the most transformative, energising, and challenging group of people to work with. What is the degree of the contribution by the group? We wanted to address the context within which we were working and to enter into a dialogue that we could make visible to a broader public what was going on globally in contemporary art. And I deliberately chose people who were not curators by profession.[23]

By choosing people 'who were not curators by profession', Enwezor not only sought a dynamic diversity of voice but was in effect re-injecting the exhibition with a level

of intellectual engagement that is commonly vitiated through many contemporary curatorial processes that, indeed, mirror political machinations, namely professional friendships with artists and the interests of sponsors and donors.

In addition to Enwezor's "deterritorialising" initiative, I will pose two other ethical responses to curatorship that attempt to displace the corporatist trap. The word "displace" has been used advisedly, as it suggests a grasp of capitalist systems that is not naïve. That is, it is a position that admits that there is no "revolutionary" escape from the capitalist system only slippages and gaps that arrest its most damaging development. The two ethical strategies are first, direct and empathetic engagement with the artist and his or her process, and second, the attempt to use art – objects, interventions, events, performances – with the ambition not only to reflect knowledge but to create new knowledge. The former position acknowledges the position of the artist within the overarching formula of the curator, the latter places *ideas* back into the epicentre of the *experience*. In both cases, we move close to what the academy calls 'research'. For although, since the 1980s, there have been repeated critical comments about the similarity of the curator to an installation artist, a corollary that has its merits, a curator is a researcher where the artist is not.

The Two-Step Program Out of Curatorial Delinquency [24]

Enwezor's curatorial strategy was an exceptional, yet far from isolated, move to allow for a more direct and engaged form of curatorial practice in which the artist is not treated as a pawn, brand, or covert cultural indicator. In other words, it is common for curators to cater to denominations of race in the manner of a pie chart. To put this another way, there is an unspoken mandate that the "artistic director" of a biennale or equivalent incorporate artists from the Middle East by dint of what is going on there, or gays and lesbians because of the international ferment over same sex marriage. Large exhibitions therefore begin to take on the look of a Baskin Robins ice cream parlour with all manner of cultural "flavours", which, as I have suggested already, creates a politically correct smokescreen that actually allows for atrocious political events to go on as is.[25]

This means that artists are plucked out for 'use' as artistic-cultural products, based on a set of unspoken reasons and expectations. An adverse effect of this is that, where applicable, the artist is effectively expected to 'perform' race, or if a brand/name artist (Serra, Barney, Koons, Sherman), "perform" what he or she is best known for. While I am in no way decrying the need for overstepping cultural boundaries and norms, it must be done ethically, together at the behest of the artist, that is, in immersive, frank discursive exchange between curator and artist. This takes time to be executed properly and, without wanting to lapse into Habermasian sentimentality about communication, it is a level of attention that is essential in order to generate something that is specific to the aims of both artist and curator.

The second, step, tied to the first, is the need not to repeat knowledge, but to open up new techniques – on the part of both curator and artist – of concept, expression and the platforms from which art can be *critically* received. Here was call on the distinction that Jacques Lacan stipulates between "ethics" and "morality" in his *Ethics of Psychoanalysis*. Making out a different turn from Aristotelian ethics, Lacan articulates the need for 'subversion' and 'surprise' in the subject to provide for new positions that do not participate in the socially regulated habitus, which for him is the symbolic order.[26] The philosophical corollary to Lacan's position is Nietzsche's immoralist or his "hammer" that ruptures the sclerotic framework of a morality driven by power and fear. Lacanian ethics suggests a reach to areas that would, in the first instance, be measured as immoral, but whose results, while explosive, would ramify to something more creditable. In short it is the role of ethics to crack open moral law.

But as I began with Benjamin, so I will conclude with him. In his essay "Surrealism: The Last Snapshot of the European Intelligentsia", he remarks that the Surrealists were "the first to liquidate the sclerotic liberal-moral-humanistic ideal of freedom".[27] This "ideal: is what Lacan calls "morality", that is, ethics that have lost their rudder and used for purposes that are unethical, yet do not appear as such because governed by craven consensus. "Characteristic of this whole left-wing bourgeois position" writes Benjamin, "is its irremediable coupling of idealistic morality with political practice".[28] This extends precisely to what was asserted earlier with respect to the soft politics of curating. The curator, as ethical translator therefore, knows of the sacrifice that need to be made in a "good" translation and can satisfy the inevitable misgivings with a result that is not a shadow, but a new creation that, as a sum of parts, a posteriori justifies the kinds of ethical violence it needs to perform.

Notes

1 Walter Benjamin, "The Task of the Translator," in *Walter Benjamin: Selected Writings Volume 1, 1913-1926*, ed. Marcus Bullock and Michael Jennings (Cambridge, MA: Belknap Press of Harvard University Press, 2002), 253.

2 See my Introduction and Chapter One in: Adam Geczy and Jacqueline Millner, *Fashionable Art* (London: Bloomsbury, 2015). See also the Introduction in: Adam Geczy and Vicki Karaminas, *Critical Fashion Practice: From Westwood to Van Beirendonck* (London: Bloomsbury, 2017).

3 Benjamin, "The Task of the Translator," 253.

4 Daniel Heller-Roazan, "Tradition's Destruction: On the Library of Alexandria," *October* 100 (2002): 136-37.

5 Heinrich Wölfflin (1864-1945) was a Swiss art historian who was one of the key founders of formalist analysis and classification of art, including binaries such as linear versus painterly. Influenced by Hegel, he was also highly influential in classifying the strength and quality of styles belonging to a particular epoch. It is thanks Wölfflin, for example, that the notion that the Baroque style is decadent has been so tenacious.

6 See: Adam Geczy, "Display," in *Art: Histories, Theories and Exceptions* (London: Berg, 2008).

7 German nouns are capitalised.

8 Andrew McClellan, *Inventing the Louvre: Art, Politics, and the Origins of the Modern Museum in Eighteenth-Century Paris* (Berkeley: California University Press, 1999), 2.

9 Ibid., 3.

10 Ibid., 189.

11 Karsten Schubert, *The Curator's Egg: The Evolution of the Museum Concept from the French Revolution to the Present Day* (London: Ridgehouse, 2009), 21.

12 Ibid., 21-22.

13 See: Sybil Gordon Kantor, *Alfred H. Barr, Jnr. And the Intellectual Origins of the Museum of Modern Art* (Cambridge, MA: MIT Press, 2002); Alice Goldfarb Marquis, *Alfred H. Barr, Jnr.: Missionary for the Modern* (Chicago: Contemporary Books, 1989). See also: Alfred H. Barr Jr., *Defining Modern Art: The Selected Writings of Alfred H. Barr, Jr.* (New York: Abrams, 1986).

14 Cit. Schubert, *The Curator's Egg: The Evolution of the Museum Concept from the French Revolution to the Present Day*, 45.

15 Sybil Gordon Kantor, "The Multimedia Museum," in *Alfred H. Barr, Jnr. And the Intellectual Origins of the Museum of Modern Art* (Cambridge, MA: MIT Press, 2002), 222-25.

16 Ibid., 330.

17 For a good account of the notion of the laboratory in the contemporary context, see: Paul O'Neill and Mick Wilson, eds., *Curating and the Educational Turn* (London and Amsterdam: Open Editions/de Appel, 2010).

18 Beryl Graham and Sarah Cook, *Rethinking Curating: Art after New Media* (Cambridge, MA: MIT Press, 2010), 235. The reference in the text is to Eva Diaz, "Futures: Experiment and the Tests of Tomorrow," in *Curating Subjects* (London and Amsterdam: Open Editions/de Appel, 2007), 92-99.

19 Hans Ulrich Obrist, "Interview with Harald Szeemann," in *A Brief History of Curating* (Zürich: JRP/Ringier Verlag, 2008), 84.

20 For a lucid account of this see: Colin Crouch, *Post-Democracy* (New York: Polity, 2004).

21 Slavoj Žižek, *The Puppet and the Dwarf: The Perverse Core of Christianity* (Cambridge, MA: MIT Press, 2003), 44.

22 Carlos Basualdo, Ute Meta Bauer, Susanne Ghez, Sarat Maharaj, Mark Nash and Octavio Zaya.

23 Okwui Enwezor interviewed by: Paul O'Neill, "Curating Beyond the Canon," in *Curating Subjects*, ed. Peter O'Neill (London and Amsterdam: Open Editions/de Appel, 2011), 117.

24 This is a loaded reference to the panel delivered at the 2014 CAA (12 February) by Brad Buckley and John Conomos, "The Delinquent Curator: Has the Curator Failed Contemporary Art?"

25 This predicament has been thoroughly dealt with in: Adam Geczy, "'Look at Me I'm Different!': Identity Art and the Expectations of Race," in *Fashionable Art*, ed. Adam Geczy and Jacqueline Millner (London: Bloomsbury, 2015).

26 Jacques Lacan, *The Ethics of Psychoanalysis, 1959-1960: The Seminar of Jacques Lacan*, trans. Dennis Porter, vol. Book VII (London: W.W. Norton, 1997), 5, 7.

27 Walter Benjamin, "Surrealism: The Last Snapshot of the European Intelligentsia," in *One-Way Street* (London: Verso, 1997), 236.

28 Ibid., 234.

Because We Can: Curatorial Intervention at the Intersections of Intention and Reception

Brett M. Levine

I After Authorship

B ECAUSE WE CAN. AT first glance, it may be difficult to comprehend how such a seemingly innocuous statement is imbued with great significance, but in this instance these three words are an exception. They are an exception, in part, because of the context in which they first occurred. They were uttered by an arts administrator in Australia just prior to the opening of an exhibition. A decision had been made by the project's curator – although the exhibition was not curated in the traditional sense, but instead consisted of works that had been submitted for selection by an external juror – to install a portion of the works using a traditional linear-style museum hang, and the remainder salon-style, edge-to-edge, and floor to ceiling. Given the problematics of such an approach, at least in the absence of any contextualising materials, a simple question was asked: "How can you do this?" The response: "We do it this way because we can".[1]

In that instant, those three words were transformed by autonomy, agency, and power, yet not contextualised with any corollary transparency. Instantaneously, a shift occurred, one that marked the transition from artist-driven intentionality to curatorially mediated interventionality. Arguably, these two poles represent the only two available modalities for exhibition-making today. At one end of the spectrum is the residual frame of reception theory, where the problematics of intentionality and reception still reside. Situated firmly within the parameters of theorists including Hans

Robert Jauss, Wolfgang Iser, and Roman Ingarden, reception theory – when overlaid on the visual arts – creates not simply one, but a multiplicity of challenges.[2] At the other pole lies something else entirely: whatever it is, what it is not is simply the unmediated space between intention and reception, although it requires a detour through reception theory to illustrate why.

In its most reductionist form, reception theory, according to Jauss, places the artist-audience exchange in an unanticipated position. It situates both the art object, and synonymously the object exchange, outside a space of shared experience. Instead, reception theory constructs an encounter that highlights and reinforces that it is instead a *lack* that two participants share. The artist, having completed the work, releases it to the experiential sphere, and withdraws; the audience, whether singular or plural, (generally) never encounters the artist. Instead, they encounter and experience the work – at which point they bring the totality of their interpretative resources and prior experiences to bear. To state the problem even more simply, the audience never knows what the artist intends; and the artist never knows what the audience receives. Instead, what occurs is always already mediation. As Jauss explains,

> it is only through the process of its mediation that the work enters into the changing horizon-of-experience of a continuity in which the perpetual inversion occurs from simple reception to critical understanding, from *passive to active reception,* from *recognized aesthetic norms to a new production that surpasses them.* [italics added.][3]

Or, perhaps more intriguingly, and more problematically, is the idea that in fact the same individual can occupy two positions – that of writer and reader, or that of artist and viewer – just obviously not at the same time. This duality is problematic, and it seems overlooked in much thinking and writing about Jauss, but briefly, he suggests that

> [t]he creative artist can adopt the role of observer or reader toward his own work. The fact that he cannot produce and absorb, write and read at one and the same time, will make him experience the shift of attitude from poiesis to aesthesis. In the reception of a text by the contemporary reader and later generations, the gap between it and poiesis appears in the circumstance that the author cannot tie the reception to the intention with which he produced his work: in its progressive aesthesis and interpretation, the finished work unfolds a plenitude of meaning which far transcends the horizon of its creation.[4]

There are two operations that occur – one, an oscillation between constructor and interpreter, and the other a shift from passive to active. Yet for these mediations to occur, each must presuppose the absence of a third party: the curator. Jauss' construction of reception theory – and the construction of reception theory in general – relies not on the invisibility of the curator, but on the fact that they are simply not there. Any other interpretation creates an impossibility because it inserts a third party

within the exchange. For reception theory to function, it operates within a duality, and the dialectic is that of intentionality and reception. And if there were a third variable to the equation – or a third contributor to the exchange – what might that possibly mean?

Finally, one must also pause, briefly, to recognise – if not fully situate – the "thingly" qualities of the art object. Followed to its obvious conclusion, one might interpret that an outcome of Jauss' active reception and progressive interpretation would be the Heideggerian allegorical, which would then turn back onto itself as an interpretative frame. As Heidegger remarks,

> Presumably it becomes superfluous to inquire into this [thingly] feature, since the art work is something else over and above the thingly element. This something else in the work constitutes its artistic nature. The artwork is, to be sure, a thing that is made, but it says something other than the mere thing itself is, *allo agoreuei*. . .[5]

This situates the totality of the art experience in a frame of intention, reception, indeterminate allegorical interpretation. Yet one could deviate, and offer a theoretical alternative situated within the guise of construction. Perhaps an alternative approach that could solve this riddle would be curatorial authorship. The construct of curators as creators has generated such interest within contemporary practice that an entire journal – *The Exhibitionist* – was grounded in, and based upon, critical interrogations of these phenomena. In its inaugural issue, editor Jens Hoffmann remarked,

> In recognition of the set of operations and frameworks for the production and circulation of meaning that Foucault was keen to foreground, we concur that the curatorial process is indeed a selection process, an act of choosing from a number of possibilities, an imposition of order within a field of multiple (and multiplying) artistic concerns. A curator's role is precisely to limit, exclude, and create meaning using existing signs, codes, and materials.[6]

The Exhibitionist defined its theoretical genealogy by situating *Cahiers du Cinéma*, and thereby auteur theory, as its intellectual forebear. Yet such a hyper-focused emphasis on curatorial author*ship* had the potential to direct potential enquiries away from a more problematic occurrence: the opaque exercise of curatorial *authority*. For where curatorial authorship centres around the structure of an exhibition, curatorial authority is instead primarily concerned with the source of its power. Whereas one constructs its narrative, the other defines its economy. The former defines the "what"; the latter the "how".

Even more problematically, the very construction of curatorial authorship could have been over before it began. Harald Szeemann's groundbreaking exhibition documenta 5 (where, arguably, curatorial authorship first emerged,) illustrates clearly that artists were already deeply distressed by assertions of curatorial autonomy. Hence the petition, and the observation by Charles Green and Anthony Gardner that

> [e]ven if the form of many of the works in documenta 5 was open-ended, artists like Haacke et al. – the signatories of the artist's petition against

curatorial hegemony – wished to return the artist's intentions to the center of intention, and definitely align and stabilize a viewer's experiences in relation to these intentions.[7]

Szeemann grasped that the idea of authorship could anchor curators to ever-expanding fields of autonomy and responsibility. But perhaps he overlooked Clement Greenberg's great remark: "The essence of Modernism lies, as I see it, in the use of characteristic methods of a discipline to criticize the discipline itself, not in order to subvert it but in order to entrench it more firmly in its area of competence."[8] One must ask what the true area of competence of curating is – and in what practice, if not itself, it might become more fully entrenched.

II Toward Intervention

Clearly, reception theory is dialecticism by another name. It constructs an oppositional binary without a synthesis, meaning that it constructs an exchange in which the parties never meet at the synthetic object. And curatorial authorship is simply autonomy by a third party. Instead of 'intentionality', 'reception', or 'authorship', the true theoretical emphasis should be curatorial intervention. How can a framework be constructed that adequately addresses transparency, while at the same time foregrounding issues of curatorial agency and power? How is it that the individual and institutional frames allow for the insertion of this third party into the dialectic, and how are the implications of this to be understood?

Before moving forward, it is important to note that the curator is not to the artist as the editor is to the author, as some might commonly argue. At the point at which the writer-reader exchange occurs – the book – the work of the editor has always already been done. The reader/receiver may then experience the work however they choose; they may read it in bright sunlight, or in a dimly lit room; they may skim it quickly, or they may pore over every word; they may use a bookmark, or they may keep their place by folding a corner; the experience of the object is theirs. But an experience of an artwork is not the same, in most instances. Apart from some encounters with outdoor sculpture, or some other experiential works, in many instances curators control not only the content of the exhibition, but also its context; they may control the lighting, the colour of the walls, the arrangement of the images, the inclusion or exclusion of pedestals, three-dimensional pieces, curtains, benches, or other enticements or obstructions, labels, flyers, publications, and more. So, the encounter with the curator extends beyond the audience's preparations to experience the object. Unlike the reader's understanding of the editor contra the book, the viewer's engagement with the curator must seem endless.

III Intervention as Both Agency and Power

Because of these theoretical and practical extensions, in many instances artists feel continually disempowered by the practices and processes of curatorial intervention. Recent qualitative research with artists, curators, and administrators in Australia, New Zealand, and the United States highlights two facts: one, that individuals across these three cohorts recognise the implications of curatorial intervention (even though it has not previously been constructed in this manner); and two, that curatorial intervention is distinguishable from constructions of curatorial authorship.

What does it mean to intervene? The Oxford English Dictionary (OED) defines this verb as to "[t]ake part in something so as to prevent or alter a result or course of events".[9] The notion that disparate power relationships are a core construct of intervention is evident in the definition. The example the OED uses states, "he acted outside his authority when he intervened in the dispute". And it is within this notion of disparate power relationships that the first suggestions of curatorial intervention can be found. Arguably, once outside the sphere of artists working solely within major, top-tier commercial galleries, many artists regard themselves as subject to the vagaries of curatorial power. An established creative practitioner from New Zealand remarked recently,

> the curators have the ultimate decision, because it's their gallery [. . .] The curators are in control of the artists, and if you want to show, you do what they say, that's it.[10]

This perception, or experience, simply represents one of many modalities for curatorial intervention. From the outset, research suggests that curatorial intervention takes many forms: curators may encourage artists to produce or reproduce certain works or types of works; curators may alter, amend, or change either the content or contexts of artists' projects; or curators may simply recontextualise artists' works with or without their consent or knowledge. And the frequency with which these three interventions occur would appear to be staggering.

Consider, initially, instances in which curators encourage artists to either produce or reproduce certain types or styles of work. Over the course of recent research, artists recounted instances in which curators' perceptions of an artist's practice were at odds with their current intentions. A mid-career New Zealand artist who had been invited to participate in an exhibition with a specific curatorial theme for which the curator wanted a suite of pre-existing work recounted,

> there wasn't any opportunity to reconfigure the work or re-present it, so it all of a sudden got a little bit uninteresting. And [they were] also wanting to overemphasize that little bit in that one artwork as more of a global theme of mine. So [they] wanted to exaggerate how much I used the influence of spell-making or whatever in my work, even in the ritualistic way of making the work; you know, sort of trying to make me out as some sort of shaman or warlock or

something like that. And I sort of said, 'No, no, you're going over the top with this.' So, it sort of got to a point where I said, 'Oh no, I can't come up with any new ideas around this theme,' so I didn't take part in that show.[11]

And yet, at times, artists find themselves in cultural or economic conditions which may in fact compel them to consider or act upon these requests in ways that may be contrary to their intentions. Consider, instead, the remarks of another New Zealand artist, who observed,

> someone that approaches you to be in a show, and they talk about the ideas of what the show's about. *And you say, 'This is the work I'm working on the moment, and this is how this could fit in.' And then they look at it and they go, 'Actually – aren't you making any of those figures anymore? Are you making those?' and you kind of go, 'No one was interested in them, so I moved on,' and then they kind of go, 'Well, it would be great if you could do one of those.'* You sort of go and revisit something and go and make something kind of a . . . something that may be slightly annoying or something.

> [. .] I'm sort of open to – because you're often so broke that you kind of go with the offer to – you know, to get make some money to make something is hard to resist, because it's a commission . . . (italics added).[12]

So where might the implications of this intervention reside? How might these actions be made transparent, and where are the responsibilities for the exercise of agency and power to be situated? Is it simply a matter of making these exchanges transparent? How might the viewer consider or reconsider their experience of the work if they knew that the artist had been requested to reproduce a particular subject – or that they were simply motivated by need, or by economics?

Neither reception theory nor constructions of curatorial authorship can account for any of these actions. Neither has a modality by and through which the intentionality of the artist is mediated through the agency or power of the curator. Nor does either deal formally with issues of transparency – to the extent that in the former, reception theory, there is no curator, and in the latter, curatorial authorship, there is nothing but the curator. Arguably, then, in reception theory there is no need for transparency, for one may not show what is not there, and in curatorial authorship there is no need for transparency because there is no need to restate the obvious.

Obviously, however, exhibition theory and exhibition practice do not reside at the extremes of either of these two poles. Pure reception theory cannot account for curators, yet curators do practice; and every exhibition is not an exercise of curatorial authorship, with unchecked curatorial agency driving every individual or institutional decision. As a result, there is still a need for a theoretical framework within which one might situate curatorial practice. There is still a need to situate the agency and power of curating, and to make the exercise of its practice transparent. Again, it appears that this site is that of curatorial intervention.

IV Intervention Contra Intention

At times, the exercise of curatorial intervention can serve to circumvent or silence both intentionality and reception. Consider, for example, instances in which curatorial agency mutes dialogues regarding the content or experience of works of art. Such a case was outlined by an administrator from a major museum in the United States, who recounted an instance in which community members had become concerned by the content of a video on display. As they explained,

> a trustee [and their spouse] came in one Sunday afternoon, watched the entire [video] and spent a lot of time with it. And I talked to [the curator], and I said, you know, 'I think we need to – this is a great moment to talk about, to have people in and have this conversation about intention, non-intention, what the piece is about.' And [the curator], instead, just took it down. And I said, '[. . .] that wasn't – ' and they said, 'I'm just going to take it down.' They said, 'It was going to come down in another week anyway.' And I said, 'Well, I don't think that solves the problem, though.' I said, 'We're not talking about it.' And they said, 'You know [. . .] the reason I don't want to is that it's just not a great piece, and we're going to take it down in a week anyway [.]¹³

It is difficult to determine the most problematic aspect of this event – the curator's removal of the work from the exhibition, or their evaluation of the video as "just not a great piece". One must wonder if the explanatory materials that accompanied the work either during the duration of its display, or upon its removal, included the statement, "Video X, by artist Y, which the museum regards as 'not a great piece,' considers…". Of course not. The audience's experiences of the work were not mediated in this way. Yet the justification for its removal was its objective aesthetic value. The curator, in exercising their agency, and power, acted opaquely to determine the significance of the object.

Yet, strangely, the possibility of value judgments appears open within the processes of reception, although in practice the operation of these processes seems less certain. If the curator based their determination on the work's value, rather than the artist's intentions, they may have fallen victim to a conundrum first raised by Hans-Georg Gadamer in *Truth and Method*:

> [i]f it is true that a work of art is not, in itself, completable, what is the criterion for appropriate reception and understanding? A creative process randomly and arbitrarily broken off cannot imply anything obligatory. From this it follows that it must be left to the recipient to make something of the work. One way of understanding a work, then, is no less legitimate than another. There is no criterion of appropriate reaction. Not only does the artist himself possess none – the aesthetics of genius would agree here; every encounter with the work has the rank and rights of a new production. This seems to me an *untenable hermeneutic nihilism.* [italics added.]¹⁴

An untenable hermeneutic nihilism. Obviously, this cannot be the intended outcome of experiencing a work of art. Nor, however, can it be an endless construction of open-ended, subjective, individuated interpretations that seem more or less legitimate. In the video example, instead, one finds both the pure nihilism of agency plus power – the removal of the artwork is absolute, since it is no longer on view – and the opacity of its motivations – it was removed because it is "just not a great piece". Hence, one experiences the two constructs of curatorial intervention.

One may also encounter instances in which curatorial intervention is 'speculative', to the extent that its agency relies upon its understandings of and interpretations regarding an artist's existing or asserted intentions. An argument could be made that the circumstances surrounding Christoph Büchel's exhibition Training Ground for Democracy at MASS MoCA is an example of this type of intervention to the extent that, under the direction of the Museum's then director, a decision was made to proceed with a project from which the artist was not actively engaged.[15] The artist had in fact issued a series of statements, or demands, in a letter to the director of the museum. In his words,

> There is NO negotiation about the scope of the project.
>
> There are no elements to be eliminated as you propose and I don't accept any orders and any more pressure or compromises how things have to be done, neither from you or your crew.
>
> I will not give you any permission to show an unfinished project nor will I show nor let you show any work in progress, as you proposed already earlier.
>
> I will not accept without consequences any additional sabotage acts, as done to artworks of mine and as well done to the installation in progress[.][16]

There is NO negotiation about the scope of the project. There are no elements to be eliminated. These imperatives, as they are, situate the parameters within which it appears that both curatorial and administrative intervention should be able to operate. If one were to apply these same principles to other interactions between artists and curators, one would emerge with a set of guidelines by and through which it was the artist, not the curator, who had determinative power regarding the installation of their artworks. Yet what has emerged over the course of recent research is that neither this perception, nor this actuality, is the case. Audiences engage with artworks with the perception, often incorrectly, that the space of experience is both neutral, and unmediated, when in fact it is both powered and mediated.

One must pause, for a moment, to situate the idea of these types of imperatives against alternative curatorial propositions such as those offered by a contemporary curator who remarked,

I started curating [. . .] working with collections. There, my approach was informed by 'the death of the author'. *I operated with the view that, so long as you didn't hang a work upside down, you could present it in perverse company and make it operate in ways that were outside the scope of the artist's intention.* Back then, I thought the role of the curator was to take such liberties. Later, when I had to source works more through artists and dealers, things became harder, more constrained, less creative. (italics added.)[17]

How should one address this disparity? How does one situate the dichotomy of the specific intentions of the artist contra the interventions of the curator? According to this curator, as long as the material conditions of the work were not altered, it was acceptable to recontextualise an object to make it operate outside its original intentions.

IV Against Opacity

One must wonder what the implications of a more transparent curatorial practice might be? How would audiences benefit from an understanding of the dynamics of the artist/curator exchange? When managed sensitively, curatorial intervention can facilitate artists' abilities to focus or extend the intentions and significances of their overall project outcomes. This may include ensuring that artworks or exhibitions are not unintentionally redirected or misinterpreted due to marginal or peripheral content. Consider, as an example, a curatorial intervention in which a gallery director worked with a video artist to mitigate potential issues within a larger project:

[An artist] did this beautiful project where he would be online, I guess trying to find a same-sex sexual partner. And he managed to establish a relationship [. . .], and that became a part of his work, a really intimate video piece about their liaisons. And in that was the distance of being away from this person and documenting their life in their apartment: from urinating, to showering, to having a bath, to making a cup of tea, to sexual encounters and masturbations and things like that. And most of it was really good, because [the artist] understood that the exhibition would have young people, and we provided the appropriate signs. It wasn't the public that we were concerned about; it was more the conservative element within the council that had sort of shifted over a period of my directorship. And [the curator and I] did – I did ask [the artist] if the money shot on the masturbating piece could be perhaps darkened a little bit – and [the artist] said, 'No worries; I know what to do.' So, he was wonderful; he just made it a bit darker. And sure, we did, in a sense, ask [him] to censor his work, but it kind of would've put all the work in building up the exhibition on [his] work, and it really was 15 other excellent works. And he was wonderful in that process, because he was not just thinking about his own work, but also the others. And no one [. . .] everyone walked past it.[18]

Clearly, in this instance, the specifics of the curatorial intervention under discussion could not be made more evident because it would defeat the purposes of the intervention itself. At the same time, the processes and practices by and through which such decisions were analysed, and made, are of significant value. Understanding how directors, or curators, perceive the problematics of interpretation provides an interventionist framework. What knowledge, or experience, did the director rely upon to perceive the disparities between the intentionality of the larger project and the problematics of the money shot? And how did they share these concerns with the artist in a way that was non-confrontational, positive, and designed to further enhance both the work itself and the larger curatorial project? It is within these frames that curatorial intervention exists. The nature of curatorial intervention is such that it may operate positively, negatively, or neutrally, and both its agency and its impacts may be significant, or insignificant. In this example, the agency was insignificant, but its impact significant, and its outcome was positive.

In another instance, the agency was significant, the impact was significant, the outcome was negative, and the curatorial intervention remained opaque. In this situation, an artist was advised by a curator – after a body of works had been selected, and after a contract had been signed – that they would not be allowed to exhibit the work that had been chosen. They were provided with two alternatives: select and exhibit different pieces, or cancel the exhibition:

> RESEARCHER: Was there a possibility, in terms of your thinking about the exhibition, that there was a portion of it that they might have acceptable? Were you willing to explore the idea of an image-by-image evaluation, or did you just take the approach that your works would be seen as a body of work, and you, as the artist, had made the selection, in consultation with the curator, and it was that or nothing?
>
> ARTIST: Well, I wasn't really given that choice. I'd like to say I was given that choice, and had I been given that choice, I might very well have rejected it on the basis that this particular series is very much intended to hang together as a series; it's not – individual images are not the point. And so, had I been given that choice, I might well have objected to it and refused and simply said, 'That's not how this is meant to be seen.' On the other hand, I wasn't given that choice. I was simply told, 'This show cannot go up. You either change the show or you don't have a show.' And there was never any discussion about, 'Well, let's just modify which pieces are in the series, which pieces we put on the wall.' I was never offered that possibility. I was told the series was entirely unacceptable and it needed to be changed.[19]

When asked if the alteration to the exhibition plan had ever been made public in any way, the artist advised that it had not.

V Intervention as Normative Practice

Curatorial practice stands at the precipice of its own relevance, situated between the complexities of its assertions of authorship and the contemporary assaults on its validity and value. Recognising and acknowledging the existence and implications of curatorial intervention may go some way toward rectifying these issues to the extent that a new model of practice would situate curators within a dialogue of transparency. Clearly, the mediating practices of curatorship reveal that the traditional model of reception theory is fundamentally flawed, having created a dialectic of exchange between artist and audience from which curators are always already absent. That contemporary curators should revel in this absence is nonetheless problematic.

Situating curatorial practice within the confines of authorship does little to resolve the problem. Simply asserting that curators are constructors of meaning outside the artist/audience exchange does little to create frameworks of transparency or accountability for the exercise of agency and power. By compelling curators to be transactionally visible curatorial practice itself will emerge as an element of a tri-nodal, rather than simply dialectical, exchange. In this alternative model, curatorial practice would neither be opaque, hidden outside the experiential exchange of the art object occurring at the intersectional absence between artist and audience. Instead, the relationships between artist and audience, artist and curator, and curator and audience would each come fully into view. When a viewer moved from room to room, there would be more to contextualise the differentiations between a suite of works hung in a traditional, linear, museum-style hang in one and a cacophony of pieces, floor-to-ceiling, and edge-to-edge in another.

If there is a motivation for situating this exchange in a more complex manner – within a frame that is tentatively termed intervention theory – it is because both reception theory and curatorial authorship both fail to situate the curator anywhere. If there is another reason for doing so it may be stated quite simply: because we can.

Notes

1 Conversation with arts administrator, July 1994. For the purposes of what follows, all interviews were conducted in confidentiality, and the names of interviewees are withheld by agreement.

2 The fundamental texts that structure this investigation and analysis are: Hans Robert Jauss, *Aesthetic Experience and Literary Hermeneutics* (Minneapolis: The University of Minnesota Press, 1982); Hans Robert Jauss, *Toward an Aesthetics of Reception* (Minneapolis: The University of Minnesota Press, 1982); Wolfgang Iser, *The Implied Reader: Patterns of Communication in Prose Fiction from Bunyan to Beckett* (Baltimore: Johns Hopkins University Press, 1978); Roman Ingarden, *Ontology of the Work of Art: The Musical Work, the Picture, the Architectural Work, the Film* (Athens, OH: Ohio University Press, 1989).

3 Jauss, *Aesthetic Experience and Literary Hermeneutics*, 19.

4 Ibid., 35.

5 Martin Heidegger, "The Origin of the Work of Art," in *Poetry, Language, Thought* (New York: Harper and Row, 1971), 19.

6 Jens Hoffmann, "Overture," *The Exhibitionist* 1 (2010): 3-4.

7 Charles Green and Anthony Gardner, *Biennials, Triennials, and Documenta* (Chichester: John Wiley and Sons, 2016), 34.

8 Clement Greenberg, "Modernist Painting," in *The New Art: A Critical Anthology*, ed. Gregory Battcock (New York: E.P Dutton, 1973), 67.

9 "Intervention," Oxford Dictionaries, https://en.oxforddictionaries.com/definition/intervention.

10 Interview with artist, 28 February 2016.

11 Interview with artist, 3 November 2015.

12 Interview with artist, 27 August 2015.

13 Interview with arts administrator, 20 May 2016.

14 Hans-Georg Gadamer, *Truth and Method* (London: Bloomsbury Academic, 2014), 82.

15 Christoph Büchel's exhibition *Training Ground for Democracy* was the subject of two US Federal Court cases and numerous articles. A range of primary and secondary material is available. Of particular interest are: "Massachusetts Museum of Contemporary Art Inc. v. Büchel," FindLaw, http://caselaw.findlaw.com/us-1st-circuit/1500091.html; K.E. Gover, "Christoph Büchel V Mass Moca: A Tilted Arc for the Twenty-First Century," *The Journal of Aesthetic Education* 46, no. 1 (2012): 46-58.

16 "Massachusetts Museum of Contemporary Art Inc. V. Büchel".

17 Interview with curator, 12 August 2015.

18 Interview with arts administrator/curator, 3 September 2015.

19 Interview with artist, 1 March 2016.

Part III: Ethics

Bodies for Sale

Amelia Jones

New Prologue to "The Contemporary Artist as Commodity Fetish"

R ETHINKING THIS QUESTION OF the "artist as commodity fetish", I was not surprised to come across today (in January 2017) a typical new year's article in the art press (in this case the online magazine *artnet news*), the headline of which asserts: "These 11 Artists Will Transform the Art World in 2017".[1] While briefly acknowledging the shambolic state of the Western world (and beyond), the author, Christian Viveros-Fauné, also notes the continuing "bullish days for the art market... [and] expensive art's growth as an alternative currency", claiming that artists and art only in 2017 will begin to "encounter politics and cultural commentary head on" (we have now lost historical consciousness altogether: so much for the historic avant-gardes, the Situationists, the feminist art movement, the Black arts movement, and so on...). This article – with its cheery neoliberal celebration of art as product, subsuming radical social practice and activist works (such as those of Jimmie Durham and Tania Bruguera) into a happy art marketplace – points to the continued and even ratcheted-up commodification of the artworld since I wrote "The Contemporary Artist as Commodity Fetish", over a decade ago (in 2004–5).[2]

I wrote the original article just as I was finishing my book *Self/Image: Technology, Representation, and the Contemporary Subject*, and the value and significance of artistic self-imaging strategies was on my mind.[3] Key to the analysis in my essay is thus a definition of self-imaging as "a performance of the self for the purposes of creating an *image* to be circulated in the institutions of art (including the market)", eschewing the live event's emphasis on the actuality of the artist's body being enacted as the work.

Since that time, I co-edited (with Adrian Heathfield) a major book on the question of how live art is remembered, theorised, and marketed (*Perform Repeat Record: Live Art in History*, 2012) and wrote a scholarly article in *The Drama Review/ TDR* reflecting on a live art work that foregrounded the living body of the artist and spectacularised it as marketable "object" of choreographed emotional responses. Both of these projects shifted my thinking on the myriad ways in which the artworld commodifies the artist. The latter article focused on the recent work of Marina Abramović, in particular two shows, both in New York: her 2005 *Seven Easy Pieces* series of reenactments of classic performance works at the Guggenheim Museum and her 2010 *The Artist is Present*, an exhibition and live performance at the Museum of Modern Art (MoMA) in 2010.[4] This latter retrospective included documentation and relics from her earlier performances as well as a performance billed as new but actually copying *Nightsea Crossing*, a durational work she had performed numerous times in the early 1980s with her then-partner Ulay sitting across a table from her, with the two gazing for hours directly at each other. The new version involved her sitting across from visitors (who were lined up to take the seat across from her one by one – including Ulay himself) for the duration of the opening hours of the museum.

My article on the show critiqued the premise behind it, encapsulated in the very title (*The Artist is Present*), which asserted that Abramović was fully "present" and available to visitors. "Presence" itself, as any good poststructuralist would know, is a metaphysical conceit that has no traction in philosophical understandings of human existence in the world. It is a claim raised by institutions or individuals, in this case MoMA, the curator Klaus Biesenbach, and Abramović herself, most often when there is a desired cultural-cum-economic value the assigner of the term is striving to secure – a value that is, through the gesture of claiming of presence, implicitly aligned with more inchoate and even spiritual values through its metaphysical connotations. It is this gesture, precisely, that cleverly obscures the workings of capital, presenting an illusion of value that is inherent and transcendent rather than invested and economic, and hence (I argued) we should be wary of claims of presence rather than embracing them wholesale, as the art press and performance reviewers did in writing about the exhibition in 2010.

What is important to note in early 2017 as I write this new introduction to an article finalised in 2004 is this broad shift in this period (in my work but also arguably in the artworld at large) from a concern with the image itself as the means through which artists both create their work and circulate and/or deconstruct their identities as creative "origins" to an interest in the capacity of the *live* body to undermine or ratify these circuits of value. In its hyperbolic claims, Abramović's *The Artist is Present* exhibition and performance perfectly encapsulated the way in which a live performance – and a live artist's body – can themselves become easily spectacularised and commodified, paradoxically as signifiers of authenticity. Abramović was lauded across popular press and art media for her endurance and authenticity; even the emotional responses to the works were immediately capitalised on in websites such as "Marina

Abramović Made Me Cry", replete with dozens of photographs by Marco Anelli of tear-stained faces, captured as they faced the exhausted artist during the live performance.[5]

The paradox of the Abramović case was that she (and her promoters, including Biesenbach, MoMA, and her gallerist Sean Kelly) made use of the cultural value attached to live performance, often romanticised as more "authentic" than object-based art forms and as inherently anti-capitalist in its ephemerality. While at the same time selling the body of the artist as spectacle (fetishized, frozen in space and time), marketing the experience of the work as having emotional/cultural capital, as well as peddling the images of Abramović and her viewers through some of the same circuits I elaborate in the original 2004 article that follows this introduction.

The photographic is thus still very much at issue in more recent cases, but so is the larger structure of spectacle. The earlier self-imaging practices I foreground in the original article deploy performance or the performative through the means of photographic technologies, which function as vessels for dissemination (albeit, in the case of circulation on the internet, these "vessels" are virtual/digital rather than actual objects). The shift here is that, with the marketing of the body of the artist through live art spectacles such as Abramović's MoMA performance, the photographic is subordinated to performance. In this case, the live event, and the hyperbolic claims surrounding it, serve to mask the structures of commodification that are still at work. In both cases (self imaging and the kind of live art practice that Abramović's work epitomises), complex human emotions and experiences are debased and oversimplified to fit into the structures of the marketplace – one glance at the "Marina Made Me Cry" website, which spectacularises "live" emotion itself by congealing and circulating it through photographic means, makes this extremely clear.

Other counter examples of live art practices that eschew circulation or easy commodification are myriad, and these examples point to the fact that it is difficult to write about or curate such practices without effectively reducing their nuances, turning them into to "objects" to be circulated throughout the global art marketplace of ideas. This conundrum is pressing to anyone trying to historicise or curate performance art of any complexity. For example, I am currently working towards mounting some kind of retrospective of the work of radical queer s/m performance artist, Ron Athey. The work is so spectacular in its live forms, and yet so impossible fully to understand or represent curatorially (or for that matter art historically), that this has proven to be the most challenging projects of my career. I am bringing to bear all of my theoretical interest in the conundrum of live art as ephemeral yet commodifiable, as time-based and always-already unknowable – and so far, this has brought moments of paralysis, given the difficulties of conveying the explosive emotional and psychic impact of Athey's work. Putting detritus or remainders (costumes, flyers, and other documents) from Athey's work in vitrines, in combination with the display of video

footage and photographs made during the performances, per the common strategies of performance art retrospectives (both in evidence at the Abramović show) would destroy the power of Athey's ongoing practice, wherein complex tropes from the intertwined image and aural histories of religious ritual, sexual striving, wounding, and healing, and body-compromising illness (in particular AIDS) are enacted in generous yet cutting ways by himself and collaborators. Athey's work might be paradigmatic of a kind of art practice that resists commodification – both as object, and as subjectified by Athey himself (he struggles to make a living in non-art related ways).

If the artists featured in my original article below deployed technologies of representation to question the way in which, arguably in the 1970--1990s, we understood the subject through the "circulation of images, of capital, and of aesthetic or cultural value," with the apotheosis of this kind of work the practice of Vanessa Beecroft in the late 1990s and early 2000s, then we could say that in the 2000s we have come to understand being human in relation to the simulacral nature of all embodied experience, whether representational or "live." Even the notion of "subjectivity," so central to my 2004 article, is of little theoretical use today, hence my reference to human experience: we have, I think, moved beyond the then-useful but somewhat instrumentalised, psychoanalytically based, postmodern concept of subjectivity as it came to be mobilised in the late 20th century. Today our experience seems less capable of being structurally analysed, perhaps because we are turning into extensions of the machines we mobilise and we are no longer sure where we begin and end as humans.

The trick, then, is to try to understand fully what is happening to us – and how we are ideologically bound to the forces we may well wish to contest or resist. Understanding what is happening to us now, in an era when individualism and an attendant nationalism and xenophobia tied to racisms of all kind are on the rise across the western world, requires we comprehend what was happening in the past and strategies that helped mitigate the oppressions and stratifications of capitalism and late capitalism. Studying the strategies of artists – the most compelling of whom are always at the cutting edge of exploring the structures of power that coerce us but that we also inhabit and promote, often in spite of our better selves – could not be more important. Facing directly the ways in which people like me participate in the commodifying logic of academic work as well as of the artworld is important, but we must go further than attaining a state of self reflexivity. We must look to artists such as Ron Athey, whose work refuses curatorial logics through its mobilisation of the radical frisson of the live as potentially confusing and resisting the capacity to circulate and thereby *sell* bodies as art or as image. In the best cases, as with the work of performative artists today who refuse to succumb to the machines of late capital, we might find key ways of moving forward in a culture colonised by corporate capital.

The Contemporary Artist as Commodity Fetish[6]

In the very act of resisting commodification the work of art becomes subordinate to its values, only able to define itself through a process of cultural negation…. The ethical pathos of [contemporary] art derives from the tension between what it promises (an aesthetic community which transcends the relentless self-interest of the capitalist system) and the fact that its continued existence as a cultural form depends on precisely this system.

Grant Kester, 2004[7]

There is a long history in Euro-American art of artists documenting themselves in photographic (including cinematic, televisual, and digital) images that are circulated through artistic and commercial networks.[8] From Marcel Duchamp's 1924 *Monte Carlo Bond*, to Andy Warhol's reiterative self-portrait silkscreen images and performances for media cameras from 1960 onward, to the burgeoning artistic self-imaging projects since the 1960s by artists such as Cindy Sherman, Nikki Lee, and Yasumasa Morimura, artists have explored the role of photographic imaging technologies in rendering or conveying the self, and correlatively in circulating the artist as an image (a commodity that can be reproduced, looked at, purchased, and/or downloaded and "possessed").[9]

This particular trajectory of self-imaging indicates a shift that has accelerated in recent years away from either the veiling of the artist's body (as in high modernism) and from the live performance of the body common in some of the early 20th-century avant-gardes (in particular the various effusions of Dada) and resurfacing in 1960s and 1970s performance art. Self-imaging per the projects of Warhol or Sherman – a performance of the self for the purposes of creating an *image* to be circulated in the institutions of art (including the market) – thus eschews the "live" event's emphasis on *presence* as having a compelling, even violent critical effect on spectatorship and focuses instead on a rendering of the artist's body such that its cultural value and significance is exposed as being inevitably predicated on *absence*. This turn towards artifice and simulation (itself, of course, typical of what many have theorised as the postmodern condition, linked to the economic and social shifts of late or global capitalism) makes use of the capacity of photographic technologies of representation to turn the artist's body into a spectacle to be circulated through the commodity systems of the artworld and its corollary discourses, such as art criticism and art history.

What does it mean that artists now elaborately, wilfully, and increasingly frequently perform themselves within the joint commodity-media systems that comprise the art market, such that the value of their work – indeed its very character – is defined in and through their bodies, but their bodies signified as absent referents, made visible only through representation? Through deliberate self-fetishisation in projects revolving around pictures of their own bodies, artists from Yayoi Kusama to Nikki Lee

159

have performed themselves as images – images that are inherently commodified and yet are positioned so as to be seen, displayed, and consumed *as* art. There are thus two profound paradoxes linked to this kind of artistic production: 1) while these images are produced as art (that is how they have their value), they are simultaneously overtly circulated as commodities and mass cultural products; 2) enacting themselves first and foremost as *objects* of cultural desire, the artists' "subjectivity," if we can call it that – or their agency – rests in the "authority" that substantiates our interest in their production of themselves as spectacle.

It is the purpose of this essay to explore what this shift to wilful self-commodification through self-imaging – where the artist embraces and even exacerbates the processes and effects of late capitalist commodity culture, to produce her or himself as a photographic or imagistic fetish (one that also circulates as a sexual, commodity, and even ethnographic or racial fetish) – might be understood to signal in terms of broader conceptions about the meaning and significance of the self in global late capitalism. How, I will ask, have artists navigated and/or produced the subject via representation? How and why have they increasingly often, as in the practices noted above, shifted the terms through which art is interpreted, given value, institutionalised, and marketed – from an emphasis on style and form as the bases of cultural value paramount in modernism (at least in its dominant formalist variants) to structures of subjectivity and visibility as the foundation for an aesthetic value that has come to be conflated with commodity value?[10] Ultimately, these artists' works suggest that we now *understand ourselves* not through new "styles" of self-expression, codified through visual form, as dominant modernist and postmodernist theorists would so often have it, but through changed conceptions of the self *as* represented, as constituted in and through the visual – and thus as circulable in the rapid circuits of exchange of money and cultural value that constitute global capitalism.

While it is somewhat of a truism at this point to argue that US modernist theorists who rose to dominance in the post-World War Two period such as Clement Greenberg and Harold Rosenberg promoted an idea of modernist art as a more or less direct expression of individual feeling and/or of authentic "being", the extent to which many postmodern theorists replicate such ideologies of art as subjective expression and/or art as determined through individual style on the deepest level is rarely noted. Fredric Jameson, one of the most influential US-based postmodern theorists, for example, argues,

> …if the experience and the ideology of the unique self, an experience and ideology which informed the stylistic practice of classical modernism, is over and done with, then it is no longer clear what the artists and writers of the present period are supposed to be doing…in a world in which stylistic innovation is no longer possible, all that is left is to imitate dead styles, to speak through the masks and with the voices of the styles in the imaginary museum. But this means that contemporary or postmodernist art is going to be about art itself.[11]

Jameson, while arguing for a shift in the understanding of the self in postmodernism, retains the idea of art being about style on some level (and thus reiterates the modernist idea of art as an expression of individual subjectivity, as being about "art itself"). It is my attempt here to provide a different framework for understanding a dominant trend in contemporary art, one that acknowledges a profound shift (articulated in part from this very work) in the conception and experience of the self. It is my view that we can learn from artists such as Sherman, Morimura, Renée Cox, and Mariko Mori, who push the capacity of technologies of representation to "produce" the self as image in order to interrogate the boundaries of contemporary subjectivity and identity as these develop in relation to the circulation of images, of capital, and of aesthetic or cultural value today.

Performing the Body (as Fetish)

In the 1950s US, Abstract Expressionism (or Action Painting, as critic Harold Rosenberg would have it), was proclaimed the heir to the European avant-garde tradition and was marketed by forces allied both with the Museum of Modern Art and the US government as exemplary of American freedom and individualism.[12] Within this logic, the *subject* of Euro-American modernism was ideologically secured as the centre of a self-willed and coherent creativity while at the same time rendered implicitly invisible as an *actual* (ideologically, emotionally, sexually, racially, and otherwise invested and identified) body making the work of art. The body of the artist was necessary as origin of the work but had at the same time to be veiled or occluded for only as such could it sustain the myth of its potential transcendence.

The competing ideological forces conspired to construct a self-contradictory system that could be sustained only through the occlusion of the fact that the body of the artist at the centre of creation could only ever be identified as that of a Euro-American, Caucasian man. The stakes of continuing to veil the artist's body were extremely high. Paradoxically, however, with the simultaneous rise of mass media culture, the "subject" per se was also "subject" to representation – as the circulation of images of Jackson Pollock's body during the 1950s made clear. Just as the need for centring the subject became the most acute, with the increasing challenges posed to dominant Euro-American cultural values by the advent of postcolonialism and the rise of the various rights movements in the 1950s and 1960s, the mass media were starting to make use of that subject for their own ends. The media aimed at further substantiating the visibility of artistic subjects as marketable images and by representing their bodies it paradoxically led to the feminisation and commodification of these same subjects. Pollock, whose veiled body secured both Greenberg's and Rosenberg's claims for American artistic dominance, was caught up in this system. In the greatest irony of all, Pollock's international fame rested increasingly, after the publication of the famous 1949 *Life* magazine article that asked "Is He the Greatest Living Artist?" on the visibility of the very body Greenberg and Rosenberg laboured to suppress.[13]

Aligned intimately with capitalism, and so with media culture, modernism thus both substantiated the cantered subject so central to Euro-American political and economic dominance and provided the means to destroy it. Photographic media, and particularly the photographic self-portrait, bear out this paradox. While photographic technologies, including proto-photographic devices such as the camera obscuras and drawing devices developed in the Renaissance serve to concretise the centred subject, literally positioning the artist – and his viewer-to-be – at the centre of the perspectival cone of vision, the self-portrait image also produces the artistic subject as an object and so installs an impossible contradiction at the core of modernism. [14] I am arguing here that it is this contradiction – that the artist in capitalism and late-capitalism must be made into an "object" in order to gain authority as a "subject" of making – which became one of the most productive aspects of a particular kind of contemporary visual practice.

Japanese artist Yayoi Kusama's work exemplifies the postmodern shift in emphasis, whereby the contradiction is exacerbated rather than suppressed. Working in New York in the late 1960s as a Japanese woman (and thus doubly othered by American culture), Kusama had picked up on the specifically feminising aspect of Warhol's relentless self-promotional self-displays to perform herself in New York's public spaces. She staged numerous performative events, which she promoted through elaborate public relations strategies – designing body ware, organising group and self-performances, producing and disseminating her own public relations materials, and otherwise making herself ubiquitous. Kusama made clever use of the political energies of the time to produce herself as, simultaneously, fashion maven, avant-garde artist, seductive sex object, and political activist.

Kusama can be seen as a kind of hinge between photographic self display and live performance, as she produced the latter to generate the former (and vice versa). The difference between the body art of that time, however – with its links to Fluxus, Happenings, theatre, and dance – and the kind of obsessive self-imaging of Warhol and Kusama must be stressed. The critical effectiveness and emotive force of body art – its capacity explosively to expose and even exaggerate the artist/artwork/spectator circuits of desire and meaning formation – are derived in part from its complex relationship to "liveness" or "presence" (however much the artists in question interrogated what this claim to presence might mean). The model of fetishism provides a way of understanding the different effects and values of different modes of self-display.

Thus New York body artist Vito Acconci's 1974 *Command Performance* overtly choreographed the circuits of fetishism veiled in conventional modernist accounts – placing the viewer in front of a video monitor where Acconci appears; unbeknownst to the viewer, she is being simultaneously filmed by a video camera, her image playing in real time on a monitor set directly behind her. Acconci's piece, typically of the early 1970s body art works, thus aggressively conveys art as a process, a system of exchange

with an audience. Within this system, the artist's body is representational and simulacral – it is "present" only through videography. It is the spectator, embarrassingly enough, who finds her "presence" registered (but, again, through videography, as simultaneous "absence") in the real-time of her visit there – for others to see. The circuits of fetishism here are complicated and critically self-reflexive.

In contrast, the self-displays of Warhol and Kusama draw on a related but different trajectory – one in which "presence" or the pretence of its possibility is completely abandoned, and in which a *confluence of fetishisms*, such as that identified by Abigail Solomon-Godeau in her study of the 1860s photographs of the Countess of Castiglione by the Mayer & Pierson firm in Paris, is embraced. Per Solomon-Godeau's model, this confluence consists of an interconnection of sexual, commodity, and photographic fetishism.[15] As with all historical shifts, then, Solomon-Godeau's model suggests that the "seeds" for the exaggerated photographic self-displays we find in postmodern art can be found in earlier modernist practices and in structures of subjectification that started to take place much earlier in Euro-American culture.

How much more, then, with the explosion of mass media products and processes from cinema around 1900, to the first colour news magazines to include pictures and text together (1920s and following), to television (1950s), video culture (1965), and the image cultures spawned by the home computer, do these fetishisms now take a central role in the articulation and experience of subjectivity in globalised circuits of late capitalism? If the Countess's self-performances in the mid-19th century photographs show a complex "imbrication of narcissism and fetishism", as Solomon-Godeau argues, [16] then what could we say is going on with the increasingly common, even ubiquitous photographically rendered self-displays of artists that fill art magazines and galleries from the 1960s onward?

With Cindy Sherman, for example, we now have a 25-year long career of reiterative self-imaging projects, each of which articulates a different, but always critical, relationship to the confluence of three fetishisms noted above. With her society portrait series from 2000, she jacks up the stakes of her project by crossing the line between self and other – and between identification and parody. The camera indexically, and so paradoxically, documents an endless array of female subjects who are both exaggeratedly fake and disturbingly "real" to the extent that they represent the only Cindy Sherman we can ever "know". If the Countess of Castiglione performed herself over and over again for the camera, only to run up against the "difficulty, if not the impossibility, of the attempt to represent herself," as Solomon-Godeau puts it, then Sherman's work appears to take as its primary theme precisely this impossibility.[17]

It is worth stressing the way in which Sherman's project, which has been one of the most inventive in the visual arts since the 1970s, confirms my point about developing a very different way to view postmodernism from that offered by Jameson. Rather than fixating on borrowed styles, making art about art itself as Jameson argues that postmodern artists do in the quotation above, Sherman produces work that – like

that of the other artists whose works are being discussed here – insists on and even embraces the confluence of fetishisms through which the modernist and now, more violently, the postmodernist subject situates herself in the confusing matrices of late capitalist cultural production, dissemination, and institutionalisation.

Sherman's resolutely postmodern project is extended in the recent performative self-imaging works of Nikki Lee, who continues to use analogue photography as a more or less "documentary" mode of rendering referentially "real" situations. In her "Projects" series begun in 1997, Lee attaches herself briefly to various communities, refigures herself according to their bodily and behavioural norms, and has herself photographed in more or less amateurish snapshots – unstaged, and randomly shot by a friend or bystander using an inexpensive automatic focus camera. Through these photographs, in which she momentarily adopts the identity signifiers of everyone from yuppies, to elderly women, to lesbians, Lee explores even more aggressively the powerful confluence of identity politics and representational artifice. Like Sherman, Lee *begins* from the point of self-manipulation, while using straightforward, unmanipulated analogue photographic techniques;[18] but Lee produces herself in relation to "minority" and other marked identities as the "source" of the simulacral effects of photographic (mis)representation, placing identity at front and centre of her project. While Sherman has explicitly and extensively addressed the photographic commodification of the artist *as* a feminised body of display – especially in the "fashion spread" series of the early 1980s – younger generation artists such as Mariko Mori have adopted the poses, outfits, and environments of cyber-culture to instantiate themselves in newly digital versions of the commodity/sexualised body/photograph matrix identified by Solomon-Godeau as linked to the subjectifying structures of 19th-century French culture. Mori, a Japanese woman artist trained initially as a model and fashion designer in Tokyo (thus both to be an object and a subject of clothing design) refigures herself as a digitally rendered (and thus, in material terms, non-existent) character: a high-tech robot cum Geisha-prostitute cum passive little Oriental girl – the latter, one assumes, for Western eyes.

It should be stressed, then, that there is another kind of fetishism that Solomon-Godeau did not acknowledge in her otherwise brilliant account of the uses of photography in structuring modern European subjectivity. Certainly, when they perform themselves for Western culture, Kusama and Mori, whether they like it or not, enact on some level the Orientalist or ethnographic (racial) fetish about which theorists such as Malek Alloula and William Pietz have written so perspicaciously.[19] The power of the self-performative imaging by these artists derives from the inextricable interconnections among photographic, sexual, commodity, but also *ethnographic* or *racial* fetishism. The tendency of many artists dealing explicitly with race to deploy photographic technologies, I am suggesting, might have something to do with the fact that the conundrum of how representations relate to the real, or how or whether visibility conveys identity, is begged with both kinds of fetishism (racial/ethnographic and photographic).

The work of artists such as Kusama, Lee, Mori, and Morimura – as well as that of Lyle Ashton Harris, Renée Cox, Laura Aguilar, and many others – highlights the confluence of the photographic, sexual, commodity, and ethnographic fetish. Each artist performs her/his visibly "raced" and gendered/sexed body in ways that challenge the identifications usually ascribed to such a body. In his self-imaging works from the late 1980s and 1990s, Ashton Harris flaunts his gorgeous black male body in feminised poses, sometimes in whiteface. Cox produces herself wilfully as classic sexual fetish in images such as the 2001 *The Good Little Catholic Girl* (facing away from the viewer on stiletto heels, she bares her fishnet-hose-covered ass to us, nothing else of her torso or head visible except her dreadlocks), confusing the cues of sexual fetishism by merging them with racial fetishism (coded as countercultural, with the appearance of the dreads).[20] Aguilar, in her late 1990s "Nature Series", performs her vast, zaftig Latina body within Western US landscapes, perverting a pristine modernist style and the tradition of fetishizing women's bodies in landscape settings (à la Edward Weston) with a gorgeous but unwieldy body that is blatantly antithetical to the Euro-American (thin, white) ideal.

Within the context of the white-dominated Euro-American artworld these renderings of highly charged bodies activate the viewer's complex responses to otherness (or sameness, as the case may be), linking the power of the fetish inexorably to the desire of the person who is attracted to (and/or circulates or consumes) it. These artists thus deploy the quadruple fetishisms explored here in order to stress the aspect of fetishism that calls up the *viewer* as the propagator of the meaning and value of the fetish (or, more accurately, as the producer of the fetish *as* fetish). Activating the viewer as part of the circuit of determining the meaning and value of the bodies being rendered in the image puts questions of identity where they belong. Identity is determined, or so these images insist, in a complex interrelation between the body perceived as being "behind" the image (the artist), the body perceived "in" the image (in our case, the artist, again), and the body viewing or otherwise handling the image. Finally, then, photographic renderings of the coloured, sexualised body beg productive questions about where and through what processes "race" and "sexuality/gender" take their meaning; and questions about which bodies these (and other) identifications relate to, why, and in what way.

Representation, in this work, delivers the visible body of the artistic subject to the world as multiply fetishized; these artists perform themselves in various artificial and charged guises, flamboyantly "self revealing" but inexorably bound by the limits of representation and, ultimately, of "presence" itself to confirm any "essential" identity for the subject (so much Lee's blithe adoption of other ethnic identities or Ashton Harris's cross-gendered, cross-raced self-portraits suggest). Identity, their work seems to tell us, is not *only* in the eye or mind of the beholder. It is a profoundly complex mutual enactment across bodies and (or as) representations which potentially produce queer, cross-racial, and otherwise unsettling identifications on either side of the equation.

Digital Fetish

This complicated relationship to the "real" is made more complex in projects making use of *digital* imaging technologies. Sherman's, Lee's, Ashton Harris', and Cox's masquerading photographic self performances still promise an indexical tie to a referent – the multiply articulated Sherman or Lee, whose artifice lies in their self performances (and, correlatively, in the uncertainty of the body itself) rather than in the "lie" of the photographs, which are still tied to analogue photography and so indexically tied to bodies posing in the "real." Self-display projects that highlight the qualities of digital imaging technologies push the level of simulation even further. Via digital composites and digital video, artists such as Morimura, Mori, and Pipilotti Rist perfect and extend the self-as-spectacle, with spectacle now articulated through the digital matrix of zeros and ones and thus removed one step further from the referent of the centred, instrumentalised self.[21]

Morimura, Mori, and Rist produce themselves as *digital fetishes*, images that refer not as analogical or indexical signifiers to a "real" body that is being "betrayed" through the simulacral aspect of representation. They are, rather, representations that bear no relation (in analogue terms) to that to which they refer. While Sherman's and Lee's images still retain a lingering relationship to an idea of an actual person masquerading as someone else, they lead us in the direction of Mori's and Rist's images – where there is no longer even a reference to or promise of a "real" subject whom the image confirms or betrays.[22] Pipilotti Rist – who activates herself as moving digital image, and via digital sound, in large-scale video installations such as *Sip My Ocean* (1996) – exists only in and through mass media culture (including the photographic, televisual, and musical registers of the digital). She represents the generation born after 1960, for whom representation came to be imagined not only as the access to the real but as the only means through which the real could be apprehended, experienced, and registered.[23]

How does the digital fetish, which thus refutes (or at least mitigates) any belief in a pre-existing real, relate to the primitive or ethnographic fetish? As William Pietz has noted, the primitive fetish came to being within the context of colonialism; it "could originate only in conjunction with the emergent articulation of the ideology of the commodity form that defined itself within and against the social values and religious ideologies of two radically different types of noncapitalist society". Pietz argues that the primitive fetish is thus characterised by an "irreducible materiality", in that so-called primitives supposedly venerate objects which they view as the "thing itself" (i.e., as god).[24] Correlatively, one might say that the digital fetish is irreducibly *immaterial*, and that this immateriality destabilises our belief in the materiality of the bodies depicted therein. For an artist, whose body is recognisable as "not white", for example, as implicitly raced and "primitive" in signification, to use digital imaging technologies to render her body visible (like Mori) is to work at the deepest level of representation and identity formation to unhinge the link between the sign and the

referent (predicated on the belief in a material "anchor" as the basis for signification) – and thus to destabilise the racist logic of primitive fetishism.[25]

Within the context of the Euro-American art market (including its intellectual variants, art criticism and art history), artists of colour, then, have a multiple and in some ways conflicting project – to insist that they are not just bodies (they are also subjects, with thoughts of their own); to prove they are "real" (in the sense of being representable); and to destabilise any attempt to attach stereotypes to their bodies, visibly recognisable as "raced", by refusing the link between their bodies and the significance attached to them by external desires and social forces. It is the photographic (and particularly the digital) that enables such a project. At the same time, as Pietz's quote points out, it is precisely the rendering of the body as image that turns it into a commodity that can be circulated across, within, and beyond the "material" conditions that brought that body to life otherwise. With the digital image, the body becomes all the more definitively unhinged from the real as it is dematerialised in its instantaneous dissemination – most strikingly when it is conveyed across the World Wide Web network.

Postscript: Performance and the Photographic Self-Image in the Service of Commodity Culture

In the last decade, extending the examples of Duchamp, Warhol, and Kusama, a new tendency has emerged at the centres of the Western artworld – particularly London and New York: the overt performance of the artist as celebrity through the popular and art media. While artists such as Matthew Barney, Tracey Emin, and Vanessa Beecroft do not make self-portrait images as their primary mode of production, their practices take their cue from the long history of artists displaying themselves in photographic images. Like Kusama or Jeff Koons, they transform the work of art into an extended field that includes the body/subject of the artist (whether or not "realistically" conveyed).

Matthew Barney, a key figure in this elaborate manipulation of the various circuits of commodification available to the artworld, reached the apotheosis of public acclaim with the solo exhibition of his work mounted at the Guggenheim Museum in New York and the simultaneous publication of a *New Yorker* profile on his career by Calvin Tomkins in 2003. Tomkins' melodramatic encomia, and their placement in one of the most respected and widely circulated magazine for American intellectuals, exemplify Barney's usefulness to an artworld that still thrives on white male artists as the guarantor of aesthetic and economic value (and he's heterosexual! [as secured by his highly visible romantic partnership with the rock singer Björk] and good looking too! – many articles about Barney begin by noting that he began his adult career as a model). Making the stakes of his claims explicit, Tomkins makes this ideology explicit in his comment that, "[a] lot of people are wondering what's next for Matthew Barney.

If we consider that the prevailing metaphor of the 'Cremaster' Cycle was pre-genital, there's no telling what he'll bring us when the creative organs [i.e., the testicles] fully descend".[26]

Then there's the case of Tracey Emin, the Young British Artist (YBA) whose relentless self-confessions in her works and her frequent appearances in the British mass media produce a public artistic subject who is at the same time a package of private revelations. In the 1999 *My Bed* she literally displays the site of her sexually intimate life; in works such as the video installation *CV C*** Vernacular*, 1997, she tells us the supposed story of her life in a dead-pan voice, including stories of her rape at the age of 13, and her subsequent promiscuity and suicide attempt. The narrative Emin produces is on level with her self-displays via her own body or, as with the infamous *My Bed*, via synecdochal extensions of it; together, these conspire to elaborate a network of fetishistic images and objects that collectively delineate the artistic subject "Emin". The fact that Emin, a woman of partly Turkish descent living and working at the centre of the British artworld, can only command about a tenth of what her fellow YBA artist, Damien Hirst, is able to make from equivalently ambitious works of art (Charles Saatchi recently paid only £150,000 for *My Bed*, while he paid £1 million for Hirst's piece *Hymn* around the same time) shows that, self-performance and simulation aside, some kinds of bodies are still "essentially" worth more (as origins securing the value of works of art) than others. [27]

Vanessa Beecroft, the superstar Italian/American artist, removes her literal body from her performance works, most often replacing it with multiple duplicates in the form of slim, white women whom she hires to stand in high heels, naked, for durational performances.[28] It is in the sense that these women replicate Beecroft's own ideal body image that these works can be discussed as part of the trajectory I am addressing here. For example, in *VB46*, performed at Gagosian Gallery in the exclusive LA community of Beverly Hills in 2001, a bevy of white women with bodies covered in white makeup and sporting white wigs stood for around three hours, reaching various states of exhaustion. As they stood and then collapsed over time, an Asian woman with a wig of long red hair circled them auspiciously on equally high heels.

If the racial and sexual fetishism of Beecroft's piece were not already explicit – and problematic – enough, a group of black women and men worked as guards in the gallery; wearing "men in black" type business suits and earpieces, their racial and class difference was sartorially marked (though notably, they are not visible in any of the glossy commercial stills I've seen taken of the piece). According to the research of Jennifer Doyle, who spoke to the gallery directly about the guards, they were hired and deployed without the slightest self-consciousness about the symbolic value of *their* performative presence in relation to this project, in this gallery, in whiter than white, wealthy Beverly Hills.[29]

The cultural and literal economic value of Beecroft's work also hinges of course on the photographic fetish. Beecroft has the works photographed and, through the

gallery, sells these photographic documents of the performances at around $10,000 a pop (and rising yearly).[30] Coming full circle from the situation in 1970s body art, the photographic documentations of Beecroft's elaborately simulacral performances (which render *others'* bodies as artifice) are now unselfconsciously marketed as fine art fetishes. There is no pretence of Beecroft being interested in the raw energy of live performance; the events themselves are rigorously choreographed, the models directed to control their bodies as much as possible. They are pictures even before they are pictures (many if not most of the photographs are taken in controlled circumstances *before* the actual event takes place). The live has been subordinated *before the fact of its enactment* to the commodity object of the photographic document.

The practices of Barney, Emin, and Beecroft exaggerate the fact that self-display inevitably slides into self-commodification. What none of them bring to the foreground, however, is the crucial fact that *the perceived identity of the artist on display has everything to do with how the images are valued* in both aesthetic and economic terms. Barney, the handsome white male who is reiteratively produced as heterosexual and virile, can display himself without mitigating the phallic privilege assigned to his work by critics such as Tomkins. Emin is compromised, as so many women artists have been, by her own tactics, which draw on the stereotype of white female hysteria (regardless of the ethnic complications in her own background) in order to gain visibility, but thereby reduce the economic value of her work (as having been produced by, precisely, a feminine hysteric). Beecroft unabashedly deploys the triple regime of fetishisms Solomon-Godeau noted to profitable ends, while totally missing the point of racial fetishism by deploying it deliberately on one end and failing to see its significance (and the role it plays in substantiating the class values embedded in her work) on the other.

In closing, I would like to take inspiration from two projects that specifically respond to Beecroft and explicitly surface all *four* kinds of fetishism, complicating the links among them and refusing any simple marketing of their bodies or their work along racial or sexual lines. The Beecroft spoofs are by Los Angeles based Toxic Titties collective, a group of young queer feminist artists, Heather Cassils, Clover Leary, and Julia Steinmetz, who describe themselves as "a lesbian biker gang with no bikes",[31] and by Los Angeles based impresario (a drag performer, writer, filmmaker, musician, and cabaret diva) Vaginal Creme Davis.[32]

Crucially, two of the Toxic Titties infiltrated Beecroft's *VB46* by answering her advertisement, posted at California Institute of the Arts (CalArts, where they were then students), and promising a "day of beauty" for young white females.[33] In this way, they learned about her methods for extracting intimate details from her participants; they describe her as extracting the personal details from her "assistants" by having them fill out elaborate biographical forms, then moulding them into identical objects to enact the inexorable sexual fetishisation of women's bodies, only to profit through

photographic and commodity fetishisation by selling pictures of them (a profit secured by their whiter than whiteness). They were first forced to stand in formation in their painfully uncomfortable stiletto heels at a sound stage in order to be photographed in formation before the actual performance and instructed before the public event to "be detached" and not to make direct eye contact with any person or camera or to speak.

In her contribution to the Toxic Titties MA Thesis show, discussing the actual performance event at the gallery in Beverly Hills, Heather Cassils noted Beecroft's exhortation that they could sit down on the floor but only if they maintained the blank emotional demeanour her works demands and her own decision to stand for the duration of the performance in protest. Cassils described how demeaning it felt to be one of Beecroft's stand-ins:

> As viewers entered the white cube my quadriceps started to shake so hard I thought I was going to fall out of my designer heels that cost more than my rent. My fists were clenched, my stomach taut. I felt like my skin was a force field against the eyes that were drinking me in. I wanted to make myself menacing and indigestible…. The more I stood the more energy built up in me until I thought I was going to explode in my stillness. 'Wow, she's so angry. Wherever did she [Beecroft] find her? Really great.' And it was this moment I realized I was powerless in this situation. My silent anger was easily subsumed by the artwork. No one could tell my anger was my own and not a possible instruction from the artist. Despite all my intentions, I had sold my body and my voice.[34]

Drawing on this experience, and propagating a sweet yet highly productive revenge on Beecroft's manipulative disempowerment, the Toxic Titties then produced their own perverted version of Beecroft's work in a performance entitled *Toxic Troopers* staged at University of California, Riverside in the Spring of 2003.[35] For this piece, they participated themselves, along with a decidedly motley crew of female and male bodies of all shapes, sizes, and colours, in a pseudo-fascistic display of bodies, their sexual "perversity" exaggerated through the prosthetic enhancement of large dildos and other accoutrements. The Toxic Titties insist in this piece on the intersectional complexity of identity, and its resolute performativity in relation to others, beyond the heteronormative, white feminine body assumed in the logic of Beecroft's pieces. In activating the multiply identified participants (who are made so passive in Beecroft's work), the Toxic Titties refuse the static racial and sexual fetishisation at work in Beecroft's elaborately staged performance (living bodies that provoke and respond to the audience cannot be fetishes in the traditional sense). Too, as "live" performance, with the photographic documents and videotape produced more as an afterthought than as a marketing ploy, the piece mocks the precious aestheticism and the assumption of homogeneity that underlies the artworld value systems Beecroft's work both exposes and relies on.

Vaginal Cream Davis's Beecroft-related piece, *VDasVB 1434578 (Guggenheimy Bikini Show, Spicy Beef Curtains at the Parlour)*, performed at the Parlour Club in West Los Angeles on June 15, 2002, equally brazenly activates the rough aggressive potential of live culture to spark the visitor's corporeal responses.[36] In its savage wit and wilful debauchery, the work also parallels the Toxic Titties' funny yet deeply cutting attitude towards Beecroft's performance events. In particular, as with the Toxic Titties piece, Davis's work comments on Beecroft's seemingly unwitting or uncritical manipulation of the quadruple fetishisms noted above – with *VB46*, the marking of the "ideal" white female body (as a stand-in for Beecroft's own) as a photographic, commodity, sexual, *and racial* fetish.

Vaginal Davis's ("VD's") debut *as* VB automatically perverts this ideal in at least two ways – first, by presenting the artist herself, an impressive six foot six inch cross-gendered Black/Chicano impresario, speaking "as" Beecroft briefly at the beginning, surrounded by an extremely heterogeneous crew of lingerie-clad men and women standing on display on scaffolding.[37] Second, by producing the work within her own counter-cultural cabaret, increasing the intimacy effect (Davis notes that audience members freely fondled the models, in particular the young men), and by documenting the performance event with snapshots (the rough and ready appearance of which contrasts strongly with the pristine, fetishistic images of Beecroft's performances).

Furthermore, the fact that the photographs were themselves taken by Davis, in double (triple?) masquerade as "Loria de Haven" – and made available as freebies to be dragged easily off Davis' website – ratchets the intervention up another notch. As Davis put it to me, "the photos on the webpage are taken by me as Loria mocking how photographers take pictures of the Beecroft presentations that are then sold at galleries for oodles of filthy lucre$".[38] In contrast to Beecroft's overtly craven pandering to the art market, Davis makes his snaps available to anyone with access to a computer (I am quite certain she would be more than happy to mail copies to anyone who did not, as well!). The digital fetish replaces the analogue fetish even as the circuits of commodity culture that serve to ratify certain artistic bodies as origins for valuable works of art are stymied. The photographs are not for sale – they are free, and circulate as such on the Web.

The brilliance of the Toxic Titties' and Davis' parodic engagements of Beecroft's work is precisely their attention to the way in which the four fetishisms noted above – photographic, sexual, commodity, and racial – work together to produce some bodies as desirable commodities and produce other bodies as the privileged reposi-tories of cultural capital. In this way, these projects extend the insights of the work of Ashton Harris and Cox – artists who explicitly point to the ways in which photographs of black bodies so often function to guarantee the privilege of non-black subjects. Too, by making their bodies "present" within an array of *other* bodies, and marking all as sexually perverse, cross-gendered, non-ideal, and definitively raced (whether

white, black, yellow, or brown), the Toxic Titties and Davis expose the way in which the white female body can be circulated as a sign of "aesthetic" turned commodity value so as to secure the "authority" of the artist who wields them (even if the artist is a white woman, as with Beecroft).

Far from the sublimatory and self-congratulatory (as well as highly lucrative) theatri-calisations of masculinity that serve to bolster Matthew Barney's visibility and wealth, and beyond even the sharp but localised interventions posited through the self-imaging practices of artists from Kusama to Sherman and Mori, the Toxic Titties and Vaginal Davis produce and perform radically heterogeneous bodies that subvert and pervert while paradoxically also embracing (through exaggeration and parody) the confluence of four fetishisms that determine the cultural and economic value of bodies in and as art. They open a way to rethink the fetishisation that occurs with the self-display of the artist's body – one that acknowledges the role of all kinds of difference in determining just how this fetishism functions and how its fetishes come to mean. In this way, they point to new ways of understanding how and in what ways we exist in contemporary image culture.

Notes

1 Christian Viveros-Fauné, "These 11 Artists Will Transform the Art World in 2017," *artnet news* (2017), https://news.artnet.com/exhibitions/11-contemporary-artists-for-2017-800375.

2 The article was published first as follows: Amelia Jones, ""The Contemporary Artist as Commodity Fetish," Art Becomes You! Parody, Pastiche and the Politics of Art," in *Materiality in a Post-Material Paradigm*, ed. Henry Rogers and Aaron Williamson (Birmingham: Article Press, 2006), 132-50. I am extremely grateful to Henry Rogers in particular for the original conference in Birmingham, UK, soliciting this work, and to both editors for the publication.

3 See my: *Self/Image: Technology, Representation, and the Contemporary Subject* (London: Routledge, 2006).

4 See my: "'The Artist Is Present': Artistic Re-Enactments and the Impossibility of Presence," *TDR: The Drama Review* 55, no. 1 (2011): 16-45.

5 See: "Marina Abramović Made Me Cry," Tumblr, http://marinaabramovicmademecry.tumblr. com/.

6 I am grateful to Henry Rogers for the opportunity to develop these ideas, and to the students in my "Self/Image" seminar at the University of Manchester, who provoked my thinking in productive ways. "The Contemporary Artist as Commodity Fetish" was first published in *Art Becomes You! Parody, Pastiche and the Politics of Art. Materiality in a Post-material Paradigm*, (eds.) Henry Rogers and Aaron Williamson (Birmingham: Article Press, 2006).

7 Grant Kester, "Crowds and Connoisseurs: Art and the Public Sphere in America," in *A Companion to Contemporary Art since 1945*, ed. Amelia Jones (London: Wiley-Blackwell, 2006), 254.

8 It is worth emphasising that I am using the term "photographic" very broadly, to include these other modes of representation that draw on the *logic* if not the formal or technological properties of analogue photography.

9 Claude Cahun's brilliant performative self-portrait images from the 1920s and 1930s are crucial examples of self documentation, but Cahun did not "market" the images overtly as did Duchamp, Warhol, and the other artists whose self-images are discussed here.

10 In this sense, the shift I am noting parallels the turn to the subject in twentieth-century philosophy, especially in its French variants. Carolyn Dean, *The Self and Its Pleasures: Bataille, Lacan, and the History of the Decentered Subject* (Ithaca, NY: Cornell University Press, 1992).

11 From: Fredric Jameson, "Postmodernism and Consumer Culture," in *The Anti-Aesthetic: Essays on Postmodern Culture*, ed. Hal Foster (Seattle: Bay Press, 1983), 115. This essay is a short, earlier version of "Postmodernism, or, the Cultural Logic of Late Capitalism," in *Postmodernism, or, the Cultural Logic of Late Capitalism* (Durham, NC: Duke University Press, 1991), 1-54.

12 On the marketing of American art internationally in the 1950s see: Serge Guilbaut, *How New York Stole the Idea of Modern Art* (Chicago: University of Chicago Press, 1985).

13 I discuss this dual dynamic at some length in: Amelia Jones, "The 'Pollockian Performative' and the Revision of the Modernist Subject," in *Body Art/Performing the Subject* (Minneapolis: University of Minnesota Press, 1998), 53-102. Notably, as I point out here, in his famous essay (Harold Rosenberg, "American Action Painters," *Art News* 51, no. 8 (1952): 22-23, 48-50.) Rosenberg is clearly *describing* Pollock when he rhapsodises about flinging paint and the canvas as an "arena in which to act"; but he never names Pollock by name. My argument, then, is that, while invoking the body of Pollock, Rosenberg still avoids naming him. Such an overt acknowledgment of the specific body of the artist would unhinge the repressive system of art criticism, whereby the critic (per a watered down version of Kantian theory) claims disinterestedness (i.e., a lack of sensual engagement) in relation to the work he is analysing.

14 The idea of the camera obscura as a darkened room with a pinhole through which an image outside the room would be projected was discussed in ancient Chinese philosophy and by Aristotle thousands of years before the modern era; however, in the European context the camera obscura was constructed as a box (a precursor to the analogue camera as we know it) and thus became means to instrumentalise (literalise) ideas about the ability of a subject situated in the "right" place to mimetically capture the real.

15 Abigail Solomon-Godeau, "The Legs of the Countess," *October* 39 (1986): 67-68.

16 Ibid., 70.

17 Ibid.

18 I am indebted to Leslie Tonkonow, Lee's dealer in New York City, for providing me with detailed information about the artist's processes (in emails of 22 June and 3 July 2004); Lee continues to use 35mm film, and uses no cropping or manipulation (after the image is captured, that is) of any kind. The only digital element comes in with the larger prints, which are printed digitally (but as scanned from 35 mm negatives).

19 See: Malek Alloula, *The Colonial Harem*, trans. Myrna Godzich and Wlad Godzich (Manchester: University of Manchester Press, 1986); William Pietz, "The Problem of the Fetish, I," *Res* 9 (1985): 5-17; "The Problem of the Fetish, II/ the Origin of the Fetish," *Res* 13 (1987): 24-46.

20 Ashton Harris and Cox produced images together in the mid-1990s; see for example their *Queen Alias and Id: The Child*, 1994, where Cox – the taller of the two – is dressed as a man and sports a moustache and goatee, and Ashton Harris wears a man's blazer but a feminine bandana and makeup, cradling a baby in his arms. For an overview of Cox's work, see: Renée Cox and Jo Anna Isaak, *Renée Cox: American Family* (New York: Robert Miller Gallery, 2002). Here, it is apparent that Cox conceived overtly fetishistic images such as *The Good Little Catholic Girl* to be displayed in a complex framework combining family photographs (historic images relating to her psycho-sexual formation in a part Jamaican, part white European family) with these staged self images. Her wilful self-fetishization, then, can be richly viewed in this complicated context – which includes references to her Catholic schooling, etc., and raises the point that this multiple register of fetishisms takes on a particular cast in the formation of the cross-racial subject in the US (and what subject in the US is not cross racial to some degree, after all?).

21 On Rist's work, which has been inspirational to me in thinking through these issues, see my essay: Amelia Jones, "The Televisual Architecture of the Dream Body: Pipilotti Rist as Parafeminist," in *Self/Image: Representation and the Contemporary Subject* (London: Routledge, 2006).

22 Many other creative projects have explored this loss of a belief in a "real," centred, or stable subject posited at the origin of knowing and seeing, or at the other end of the equation, as the object of desire. The 2002 mainstream Hollywood film *Simone* (starring Al Pacino) narrates the story of a film director who manufactures the "perfect" (digital) actress, only to find that she becomes more visible and famous than he (sadly, rather than following this up by exposing *his* failure to cohere in the face of the bogus values of Hollywood media culture, the film reinscribes his authority; his ex-wife returns to him, reasserting the heterosexual matrix, and together they continue to deploy "Simone" (the actress) to make money and promote their own careers). In the 2004 play *Perfect*, produced at the Contact Theatre Manchester, a young man devises his "perfect woman" out of computer software only to have his father surreptitiously arrange a meeting with an identical, flesh and blood woman through an escort service – begging questions of whether the ideal is "produced" by the young man, or whether she simply exists in his own mind. It is notable, and disturbing, that the trend seems to be to explore these issues relating to bodies and new technologies and representation via very old-fashioned tropes of "perfect" womanhood (even in the play, which was produced out of a script by a woman playwright, Kaite O'Reilly, and directed by John McGrath.

23 I can testify to this, given that I was born a year before Rist – in the early 1960s.

24 Pietz, "The Problem of the Fetish, I," 7.

25 Although it must be said that the apparently "Asian" body (i.e., Mori's visible identity as Japanese) is not viewed as "primitive" within Euro-American culture in the same way that the African body is.

26 Calvin Tomkins, "His Body, Himself: Matthew Barney and the 'Cremaster' Cycle," *The New Yorker*, 27 January 2003, 59. Tomkins does not hedge his eulogistic tone, noting that "a sort of critical euphoria has attended his career ever since [his 1991 NY début at Barbara Gladstone]. Instant recognition, however, seems to have left this young man's very real talent unscathed," (50).

27 See: Alicia Foster, "Is This Fair?, Two Renowned Brit-Artists; Two Very Different Price Tags," *The Guardian*, 7 April 2004.

28 Like Barney, Beecroft has also recently been profiled in *The New Yorker*. In contrast to Tomkins' hagiographic paean to Barney's virility and originality, however, Beecroft is narrated as a bulimic and a hysteric, indicating once again the limits of self-marketing when it comes to a body that is gendered or raced in a non-normative way. See: Judith Thurman, "The Wolf at the Door: Vanessa Beecroft's Provocative Art Is Inextricably Tied to Her Obsession with Food," *The New Yorker*, 17 March 2003, 114-23.

29 Per Doyle's account, the gallery staff stated to her when she inquired about the guards, "We hire security guards for some openings, and, for this one, security was a must." Jennifer Doyle, "White Sex: Vaginal Davis Does Vanessa Beecroft," in *Sex Objects: Art, Sexuality, and the Dialectics of Desire* (Minneapolis: University of Minnesota Press, 2006), 174, note 20. This text is a brilliant reading of the limits of Beecroft's work in terms of sexuality which function not in a radically destabilising way but only to "lend her work a gallery-sanctioned radicalism."

30 Notably, from 14 December 2002 to 1 February 2003 the Gagosian hosted an exhibition of the photographs documenting *VB46*. Drawing on the usual tropes of modernist formalism to gloss over the offensive racial and sexual politics of the piece, the Press Release for this show notes, "Their bodies are painted white, and against the white cube of the gallery space, this decidedly monochromatic performance recalls the work of artists like Malevich and Ryman."

"Vanessa Beecroft: VB46 Photographs," Gagosian, https://www.gagosian.com/exhibitions/vanessa-beecroft--december-14-2002.

31 Per their website: "The Toxic Titties are three different people, and one collective identity. Heather Cassils, Clover Leary and Julia Steinmetz have been working together as artists for two years now (Barb Choit worked with them for the first year). They are 'a lesbian biker gang with no bikes.' Their most recent project involved forming a business partnership which they are a metaphorically turned into a marriage contract, complete with a wedding ceremony, rings, cake, invitations, and a party." "The Toxic Titties," The Essential Guide, http://www.turbulence.org/cgi-bin/michael/guide.cgi?chap=33

32 Another project, *Boys*, produced by Polish artist Katarzyna Kozyra also reworks Beecroft's events – in this case three videos and a number of photographs document a group of naked young men standing in sloppy formations with cunt-like thongs strapped to their pubises. According to the artist's website, "[p]laced in front of the camera and given no specific instructions from the artist, the men [were] left to their own devices," in contrast to Beecroft's highly choreographed and idealised female bodies. See: Katarzyna Kozyra, "Boys," http://katarzynakozyra.pl/prace/boys-2/. I am not discussing this project here because it does not explicitly address racial fetishism, given that all the young men are white.

33 I am indebted to Jennifer Doyle's research and to the Toxic Titties themselves for this information. See: Doyle, "White Sex: Vaginal Davis Does Vanessa Beecroft." See also the critical account of her colleagues' intervention: Julia Steinmetz, "Showing Us What's Wrong: Vanessa Beecroft and the Model's Body," *Signs: A Journal of Women in Culture: special issue on "New Feminist Theories of Visual Culture"* 31, no. 3 (2006).

34 Heather Cassils, MA Thesis show text, CalArts, May 2003. Cited in: Doyle, "White Sex: Vaginal Davis Does Vanessa Beecroft," 174, note 19.

35 This performance was part of a conference I co-organised with Jennifer Doyle and Molly McGarry entitled "Intersectional Feminisms," in April of 2003.

36 Also notable is Davis' Beecroft related piece, "Don't Ask, Don't Tell, Don't Care," enacted as part of her cabaret performance evening at the Zen Bar in Los Angeles; Jennifer Doyle discusses this work, based on Beecroft's less common projects including male bodies (those of marines) rather than female, in "White Sex." This discussion of Davis' piece is based on descriptions and photographs from her website, see: http://www.vaginaldavis.com/; I am also indebted to Davis' own input (in an email of 21 June 2004), for which I am deeply appreciative, as well as to her important "White Sex." I am grateful to her for sharing this manuscript with me and for being in ongoing dialogue about these works. José Esteban Muñoz must be credited for bringing Vaginal Davis' radical "disidentificatory" practice to wider public view in his brilliant chapter: José Esteban Muñoz, "'The White to Be Angry': Vaginal Crème Davis' Terrorist Drag," in *Disidentifications: Queers of Color and the Performance of Politics* (Minneapolis: University of Minnesota Press, 1999), 93-115.

37 As Davis and Doyle pointed out to me, Heather Cassils and Clover Leary, the two Toxic Titties who appeared in Beecroft's *VB46*, were among the poseurs. Doyle, in an email dated 22 June 2004; Davis, in an email to me dated 21 June 2004. Davis notes that this was "deliberate in that I knew they had appeared in one of her Beverly Hills Gallery shows and had been somewhat mistreated by the Beecroft staff."

38 Vaginal Crème Davis, email, 21 June 2004.

Lost Causes and Inappropriate Theory: Aboriginal Art It's a White Thing and Other Tales of Sovereignty

Ian McLean

Personal strategies and systems, devised in order to attain a point of certainty
seem inexplicably bound to fail. The desired unambiguous 'point' expands into an
'area' of concern – the triangle of doubt.

Imants Tillers, 11 December 1981, Sydney[1]

I N THE TEMPLE, THESE days even Jesus would not spot the Pharisees, so perfect is their salesmanship. It's the same pushing through the crowds at Tate Modern: the vox populi is at one with the senators. This egalitarian ethic is the achievement of contemporary art, setting it apart from the transgressive ethos of the much-maligned modernism of day's past. The tension between the open inclusiveness of the demos and the enigmatic exclusiveness of fine art is so well resolved that, as with any popular masterpiece, we can be sure it is ideology at its most perfect and purest: unseen unheard unfelt. Here everyday curios effortlessly mix with the elite manna that formerly delimited fine art, and their creators are not just the familiar Western masters but from around the world. Even the ugly, rejected and abject have become aesthetic. Has mass education raised us all to sit in the laps of the gods or is it the public relations people, seamlessly veiling the dark mysteries of the artworld with their many coloured cloaks? In this inner sanctum of the contemporary artworld, what is sovereign: the artworld or the demos?

Even though its subject is the national story, Tate Britain is little different. Because its narrative is one in which sovereignty passes from the Crown to the British people, Tate Britain is also a temple to the modern idea of the demos. As well, it is a temple to the artworld. Tate Britain shows the artworld in the British artworld; whereas Tate Modern shows the artworld in the world of art. In each the demos and the artworld are bound to the other. Each gained its sovereignty at the same time from a similar matrix of events and today's art museum is their joint apotheosis. It is not a question of the artworld or the demos; they are two sides of the same coin, or two lines that meet at the vanishing "point of certainty". There is, as Imants Tillers would say, no triangle of doubt.

At the Art Gallery of New South Wales there is less of a crowd. It combines a national focus with a regional view of the world but it's the same alchemy, all milk and honey. Even the priceless relics that draw us to these places are similar. We are, after all, in the same gene pool, a local office of the egalitarian contemporary artworld. In Sydney, for example, you are bound to see large colourful canvases of remote indigenous art that, once excluded from fine art museum, are the new brand of the Australian settler nation despite their contested claims of sovereignty. Proudly and beautifully displayed, they look just like the other art. Is there anywhere a neater nexus of the local in the global and vice versa?

Certainly, not in Tate Modern; there is no indigenous art there.

The Artworld

Arthur Danto took the artworld's exclusiveness for granted. It's in his very terminology. He made 'artworld' one word, a single noun or thing in its own right. Copy editors still rule that it's two words, but in reducing art to an adjective they miss Danto's ideological point. He even capitalized Artworld, giving it more weight as a proper noun. It is not a messy pluralistic anything-goes place but a singular transcendental sovereign space that, Danto said, theory takes us up into.[2] There would, he insisted, be no "artworks without the theories and the histories of the Artworld".[3]

Danto did not attempt to justify the Hegelian assumption behind this claim, namely that at any one time there is only ever one dominant artworld (Idea or paradigm) that shapes the meaning and value of the art that matters. Then, in 1964, when Danto published his musings on the artworld and the rule of modernism was taken for granted, this was self-evident. It was still self-evident a decade later, even to those, like Terry Smith, whom it deeply troubled.[4] Danto didn't deny that there are many artworlds, but their provincialism was of only local not world-historical import.

Despite its world-historical import, Danto's artworld was a relatively small and exclusive pool, though it couldn't be pinned on any one artist, school, critic, collector or institution. Rather it was, said Danto, "an atmosphere of artistic theory",[5] which is to

say a living discourse and politics (in Aristotle's sense). Thus, it had a polis, a place of argumentation. It was a few blocks in Manhattan, and few doubted it in 1964, not even the French. From this flowed Danto's main point. As he shows from the very first sentences of his article, a discourse has factions: it is contested, often fiercely, but being politics it is also one in which consensus reigns. Artworld taste is the consensus that reigns among the "makeweights in the Artworld" until a new consensus takes hold.[6]

As Danto explained it in 1964, this atmosphere of artistic theory was essentially Hegelian in form. On a quest of self-understanding, in which art would establish its ontological ground, artists submitted themselves to the dialectical working out of this telos. In doing this they created a sovereign or autonomous artworld dedicated wholly to interrogating the idea of art through its negation, which they took to be reality. In this bickering between art and the real (often figured as the primitive or the abject), each pushed against the limits of the other until some breakthrough or turning point occurred (such as the invention of perspective, Cubism or the readymade) and then the process started all over again. Like many at the time, Danto believed the quest was at another turning point. He saw it in Andy Warhol's *Brillo Boxes* (1964), which literally collapsed art into the real, their former difference annulled in a point of certainty. "It could not have been art fifty years ago", he said.[7]

Fifty years later and Danto's understanding of the artworld and its telos no longer holds – though aspects of it linger in some quarters. The postmodern critic Hal Foster still talks about the "return of the real".[8] And who can deny that there is not a semblance of a sovereign artworld when its discourse is more pervasive and powerful than ever. It might be dispersed across many artworlds as if a world spirit – its polis is the fully wired globe – but it is possible to guess in which artworlds the next world-historical moves are likely to be made. There might be no centre but there is a mainstream. Few doubt that, like transnational companies, the artworld is largely in the hands of Western interests. Internet-users may believe they live in transnational social networks, but as Boris Groys retorted, "the big companies that own and operate the internet are not founded in cyberspace, but on fixed territories and subject to the relevant legislation – mostly American".[9]

The art biennale culture that took off around the world in the 1990s in response to accelerating globalism put the artworld's decentring beyond doubt. A few other things had become blindingly obvious by this time. In 1964, despite the liberalism of Danto's artworld, few noticed how racist and sexist its exclusions were, or that the art historiography sustaining it rested on the belief that modern subjectivities can only emerge from a Western and male mode of being. This belief – which the curator Okwui Enwezor aptly dubbed "Westernism"[10] – is now a spent force.

Stuart Hall's essay of 1992, "The West and the Rest",[11] signalled that a post-Western shift was already in swing. Admittedly this newfound attention to the rest – to what once was peripheral to the universal or world-historical pulse of art – is often tokenistic and

without significant analysis, but the tide had turned. It was most visible in contemporary art venues but more important in the long run will be its impact on historical research. This is because contemporary art requires a genealogy that cannot be found in the art histories of Westernism. Without new ancestors, post-Western art will remain bound to a Western sovereignty. In this spirit Enwezor's exhibitions pay as much attention to establishing a post-Western genealogy of contemporary art as they do to the emergent transnational and transcultural attributes of the contemporary artworld.

History Lessons

In preparing new historical ground upon which to map the globalising tendencies of the contemporary artworld, Enwezor's most recent exhibition, *Postwar: Art Between the Pacific and the Atlantic 1945-65*[12] – which at the time of writing had recently opened at the *Haus der Kunst*, Munich – serves as a benchmark for a genealogy of contemporary art.

Based on the failure rather than triumph of European humanism and modernism, the exhibition is forcefully framed by the race-driven nightmare of the Holocaust and the equally apocalyptic horror of the Atom Bomb. *Postwar* thus begins its alternative history in Auschwitz and Hiroshima rather than New York. Its major themes are not the impact of capitalism's culture industry that until recently preoccupied art historians and theorists, but political upheavals across the world due to the disintegration of autocratic empires into many modern nation states. This telos of national sovereignty had been slowly gathering pace during the previous few centuries in Western countries as sovereignty was transferred from the unelected elites of the Crown and the Church to the demos or people, but the World Wars in the first half of the 20th century rapidly brought it to a head. The Western empires suddenly surrendered their colonies to this telos and the whole world became a postcolonial mosaic of sovereign nation states with a representative body, the United Nations (UN).

If in the aftermath of imperialism, the telos of national sovereignty reconfigured regions into new national polities, it inherited and intensified imperialism's implicit transculturation. Fernando Ortiz, who coined the term "transculturation" in 1947, pointed out that colonial cultures were sites of multi-ethnic and multinational crossings.[13] These crossings countered colonialism's demands of acculturation. This dialectical tension shaping colonial cultures ratcheted up in the postwar pull between transculturation's deterritorialisation and ethnic essentialism's reterritorialisation, and continues to shape the telos of national sovereignty.

If Enwezor is right, even in 1964 the artworld was not New York bound, and shaping its discourse was a new telos instigated by the fallout from the World Wars. Danto, with his eyes fixed on New York, thought he saw a transcendental sovereign artworld but it was a giant star in its death throws, blinded by the afterglow of its anachronisms. The artworld was already dancing to a different tune.

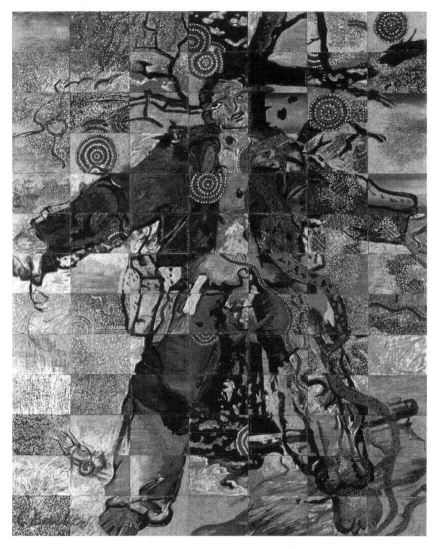

Figure 4.1 Imants Tillers, *The Nine Shots* (1985), acrylic and oilstick on 91 canvasboards (nos. 7215 – 7305), 330cm × 266cm, National Gallery of Australia. Courtesy of the artist.

With artists from more than 60 countries, *Postwar* is typical of the transnational mood of the contemporary artworld. However, *Postwar's* main achievement is historical: in juxtaposing canonical late modernists from Europe and the US with an unfamiliar cast from Asia, Africa, East Europe, South America and minority groups such as African Americans, it offers an historical explanation for contemporary art not available in Westernism's accounts.

Enwezor's history lesson is that the demographics of contemporary art are the result of postcolonial politics not globalism. Recent technological innovations have accelerated globalization but its transnational demographics were established in the period immediately after 1945, when the centre's cultural mix caught up with that of its periphery. The demands of colonialism had already globalised the economy and culture of modernity, in the process drawing many settler artists to the Western metropolises of Paris and London. But only after 1945 was this migration racially inclusive. Then an increasing number of black artists became part of this exodus. This postcolonial diaspora and its postnational tendencies that challenged the assumptions of Westernism, are the starting point of *Postwar*.

In juxtaposing a dominant artworld discourse in such close proximity with its peripheral other, *Postwar* shows that the absence of the periphery in Westernism's histories is an endemic blindness. Danto's artworld, after all, did not have to look very far. Fixated on heaven, it failed to see the transcultural ground upon which it stood. *Postwar* shows that by 1964 the periphery was not only in the centre, it was engaged in a similar if differently accented practice.

In extending the history of late modernism beyond the geo-political boundaries of Westernism, *Postwar* tracks new postcolonial movements of non-Western artists. Take the example of black African artists. In becoming citizens of newly formed nation states they were theoretically in a position to escape the trope of primitivism that had formerly imprisoned them. Indeed, as *Postwar* shows they were active in the Western scene of late modernism. However, because primitivism prevailed in the postwar artworld, black African art was perceived as on par with indigenous art, as if colonial law – which "made a fundamental distinction … [between] those indigenous and those not indigenous" – still operated. "If Europe had nations, Africa was said to have ethnicities, called tribes". Thus, concluded Mahmood Mamdani, postcolonial African "nationalism was a struggle to be recognized as a transethnic category":[14] it had to "challenge the idea that we must define political identity, political rights, and political justice first and foremost in relation to indigeneity".[15]

While both indigenous and black African artists modernized their products in the 20th century, each was forced into the same categories of folk, souvenir and primitive art. Despite their achievements as shown in *Postwar*, as late as 1998 the prominent contemporary art fair Art Cologne excluded Australian indigenous and black African art on the grounds that they were folk not contemporary art.[16] At the end of the century each began to find a place, albeit equivocal and insecure, in the more lucrative contemporary art market, but only black African contemporary art actually found a home here. Mamdani's challenge finally paid off for black African artists: the telos of national sovereignty was eventually a ticket into the contemporary artworld. The US civil rights movement created a similar paradigm shift for African Americans, though with its own permutations. But where are indigenous art and its ambivalent sovereignty in the telos of nationalism?

Today nearly all black Africans are, like Europeans, citizens of a nation state. In Africa "indigenous" is a word reserved for about 5% of the population – communities such as the San or "Bushmen". Their art does not appear in *Postwar* or in Enwezor and Chika Okeke-Agulu's survey *Contemporary African Art since 1980* (2009), and Enwezor has been scathing of South African contemporary art that reinvests in "the so-called endangered Bushman"[17] who live across several nation states. "There are", wrote Enwezor, "no ancient riverbeds to excavate in order to find continuing traditions … there is no need to revivify expired authenticities, nor to mourn the death of autochthonous traditions",[18] and he dismisses identity-based discourses as "wrong-headed and regressive".[19] Thus it is surprising that indigenous art was present at all in *Postwar*.

Indigenous Art in the Age of the Nation State

Mawalan Marika's *Sydney From the Air* (1963) – despite its title it is painted in a traditional Yolngu style and format – is the only indigenous artwork in *Postwar*, unless one counts work by African artists such as Twins Seven Seven or Susanne Wenger, the Austrian-born Yoruban priestess who went well beyond the indigenism (the assimilation of indigenous imagery into nationalist discourses) that is canvassed elsewhere in the exhibition. African American artists feature extensively in *Postwar*, so why are Native American artists absent? And why are Pacific Islander artists not represented despite 'Pacific' being in the exhibition's subtitle. After all, the dialogue between several Maori modernists and Pakeha indigenists exemplifies the transculturalism that Enwezor celebrates?

One explanation for Enwezor's omissions is that because mainstream artworld discourse still doesn't critique indigenous art as a living contemporary practice, it doesn't have place in its genealogy. Another explanation is the dubious motives of the few small artworlds – the settler nations of Australia, Canada and New Zealand – in which indigenous contemporary art has gained some traction since the 1980s. Why did these three former settler colonies, each with a history of slavishly following British models and with artworlds that mimicked trends in the mainstream artworld, suddenly pursue an independent course in the 1980s? The Australian postmodern artist Imants Tillers cynically answered this question in 1982, at the very moment that the Australian artworld discovered indigenous contemporary art:

> 'Cultural convergence' is attractive as an idea because it offers a painless way to expiate our collective guilt of this [colonial] history while simultaneously suggesting an easy solution to the more mundane but nevertheless pressing problem of finding a uniquely Australian content to our art in an international climate.[20]

Settler redemption would cut even less ice with Enwezor than with Tillers. What matters for Enwezor is the place of indigenous art in the telos of national sovereignty

and its logic of decolonization. Indigenous claims of sovereignty remain unrecognized in settler nations.

Settler colonies were just as subject to the postwar telos as the rest of the world, but they took a course that was very different from Europe's African and Asian colonies. In the 1950s and 60s the world's focus on African and Asian decolonisation sidelined the anti-colonial struggles of indigenes. The UN regarded their struggles as an internal national not international problem. Indigenous peoples did not get their turn until the 1970s when they internationalised their struggle with the establishment of the World Council of Indigenous People in 1975, culminating in the UN Declaration on the Rights of Indigenous Peoples in 2007. However, the need for a special Declaration of Indigenous Rights was because the UN Declaration of Human Rights (1948) – which is a justification of decolonization, and said Enwezor, a founding document of the postwar period[21] – is framed in terms of national rights and citizenship that marginalized indigenes.

To this day struggles for indigenous sovereignty have met limited success, and none more so than in Australia. Here it amounted to no more than "Native Title", which is a partial form of land tenure only available to a fraction of Australian indigenes. The ruling of the Australian High Court recognized Native Title only "under the paramount sovereignty of the Crown".[22] Arguing that indigenous Australians are subject to the laws of the Australian nation state, and having "no legislative, executive or judicial organs" except those that the state "might confer upon them", the High Court was unequivocal: "The contention that there is in Australia an aboriginal nation exercising sovereignty, even of a limited kind, is quite impossible in law to maintain".[23] While the High Court rejected the British Privy Council ruling of 1889 "that the Australian colonies were acquired by Great Britain by settlement and not by conquest", it ruled that "the annexation of the east coast of Australia by Captain Cook and the subsequent acts by which the whole of the Australian continent became part of the Dominions of the Crown were acts of state whose validity could not be challenged".[24]

Enwezor's success in advancing the cause of black African contemporary art was due to a convincing theory, convincing because it resonated with the postcolonial telos of national sovereignty that has been in play since the mid-20th century. However, Enwezor failed to find similar resonances in indigenous art. He was not the only one. While curators did theorise indigenous art as it gained unprecedented visibility in contemporary art venues towards the end of the 20th century, they did so it in ways that did not rhyme with the telos of national sovereignty.

Decolonizing Indigenous Art: A Brief History 1945–2000

After dispossessing indigenous peoples of their sovereignty, each of these settler nations began appropriating aspects of indigenous heritage for its own national identity. This eased the entry of a small number of indigenous artworks into Australian

state art galleries in the 1950s, but they did not find a proper home there until the 1980s. Then, with unprecedented suddenness, the take up of indigenous contemporary art transformed the Australian artworld. This was a significant sign of decolonization, especially since it occurred more or less simultaneously in settler nations, and at the same time as the surge of non-Western art into the wider contemporary artworld.

As elsewhere in the world, indigenous decolonisation occurred within the terms of the telos of national sovereignty, but in settler nations it took the path of assimilation into the existing nation state not the creation of a separate indigenous sovereignty. The dialectic of assimilation, which moved between transculturation and acculturation, structured the production and reception of indigenous art in settler colonies during the postwar period.

Nascent signs of assimilation were evident from the beginning of the postwar period when a few indigenous artists, such as the Australian Albert Namatjira (1904–1959) and the American George Morrison (1919–2000), gained some traction in their respective mainstream artworlds. However, generally the artworld resisted assimilation, be it by acculturation or transculturation. It preferred indigenous art to remain isolated in an ethnic dimension that Western art escaped. While Western art was also ethnic specific, it dodged this restriction via the universal claims made for the aesthetic. This led a few enthusiasts of indigenous art – such as the Australian curator and abstract expressionist painter Tony Tuckson (Enwezor included an example of his work in *Postwar*) – to frame indigenous art in purely aesthetic or modernist terms.[25]

The most significant outcome of this approach occurred in New Zealand – significant because of the level of transculturation its artists achieved. Between the late 1950s and mid 60s a group of Maori art graduates – Selwyn Wilson, Ralph Hotere, Paratene Matchitt and others – working as art teachers in a government education department initiative to revive Maori art, in tandem with Pakeha (white) modernists such as Gordon Walters and Colin McCahon, developed a distinctive Maori modernism from affinities between each tradition's abstraction. Hotere also studied and practiced in Britain and France for three years in the early 1960s. However, while now highly acclaimed, at the time these artists did not gain much recognition in the New Zealand artworld let alone the wider artworld.

A similar move was made in Australia. In 1969 Ulli Beier – the former husband of the aforementioned Susanne Wenger – who had extensive experience in Nigeria and New Guinea in modernizing indigenous art and literature, was commissioned to write a report on contemporary Australian indigenous culture.[26] While the report was suppressed because of its scathing criticism of current practices, its recommendations formed the basis of the Aboriginal Arts Board (AAB), which was established in 1973. It funded art advisers on remote communities to foster greater professionalism in art production, promoted art exhibitions within a fine art context and lobbied state art galleries to collect the art. It had limited success until the late 1970s and early

80s, when an opening suddenly appeared in the Australian artworld. This was the turning point from which the phenomenon of Australian indigenous contemporary art rapidly took shape as a postcolonial narrative.

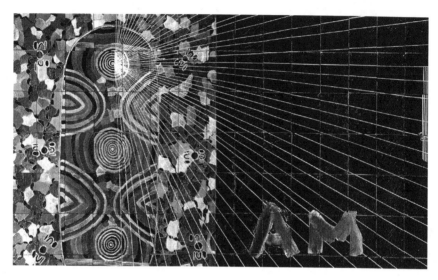

Figure 4.2 Imants Tillers, *I am Aboriginal* (1988), oilstick, gouache, synthetic polymer paint on 105 canvasboards (numbers19057–19161), 124.5cm × 190.5cm. Photographer Simon Cowling, Private collection, Perth, Australia. Courtesy of the Artist.

The usual starting point of the story is a handful of young artists and curators becoming intrigued in the large abstract acrylic canvases being produced by Papunya Tula Pty Ltd – an indigenous company formed in 1971 in central Australia to support and market their art. The paintings seemed to address in unexpected ways an impasse felt by an emerging generation of contemporary Western artists. In this respect, it opened a space for transculturation, and it did so at a time when contemporary art had moved on from questions of national identity to more postnational and universal ones.

Tillers remembered the interest initially coming from European 'artists and critics' he met at the Biennale of Sydney in 1979 and 1982.[27] Their interest was more than academic. Nikolaus Lang and Marina Abramović and Ulay, for example, used the opportunity to engage with Australian indigenous communities, which in turn led to collaborative artworks.[28] Other young artists, such as the Australian Tim Johnson and the Englishman John Wolseley, were also engaging directly with indigenous artists at this time. As if glimpsing a new transcultural future for contemporary art, the Artistic Director of the 1979 Biennale of Sydney, Nick Waterlow, enthused about Lang's work, which he said "combined Aboriginal ochres from South Australia with European

pigments – literally a bringing together of two cultures, a real dialogue".[29] The next year the preeminent historian of Australian art, Bernard Smith, who had hitherto ignored indigenous art, called for just such "cultural convergence" or transculturation.[30] Waterlow had beaten him to it by inviting three Yolngu artists from Ramingining to participate in the biennale, the first time that Australian indigenous art was exhibited as contemporary art.

In a similar transcultural spirit, three Papunya Tula paintings were selected for the inaugural *Australian Perspecta 1981* biennial of Australian contemporary art. Building on this momentum, the late William (Bill) Wright, Artistic Director of the Biennale of Sydney in 1982, invited a contingent of Warlpiri men to make a ground painting, which was displayed amidst a feast of the latest manifestation of conceptual primitivism then sweeping the artworld: Neo-expressionism. Next year the Australian presentation at the XVI Bienal de São Paulo featured an all Aboriginal cast from Papunya Tula and Ramingining, and an indigenous commissioner, the ceramicist Thancoupie. Also, that year the University of Sydney's Power Gallery of Contemporary Art (later Sydney's Museum of Contemporary Art Australia), which had a large collection of the latest artworld offerings from Europe and the US, began acquiring a large collection of some 200 works from Ramingining, exhibiting it in 1984.

The pace quickened and globalised during the rest of the decade. The ground painting at the Biennale of Sydney in 1982 had impressed two visiting French curators, Suzanne Pagé and Jean-Hubert Martin.[31] Pagé invited the Warlpiri men to the Paris Autumn Festival the next year, along with a large contingent of settler Australian Neo-Expressionists, and the seeds were sown for Martin's grand vision that culminated in *Magicians of the Earth* (1989) at the end of the decade. Under the auspices of the Centre Pompidou, Paris's main venue for modern and contemporary art, Martin's *Magicians* paired Western and non-Western artists, including a considerable contingent of indigenous artists from Australia and elsewhere – thus making a clear statement about the contemporaneity of their art and transculturation and transnationalism more generally.

Magicians was part of an emerging trend in which non-Western artists infiltrated the mainstream artworld. Emboldened by this new climate, a series of impressive indigenous art exhibitions left Australia for overseas during the next decade, each determined to make its mark as contemporary art. Several ground-breaking exhibitions of indigenous contemporary art also appeared in Australian state art galleries. Clearly the Australian artworld had been won over. Collectors from around the world flocked to mop up the spoils. The mainstream artworld also came, took a brief look but turned away. The reason was the lack of an appropriate theory. The recent artworld success of indigenous art was an aspect of the postnational mood of contemporary art but it foundered on the residual primitivism in the theorization of indigenous contemporary art.

Colonizing Indigenous Art 1945–2000

The sudden influx of indigenous art into contemporary art venues during the 1980s made it the flashpoint of theoretical speculation. For example, Tillers and Johnson, both of whom had embraced the legacy of conceptual art in the 1970s, considered the Papunya Tula canvases to be, like theirs, a form of conceptual art. Others compared the art to late modernism but the most powerful current was what I call 'conceptual primitivism', which drew connections between the indigenous ritual practices and recent Earth, Performance and Body Art.[32] Conceptual art's legacy was felt so widely in the 1970s that it permeated even these more romantic strains of art practice, from which, for the sake of argument, it is necessary to distinguish the more classical conceptualism of postmodern deconstruction.

Boris Groys drew a similar distinction between the classical conceptualism of Joseph Kosuth and *Art & Language*, and what he called the 'romantic conceptualism' of Yves Klein and various Moscow conceptualists.[33] However, classical conceptualism was not immune to primitivism. For example, after studying anthropology in 1971, Kosuth 'went to South America and lived with the Yagua Indians in the Peruvian Amazon, and Alice Springs in Australia, where', he said, 'I lived with Aborigines'. He added, 'I never had the pretence that I would enter their space but I wanted to feel what was the edge of mine',[34] yet, Kosuth believed that 'the longing for a primitive mode of existence is no mere fantasy or sentimental whim; it is consonant with fundamental human needs'.[35] The important point for distinction is that postmodern deconstruction worked with the limits of discourse, while conceptual primitivism looked beyond these limits for what it considered more fundamental truths in the earth and the body – a classic example being Abramović and Ulay's search amongst Aborigines in central Australia for the secrets of telepathic communication.

In vogue, internationally in the late 1960s and 70s, conceptualist primitivism was popular in Australian contemporary art practice, as Suzi Gablik noticed when she visited the country in 1980. Reporting her visit in *Art in America* and clearly primed for what she discovered, she fell under the spell of "the aboriginal presence of the bush":

> when I touched the country – which hangs back aloof and unapproachable
> just beyond the cities – and encountered a landscape so fierce and
> primevally strange … I felt myself in the presence of something uniquely
> Australian, a stored power … it certainly changed me forever.[36]

Gablik's enthusiasm for indigenous practices in remote Australia rubbed off in her experience of white Australian art: Tom Arthur's "totemic landscapes",[37] John Davis' "'low-tech' … materials of nature" that resembled "aboriginal ceremonial sticks, shamanistic prayer arrows or healing wands", and Peter Taylor's lyrical carvings that reminded her of "American Indian totems".[38]

Similarly, Bernice Murphy, the curator *Australian Perspecta 1981*, included three Papunya paintings as part of her focus on "a ritualistic, tribal and sub-rationalistic connection

with the environment".[39] While such neo-primitivism became the main theoretical means by which curators brought indigenous contemporary art into the artworld, it would also prove its main impediment, especially in the aftermath of the critical storm unleashed by MoMA's ambitious 1984 exhibition, *"Primitivism" in 20th Century Art.*

Curators did more than anyone else in the artworld to open its gates to indigenous contemporary art. Artists and critics of a postmodern persuasion tended to be more sceptical of this curatorial push.[40] The critical reaction against MoMA's *Primitivism* exhibition sharpened the knives of such critics, who were quick to dismiss both the exhibition and primitivism more generally as a fantasy other: "an illusion of the West's own making: a phantasmic projection of its fears and desires which have never produced anything but a misrecognition and, in consequence, a fatal disruption of the culture of other peoples".[41] One consequence, which became very evident after the criticism of *Primitivism,* was that indigenous art was no longer available as a figure of the primitive – unless it was played as irony, pastiche or farce, and preferably in the hands of a black artist, as in the work of Bennett or Kara Walker. This, however, shows that the trope still operated in new postmodern guises. Fantasy is ever powerful. Not easily eradicated from the human psyche, primitivism found its way into all sorts of discourses, including postcolonial and indigenous ones.

But there was a deeper problem. Indigenous art had come to be something more substantial in the minds of modernists than a fantasy other. As modernity's radical 'Other' – in the Lacanian sense of an a priori or transcendental Other – the primitive (from Latin *primus* "first") is a figure of origin, in this case the origin of the modern subject (and of modernism). This produced a double bind. On the one hand, in the telos of modernity origin narratives are, like childhood, forever left behind in the fulfilment of the modern project. However, if this made the primitive a figure of infantilism (as well as fetishisation), it also produced an intractable ancestral scene that could not be wished away as a fantasy projection. This is evident in modernism's submission to the formal language of indigenous art as the first law in which the symbolic order is formed. As late as the 1950s and 60s the Czech modernist artist Karel Kupka – an associate of Surrealist leader André Breton – journeyed to Arnhem Land "in search of the origins of art".[42] The value of the indigenous art he brought back to Paris, said Breton, is that it gave us access to 'lost powers': "by laying bare to us the roots of the plastic arts it helps us to reconcile man with nature and himself". "We are here at the source of conceptual representation".[43]

In instantiating indigenous art as its a priori Other, the trope of primitivism established – as it had for Breton – a conceptual bond between modernism and indigenous art. Thus, it was common for curators and critics to comment on their many affinities. Indeed, this was the basis of MoMA's *Primitivism* exhibition. This conceptual bond meant that there was nothing peripheral about indigenous art. "Tribal art", said Foster, was "constructive, not disruptive, of the binary ratio of the west [that dialectic quest

Danto referenced]; fixed as a structural opposite or a dialectical other to be incorporated, it assists in the establishment of a western identity, centre, norm and name".[44] Thus nurturing the indigeneity or ab-originality of indigenous contemporary art in the name of identity politics leaves it susceptible to the trope of primitivism. In claiming to be the first people indigenous people assert their primitiveness (primitive: from Latin *primus* "first") and rule out their modernity. No wonder Enwezor is wary of indigenous contemporary art.

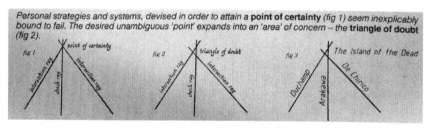

Figure 4.3 Tillers, Imants. "One Painting Cleaving (Triangle of Doubt) (1982)." In *Eureka! Artists from Australia*, edited by Sue Grayson, and Sandy Nairne, 36. London: Institute of Contemporary art and the Arts Council of Great Britain.

The Declaration of Human Rights in 1948 and the political realignments of the postwar period spelt the end of cultural primitivism as a viable trope – an end already prefigured in earlier anti-colonial and anthropological theory. However, the artworld clung to the trope of primitivism well after its use-by date. As Kupka was searching for the origins of art in the well-kept missions of Arnhem Land courtesy of modern air transport, a new generation of anthropologists was studying indigenous communities as contemporary living cultures rather than fossils of a lost age. Anthropological discourse discarded the term primitive in the postwar era but it regularly appeared in artworld discourse as late as the 1980s – most famously in MoMA's *Primitivism* exhibition. Well aware that times had changed, William Rubin – the curator of the exhibition – felt it necessary to mount a concerted defence of his terminology. But by then, said Foster, it was indefensible. 'The romantic artists at the end of the last [19th] century' can "be pardoned" for their primitivism, said Foster, but this is not the case with "an art historian at the end of this [20th] century".[45]

It may have been indefensible but at the time of MoMA's *Primitivism* exhibition primitivism was a going concern in the most celebrated avant-garde art. Indeed, the *Primitivism* exhibition had concluded with examples of recent conceptualist primitivism. No wonder postcolonial critics were suspicious of the artworld's sudden flurry of interest in non-Western art. Rasheed Araeen, chief editor of the postcolonial art journal *Third Text*, warned that it was a smokescreen behind which the artworld would maintain its hegemonic "exclusion of non-white people as historical subjects from the grand narratives of modernism".[46] The London-based Nigerian-born artist

and critic, Olu Oguibe, was also dubious. He believed the artworld was essentially racist and only interested in black artists if they played to its "neo-primitivizing" desire.[47] The Australian artist Gordon Bennett similarly complained of the racism in which his art was received. Like Araeen and Oguibe he too was sceptical that the artworld had changed its colours and was wary of the new identity politics in Australia in which Aboriginality was flavour of the month. Rejecting "the grounds of any ethnic essentialism", he warned against the "trap" of "Aboriginality" and the polarization of "identity into black and white opposites".[48]

All three were speaking at a conference organized in 1994 in London to discuss the emerging postWestern artworld.[49] Believing that the discredited trope of primitivism was deeply ingrained in artworld thinking, they were sceptical that it could be thrown off with a bit of postmodern transnational transculturation. For example, while in *Magicians* Martin rebuked the temporal logic of primitivism by placing contemporary artists from Western and non-Western cultures in conversation, critics attacked *Magicians* for its own primitivism. Having "opened a potentially fruitful internal reflection on 'the relationship of our culture to other cultures of the world', said the British critic Jean Fisher (an editor of *Third Text*), Martin then buried it under the obfuscating ahistorical and apolitical sign of 'magic'".[50] She concluded that Martin's approach "becomes no more than a means to reclaim a value for dominant Western art, to rescue it from its tired and debased status as a reified commodity in a capitalist market".[51] What, she wondered, was exchanged in the supposed dialogue in the most reproduced image of the exhibition – the juxtaposition of the ground painting *Yarla* by Warlpiri artists from Yuendumu and Richard Long's mud mural on the wall behind it? There was no explication of its supposedly transcultural context and, looking beyond its powerful aesthetic appeal, she described Long's mud mural as a "Western neo-primitive aestheticisation of the sign of others' cosmogonies", and complained that it "dominated the horizontal Yuendumu earth painting below it … Far from reflecting a dialogue between the two, the relationship replicated the juxtaposition of the colonized and the coloniser".[52]

Against Indigenous Art

The most intractable problem for indigenous art was not Rubin's primitivism or Martin's exoticism, which was anachronistic, but contemporary art theory, which excluded indigenous art from the discourse of contemporary art. It did this from the two most powerful theoretical currents of the 1980s, postcolonialism and postmodernism.

As we have already seen, African postcolonial critics marginalized indigenous art. For African expatriates such as Enwezor and Oguibe the mistake made by the new African nation states was that having gained their freedom from the colonising straightjacket of ethnicity and indigenity, they adopted the tropes of indigenism to

ferment a national identity. Turning away from indigeneity – or what for their parent's generation had been Négritude – and towards transculturation, these postcolonial critics found vindication in the transnationalism of their diasporic condition.

This journey from colonized indigenous to postcolonial national citizen and finally contemporary transnational cosmopolitan is the story Enwezor told in his acclaimed exhibition, *The Short Century* (2001). The effect was to discredit indigenous art as a viable form of contemporary art. A similar logic is evident in Oguibe's complaint in 1994 about the "race-specific" nature of the new interest in "indigenous Australian artists": it "is viewed as traditional or transitional art, and thus inappropriate to be qualified as international"[53] – international being a signifier of contemporary art. The problem for Oguibe was the mixed signals. Indigenous art was being sold as both contemporary art and in ways that emphasized its indigeneity, which in his mind reinforced its association with primitivism.

Postmodern anti-primitivism threw the baby out with the bathwater. The one achievement of MoMA's *Primitivism* exhibition in Foster's opinion is that it did establish "our distance from the modern and tribal objects". Both had, in the postmodern age, become anachronistic objects: "though presented as art, the tribal objects are manifestly the ruins of (mostly) dead cultures now exposed to our archaeological probes".[54] Rejected was not just the trope of primitivism that had been the initial platform for the entry of indigenous art into the modern artworld but also everything with which modernism was associated, including indigenous art.

While Foster harboured nostalgia for the transgressive achievements of modernism's primitivism, and criticized Rubin for not engaging "with an outside (tribal traditions, popular cultures etc.) that might disrupt the order of western art and thought",[55] his dismissal of primitivism was for historical rather than ethical reasons: its potential for critique had become impossible because "there are now few zones of 'savage thought' to oppose the western *ratio*, few primitive others not threatened by incorporation".[56] He ultimately blamed the modernist vogue of aestheticising indigenous art, which he believed was on full display in the *Primitivism* exhibition: "The founding act of this recoding is the repositioning of the tribal object as art ... This aestheti-sation allows the work to be both decontextualized and commodified".[57] Thus contemporary indigenous art was unequivocally sidelined as crass commercialisation.

The problem for indigenous contemporary art is that its artists had, like their curatorial supporters, self-consciously taken the route of aestheticisation and commodification. What happens, asked Foster, when even "the unconscious and the other are penetrated – integrated into reason, colonized by capital, commodified by mass culture?"[58] Indigenous artists had an obvious answer: it becomes contemporary art.

By refusing indigenous artists permission to play the politics of transculturation, they are excluded from the processes of modernization and national sovereignty. Such

thinking peppered critical reaction to exhibitions of indigenous contemporary art in the 1980s and 90s, in which critics complained that curators had decontextualised indigenous art by framing it as contemporary art.[59]

Conclusion: An Inappropriate Theory of Indigenous Contemporary Art

If postmodern and postcolonial critics based in New York and London were suspicious of indigenous art, in settler nations like Australia this was less the case. In 1996 Foster proposed "two contradictory imperatives in culture today: deconstructive analysis and identity politics".[60] In Australia these two imperatives were evident in indigenous and non-indigenous contemporary art but it is the former, deconstructive analysis – which is associated with postmodernism and the transculturation of postcolonialism – that most effectively addresses Enwezor's omission of indigenous art.

For example, Trevor Nickolls and Lin Onus – both pioneers, in the nascent Australian urban indigenous art scene in the early 1980s – sought common ground between indigenous and Western art practices. At much the same time Tillers also embarked on a transcultural and highly deconstructive practice that in 1982 crossed over into the territory of indigenous art. Within a decade Tillers' practice had merged with the urban indigenous current Nickolls had generated into an explicit postcolonial conceptualism that thrives to this day – evident in the work of some of Australia's most prominent second and third generation urban artists of indigenous origin, such as Vernon Ah Kee, Brook Andrew, Richard Bell, Gordon Bennett and Tracey Moffatt.

Figure 4.4 Michael Nelson Jagamara and Imants Tillers,
Hymn to the Night (2011- 2012), synthetic polymer on
165 canvasboards (numbers 89763 – 89927), 277cm × 532cm.
Private collection. Courtesy of the artists and
Fire Works Gallery, Brisbane, Australia.

Bennett and Bell are Tillers' most obvious progeny. However, as a white settler artist of Latvian origin – his parents were postwar refugees – Tillers is an inappropriate practitioner let alone ancestor of indigenous contemporary art, even I imagine for the cosmopolitan Enwezor let alone for the artworld and least of all for the Australian artworld. However, the very audaciousness of this transcultural idea clearly incited Tillers from as early as 1982, when he wrote: "We do not yet have a white artist who can declare with conviction: 'I am aboriginal'".[61] Six years later, during the bicentenary of British colonial settlement of this Aboriginal continent, Tillers painted I am Aboriginal – a work that draws into conversation three strands of thinking that have long preoccupied him, each of them deeply metaphysical and esoteric: Colin McCahon, Arakawa (the New York based Japanese mystic and post-Duchampian artist whom Danto admired) and central Australian indigenous art. The work is a typical Tillers' tableau of transculturation: three lines (trajectories) that cross to form his' "triangle of doubt" – a figurative overlapping space in which opens "the expansion of possibility and knowledge".[62] As I am Aboriginal testifies, throughout his career Tillers has taken several guises – often at the same time – of which indigenous artist is just one.

During the 1970s, then in his twenties, Tillers earned an enviable reputation in Australia as a conceptual artist. He was one of two Australian artists invited to participate in Rudi Fuch's Documenta 7, which like Wright's Biennale of Sydney of the same year (1982), had celebrated the arrival of the latest version of conceptual primitivism: Neo-Expressionism. Wary of conceptual primitivism's 'artificial blending' of 'the exoticism of Aboriginal culture with certain manifestations of contemporary art',[63] Tillers took a stand against it. He was critical of the rhetoric around Neo-Expressionism and withdrew from Pagé's Paris Festival exhibition in 1983 because he believed placing the Warlpiri ground painting in the context of Neo-Expressionism played into the myths of primitivism.[64]

Despite Tillers' objection to conceptual primitivism and the connections it drew with indigenous contemporary art, this was the very moment that he was converted to the idea of putting both in conversation, as if it demonstrated "unexplained connectedness between events in different 'space-like separated' places".[65] It resonated, he thought, with a theory in quantum physics known as 'Bell's Theorem', that had been published in 1964. In late 1982, as he prepared to launch an international career as an appropriation artist, Tillers completed his first appropriation of an indigenous artwork in Neo-Expressionist style. He called it Island of the Dead, which references Böcklin's painting of the same name and the "extermination of the Tasmanian aborigines by the white settlers".[66]

It was part of a new beginning for Tillers, quite literally in the sense that it was the start of what would become his signature canvas board format – a format then associated with early Papunya Tula paintings. Since then Tillers has dutifully numbered each canvas board as if each is a segment of one extended lifework that he named The Book of Power. Like the Book of the Dead, it is one long genealogical tract of his

artistic ancestral relations, and "maybe even," said Tillers, "to use Arakawa's term, a crude 'model of being'".[67]

Shortly afterwards, in early 1983, Tillers painted the enigmatic *White Aborigines* and wrote an article about the confluence of 'Papunya canvasboards' and conceptual art, which he said can be literally seen in the figure of the artist Tim Johnson, who is "a conceptualist" and "one of Papunya painting's chief publicists".[68] That same year Tillers explored this idea in an exhibition he curated at the Yuill/Crowley gallery in Sydney. Called *Waiting for Technology*, it juxtaposed four paintings by Johnson that depicted Papunya Tula artists with their paintings, with the actual paintings – as if these eight works were a collaborative inter-subjective event of an as yet unarticulated cosmology.

What Tillers did not know but would discover the next year is that his juxtaposition of Western and indigenous art had pre-empted MoMA's *"Primitivism"* exhibition. However, whereas *Waiting for Technology* had explored intimate contemporary connections between the artists and the artworks, to his frustration the MoMA exhibition used indigenous art as a prop to explore ideas about Western art and its artists exclusively.

Tillers' critical response was to paint *The Nine Shots*, first exhibited in New York in 1985. It put into conversation appropriated imagery from an early painting by the famous Neo-Expressionist artist Georg Baselitz, *Forward Wind*, completed in 1966, and a painting from 1984 – the year of MoMA's *Primitivism* exhibition – by the relatively unknown Warlpiri artist Michael Nelson Jagamara; thus, reversing the assumed temporalities of primitivism that Rubin had employed.

In the Australian artworld *The Nine Shots* quickly become a seminal painting of the period. Controversial in its time – his appropriation of an indigenous design was seen as an act of colonisation[69] – it was an early target for Bennett's influential deconstructive appropriation strategies. He and later Bell took up Tillers' challenge by appropriating his work and, like him, developing their own open-ended conversations with both the artworld and colonial history.[70] It also instigated what, some 15 years later, became a lengthy commitment to a series of collaborations between Jagamara and Tillers, thus establishing the sort of intimate transcultural exchange that MoMA's *Primitivism* exhibition prohibited in its very conception. Despite being at the instigation of Jagamara, this aesthetic transculturation has been treated with suspicion, mainly because the relationship between an indigenous artist – even one as savvy as Jagamara – and a postmodern artist like Tillers is considered within the frame of colonialism rather than postcolonialism. The Australian settler nation remains a site of plural and contested sovereignties, as are Jagamara and Tillers' collaborative canvases.

What this alternative transcultural history tells us about either indigenous contemporary art or the artworld, let alone what its genealogies might be, is as yet

unexplored. Tillers, however, is by his own actions unavoidably immersed in these other alternative histories, and very occasionally, when pried, he voices some ideas about their poetic relations. On 21 December, 2016, he wrote:

> In 2001 at the invitation of Michael Eather I began a collaborative relationship with Michael Nelson Jagamara at Fireworks Gallery in Brisbane, and it was here that I met a number of other artists from the stable of Fireworks Gallery including Richard Bell ... Soon after in 2002 he produced a painting on 25 canvasboards in the manner of 'Imants Tillers' which he titled *Bell's Theorem* ... The work is dominated by the text, a catch-cry that Bell has subsequently frequently repeated:
>
> ABORIGINAL ART IT'S A WHITE THING
>
> Was this a personal message for *me*? Bell's *Bell's Theorem* was then included as part of the exhibition held at Fireworks Gallery in 2002 called *Discomfort: Relationships within Aboriginal Art: Richard Bell, Emily Kngwarreye, Imants Tillers, and Michael Nelson Jagamara.*
>
> After this *Bell's Theorem* 2002 disappeared completely from my view until, that is, I began writing this text. A Google search on John Bell uncovered a BBC News report in 2014 entitled *John Bell: The Belfast Scientist who Proved Einstein Wrong.* This report revealed a commemorative exhibition to coincide with the 50th anniversary of Bell's momentous discovery [Bell's Theorem]... 'including a contemporary piece by Aboriginal artist Richard Bell that is on show in Europe for the first time.' I was quiet taken aback! But then it dawned on me that I too was in this exhibition and *my inclusion had happened without my knowledge.* And it was not just the direct references to me in Bell's paining. This was a painting by Imants Tillers executed by Richard Bell. It's now part of my *Book of Power* and has been allocated the following numbers: 99826 to 99850.[71]

Sovereignty it's an elusive thing. Here, as in his collaborations with Jagamara, it's also a bargain – a throw of the dice – struck and recorded by Tillers in the numerology of the *Book of Power*. Not numbered but surely implicated are the numerous examples Bell has painted since then in his *Bell's Theorem* series, upon which he has written innumerable slogans about sovereignty, such as (again) "Aboriginal art it's a White Thing" – in *Scienta E Metaphysica (Bell's Theorem)* 2003 – "Australian Art Does Not Exist", in *Judgement Day (Bell's Theorem)* 2008 – "I am a Noble Savage", in *Life on a Mission (Bell's Theorem)* 2009 – and "Western Art Does Not Exist" in *Prelude to a Trial (Bell's Theorem)* 2011.

This deconstructive indigenous contemporary art chimes nicely with Enwezor's vision that "transnational, transurban, transdiasporic, transcultural practices are transforming the ways in which we understand the world".[72] As it happens, Tate Modern has recently had this deconstructive current of indigenous contemporary art in its sights. Soon, it seems, this inappropriate art will make it into the inner sanctum.

Remote indigenous contemporary artists will just have to wait a little longer, until someone at Tate Modern stumbles on a way in which their large colourful paintings might be brought in from the cold. The artworld's dialectical working out of an idea never stands still.

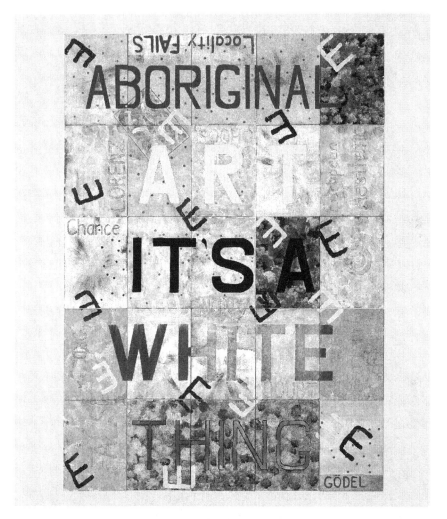

Figure 4.5 Richard Bell, *Bell's Theorem* (2002), acrylic on 25 canvas boards, 173cm × 127cm. Collection of the artist. Courtesy of the artist and Milani Gallery, Brisbane, Australia.

Notes

1 Imants Tillers, "One Painting Cleaving (Triangle of Doubt)," in *Eureka! Artists from Australia*, ed. Sue Grayson and Sandy Nairne (London: Institute of Contemporary art and the Arts Council of Great Britain, 1982).

2 Arthur C. Danto, "The Artworld," *The Journal of Philosophy* 61, no. 19 (1964): 581.

3 Ibid., 584.

4 Terry Smith, "The Provincialism Problem," *Artforum* 13, no. 1 (1974).

5 Danto, "The Artworld," 580.

6 Ibid., 584.

7 Ibid., 581.

8 Hal Foster, "The Return of the Real," in *The Return of the Real: The Avant-Garde at the End of the Century* (Cambridge, MA: MIT Press, 1996).

9 Boris Groys, "Lasst Euch Nicht Täuschen!," *Zeit Online*, no. 14 January 2017. translation Paris Lettau
http://www.zeit.de/2017/03/donald-trump-renationalisierung-russland-propaganda

10 Okwui Enwezor, "The Black Box," in *Documenta 11 Platform 5: Exhibition Catalogue* (Ostfildern-Ruit: Hatje Cantz, 2002), 46.

11 Stuart Hall, "The West and the Rest: Discourse and Power," in *The Formations of Modernity: Understanding Modern Societies an Introduction Book 1 (Introduction to Sociology)*, ed. Stuart Hall and Bram Gieben (Cambridge: Polity Press, 1992).

12 At the *Haus der Kunst* in Munich.

13 Fernando Ortiz, *Cuban Counterpoint: Tobacco and Sugar*, trans. Harriet de Onís (New York: Alfred A. Knopf, 1947).

14 Mahmood Mamdani, "Beyond Settler and Native as Political Identities: Overcoming the Political Legacy of Colonialism," in *The Short Century: Independence and Liberation Movements in Africa 1945-1994*, ed. Okwui Enwezor (Munich: Prestel, 2001), 22-23.

15 Ibid., 27.

16 See: John McDonald, "Faint Heart Never Won Fair Deal," *Sydney Morning Herald*, 20 November 1998. In 1997 Art Basel had applied a similar ban as had Art Cologne in 1994 (though it eventually relented). See: David Throsby, "But Is It Art," *Art Monthly Australia* 105, no. November (1997).

17 Okwui Enwezor, "Reframing the Black Subject: Ideology and Fantasy in Contemporary South African Representation," *Third Text* 40, no. Autumn (1997): 28.

18 Okwui Enwezor and Chika Okeke-Agulu, *Contemporary African Art since 1980* (Bologna: Damiani, 2009), 13.

19 Okwui Enwezor, "The Postcolonial Constellation: Contemporary Art in a State of Permanent Transition," in *Antinomies of Art and Culture: Modernity, Postmodernity, Contemporaneity*, ed. Terry Smith, Okwui Enwezor, and Nancy Condee (Durham: Duke University Press, 2008), 226.

20 Imants Tillers, "Locality Fails," *Art & Text* 6, Winter (1982): 53.

21 Okwui Enwezor, "The Judgement of Art: Postwar and Artistic World Worldliness," in *Postwar: Art between the Pacific and the Atlantic 1945–1965*, ed. Okwui Enwezor, Katy Siegel, and Ulrich Wilmes (Munich: Haus der Kunst and Prestel, 2016), 53.

22 Chief Justice Mason, "Coe V Commonwealth [1993] Hca 42; (1993) 68 Aljr 110; (1993) 118 Alr 193 (17 August 1993)," (High Court of Australia, 1993), Decision #27.

23 Ibid., Decision #24.

24 Ibid., Decisions # 22–24

25 J. A. Tuckson, "Aboriginal Art and the Western World," in *Australian Aboriginal Art*, ed. Ronald M. Berndt (Sydney: Ure Smith, 1964).

26 Ulli Beier, "Encouraging the Arts among Aboriginal Australians: A Report for the Australian

Council of the Arts," in *Encounters with Aboriginal Australians*, ed. Ulli Beier (Sydney: Ulli Beier, 1969).

27 Tillers, "Locality Fails," 54.

28 Charles Green, "Group Soul: Who Owns the Artist Fusion," *Third Text* 71 (2004); Stephanie Radok, "Focus: No Man Is an Island: A Two Part Reading," *Artlink* 21, no. 2 (2001); H. R. Bell, *Storyman* (Cambridge: Cambridge University Press, 2009).

29 Nick Waterlow, "1979 European Dialogue," in *Biennale of Sydney 2000*, ed. Ewen McDonald (Sydney: Biennale of Sydney, 2000), 169.

30 Bernard Smith, *The Spectre of Truganini: 1980 Boyer Lectures* (Sydney: Australian Broadcasting Commission, 1980).

31 Sally Butler, "Multiple Views: Pluralism as Curatorial Perspective," *Australian and New Zealand Journal of Art* 4, no. 1 (2003).

32 Nicholas Baume, "The Interpretation of Dreamings: The Australian Aboriginal Acrylic Movement," *Art & Text* 33 (1989).

33 Boris Groys, "Moscow Romantic Conceptualism," *A - ja / Contemporary Russian art* 1 (1979).

34 Quoted in: Payal Uttam, "The Writing on the Wall," Prestige Hong Kong, http://prestigehong-kong.com/2012/11/writing-wall.

35 Joseph Kosuth, "The Artist as Anthropologist," in *Art after Philosophy and After: Collected Writings, 1969-1990*, ed. Gabriele Guercio (Cambridge: MIT Press, 1993), 115.

36 Suzi Gablik, "Report from Australia," *Art in America* (1981): 29.

37 Ibid., 32.

38 Ibid., 35.

39 Bernice Murphy, *Australian Perspecta 1981* (Sydney: Art Gallery of New South Wales, 1981), 13.

40 Examples include: Krim Benterrak, Stephen Muecke, and Paddy Roe, *Reading the Country: Introduction to Nomadology* (Fremantle: Fremantle Arts Centre Press, 1984); Marcia Langton, *Well, I Heard It on the Radio and I Saw It on Television...* (Sydney: Australian Film Commission, 1993); Vivien Johnson, "The Art of Decolonisation," in *Two Worlds Collide: Cultural Convergence in Aboriginal and White Australian Art* (Sydney: Artspace, 1985); Eric Michaels, *Bad Aboriginal Art: Tradition, Media and Technological Horizons* (St Leonards: Allen & Unwin, 1994); Tony Fry and Anne-Marie Willis, "Aboriginal Art: Symptom or Success?," *Art in America* 77, no. 7 (1989); Anne-Marie Willis and Tony Fry, "Art as Ethnocide: The Case of Australia," *Third Text* 5 (1989).

41 Jean Fisher, "Fictional Histories: Magiciens De La Terre—the Invisible Labyrinth," in *Making Art Global (Part 2): 'Magiciens De La Terre' 1989*, ed. Lucy Steeds (London: Afterall Books, 2013), 251.

42 Karel Kupka, *Dawn of Art: Painting and Sculpture of Australian Aborigines* (Sydney: Angus and Robertsoon, 1965).

43 André Breton, "Preface," in *Dawn of Art: Painting and Sculpture of Australian Aborigines* (Sydney: Angus & Robertson, 1965), 9-11.

44 Hal Foster, "The "Primitive" Unconscious of Modern Art or White Skin Black Masks," in *Recodings* (Seattle: Bay Press, 1985), 196.

45 Ibid., 197.

46 Rasheed Araeen, "New Internationalism, or the Multiculturalism of Global Bantustans," in *Global Visions: Towards a New Internationalism in the Visual Arts*, ed. Jean Fisher (London: Kala Press in association with The Institute of International Visual Arts, 1994), 5.

47 Olu Oguibe, "New Internationalism," in *Global Visions: Towards a New Internationalism in the Visual Arts*, ed. Jean Fisher (London: Kala Press in association with The Institute of International Visual Arts, 1994), 56.

48 Gordon Bennett, "The Non-Sovereign Self (Diaspora Identities)," in *Global Visions: Towards a New Internationalism in the Visual Arts*, ed. Jean Fisher (London: Kala Press in association with The Institute of International Visual Arts, 1994), 120, 25.

49 *A New Internationalism,* it was devised and managed by the London-based South African artist Gavin Jantjes for the newly established Institute of International Visual Arts (InIVA).

50 Fisher, "Fictional Histories: Magiciens De La Terre—the Invisible Labyrinth," 250.

51 Ibid., 253.

52 Ibid., 255.

53 Oguibe, "New Internationalism", 56.

54 Foster, "The "Primitive" Unconscious of Modern Art or White Skin Black Masks," 191.

55 Ibid., 190–91.

56 Ibid., 206.

57 Ibid., 186.

58 Ibid., 206.

59 For example: Fry and Willis, "Aboriginal Art: Symptom or Success?."; Willis and Fry, "Art as Ethnocide: The Case of Australia."; Rasheed Araeen, "Come What May: Beyond the Emperor's New Clothes," in *Complex Entanglements: Art, Globalisation and Cultural Difference,* ed. Nikos Papastergiadis (London: 2003).

60 Foster, "The Return of the Real," 168.

61 Tillers, "Locality Fails," 60.

62 *Eureka! Artists from Australia: Ica and Serpentine Gallery,* (London: Arts Council of Great Britain and ICA, 1982), 36.

63 "In Perpetual Mourning," in *Imants Tillers: Venice Biennale 1986 Australia,* ed. Kerry Crowley (Sydney and Adelaide: The Visual Arts Board of the Australia Council and Art Gallery Board of South Australia, 1986), 18.

64 Communication with the author.

65 Tillers, "Locality Fails," 55.

66 Ibid., 57.

67 Imants Tillers, "Metafisica Australe." Art + Australia 53, no. 2 (Issue One May 2017): 52-59.

68 "Fear of Texture," *Art & Text* 10, Winter (1983): 16-17.

69 Juan Davila, "Aboriginality: A Lugubrious Game?," *Art & Text* 23/4, March-May (1987).

70 I have explored in detail the connections between these artists' works in: Ian McLean, "Post-Western Poetics: Postmodern Appropriation Art in Australia," *Art History* 37, no. 4 (2014).

71 Tillers, "Metafisica Australe."

72 Okwui Enwezor et al., "Introduction," in *Documenta 11 Platform 3: Créolité and Creolisation,* ed. Okwui Enwezor, et al. (Ostfildern-Ruit: Hatje Cantz, 2003), 16.

The Space of Reception: Framing Autonomy and Collaboration

Jennifer A. McMahon and Carol Ann Gilchrist

I N THIS CHAPTER, WE analyse the ideas implicit in the style of exhibition favoured by contemporary galleries and museums, and argue that unless the audience is empowered to ascribe meaning and significance to artwork through critical dialogue, the power not only of the audience is undermined but also of art. We argue that unless (i) *indeterminacy* is understood, (ii) the *critical* rather than *coercive* nature of art is facilitated, and (iii) the conditions for *inter-subjectivity* provided, galleries and museums preside over an experience economy devoid of art.

I Introduction

The communicative basis of art has always been unique in the way it involves expression without argument, and in some cases, evokes ideas which make a point. In this chapter, we will refer to this quality of a work as its *indeterminacy*. It is not a matter of anything goes regarding interpretation but neither is it a case of explicit rule-following. Hence the object of our appreciation when in dialogue about a work is never fixed. We are constantly re-aligning our perceptions based on new ideas, analogies, metaphors and examples. The in-flux nature of the art object is its strength. While the artwork must offer the promise of resolution in order to prompt interpretation, it must never provide it. All the patterns of our communicative strategies nonetheless reveal our aim is to reach correctness and consensus. The fact that we

never reach this end does not undermine the integrity and the insight such exchanges provide, but rather conditions them.

In this chapter, we assume that art is *critical* by definition, as opposed to *coercive*. As a critical entity, art occasions a rationally grounded interpretative process. This means that in the descriptions under which we perceive a work, there is a sense in which we might misrepresent a work's meaning. On the other hand, the descriptions we raise may be those through which the work is more insightful, satisfying or pleasurable, (where certain pleasures are susceptible to acculturation rather than simply given). That is, we do not treat rationality and emotion as polarised. Coercion, on the other hand, operates on a kind of mindless pleasure. A coercive work plays to our prejudice, distracts us from care, flatters our concepts of self-worth and by these means shapes experience through a kind of positive reinforcement. A coercive work can be like a mindless training device if you will. This is what we would call entertainment rather than art.

The sense in which art is critical, is not necessarily that it criticises. Instead its critical aspect is defined as such by the kind of engagement it invites. Above in discussing indeterminacy the dialogical nature of artistic reception was highlighted. And this involved a volatile configuration as art. This necessarily engages one's subjectivity. The idea of subjectivity is not a straightforward concept. It might be thought that one is referring to personal impressions or idiosyncratic responses. However, when one can be said to be responding to art critically rather than some chimera one imagines in its place (where art is treated as springboard to private reverie), one is necessarily engaging with a public system of meaning. The way one locates this system of meaning is in finding the terms by which one can communicate indeterminate meanings. The larger the group within which one engages in dialogue about indeterminate meanings, and makes oneself understood, the more one is settling upon a shared system of meaning. It is in this sense that art is critical. In this way, art's *indeterminacy* creates the conditions of the establishment of *inter-subjectivity*. The more communicable one's response to an artwork, the more publicly structured one's response can be said to be. The thought is that to communicate feeling one must have structured that feeling according to shared terms.

Art can broaden what one can conceive, or how one carves up experience and in turn what one *can* experience. Because it does this without argument, it presents an interesting example of the way one can have commitments without intolerance to opposing views. This does not make the commitment any less strong but if taken as a model for engaging more broadly, it does influence the way one engages with difference or opposing views. The practice of artists might be where we need to look in order to find a model for commitment compatible with tolerance; or commitment compatible with pluralism.[1]

The above concepts, *indeterminacy, art-as-critical rather than coercive*, and *inter-subjectivity*, are the terms by which we will analyse the assumptions demonstrated by

certain contemporary gallery and museum practices. We find that many standard practices undermine the potential of art to model "commitment with tolerance". An analysis of these practices suggests that mistaken assumptions made about indeterminacy and subjectivity undermine the critical aspect of art in favour of either passive learning or the coercive aspect of art. When this is the case, control of art is in the hands of the museum or gallery professionals and the power of art is diminished.

In the following three sections, we focus on "art as information", "art as personal branding" and in contrast, "art-engagement-as-a-model-for-pluralism" respectively.

II Art as Cultural Information

Many galleries today use two models of audience engagement: one involves providing information and the other providing experiences. The method and rationale of the former is to provide audiences with a sense that the gallery is educative and in the current climate this 19th and 20th centuries, art galleries in particular assumed that their audiences shared the same cultural knowledge or at least aspired to, and so the effort was all on the part of the audience to calibrate their cultural stock with some idea of the standard gallery audience. Today audiences are very diverse regarding background knowledge and experience, but the gallery's response to this is often counter-productive.

It is standard practice in galleries to provide captions, interviews with the artist and curatorial justifications in an effort to inform the audience of the best descriptions under which to perceive a work so that it can be perceived in its best possible light. However, this approach inadvertently provides the audience with the impression that they have been provided with a single correct way of approaching the artwork. When was the last time you heard a group in a gallery arguing about the interpretation of a visual art work, the way book club attendees argue about the interpretation of a novel? People understand that to find a novel insightful one engages one's subjectivity but at the same time, one aims to find the correct interpretation. This prompts one to be interested in other perspectives and to share one's own. In the process one's subjectivity develops further toward inter-subjectivity. But underlying this process is the understanding that even though one behaves as though there is a correct interpretation that one seeks (irrespective of lack of consensus), it can only be apt if it engages one's own subjectivity. As Andrea Witcomb argues:

> texts that only present information, such as … narrative based exhibitions, cannot connect with experience because information renders the critical faculty inactive. This is so because the presentation of information does not encourage deep attention. For [Walter] Benjamin only art can do that precisely because it engages affective forms of response.[2]

Implicit in art gallery exhibition designs are assumptions about what one can expect of art and how the audience should orientate toward the work. When

communication is limited to a one way monologue from gallery to audience, the audience learns to defer to the gallery expert. Typically, the communication is limited to written or audio information, that is, a narrative consisting of facts about the work and expert opinion about the relevant stylistic aims. This approach produces a passive audience. The process is not critical but coercive.

This approach is based on an implicit intentionalism regarding the basis of the objective interpretation of an artwork. "Intentionalism", refers to the philosophical view that the meaning of art depends on the intention of the artist, and this intention can be either explicit, implicit or hypothesised.

On the other hand, "anti-intentionalism", broadly conceived, suggests that the meaning of the artwork, whether painting, film, music or novel, is largely created in reception. The more standard versions of anti-intentionalism or formalism as it came to be known, limit the basis of an interpretation to perceived qualities of the artwork.[3] A more enlightened anti-intentionalism, however, such as the position defended by the poet and essayist T.S. Eliot (1888–1965), holds that the relevant reception involves sharing a tradition with the artist.[4] While T. S. Eliot focused on art traditions to explain appropriate interpretation, the New Criticism to which Eliot's views gave rise, further developed his conception of formalism. According to reader-response theory for example, one's interpretation of a work can only be endorsed by a community if members of that community understand one's reasons for responding in just that way and this relies on sharing a tradition, experiences and training.[5] But furthermore, this implies that just by attempting to communicate one's perceptions of an artwork, one inadvertently goes some way toward calibrating one's terms of reference with one's interlocutor and hence, toward making of one's interlocutor, someone with whom one shares community.

According to the philosopher Stanley Cavell, both intentionalism and formalism were attempting to solve an anxiety about authorship which was based on a misconception of the artist and of artistic meaning. For Cavell, interpretation was not settled by considering the artist's psyche and intention, nor by a given set of objective properties of the artwork. The relevant basis for interpretation was masked rather than clarified by this way of carving up the possibilities.

Consider that, on the one hand, unless an individual's subjectivity is engaged, that is, unless one feels and cares about the meaning and significance of a work, one cannot be said to be engaged by a work, critically or otherwise. The idea of subjectivity is not a straightforward concept as we saw above. Subjectivity is cultivated away from the private into a shared communicative space upon developing shared terms of reference through dialogue: a given and asking for reasons of the kind conveyed through metaphor, analogy or prior example.

The idea of art as a public system of meaning involves understanding the range of choices available to an artist at the time and place in which she works. The more one

knows about this system of choices, the more one engages with what the artist creates.[6] And each new discovery in art, changes the way we engage with prior work.[7] Cavell drew our attention to the way each new discovery in art changed the terms of reference for art, even retrospectively, and consequently, what we noticed and found significant in all art.[8] In other words, our construal of an artwork, and consequently its meaning and significance, changes by what comes after it. This means that the way we perceive, what we foreground, notice and the significance we ascribe to what we see, changes over time depending on our conceptual framework.[9] Consequently, engaging subjectively with art, is not disappearing into one's own experiential bubble so to speak, but on the contrary, entering a network of shared terms of reference where feeling and value are concerned. For this reason, we refer to what art engages as our inter-subjectivity.

You can see just how important this kind of engagement is but to achieve it requires a rethink of standard contemporary exhibition design. Rather than isolated individuals absorbing information from experts, inter-subjectivity requires the facilitation of inter-perspectival exchanges. This involves engaging with responses to art which vary from one's own including those which one may feel inclined to reject. The right context is one in which there is a giving and asking for reasons among the audience. One cannot use reasons which prove the point in a conclusive way. A work conducive to this kind of conclusiveness would be a very weak work indeed. Instead there is an *indeterminacy* about the meaning and significance of art, yet it exhibits the marks of intention. Even when one is unsuccessful in showing another person what one perceives, the communicative process between different perspectives can be illuminating. If one perceives the point the other is making even when one ultimately rejects it, the familiarity with a new perspective adds to those comparisons one makes when one interprets. Interpretation is always comparative. The more interpretations one has to consider, the better the understanding of one's own interpretation and the commitments involved will be.

This is partly to do with the indeterminate – yet principled nature – of artistic interpretations. The process can be understood as an appropriate model for communication between those who hold varying cultural beliefs. That is, the kind of model of communication for which a plurality of perspectives is an invitation to reflect rather than a threat, is a model for our time. Being able to countenance a plurality of perspectives is a starting point for reason as it operates in the public realm rather than within a set of private concerns and axioms. Artistic interpretation, given that it is grounded in feeling but acculturated through communication, is the kind of experience of alternative viewpoints that facilitates empathy and communication.[10]

The nature of *inter-subjectivity, indeterminacy* and judgment are not well understood by the artworld if exhibition design policy is anything to go by. There are some notable exceptions however. Compare the response of the Corning Museum of Glass and The Metropolitan Museum of Art, New York to the September 11 2001 attacks

with the Tate Britain response to the 7 July 2005 bombings in London. The Corning Museum of Glass in conjunction with The Metropolitan Museum of Art in New York had an exhibition of Islamic glass, "Glass of the Sultans", slated to open at the MET in October 2001. After the 9/11 attack they decided to go ahead with the show realising it could be an important step in the healing of the city. In contrast, at the Tate Britain, an artwork called "God is Great No. 2" (1991) by artist John Latham was pulled from display in an exhibition opening 5 September, 2005, due to concerns that it might incite the wrong kind of responses only two months after 7/7.[11]

Tate Britain may well have been right as presumably they know their typical audiences. But nonetheless it is an indictment on their audiences. It suggests a lack of practice in engaging various perspectives when engaging with art. Tate Britain with the power they exercise in shaping responses to art would need to take some responsibility for their audiences' seeming intolerance.[12]

Many galleries misunderstand the nature of subjective responses. They assume they fulfil a serious educative role by providing facts, and seek to engage subjectivities as a pleasurable bonus. However, unless *inter-subjectivity* is facilitated, as explained above, galleries will be forced into a position reflected in the Tate Britain's approach to avoiding topics and approaches that might touch upon sensitive contemporary issues. This can only be seen as a neo-conservatism coming into gallery practice; and this can be blamed on the way audiences have been educated by exhibition design to engage in art as though its meaning was prescribed by authority rather than ascribed by a community shared with the artist either actually or hypothetically.

An artist who has spoken at various times in various contexts about this, is the Icelandic-Danish artist Olafur Eliasson. Consider his work *Little Sun* which is a collaboration between Eliasson and the engineer Frederik Ottesen.[13] It is a lamp designed in the shape of a flower or sun in a size that fits comfortably in the palm of an adult's hand. It has a light sensor on the back that, when exposed to the sun for five hours, stores enough energy to provide light bright enough for an entire evening of reading. It is designed for communities that are not attached to energy grids, and as such, *Little Sun* is an artwork that impacts upon people's lives in a functional way.[14] *Little Sun* is distinguished from other non-profit enterprises as it is intended as art. As such, it invites interpretation. However, the contemporary gallery is inclined to present a wealth of information about the artist, and opportunities to photograph the work or buy it. No context is provided for discussing how or whether this object pushes the boundaries of art. Consider Eliasson's response to whether *Little Sun* blurs the boundaries of art:[15]

> I primarily work within traditional art institutions, such as museums, galleries, etc. In these institutions, I often encounter a lack of confidence in the significance of the museological muscle within society. I've increasingly observed exhibition venues seeking advice from commercial parts of society that the museum is generally thought to be critical of. More and more, there

is a conflict between the aims you have as an artist and the way the
museum has chosen to work in terms of communication and ideology.
Museums are becoming neo-conservative. [16]

It is the *indeterminacy* of art that Eliasson suggests is being over-written by contemporary museum practices. The contemporary gallery and museum are required to meet economic targets, reach audience thresholds and satisfy various commercially based mission statements. They are pushed toward using more determinate strategies such as providing easily digestible information to gallery audiences and avoiding anything that might challenge the status quo. The physical space for objects of art is provided but little or no space for the kind of exchanges without which the objects remain unrealised as art.

III Art as Brand: the Rise of Populism

In contemporary galleries and museums, a misunderstanding of subjectivity seems to underpin a considerable amount of exhibition design aimed to promote audience experience. In the 19th century, galleries and museums put greater confidence in the educative effects of simply looking. This can be explained in part due to the assumed homogeneity of the cultural stock of gallery visitors as discussed above. The prevalent viewing platform was a standard formalist one, according to which the forms of art were understood to train the perceiver into a love of the harmony and balance which was thought to transfer from visual elements to the components of a life well lived.[17] While it was supposed that the audience would have been educated in the appropriate cultural heritage, the experience at the gallery was very much generated by the viewer.[18]

When tradition and convention are well established and endorsed, we might hardly notice that our value judgments have different conditions to matters of fact. That is, when traditions are well established and relevant to the case in hand, we do not notice the degree to which our responses and interpretations are steeped in cultural norms internalised by way of our community based exchanges. In the normal course of events, within an established and entrenched tradition, we make sense of cultural artefacts and activities by inadvertently improvising. That is, we inadvertently draw upon culturally based generative forms or heuristics through which we experience what seems like recognition of an object's meaning.

Take for example a landscape in traditional 19th-century British Romantic style like John Constable or J. M. W. Turner. We might simply respond in a stereotypical way, such as finding mild appreciation in the calm serenity of a scene, regardless of whether the historical context of its making and references within the painting are conducive to this or not. Once a painting of landscape triggers entrenched schemas (improvisations, as Cavell might say), we take ourselves to be responding to the objective standard represented by the object.

However, this confidence in the audience's ability to perceive and interpret has been somewhat eroded by new art forms. We no longer have clear norms with which to ascertain or to judge artistic intentions, and as such we become aware of trying to find the basis for distinguishing between sincerity and fraudulence. In this process, we feel the insecurity of cultural isolation.

It is assumed that all a museum or gallery can do in this time of cultural diversity (see section II above) and new art forms is either provide facts about a work or provide the context to engage in subjective reverie. However, as discussed above, subjectivity when hooked appropriately is the platform from which an experience of art is more than fact-gathering on the one hand or entertainment on the other. In Cavell, we find an implicit concept of community which grounds interpretation in a way that reverses the popular romantic privileging of the individual psyche over and above the norms of a society. For Cavell, implicitly the community is the primary unit in understanding the grounds of each individual's interpretations.

Galleries often succumb to creating the context for the individual to use the gallery experience to help create a personal brand for their social media presence. This diminishes the power of art-as-art and encourages galleries inadvertently into a very conservative agenda regarding their works just as surely as does the provision of facts alone. Even politically charged work is tamed by the sense that the audience need only engage with the portions they find entertaining: the sculptures, videos, podcasts, drawings, paintings, installations and so on, that lend themselves to their own brand. The array in many exhibitions is often varied, numerous, sprawling and overwhelming as if to mirror the frenetic editing techniques of contemporary cinema and ensure the audience is never bored. But in addition, the anxiety to avoid demanding effort from the viewer seems to drive many contemporary exhibition designs, where "challenging" is treated as satisfied by "shock" or "evoking offence" rather than engaging the audience's critical faculties.

In 2016, the National Gallery of Victoria asked patrons who were uploading photographs they had taken of their exhibits, to use the gallery hash-tag. Based on programs which automatically recognise the hash-tag and generate patterns of preference, they sent individuals updates of upcoming exhibitions that might interest them. The Cleveland Museum of Art's Gallery One provides visitors with an individualised tour of the displays based on their preferences by downloading an app or renting a museum iPad.[19] Both of these examples reflect another practice found online where gallery visitors make collages of artworks or sections thereof, which they have photographed on their gallery visits. A gallery of appropriated images is created which is meant to establish or contribute to the person's online persona. Such approaches do not facilitate a critical approach to art in the sense explained above. Instead art is turned into an occasion for personal branding. As there is no critical or objective framework, subjectivity remains solipsistic.

To create branding opportunities, is to treat subjectivity as personal and egocentric. In contrast, an understanding of *inter-subjectivity* would ground a very different kind of engagement strategy. The aim would be to bring subjectivities into critical contact with each other.

IV Art and Pluralism

In spite of some very encouraging exceptions, art galleries and museums are not, by and large, creating a community of reflective judgers in their emphasis on information or egocentric branding.[20] This is in spite of the contemporary scene offering a unique context in which the space of engagement can be re-imagined due to new art forms allegedly changing audience participation.[21] Instead, galleries often engage concepts to justify exhibition strategies which are poorly articulated or understood. For example, it is not clear what is meant by the now well established buzz words "co-creation" and "performativity". For example, Nanna Holdgaard and Lisbeth Klastrup discuss a number of museologists such as Vines et al. who point to the fact that in the so-called participatory design literature, it is rarely discussed how gallery visitors become participators, let alone co-creators.[22]

Holdgaard and Klastrup argue that more research needs to be done to ascertain whether the introduction of social media and various audience centred activities in museums is inherently positive. They point out that the current practice simply assumes that such methods "emancipate, engage and involve the public and democratise the cultural heritage"[23]. They refer to the "experience economy" adopted by galleries and museums, and note that its adoption is variously referred to in the literature as a "paradigm shift", "participatory turn" or "digital turn" according to which the gallery is "reinvented" or "re-imagined".[24] However, they write that "much of the research literature as well as the co-creation projects in museums do not define or specify the co-creative processes".[25] In response to a question regarding how art engages an audience, Eliasson notes that we:

> have now moved into a phase where institutions clearly see the co-production of the art viewer's experience as a part of museological responsibility. While I consider this development necessary, it does fail in one respect: the majority of art institutions do not have confidence in allowing for ruptures and unpredicted experiences, since the unpredictable might not be profitable. The experience management of museums has thus come very close to that of the experience economy. There is a strong degree of social control, social suppression, and hidden power structures when it comes to the definition of 'normal' behaviour. This condition, where the unpredictable is considered a threat, is creating a situation where museums essentially begin to reflect the lack of tolerance that we find in Western society in general; in my opinion, this is not at all healthy for the institution of the museum as such.[26]

The exceptions are where a more philosophical or free ranging contemplation of ideas are promoted; or where competing perspectives are presented. Eliasson has held many conferences and symposia in his Studio where the context for just this kind of exchange is made possible involving people from various areas of expertise and from all walks of life. Contrasting perspectives on artwork can be considered without this undermining the objectivity or meaningfulness of the art object.

To achieve this kind of context within the gallery setting requires a re-thinking of the fact-entertainment/branding alternative. An earlier model for this was arguably an exhibition titled *Les Immatériaux*, 28 March–15 July 1985, curated by French philosopher Jean-François Lyotard which was held at the Centre Pompidou, Paris.[27] The exhibition included interactive installations, early electronic communications and sound works aimed at demonstrating the effects of communication technology and information management on culture. Exhibits included artworks, everyday objects, scientific objects and electronic devices. The labyrinthine *parcours* exhibition design allowed multiple pathways through the exhibition, chosen by the viewer, and the loose leaf unpaginated catalogue could be arranged by the viewer as they wished. The viewer was provided with an audio guide that was triggered by their position within the exhibition space. A multiplicity of views was provided to stimulate thinking. For example, one exhibit, called the "Writing Tests" enabled the viewer to use computer screens to access dialogues between writers and thinkers including artists and philosophers on fifty topics related to the exhibition. This was revolutionary for its time not only in using technology but in the way it was used to engage alternative perspectives.

A more recent example which also avoids the fact-branding alternative involves an app that is available to the audiences at the Fine Arts Museums in San Francisco (de Young and Legion of Honour). The app provides the audience with a choice of ways of engaging with art from the curatorial, historical, philosophical and other visitor perspectives. The app provides an immersive audio experience in which the visitor can also participate by adding their own recording to the discussion. Of the people surveyed who used the app, 92% indicated that the app prompted a much closer and more satisfying engagement with the work.[28] It is only when art is experienced as art that it engages critical perspectives. And only then does its power as a model for commitment-with-tolerance gain traction.

V Conclusion

The practices of galleries and museums suggest that the *indeterminacy* of art does not fit the new "experience economy". Art is framed by the standard practices in ways that inadvertently coerce the perceiver into the passive position of a rule follower. On the other hand, when the aim is to engage the perceiver in memorable experiences, too often the strategies employed are evidence of a misunderstanding of the critical

nature of art. A condition of engaging critically with art is the exercise of *inter-subjectivity*, rather than rule-following on the one hand or personal reverie on the other. Unless (i) *indeterminacy* is understood, (ii) the *critical* rather than *coercive* nature of art is facilitated, and (iii) the conditions for *inter-subjectivity* provided, galleries and museums undermine the power of art. Unless these three conditions are met, galleries and museums preside over an experience economy devoid of art.

Notes

1 For a fuller account of these key terms of analysis, see: Jennifer A. McMahon, *Art and Ethics in a Material World: Kant's Pragmatist Legacy* (London: Routledge, 2014).

2 Witcomb discusses: Walter Benjamin, *Illuminations*, trans. Harry Zohn (London: Fontana Press, 2013), 269.

3 For an example see: W. K. Wimsatt and Monroe Beardsley, "The Intentional Fallacy," in *Philosophy of Art and Aesthetics*, ed. S. M. Cahn and F. A. Tillman (New York: Harper & Row, 1969).

4 T. S. Eliot, "Tradition and the Individual Talent," *Perspecta* 19 (1982).

5 An example of the New Criticism is reader-response theory developed by Stanley Fish. His theory can be considered formalist in Eliot's sense of anti-intentionalism. In Fish's version, tradition is replaced by community norms. Stanley Fish, *Is There a Text in This Class?: The Authority of Interpretive Communities* (Cambridge, MA: Harvard University Press, 1980).

6 Theodor Adorno, *Aesthetic Theory*, trans. Robert Hullot-Kentor (London: Athlone Press, 1999).

7 Arthur Danto, "Narrative and Style," in *Beyond the Brillo Box: The Visual Arts in Post-Historical Perspective* (New York: Farrar, Straus and Giroux, 1992).

8 Stanley Cavell, "Music Discomposed," in *Must We Mean What We Say?* (Cambridge: Cambridge University Press, 2002).

9 Jacques Ranciere, *The Politics of Aesthetics: Distribution of the Sensible*, trans. Gabriel Rockhill (London: Continuum, 2004).

10 See: Jane Kneller, "Aesthetic Reflection and Community," in *Kant and the Concept of Community*, ed. Charlton Payne and Lucas Thorpe (Rochester: University of Rochester Press, 2011).

11 Andrew Dewdney, David Dibosa, and Victoria Walsh, *Post-Critical Museology: Theory and Practice in the Art Museum* (London: Routledge, 2013), 69-71.

12 The power of museums and galleries in shaping the consciousness of an age is well documented. See: Robert R. Janes, *Museums in a Troubled World: Renewal, Irrelevance or Collapse?* (London: Routledge, 2009).

13 See: "Little Sun," http://littlesun.com/.

14 *Little Sun* is based on a social business model, and this is an integral part of the artwork. See: http://littlesun.com/about/

15 This is a truncated version of the question McMahon asked Eliasson in an email interview on t 1 November 2012.

16 Olafur Eliasson, interview by Jennifer A. McMahon, 1 November, 2012.

17 See: Roger Fry, *Vision and Design* (London: Chatto & Windus, 1920). Jennifer A. McMahon, " Immediate Judgment and Non-Cognitive Ideas: The Pervasive and Persistent in the Misreading of Kant's Aesthetic Formalism," in *The Palgrave Kant Handbook*, ed. Matthew C. Altman (Basingstoke and New York: Palgrave Macmillan, 2017).

18 The way the purpose of the gallery and museum was conceived irrespective of the exhibition strategies within, was to establish and consolidate a sense of sovereignty. See: Donald

Preziosi, "The Art of Art History," in *Museums in the Material World*, ed. Simon J. Knell (London: Routledge, 2007).

19 Leah Gelb, "Visitor Connection: Digital Integration Strategy for the Art Museum Experience" (Masters thesis, The University of the Arts, Philadelphia, 2014), 53; Gracie Loesser, "Analyzing Visitor Perceptions of Personalization in Art Museum Interactive Technology" (Masters thesis, University of Washington, 2016), 18, 20-21, 35.

20 See: Janes, *Museums in a Troubled World: Renewal, Irrelevance or Collapse?*

21 Graham and Cook discuss the changing conditions of contemporary art. Beryl Graham and Sarah Cook, *Rethinking Curating: Art after New Media* (Cambridge, MA: MIT Press, 2010).

22 Cited from: John Vines et al., "Configuring Participation: On How We Involve People in Design." (paper presented at the SIGCHI Conference on Human Factors in Computing Systems (CHI '13), Paris, 2013), 433. Discussed in: Nana Holdgaard and Lisbeth Klastrup, "Between Control and Creativity: Challenging Co-Creation and Social Media Use in a Museum Context," *Digital Creativity* 25, no. 3 (2014): 193.

23 "Between Control and Creativity: Challenging Co-Creation and Social Media Use in a Museum Context," 191.

24 Ibid., 190.

25 Ibid., 193.

26 Eliasson.

27 See: Graham and Cook, *Rethinking Curating: Art after New Media*, 19-21. See also: Hans Ulrich Obrist and Asad Raza, *Ways of Curating* (London: Penguin, 2014), 157-62.

28 Catherine Girardeau et al., "Voices: FAMSF Testing a New Model of Interpretive Technology at the Fine Arts Museums of San Francisco," in *Museums and the Web conference* (Chicago2015). This is discussed in: Loesser, "Analyzing Visitor Perceptions of Personalization in Art Museum Interactive Technology," 16.

Watermelon Politics and the Mutating Forms of Institutional Critique Today

Stevphen Shukaitis and Joanna Figiel

I N RECENT YEARS, THERE has been a rise of social movements and political formations raising questions about the operations of contemporary art institutions. These have ranged from activist groups such as the Precarious Workers Brigade (PWB)[1] and Working Artists and the Greater Economy (WAGE),[2] among others, questioning the functioning of unpaid labour in the cultural and artistic sector, to Liberate Tate's engagement in ending the relationship of public cultural institutions with oil companies, focussed on BP's sponsorship of Tate Modern.[3] While the PWB is actively engaged in the issue of unpaid and often exploitative internships within the arts and cultural sector in the UK, as well as critically examining and deconstructing dominant narratives around work, employability, and careers, WAGE made its mark on the artworld by exposing the issue of non-payment of fees for artists working within New York's non-profit arts institutions sector. Given that these groups are acting in response to similar pressures and ethical and political conflicts they may be seen as direct descendants of those originally engaged in the birth and rise of institutional critique. On the one hand, the fact that similar conditions – despite being recognised as problems for decades – continue to affect those working in the arts and cultural sector today is a somewhat depressing realisation. On the other hand, however, it seems that we are seeing a renewed, and somewhat mutated, institutional critique emerging in new forms today.

In this chapter, we would like to explore the proposition that recent developments in new forms of institutional critique, and their transformations, could be thought to exhibit a kind of watermelon politics, which is to say having an outward concern with issues of ecology and sustainability, but one that also contains – on a deeper level – concerns about issues relating to labour and production. That is to say that doubled, if not trebled, layers of ethical and political concern are central to new forms of activism around art institutions. While the convenient and perhaps somewhat comical metaphor or comparison of a watermelon might give the impression that one layer always concealing another, it is far from it. Rather, we are seeing a different layering and embedding of questions around ethics, labour, sustainability, precarity, and the nature of the institution all working with and often against each other, providing new perspectives and problems for the ongoing question: who runs the artworld, and for whose benefit?

Strike Art, or Not

In our view, the best exploration of the most recent flowering of institutional critique is Yates McKee's recent book, *Strike Art: Contemporary Art and the Post-Occupy Condition*. McKee say he intended it as a "strategic address to those working in the art field more specifically to consider how the various kinds of resources at our disposal might be channelled into movement work as it unfurls with ongoing moments of political rupture".[4] By framing his work in this way, McKee immediately re-opens the question of institutional critique not just within the framework of art history and the art historical canonisation critiques of art history, but within a genealogy of moments of political upheaval and contestation. If there would be a renewal of institutional critique today, the reasons for it would not be found within the logic of institutions but rather in the spaces formed by active revolt against them, or what McKee describes succinctly in the subtitle as the "post-Occupy" conditions. These involve and include, beyond Occupy as a discrete movement or moment, all forms of related political upheaval ranging from the Arab Spring to Black Lives Matter, also drawing from a renewed political grammar of seizing spaces to create moments of encounter where other forms of subjectivity, and thus hopefully other forms of politics, can emerge.

One of the aspects of McKee's work is that while it can be seen how such forms of political contestation are related to the artworld, they do not necessarily solely relate to – or remain within – the artworld. Instead, their orientation to the artworld is just one among many articulations of their existence. This can be seen in the exploration of the Gulf Labor Artist Coalition, which operates mainly as a coalition of artists concerned about the working conditions for migrant workers in the construction of museums on Saadiyat Island in Abu Dhabi, but extends beyond that.[5] The initial call for a boycott in 2011 thus emerges specifically out of a concern over worker rights and safety in just one location, but does move beyond this singular instance. Thanks

to various reasons including the organising of highly visible and mediagenic forms of conflict, the involvement of high profile artists, and the support organised through these actions galvanised largely through post-Occupy social movements networks and connections, the action was fairly successful. Channelling the visibility generated through this outburst into a form of political antagonism that can be moved and mutates through that movement. Or as McKee describes it, Gulf Labor created a new form of artistic organising, one that moved from the group's initial concerns to encompassing

> the inequities and complicities of the global ultra luxury economy more generally. This includes the role of art institutions in the process of gentrification, the cooperation of museums with banks and fossil fuel companies, the exploitation of the legions of precarious and low-wage workers who make the art system run, and the persistent hand-wringing on the part of artists and institutions.[6]

Arguably this dynamic where one form, or mode of conflict in the artworld spills over into other issues and areas, is not confined to or unique to the dynamics of Gulf Labor. Far from it, there is a much more general dynamic of embedding layers of ethics and politics upon and in relation to one another. Thus, more than a single watermelon where the green outside contains a red and black centre, today's conditions could be instead thought of as an entire watermelon patch, where a constellation of different layers and ethico-political assemblages is cultivated. As examples of this one could look at the way Liberate Tate's demand to end the role of BP's oil sponsorship at the Tate (and more broadly) overlaps with the Precarious Workers Brigade and Carrotworkers' campaigns against the art and cultural sectors' reliance on unpaid or very poorly paid labour in the form of internships.

These connections and overlaps are also quite literal in the involvement of many of the same people and their mutual support of each other (if not direct involvement). At a more conceptual level: both campaigns address a common concern about sustainability, whether in relation to ecological sustainability and climate change, or the manner in which making a living during periods of the acceptance of the hyper-exploitation of cultural work is completely unsustainable. Similarly, one could look at resonances in the conversations brought together in the 2009 Temporary Services publication *Art Work: A National Conversation About Art, Labor, & Economics* with proposals made by Gustav Metzger during the 1970s.[7] These include Metzger's famous *Years Without Art*, the withdrawal of labour to reshape and change the power of institutions or his demand to reduce the amount of flights taken for the continued functioning of the artworld, to reduce the climatic impact of the arts. Here, a point of resonance could be teased out more systematically drawing from Brett Bloom's project *Petro-Subjectivity: De-Industrializing Our Sense of Self8* that looks at how oil shapes our experiences of the world. Marx once observed that men make their own history, but they do not make it at as they please. Today, we could similarly conclude that while artists attempt to write their own histories, the constraining factors of

labour, resources, and myriad forms of social domination are just as present, if not more than ever before.

Conceptually, links between various forms of sustainability can be made beyond using the same words to address different areas. One could turn to the work of Jason W. Moore in formulating an emergent approach to world ecology, particularly where he explores how a devaluing of key resources, or the development of what he describes as the "four cheaps" of labour power, food, energy, and raw materials accompanies new cycles of accumulation and dispossession.[9] However this does not mean that these resources are cheap in and of themselves. Rather, they have been made so, systematically de-valued. This process of systematically devaluing a resource – whether in the form of access to the apparently infinitely abundant natural resources of colonisation or the apparently free resources of unpaid domestic labour – underpins changes in the modes of production and accumulation of capital. Beneath the mystifying growth of new riches lie the supports of the same devalued, old forms of work and human activity that have disappeared and been subsumed.

We could make a similar argument about the shifts taking place within the artworld. What Gregory Sholette describes as its "dark matter", underpins the apparently magical shifts in form and approach that are – and usually in retrospect – celebrated later.[10] In other words, the condition of global cultural ecology depends on the creation of such 'cheaps' within the artistic and cultural production. While in Moore's framing the production of such 'cheaps' is mainly the outcome of conquest and colonisation, in the arts and cultural world much of the dynamic of invisibilisation or 'darkening' of the matter of cultural labour is wilfully embraced. It is what the Belgium sociologist Pascal Gielen describes as the "artistic murmuring of the multitude",[11] or where post-Fordist work practices – characterised by highly subjective involvement yet little to no job security – were developed within the cultural sector during the 1960s, before being spreading to other sectors.[12] Initially, such practices appeared, or were presented, as a relief from the usual constraints of wage work: the formality and rigidity of the '9 to 5' workday. This "new spirit of capitalism" first appeared as an escape from work, but such an escape was only temporary, and came at a higher cost that only became apparent later.

Re-launching Institutional Critique Today?

It was in this conjunction that institutional critique first arises, at a moment during the 1960s and 1970s where a new round of accumulation by dispossession is just being launched, where shifts in global ecology and patterns of social power are beginning to accelerate in a serious manner. Boltanski and Chiapello argue that at this very moment, the "new spirit of capitalism" is born – born from separating the artistic and social critique, and separating politics based on the reduction of alienation from politics based on ending exploitation.[13] Or to continue with the image used to frame

this chapter, the moment where the "new spirit of capitalism" is constructed through the carving up of a watermelon – and the declaration that one can only really be concerned with either one or the other issue: either labour or the planet (or gender, or race, or any other particular 'issue'). While the history of institutional critique is usually narrated around a series of proper names, much like the post-Occupy condition that McKee describes, it would be much better understood in the context of the politics of the 1960s. While these kinds of broader movement, demands and politics might be left out of art historical scholarship, it is likewise disappointing that histories of social movement politics likewise can be prone to leave out concerns that are more traditionally artworld concerns, or ones that tend to stay within the artworld.[14]

We can see different waves of institutional critique, where the relationship between institutional form and social movement politics shifts over time, developing. The German filmmaker and writer Hito Steyerl suggests that the first wave of institutional critique in the 1970s "questioned the authoritarian role of the cultural institution. It challenged the authority that had accumulated in cultural institutions within the framework of the nation state".[15] And seen within the context of the time that is quite sensible, as this was before the neoliberal turn and the process the dismantling of such institutions really took place. Artists were confronted with cultural institutions that may have achieved some degree of autonomy from market pressures, but were nevertheless entangled into other forms of questionable power and patronage, such as through the arms trade and other problematic economic activities. These connections between boards of art institutions and the arms industry, implicating cultural institutions in the dynamics of war and oppression, initially led campaigns such as the Art Workers Coalition to call for an art strike.

The irony which Andrea Fraser points out about this, which is perhaps not surprising at all, is that this first wave of institutional critique then shifts from attempts at dismantling the institution of art towards defending the very institution that the institutionalisation of the avant-garde's self-criticism had created, underpinning the potential for the very institution of critique.[16] This was in some ways a double bind: the acceptance of some forms of critique within the institutional space helped, even if a small way, to take concerns raised about ethics, power and representation more seriously, yet in doing so reduced the depth at which that critique operated. Or to put it another way: the institutional response would thus be to accept the grounds of critique, but to delimit them in a more circumscribed and controlled manner, so that the main issue becomes one of representation (such as, who can appear within the institution) rather than control, power, or organisation. This overlaps with the argument Steyerl makes, as she suggests that while the first wave of institutional critique produced integration into the institution, the second wave (mainly developing during the 1980s) achieved representation. From there she adds:

> now in the third phase there seems to be only integration into precarity. And in this light we can now answer the question concerning the function of the

institution of critique as follows: while critical institutions are being dismantled by neoliberal institutional criticism, this produces an ambivalent subject which develops multiple strategies for dealing with its dislocation. It is on the one side being adapted to the needs of ever more precarious living conditions. On the other, the need seems never to have been greater for institutions that could cater to the new needs and desires that this constituency will create.[17]

Here Steyerl makes a number of important points, beginning with the idea that in a current third phase of institutional critique there is only integration into precarity. The critique of institutions has been weaponised against those institutions, however ambivalent, that previously might have provided some modicum of security (even if only for limited populations and in manners that were far from fair or representative). But most importantly, she gestures towards the idea of an emergent ambivalent subject, one that has to relate to institutional contexts, but does no longer believe that such spaces could provide a refuge. The institution has become a space that one might be temporarily within, but not a place that one could be of. It might be a resting place, but it cannot be a home.

A New Wave of Cooperativism?

This moves us from understanding institutions as specific spaces, or organisations, towards rethinking them as a kind of social field. We may be inside or outside the institutions, but how they operate can be continually shifting – especially as institutions, in the artworld and beyond, increasingly begin to operate as networks rather than solid and fixed forms. This can be seen clearly in how artists today face equally uncertain and precarious conditions both within and outside of institutions. What is then possible within these changing conditions? The shifting possibilities of institutional critique are not gestured towards here as an indication these histories should be discarded, but rather to indicate that as conditions change the question is how to interact with institutions today. What would it mean to cultivate a new crop of institutional critique within and without these changing conditions?

Of course, the answers to this question are already being developed starting from watermelon politics this chapter begins with. The strength of these emergent forms lies precisely in how they move between labour and ecology, or more generally between and around different areas, of struggle. If the "new spirit of capitalism" separated antagonistic demands into compartmentalised issued to be addressed, then a renewed institutional critique begins from a refusal of such separation. And so, we would suggest that the best way to create a space for maintaining such collectivity without separation would be returning to or reviving practices of cooperativism in the arts.

There is a long history of cooperatives in the arts and cultural labour, which we won't explore in depth here. The point is not to attempt to revive any particular model from this history, but rather to suggest that there is much to learn from it, that would require adapting and reconfiguring for the present. Such rethinking is largely necessitated by the broad changes in the working of art institutions and the cultural economy, and the social conditions in general. Rather than returning to the question of being inside or outside of the institution, the question is how to deal with constant negotiations with institutions and the shifts in the networks of how people work together and collaborate. Here we could look for examples of cooperativism in projects like the Justseeds Artists' Cooperative or the Laboratory of Insurrectionary Imagination, which have adopted such flexible models of cooperative practice and solidarity in how they organise.[18] Or perhaps we could look to the Co-op program developed by the Substation in Singapore.[19]

Platform cooperativism, as proposed by the US cultural and media theorist Trebor Scholz, attempts to take the best processes from the sharing economy and adapting those to creating a more just and equitable economic arrangement, rather than a platform for further corporate plunder.[20] That is to say the precise point of platform cooperativism is not to retreat to earlier forms of cooperatives or unions, but to develop new dynamics of cooperation from within and despite the sharing economy. What would it mean to develop a form of platform cooperativism for art and cultural workers? In *Inventing the Future*, Nick Srnicek and Alex Williams make a similar argument to Scholz: a utopian left politics can be found not by retreating to past forms, but rather through a politics articulated around a series of shared and interconnected demands: embracing full automation, developing a basic income and reducing work hours, and ending the domination of work over our lives.[21] Importantly, all of these elements must come together, as a kind of 'watermelon politics', rather than being separated into individual concerns. The separation of any one of those would just lead to yet another, "new spirit of capitalism" where one form of social improvement is met by a re-articulated form of social control.

As McKee observes, today we witness a dual process where artists are withdrawing from the contemporary art system and finding ways to reinvent art as a tool of "radical imagination and direct action that in its deepest dimension asks us: how do we live?"[22] Historically, the artworld and its institutions have played many roles: good, bad, and often indifferent. The question of institutional critique, of who runs the artworld today (and for whose benefit) is how to occupy such spaces, even if ambivalently and briefly, but also to develop forms of cooperation and collaboration that can sustain themselves above, below, and beyond institutions, even while maintaining some relationships with them. The multiple embedded labour and ecological focus of a watermelon politics is not a solution then, but a proposal to rethink ways to cultivate such a garden of cooperative practices, and why it is more necessary than ever to do so today.

Notes

1 For more information and recent publication PDF download see: "Precarious Workers Brigade," Tumblr, https://precariousworkersbrigade.tumblr.com.

2 For more information see: "Wo/Manifesto," W.A.G.E. Working Artists and the Greater Economy http://www.wageforwork.com/about/1/womanifesto.

3 Mel Evans, *Artwash: Big Oil and the Arts* (London: Pluto Books, 2015).

4 Yates McKee, *Strike Art: Contemporary Art and the Post-Occupy Condition* (London: Verso, 2016), 7.

5 For more information on the timeline of their organizing efforts here: "Who's Building the Guggenheim Abu Dhabi?: Timeline," Gulf Labor Artist Coalition, http://gulflabor.org/timeline/.

6 McKee, *Strike Art: Contemporary Art and the Post-Occupy Condition*, 179.

7 Although you could trace this back further to the Salon des Refusés in 1863, if not before.

8 Brett Bloom, *Petro-Subjectivity: De-Industrializing Our Sense of Self* (Ft. Wayne: Breakdown Press, 2015).

9 Jason W. Moore, *Capitalism in the Web of Life: Ecology and the Accumulation of Capital* (London: Verso, 2015).

10 Gregory Sholette, *Dark Matter: Art and Politics in the Age of Enterprise Culture* (London: Pluto Press, 2011).

11 Pascal Gielen, *The Murmuring of the Artistic Multitude: Global Art, Memory and Post-Fordism* (Amsterdam: Valiz, 2010).

12 For more on this see: Miya Tokumitsu, *Do What You Love: And Other Lies About Success and Happiness* (New York: Regan Arts, 2015).

13 Luc Boltanski and Eve Chiapello, *The New Spirit of Capitalism* (London: Verso, 2005). For an analysis of their arguments in relationship with cultural labour see: Stevphen Shukaitis, *The Composition of Movements to Come: Aesthetics & Cultural Labor after the Avant-Garde* (London: Rowman & Littlefield International, 2016).

14 Alan W. Moore, *Art Gangs: Protest and Counterculture in New York City* (Brooklyn: Autonomedia, 2011).

15 Hito Steyerl, "The Institution of Critique," in *Art and Contemporary Critical Practice: Reinventing Institutional Critique*, ed. Gerald Raunig and Gene Ray (London: MayFly Books, 2009), 14.

16 Andrea Fraser, "From the Critique of Institutions to an Institution of Critique," *Artforum International* 44, no. 1 (2005): 278-85.

17 Steyerl, "The Institution of Critique," 19.

18 For more information on Justseeds see: "About," Justseeds, http://justseeds.org/about/. For more information on the Laboratory of Insurrectionary Imagination, see: "More About Us," Laboratory of Insurrectionary Imagination, http://labofii.net/about/.

19 For more on this see: *The Co-Op*, (Substation).

20 Trebor Scholz, *Platform Cooperativism. Challenging the Corporate Sharing Economy* (Rosa-Luxemburg-Stiftung, 2016).

21 Nick Srnicek and Alex Williams, *Inventing the Future: Postcapitalism and a World without Work* (London: Verso, 2015).

22 McKee, *Strike Art: Contemporary Art and the Post-Occupy Condition*, 237.

Art Scene, Art Scene, Sweet Especial Art Scene *as the World Comes to us thus we Come to the World*

John von Sturmer

T HERE IS NO PRIVILEGED position to speak about art or the art scene. There are of course those who claim the privilege – and those whose claims to privilege may be accepted. What constitutes authority, what are its analogues or determinations? There are no gods of art – though some may claim that divine status.

Yes, the sacred and the sublime. We cannot speak easily of the secular. Even bad art – and yet who determines? – is accorded something of a divine status. Attack the artwork and you attack the artist. Praise the artwork and you endorse the artist. We can for the moment think of three poles: the artwork, the artist, the idea of art. To claim knowledge of art cannot be reduced to knowing or being able to recognise lots of paintings or sculptures or to be able to assert links between this and that. Oddly the latter rarely if ever takes the form of the relationship between the artwork and 'the real' – though of course verisimilitude is or has been a criterion, now considered naïve. The paintings of the deceased on the coffins of El Fayum are presumed to be accurate versions of the living person. For some reason, they did not think to paint the deceased as deceased – or in the process of putrefaction. The paintings on *lorrgon* or funerary poles represent the body post-decay.[1] It is the land of the bones – and we might wonder what it is that allows bones to serve as the living *representans* of the dead.

Is art always the dry bones of reality? The fleshiness of Rubens stands against this. His figures all have the solidity of chocolate mousse or frangipane. Not that they approach

the edible quite – but it warns us that art rests or alternates between the dry bones and the fleshy flesh. We might even say that the flesh is obscene – for it always stands in the direction of corruption. Skulls tattooed on the living body demonstrate this – and we are left to puzzle whether the skull is meant to deter death or to serve as a warning; as if representation can ward things off – or bring them on. Every skull is a participant in the *sous-réel*. And we might take our guide from this to suggest that art is the beneath of things, not a form of transcendence. Or it might be both – and invites us to consider how the transcendent links with the beneath of things; and how the beneath of things points towards a non-existent universal. We shall make that claim here: there are no universals – and where the claim is made of universal force or presence reality is thrown out the window. Can we then envisage an art at the level of things? Easily if we allow art a degree of autonomy. It is itself – but a thing in itself that has the capacity to transform. The painted initiate is made to embody the man he will become. All attire is that: a sort of masquerade meant to achieve a certain vision of the self (or the other).

Thus theme 1: art as a form of apparel – which wavers between metaphor and metonymy. And theme 2: the importance of fakery and notions of the genuine. There was a third theme but it remains unannounced, the third part of the fake – genuine triangle. What mediates art is not this dichotomy but desire – and notions of value. A question then: why should art be maintained – as an object of permanence (let us say curatorial skill and (in)competence)? We can almost certainly think of examples where art is destroyed in the performance of some ritual or other; of rendered ephemeral as what we might call 'occasional art' or festival or carnival or seasonal art. The projection of images onto the sails of the Opera House, for example – or some suburban street with elaborate Christmas lighting, a sort of Chevy Chase paradise. (We might in the future have birthday houses or saint's day houses, if we don't have them already.) Venice and Rio have Carnevale, we have our own ratty Mardi Gras wavering between glitter and tat (tat-art and glitz-art) and the local chamber of commerce. New Year has fireworks 'from around the world' – but with no Donne to celebrate it. Daylight saving with its casual shifting of midnight to somewhere else buggers up the 'authenticity' of the event in Sydney and the ritual destruction of the Bridge. Forerunners were the Royal Water Music in London, and the Royal Fireworks also on the Thames. At Versailles, you could at a stately pace walk away from the château as the waters of Marly fed first one *jet d'eau* and then another. Art as play, art as display, art as waste and excess; art as 'ooh-aah', the gasp. This is not the *frisson* one might get from the *rosace* at Reims – how often restored? – or the lofty glasswork of the Sainte-Chapelle. This is the pleasure of the kaleidoscope. Fractured light, scintillation. And shall we add other forms of display to our list, sporting events, sprint faces, bodies in motion, horse-racing, the dogs? A crowded beach on a Sunday?

The great cathedrals – Chartres, St. Denis, Ely, Peterborough – are great public artworks. The guild houses of Brussels, these too are public artworks. Does the modern *musée* compare or the royal galleries? These seem to be different kettles of fish. I shall retain

the expression 'the monarchical gaze' that attends much art watching – as if the monarch or some monarchical force is looking over one's shoulder and casting judgment on one's judgments. If there is a democratisation of art what does it look like? Surely that is not to be confused with 'anything goes' or an extreme relativism – or is it? I like the idea of inserting stray or aberrant works among the canon. I remember there was a great fuss when Pro Hart died and there was an uproar of sorts that not one of his works was in the gallery (the Art Gallery of New South Wales). (We get the same noises made routinely by current artists not represented in the 'national collection' or whatever we are to call the state collection.) So, someone had the bright idea of putting one of Hart's works up amid the main collection. A small work it has to be noted – with an extended accompanying text. I looked at it, I read the text. Nobody else paid it any attention. If there had been a visitor's book I wonder if anyone would have signed. As an exercise in PR it no doubt served its purpose – to cover the institution's tracks. But did it make its point in other ways, too?

Art notes (1)

Art resides in the recognition of an intent

The spear-maker has no intention of rendering art; the spear-maker makes a spear

But why, we may ask, is the spear decorated? The spear is decorated as the body is decorated – or as the human is decorated

The spear is a long body (*kek unggu, pam unggu*)

If decoration is intended to produce a transformation

Like the painted face: cosmetically rendered to create a face of desire – a desirable something

Yet must allure reside in the face?

Silent Night, Silent Night

I am not sure I can translate this into Kugu or Wik or Kunwinjku or any Aboriginal language, for that matter. I'm not sure the notion exists. Certainly, I cannot come up with any *heilige Nacht*. There is a dictum handy: the thing to be encountered has to be commensurate with the effort to get there. If not it is deceit and disappointment that we encounter. Our high expectations are dealt a mortal blow. But then if the expert tells us that it is indeed worth the effort and that the island of discovery is indeed that or that the vault miles beneath the earth is a worthy keeping place – for posterity and beyond, who are we to differ?

For present purposes, I plan an exhibition for a site that may or may not exist. We may consider a dispersed site – a dispersed set of sites for the exhibits themselves

or a dispersed site for encountering what is or is said to be on offer. What if we chose 5 sites from anywhere, by pin prick if necessary or exemplifying some issue or other, some set of specificities to be found nowhere else? Of course – and this is the first thing that comes to mind – there will be a demand, not by everyone but probably by most, to identify the location. I have a specific site in mind: *kalka kutharra*. I will not tell you where it is. I will not tell you where it is for that invites the site to be overrun. This is one of the characteristics of this site that it was never under pressure of mass consumption or presence. It was there, a rock shelter; a rock shelter that was painted in white clay; hardly a design, a tangle of lines; a site on an itinerary; two men; a point in a long traverse – a traverse so long it is almost incomprehensible; a traverse that can be extended, endlessly – but only at the starting point. It is the starting point that is vague and undecided. There is no orthodoxy as to its point of departure – except that the 'finishing place' is properly its point of departure for there it ends and there is no more. Ending point as finitude and, what word shall we use, rapture? Revelation certainly. And those who attend such sites – points on a swooning trail, we might say, have it as their responsibility to maintain such sites – not for themselves alone but for the 'world'. For without these cared for or attended itineraries what then? The landscape is merely adrift – adrift and abandoned and no centre to it.

I turn on the TV monitor or screen. There it is. The camera moves slowly. It follows the details of the lines, it switches off. Then it switches on again – and off. For its constancy depends on interruption otherwise it becomes merely a *scenum*. It gets consigned to a mere oblivion – like tourist sites or points of obligatory viewing. A Baedeker entry that explains nothing but creates a gap or a series of gaps that it pretends to fill. Maybe this is why I like Jacques-Louis David's *Portrait of Madame Récamier* so much: she is always there – and we see her in glimpses. And in those glimpses, she sees us as much as we see her. This is more than intimacy – and yet, though we might take on the task, we do not consider what allows some sense of propriety – if that is the right word – to prevail. But she is she, that thing there – and nothing behind it. There is no point looking. If we did look she might turn into anything – something like a teddy bear or a giant fluffy toy creature strewn of the bed of a giant pipe-smoking caterpillar called Alice. We might call this derisory. We might have to consider further before we can say anything else. We are more than baffled.

My memory of it is inexact. I prefer my memory to the thing itself. And if René Magritte substitutes a coffin for her what else might we substitute?[2] A pile of coal? No jaguar certainly. Something inert: a giant carrot courtesy of Claes Oldenburg. Each artwork has its itinerary. This may be the task of the curator – to identify and to enhance such itineraries.

Where is the power in this equation? Only in the imagination. No one would want Madame after Magritte's move – except as a cover girl, something on a calendar. This is no resuscitation.

But the odd thing: the substitution will not last either. Its apparent solidity, its apparent (even obnoxious) presence, like some bad schoolboy joke or jibe, points to its own ephemerality – its arbitrariness but an irreparable damage. There, like Horatio's skull which no one knew well. It is the ephemerality of the inert and the unchanging. A beyond of history and thus an act not just of pillage but of destruction.[3]

[Art notes (2): Works for an exhibition:

The Axe Grinder

The Haze (length of ordinary piping that from time to time emits a puff of smoke or vapour; a faint hint of burnt gunpowder)

The Colander (plain enamel colander)

The Death of Translation (diamond smashed with hammer)

Coitus interruptus (old-fashioned record-player and 'cracked' record)

The Final Word (towers of large denomination banknotes interleaved with bundles of cut-to-size news print)

Matters of Method

First, some issues of repudiation: a refusal of any attempt to position, thus a refusal of explanation as a project. A rejection of translation as a *modus operandi* – as if language merely conceals a basic similarity; in short, the world is there for translation; it is simply a matter of finding the right words or the right image. (The notion of the telling image is a tantalising prospect.)

> Languages of course are not interchangeable; nor are literary or artistic traditions.

We might at this point appeal to Marcel Mauss and his notion of the total social fact – and to consider the possibility (and reality) of the total art(istic) fact. Does it exist? Where? How are we to identify it where and if it occurs? As a not-so-preliminary formulation the tendency for the West is to divide reality – to strip things of what is conventionally called context. Of course, it is more than context; it is more an entanglement where this and that are always implicated in something, even everything else. This division of the difficulty – when there was no difficulty in the first place! – permits certain manoeuvres, to convert reality into a set of commodity forms, or short of that, a series of topics or fields. These are all devices of appropriation. Art works can be arranged along the wall like goods in a supermarket and decisions have to be made about what goes with what or, in an effort to be disturbing, to juxtapose elements that do not or normally do not go together. A considerable task in super-market shelving is to decide where the pet food goes. In general, it has to be located

as far from the 'real' food as possible. The real of course translates as 'human' – though the range of 'human food' may vary from situation to situation. Contemporaneously, the vegan foods must be kept separate from the non-vegan – though in general restaurant menus do a bad job of maintaining this distinction.

As for the total art fact, we might point to ceremonies or rituals of all kinds. Among the Kugu and Wik peoples of western Cape York Peninsula ritual performances were often accompanied – in more or less recent historical time at least – by explanatory carvings: to make explicit the various identifications being enacted. Now the carvings remain and are sponsored by the art market; the ceremonies are for the most part gone, maintained – if anywhere and significantly enough – in funerary practice[4]. The suggestion has to be that the acquisition of such objects is also an exercise in funerary practice – a sort of cult of the dead. Not that we need to insist on that here – though it goes with a method that seeks little ideas, trials as it were, trial runs. In the ceremonies to which I refer the past and the present are conjoined – with a prospect of settling and reconfirming matters for the future. An oddity is it not that death becomes the way of attempting to secure the future; an operation predicated on the notion of more or less fixed identities. Our Mona Lisa 'move' points to singularity and non-reoccurrence. This spares everything from death – but at the price of total annihilation. Correspondingly the Last Supper seeks to confirm the existence of the event – but in a form that can have no historical accuracy. The 'Last' can only be a terrifying prospect....

Pondering the question from another angle I come up with the proposal that it is sporting events that are the critical rituals of the day: international matches in which national anthems are performed – as if the nation will be born from the belly of the ball. The teams run onto the field each accompanied by an echoing team of young-sters, a future presaged with prospects of mixed genders, the halt and the lame as well as the fit and the able.... The game itself is part of the ritual (the occasion), the result unknown and unknowable. But all rituals are like that: classically involving dualities of different kinds and uncertainty as to its success or failure. When it succeeds, there is an exultation, an uplift, of a Durkheimian kind, an effervescence which in Lacanian terms becomes a *jouissance*. In this moment of uplift the world is trans-formed – yet at the heart of that transformation a promise of ongoingness.[5]

The empirical tradition relies heavily on sightedness: 'I seen with my own eyes', as I have often heard it expressed. It may also involve demonstrations – as with young Aboriginal children manipulating the leg of a dead brolga or egret, pulling each sinew in order to demonstrate the mechanics of pedalism. It may also be observed in the poke-prod of young children in their interactions with younger children and the 'I see' when the infant responds in the predicted fashion. Other cultures have similar prodding behaviours. It borders on the cruel, it often is cruel. I see in it at least the rudiments of sadism – the desire to elicit responses against the will of the person forced to respond. We may think of it as a method – the play of interpolations or interventions. You poke, you prod, you learn from the reactions. If any.[6]

Poke and note the reaction. I call this a politics of interpolation. The deathly hush that may fall, the silencing is disheartening. No doubt. Be heartened by the thought that the silence may simply mean an incapacity to respond – not just a refusal or an ignoring.

Status and the Archive: A Pompeii Drowned in Its Own Fallout

Status is not a free-floating particle. Those who claim it may never have it. It is doubtful that anyone acquires status by possessing an art work. Secretly it may always be seen as a sign of deficiency. The art work, the possession, compensates. In actual potlatch ceremonies property is destroyed. The destruction – let us say of capital for present purposes – is a necessary component. But did this occur in the case of the Nazis and their destruction of decadent work? Not really, for the work was never in the real possession of the Nazi Regime. Their interest was in warding it off. It was an act of decontamination. To destroy in these circumstances is a roundabout way of acknowledging that they could never be in possession, not really; and to acknowledge this truth through acts of annihilation. Maybe there is an element of *ressentiment* – that the 'decadent' makes too great a claim. It is the intensity of the claim that enfeebles. Like Superman in the presence of Kryptonite. In the case of potlatch, it seems that a claim is being made – that the surplus in its destruction marks the possibility of replacement. It may even be a driver to action. At the same time maintenance may weaken the spirit to renew. And the destruction a weapon aimed at the tedium of the object – something like a giant clearing sale. I say this by way of directing attention to the hazard of the archive – which becomes unfeasible and in at least two different ways: the sheer bulk of the thing, its unmanageability, its cost; and the difficulty of maintaining, in relation to certain technologies of revealing and storage, these technologies themselves. The obvious plight of video work, for example, the dependency on a *teknos* that is already out of date or rapidly shows its limitations. I worked in a zone where the abiding mantra was 'record before it is too late' – but in reality, the recording is already too late for were this not the case the items judged so precious that they demanded to be recorded and documented would be maintained by the ordinary processes of living cultures. Recording, documentation already predicts a disappearing act – but rarely is it considered that the great mass of recordings themselves are part of that disappearing and will suffer the same fate. They too will disappear – and whether that is before they are abandoned or after is a matter to be considered. Possibly but only as a moot point. Of course, we can return to the archive, mine it as the expression goes – though increasingly access is hedged round with more and more restrictions. I will not here seek to set out some of the absurdities that arise in actual practice – in which invariably the depositor or contributor to the archive is disbarred from access. It is the keepers of the archive who have access, no one else. As a young student visiting the Metropolitan Museum of Art in New York, the young woman at reception noted my interest in Cézanne and

offered to arrange for me to see his works represented in their collection. Something similar occurred in London at the Victoria and Albert Museum when the director out of the blue gave me and my companion – we were from the same home town in rural New South Wales and used to play duets together – a guided tour of their treasures. Now in one august institution with which I am affiliated if I wanted access to my own photos I would need to pay. This is not the power of the system but something else; a sort of absurdist over-commitment to procedure and protocol in which the interests of the interested are ignored or passed over. This is order which goes beyond disorder to inertia and possibly worse. An impasse of boxes and files and forgotten content. There is a solution: to permit a repersonalisation of the 'record', to put it to work, for it to be re-thought. An archive is only as smart as the ideas put into it. Its riches cannot be predicted; so, there can be no satisfactory principles guiding the selection of what is in and what is out. Not that the process of selection is random. If anything, it is overdetermined – but its determinations are never made explicit.

For myself I want a Museum of Fake Art. The fake is the emblem of the age – especially if we extend it to the availability of the image on the internet. The image precedes the work and overtakes it. There is no original anymore, just a set of reference points. Yet what they reference is arguably not themselves.

Playing Dice on Hadrian's Wall (1)

Fields of meaning, fields of response, fields of compromise, fields of refusal, fields of confusion, fields of adoration. The list is endless. At my high school, there was an assembly area called the quadrangle. One thing it was not was a quadrangle. It was in fact all over the place. Read this little observation however you will. What I will say is that the response to art precedes the question of meaning. We may even assert, with a fair degree of confidence, that the question of meaning is a displacement from the original 'shock' or surprise of the object. We may wish for a better word than 'shock' with its now reference to *The Shock of the New*. The shock of the new may be no shock at all; but the expression taps into a certain desideratum, obviously. It may well be the relief of the new or the freshness of the new or the naivety of the new or the savvy of the new. And if it is the new we are supposed to be shocked by or at or pleased by or at or nauseated at or by there has to be a pre-existent which participates in the response, whatever it is. There has to be a recognition of some sort, either for good or for ill. Even to ignore something implies a prejudgment as to what can be ignored or not – a refusal of the demand the art work puts on us. In my own experience, there are art works that place a demand on me to respond: to score the work, to write a response, to confect something I shall call an undoing. I have to be released from something we might call its power. The works that seize me in this way are often unexpected. It's like going on a bush walk and deciding that something has to be said before I can proceed – like Basho and his haiku written en route. Like the little phrase that came to me: 'Playing dice on

Hadrian's Wall'. It comes from somewhere, God knows where. As a wall, I think of it as a rather feeble effort – which itself must have some meaning. And a sense that for it to be effective there has to be a degree of fraternisation – for the keepers of the wall need to know if there are any assemblages out there, any threat, any 'new developments'. The keepers of the wall are never to be caught off guard – and the less sturdy the wall the more assiduous their efforts must be. At another level the wall concretises, makes manifest and 'deliberates' on an actual if somewhat vague division. It sharpens the divisioning of the world. … It translates fluidity into fixity and apartness. It turns the gaze outwards – that is the odd thing: the world is not the world one comes from but the world that is refused, forbidden, treated as threat and not promise. It creates and defines a theatre of anxiety.[7]

Playing Dice on Hadrian's Wall (2)

The notion of the 'scene', what is it, who has it, who 'buys' it? How dependent is any form of cultural production on a scene – and what is the relationship between a scene (a loose 'confederacy' of 'interested' personnel) and its bureaucratic parallel? Where does the academic belong in this? The very essence of a scene is that it cannot be administered; it does not or will not 'toe the line'. The academic and bureaucratic seeks to freeze time; we might think about the drive to define and to render 'official'. But the scene is unofficial – though some of its key players may seek to control – or to assert a presence at – what are generally acknowledged as key events (various biennales, art fairs, etc.).

We might wish to argue that 'being-in-art' is a way of being in the world. This has implications for how we engage – read, write, discuss, acquire, accept, dismiss. If art is one way of being in the world, how does any particular engagement reflect what we might call a world condition? Can we talk about a Great Wall of Art – when art production is as much on the side of the wilful and the wayward as it is on matters of 'significance' or, dare we say it, 'coherence': the demand that it makes sense. (The elitist demand has art hovering between the interpretable (sayable) and the relentlessly obscure.) In the writing of art history is it not the case that the focus is invariably on the 'winners'? Better and less promotional histories might be better achieved by attending to the 'losers'.

The history of all thought is the history of abandonment. This text (the above two paragraphs) is the text of the original abstract. What it would look like now I have no idea. The written text is in its essence fixed. It allows none of the ebb and flow of conversation or debate. It loses its conversational negotiability and may appear more dogmatic, even proselytising than one might wish.

And its exclusions, what of them, one's oversights? The fact is, none of us can take the whole world in. If anything, it embraces us – but largely unknown to us. We might consider a generous or expansive form of writing: a celebration. We might try something else, just as open, perhaps more so, a sort of inquiringness. A readiness for surprises and reconsiderations; unexpected leaps and unanticipated collisions.

For this brief moment, I find myself shifting to a concern with social sets and artistic circles. The set is a fashion statement – for those who can afford it. It is not creative except as to the maintenance of fashionability and 'being in the swim'; the focus is on style. Against that we might juxtapose the circle. Gertrude Stein and her gang, for example: intellectualist, creative. My inclination is to propose that both disappear, are, like the Cheshire Cat, fading away - so that neither the set nor the circle can be at the centre of a scene. Warhol had a scene with his Factory; Fassbinder with the Munich theatre group, the Anti-Teater.) We might like to suggest that Fassbinder's world combined elements of circle and set; and too rigid a classification might lead us astray in this instance as in others. In the case of Fassbinder and his world we might consider that it was sustained by a general movement which revealed itself in the Événements de mai 1968, in France, and in more extreme forms, Baader-Meinhof and the Red Army Faction (RAF) in Germany, the Japanese Red Army (JRA), and the Brigate Rossi in Italy.[8]

Yet at the same time we may need to consider the collapse of all these forms: is there an art scene, is there anywhere an artistic circle, is there anywhere a 'set'? Stable is another term in use – as if artists are gee-gees invested in by hopeful lovers of horse flesh. Artists are either good or bad bets. What the blood lines are in this case is open to conjecture.

More and more the focus is on the artist as producer or entrepreneur, self-promotion as the *sine qua non* of art production.[9]

Concluding where No Conclusion Is Possible

How to conclude when no conclusion is possible – or maybe even desirable? How to proceed in the face of a question that has already been repudiated – if not completely? The triumph of the question remains and is not easily brought down to size. It is like a cancer that cannot easily be removed and occupies with great colonising force the place of thought itself. Everywhere it reasserts itself. Our reaction to the question? To react at all we must refuse and it is in the refusal of the question that thought may redeem itself. If we do not refuse we accord it a legitimacy it does not have. There is no a priori of the validity of the question unless it is a counter-question of the sort: 'Why do you ask me that? What position do you seek to place me in? What position do you place me in? What entitles you to the up position on the seesaw of converse?' Maybe art is that activity that asks no question; or it poses a question that cannot ever be answered. We may say that Macbeth is about the inexorability of fate or the curse of ambition and the desire for recognition. But it cannot be about these things; they are merely the props. The play unfolds but it has no real tension to it; everything is pre-inscribed. This may be thought to give relief – and at the same time to permit us to examine dynamics or impulses or calculations which otherwise would have no voice. Yet to say that is to invite a judgment that art is about lack – when in reality we

might wish to assert that it announces a surplus. Much art runs counter to this surplus – or seeks to contain it.

If we repudiate the inquisitorial style or culture, we focus on reactions and thus the possibility of nuance. Knowing can just as easily as the question displace attention away from the reaction to an enumeration of knowledges or informations. It lends itself to a decoding enterprise. Decoding in itself can never have the final word. It may be as pointless and barren as turning speech acts into performances of grammatical 'rules'. The grammarician is no better equipped to interpret or to interpret speech than the flower seller at the corner kiosk. When it comes to knowing plants the flower seller will generally be at the advantage.

And if we oppose the inquisitorial style and the 'informationalising' of the lifeworld, including the artworld, we reproach any assertion of histories, art or otherwise, that seek to assert their centrality or correctness. The same applies to analytical or judgmental categories. Art might be considered a sphere in which the categorical itself is opened up to re-examination or doubt: art is everywhere inserted within or an emergence from a thought world (an idea world if one prefers), but it cannot at one and the same time claim to exceed that thought world or to be confined by it. Or can it?

This takes us to the matter of globalisation – not so much a universal 'conversation' as the imposition, largely unconscious and unthought, of categories of thought that derive from a rather limited set of 'systems' – not that they themselves will necessarily present themselves in an altogether systematic form. In reality all systems contain their opposite – and the insistence on order inclined to create disorder all about and an insistence on disorder emergent patterns of order or response. My back lane is given over to garbage collection and the illicit; yet socially it has its own rigorous rules and the garbage itself follows preordained paths, with discarded timbers arranged in careful displays and positionings reminiscent of Chardin and Morandi and adherents of the 'white on white' movement; and special treatment of wrappings and packaging which is in my view a still developing art form. I note the careful wrapping of Christmas trees in cellophane or the flattening and packaging of cardboard boxes behind McDonalds. It is almost certain that this careful arranging has both arisen from and given a lead to contemporary art practice. The main street which enjoys what I shall call an official status is both chaotic and 'respectable'. There is no need to greet passers-by or to acknowledge their presence. In the back lane, everyone knows the basic rule that acknowledgment is crucial; the situation must be socialised, otherwise it may be dangerous. One cannot feign invisibility or non-presence. My back lane cannot be translated into anything else; and my main street, the one onto which my apartment faces, has its own singularity. Not that it is of great interest. To create interest would require a very high level of attention – and some mechanism for aggregating or combining the bird calls of the pre-dawn, the passage of the street sweeper trucks, the opening of the grille to the doctor's surgery downstairs, the calls

of the scurrilous ibises, the singing and chants of German back-backers in the midnight hours: all reassuring in a fashion and establishing presence. As if the precinct has a voice. Visually it is of no great interest – or it is of no great interest beyond itself. Others may disagree and come up with something intelligent, responsive, instructive. The temptation of course will be to convert it to something of universal significance. It has no universal significance. This is inflation in the face of an overtaking blandness. My street is now a zone of prohibitions. Signs announce NO DRINKING yet skateboards proliferate. Their days are undoubtedly numbered. The magnificent trees that once lined the street and gave a total canopy in summer are now replaced by dismal replicas. In time, they may age and acquire whatever is the arboreal equivalent of personhood. For the moment, they echo the fate of the persons who pass beneath them – except that we know nothing of the allergies that the trees suffer from on account of the human presence; though complaining bitterly about the 'suffering' the trees cause at their seasonal flowering and on windy days. Soon someone will sue the council: 'YOUR TREES ARE KILLING US'.[10]

Notes

1 An alternative view might be that the hollow log represents the skinned body – that is, the body fleshed and covered in a dermis that can be painted and stencil onto the remains of the deceased that person's identity through life and into the hereafter.

2 Rene Magritte, *Perspective: Madame Récamier by David*, 1951, oil on canvas, 60.5 × 80.5 cm.

3 My memory of the painting is of the actual work – hung where it is hung as if *in perpetuo* and not in reproduction. But I suddenly realise that the 'faultiness' of my memory is the result of the interpolation of Ingres's portrait of Mlle Caroline Rivière (which even then I've managed to reverse in my mind's eye). I mention this only to be able to insist on the imperium of the error and our capacity to make our own compositions out of the material to hand.

4 One of the great furphies (erroneous stories) of the art scene is the proposition that it has 'saved' Aboriginal art from the ethnographic. On the one hand, it seeks the sacred or the 'spiritual'; on the other it hands the sacred over to the market. The market in itself does nothing to maintain or to promote cultural practice but it does detach the art object from the terrain of the sacred or the restricted. The market relies upon but never invests in the local as site of reflexion, innovation, production. And when it comes to commentary we have the crudest resuscitation of an ethnographic that no ethnographer worth his or her salt would dare promulgate.

5 Of course, we might easily extend this analysis to take into account the swapping of insignia before the game commences – an odd echo of the necessity of the other to care for or enact the identity of what for present purposes we might call 'their other half' (Refer to the *dhuwa-yirritja* relationship in NE Arnhem Land or the *kirda-kurdungurla* relationship in Central Australia). There is the matter of distinctive uniforms marking membership on the one hand and non-membership on the other. The referee might be conceived as a 'field boss' (or 'law man') regulating proceedings. There are the supporters' chants, their adornment in the apparel (body paint) of 'their' team, team songs. In short, all the apparatus of what in anthropology might be referred to as a totemic complex.

6 I am reminded of the behaviour of certain brave if foolhardy anti-Nazis in Berlin dispensing postcards here and there against the regime; or the ordinary operation of graffiti artists.

Anonymous or not so anonymous responses or interventions. We might note that the powerful can react violently and repressively – or, and this is the more usual response in the sort of society which I inhabit, not at all. Or apparently not at all. The response is silence. Everyone knows what the repressive apparatus is – but they are invited to apply it to themselves. The less response the more the tendency towards helplessness and unwitting compliance by themselves becoming silence. What strategies then, other than by compliance, to break through the wall of silence or of silencing? Anything that breaks through the carefully erected and maintained barriers of our major cultural institutions must be placed under suspicion of compliance. Most censorship is imaginary – but that does not make it any less real. The strategies of containment rely, at least in part, on a 'right to know' ('please explain') and a write to question (interrogate). The appropriate response in my own view is to note one's reactions and to generate a response: an add-on not a curtailment or a positioning. The interrogation and the demand for explanation are not occasions for promoting one's work, they are efforts at containment, a clinging to the readymade view of things and not alternate possibilities. An acceptable response is to examine one's own responses and to put them out there. As acts of generosity. Not efforts to dominate by 'getting it right'. This requires more confidence in one's judgments than most people are capable of – though every art work worth its salt offers that invitation: respond, respond, respond, where does it take you, where does it lead? The most appropriate response is to respond to the productive potential of the work – not to 'translate' it but to extend its trajectory. The refusal too can be a productive response – for identity arises through negation.

7 My efforts to pursue the myth of Romulus and Remus are initially disconcerting for there is no confirmation of Remus's mocking of Romulus's wall – and the consequences of that. Eventually it turns up in an account intended for children. I learn something, however: in some accounts, there is stress on the ongoing status over time of the Palatine Hill as a centre of the ruling class; and the Aventine as the 'outpost' of newcomers, innovation and political opposition. This is a characteristic distinction of moiety divisions in general and a good example of the geographical differentiation of opposing political, aesthetic and 'lifestyle' orientations. The other wall that comes to mind is the Taunus *limes* and the whole system of walls or barriers that constituted the *Limes Germanicus*. In the case of Hadrian's Wall there is debate as to its real function: as a military defence, a marker of boundaries, or as a taxation barrier (that is, principally economic in purpose). Maybe it guaranteed trade without the threat of brigandry. Such efforts to position it as one or the other is clearly foolhardy, and as timeless through time – no better demonstrated by the argument that it had no real military force and then informing us that a wall built to the north was abandoned because it could not be sustained militarily! The garrisons stationed there were required to retreat to the earlier wall.

8 It would be improper to proceed without at least a passing reference to the transformation and consolidation of so-called 'terrorist groups' throughout the world. It would be interesting to consider the relationship between their forms of political action and their calculated attacks on art and monuments, ancient and modern. Also, the unofficial relationship between these groups and the art scene, through the sale of artworks to finance their activities.

9 A movement may be undetectable at present – but surely the forces will be gathering somewhere. Can we legitimately speak of a decline as a movement? While we identify Beat as a movement or Op/Pop (seen on the side of the progressives), what of Trump and Trumpism? I do not intend this merely as a rhetorical move. Whatever it is it is there. Movements are more than moves – even if they consist entirely of moves and little else. The move is the current move *par excellence*. Advertising, promotion, selling points, the hard sell. Ideas are largely reiterations of reiterations and assertions of uniqueness. Excitement appears out of nowhere

as a sort of short circuit in the world's wiring system. Hip Hop is undoubtedly a movement – and fits easily within our conception of a total art fact. It has its followers and adherents. Rap, too. It seems to me that they stand against The Set.

10 Acknowledgments: With grateful thanks to Peret von Sturmer, Dr Britta Duelke and Djon Mundine for earlier readings of sections of this text and, in some cases, for factual endorsements. Toni Warburton provided useful pointers in the discussion on 'white on white'. All errors are mine.

About the Editors

Brad Buckley

Brad Buckley is an artist, urbanist, activist and Professorial Fellow at Victorian College of the Arts, Faculty of the VCA and MCM, the University of Melbourne. He was previously Professor of Contemporary Art and Culture at Sydney College of the Arts, the University of Sydney. He was educated at St Martin's School of Art, London, and the Rhode Island School of Design. He is the editor, with John Conomos, of *Republics of Ideas: Republicanism, Culture, Visual Arts* (Pluto Press, 2001), *Rethinking the Contemporary Art School: The Artist, the PhD, and the Academy* (NSCADU Press, 2009) and, with Andy Dong and Conomos, *Ecologies of Invention* (SUP, 2013). His most recent publication is (with Conomos) *Erasure: The Spectre of Cultural Memory* (Libri Publishing, 2015). Buckley has also developed and chaired (with Conomos) several sessions at the College Art Association (USA). He has been a visiting professor at the National College of Art and Design (Ireland), Nova Scotia College of Art and Design University, the Royal Danish Academy of Fine Arts, the University of Tsukuba (Japan) and Parsons the New School for Design. He is the recipient of the prestigious PS1 Center for Contemporary Art Fellowship (New York 1990–91) from the Australia Council for the Arts.

His work, which has been shown internationally for over thirty years, operates at the intersection of installation, theatre and performance, investigates questions of cultural control, democracy, freedom and social responsibility. Buckley's work has been included in the *3rd International Biennial* (Ljubljana, [former] Yugoslavia), *My Home is Your Home: The 4th Construction in Process* (the Artists' Museum, Lodz, Poland), *Co-Existence: The 5th Construction in Process*, (the Artists' Museum, Mitzpe Ramon, Israel), and the *9th Biennale of Sydney*, and in exhibitions at Franklin Furnace (New York), Artspace Visual Arts Centre (Sydney), the Kunstlerhaus Bethanien (Berlin), the PS 1 Institute for Contemporary Art (New York), the Dalhousie Art Gallery (Halifax), the Tsukuba Art Gallery (Japan) and Plato's Cave (New York).

John Conomos

John Conomos is an artist, critic and writer, and Associate Professor and Principal Fellow at Victorian College of the Arts, Faculty of the VCA and MCM, the University of Melbourne. Conomos has exhibited extensively both locally and internationally across a variety of media: video art, new media, photo-performance, installations and radiophonic art. He is a prolific contributor to art, film and media journals and a frequent keynote speaker and participant in conferences, fora and seminars.

His video *Autumn Song* received an award of distinction at Berlin's Transmediale Festival in 1998. In 2000 Conomos was awarded a New Media Fellowship from the Australia Council for the Arts and in 2004 he was awarded A Global Greek Award (Hellenic Ministry for the Arts and Culture) for his contribution to the visual arts and the Greek diaspora. In 2008, his work was included in *Video Logic* at the Museum of Contemporary Art, Australia.

Conomos is the author of *Mutant Media* (Artspace/Power Publications, 2008) and in the following year he edited, with Brad Buckley, *Rethinking the Contemporary Art School: The Artist, the PhD and the Academy* (NSCADU, 2009) and *Erasure: The Spectre of Cultural Memory* (Libri Publishing, 2015). During 2009 Conomos' video, *Lake George (After Mark Rothko)*, was screened at the Tate Modern (London), where he also spoke on his art practice.

In 2011 Conomos exhibited a large multimedia installation, *Shipwreck*, at the Queensland University Art Museum. In 2013, he exhibited *Spiral of Time*, which was accompanied by a major publication, at the Australian Centre for Photography. During 2013 Conomos also exhibited in *Etudes for the 21st Century*, Osage Gallery, Hong Kong with leading European media artists Robert Cahen and Kingsley Ng.

He was also an editor, with Andy Dong and Brad Buckley, of *Ecologies of Invention* (SUP, 2013).

Conomos also exhibited *Mediterranean* at Toowoomba's Raygun Projects in June 2016. In January of that year he also exhibited a performance video *Paging Mr Hitchcock* at the Mosman Art Gallery. Conomos has also exhibited at Cementa15 (2015) and Cementa17 (2017). With Steven Ball in October, 2016 Conomos exhibited a multimedia installation *Deep Water Web* at Furtherfield Gallery in London. He is also writing a memoir called *Milk Bar*.

About the Contributors

Bruce Barber

Bruce Barber is an interdisciplinary artist, writer and curator, and Professor of Media Arts. Art History and Contemporary Studies at NSCAD University. He holds under-graduate and graduate degrees in Sculpture and Art History from Auckland University (1969-1975), an MFA (Intermedia) (NSCAD, 1978), and a PhD in Media and Communications from the European Graduate School, Switzerland (2005). He has exhibited internationally for over three decades in New Zealand, Australia, North America and Europe and is represented in various public and private collections. Barber is the editor of *Essays on Performance and Cultural Politicization* and of *Conceptual Art: The NSCAD Connection 1967–1973*. He is co-editor, with Serge Guilbaut and John O'Brian, of *Voices of Fire: Art Rage, Power, and the State*, editor of *Condé +Beveridge: Class Works* (2008), author of *Performance [Performance] and Performers: Essays and Conversations* (2 volumes, edited by Marc James Léger, 2008), and author of *Trans/Actions: Art, Film and Death* (2008) and *Littoral Art & Communicative Action* (edited by Marc James Léger, 2013). His critical essays have appeared in numerous anthologies, art journals and magazines. Barber's interdisciplinary art practice is documented in the publications *Reading Rooms* and *Bruce Barber Work 1970–2008*.

Michael Birchall

Dr Michael Birchall is curator of public practice at Tate Liverpool and senior lecturer at Liverpool John Moores University in Exhibition Studies. Previously he has held curatorial appointments at The Western Front (Vancouver, Canada), The Walter Phillips Gallery at The Banff Centre (Canada), Künstlerhaus Stuttgart (Germany); and has lectured at Zurich University of the Arts. His writing has appeared in Frieze, ARKEN Bulletin, On Curating, Modern Painters, C-Magazine, Art & the Public Sphere, and various catalogues and monologues.

Peter Booth

Peter Booth is an artist and economist based in Oslo, Norway, and is currently a doctoral student at Erasmus University in Rotterdam. He has worked as an artist for the past 10 years and has exhibited work in Europe, North America and Australia. Primarily working within the sculptural field, the starting point for his work often relates to ambiguities and contradictions in art, and how art deals with economic influences.

Prior to beginning a formal art education in 2003, he worked in investment banking in London, and management consulting in Australia and France. He studied at Oslo National Academy of the Arts and the London School of Economics, and his current doctoral research investigates relationships and mirrored behaviours across the worlds of art and finance.

Juli Carson

Juli Carson received her PhD in the History, Theory and Criticism of Art and Architecture from MIT in 2000. She is currently Professor of Critical and Curatorial Studies in the Department of Art at UCIrvine, where she also directs the University Art Galleries. Her essays on conceptual art and psychoanalysis have been widely published in *Art Journal, Documents, October, Texte zur Kunst* and *X-Tra*, as well as in numerous international anthologies and exhibition catalogues. She is author of *Exile of the Imaginary: Politics, Aesthetics, Love* (Generali Foundation, 2007) and *The Limits of Representation: Psychoanalysis and Critical Aesthetics* (Letra Viva Press, 2011). Her forthcoming book *The Conceptual Unconscious* will be published by PoLyPen. She is currently working on a monograph entitled: *This world is a fleshless one where all I know are madness, love and heretics: Reflections on Daniel Joseph Martinez.*

Joanna Figiel

Joanna Figiel is a PhD candidate at the Centre for Culture Policy Management, City University London. Her research focuses on labour issues, unpaid work, precarity, and policy within the creative and cultural sectors. She is a member of the *ephemera* editorial collective and collaborates, among others, with Minor Compositions, Artleaks, and the Free/Slow University of Warsaw. Publications: https://city.academia.edu/JoannaFigiel.

Adam Geczy

Dr Adam Geczy is an artist and writer who teaches at Sydney College of the Arts, the University of Sydney. With over two decades' practice as an artist, his performances, videos and multimedia installations have been shown extensively in Australia and Europe. As a writer, he has produced numerous books, book chapters, journal articles and critical essays. Recent titles include *Art: Histories, Theories and Exceptions* (which won the 2009 CHOICE award for best academic title in art), *Fashion and Orientalism* (Bloomsbury, 2013) *The Artificial Body In Fashion and Art* (Bloomsbury, 2017), and (with Vicki Karaminas), *Critical Fashion Practice from Westwood to van Beirendonck* (Bloomsbury, 2017).

Carol Ann Gilchrist

Dr Carol Ann Gilchrist holds a PhD in Art History from the University of Adelaide. The title of her doctoral thesis is *Gestural Abstraction in Australian Art 1947-1963: Repositioning the Work of Albert Tucker.* In addition, she holds a Master of Arts (Curatorial and Museum Studies) from the University of Adelaide and a Graduate Certificate in Museum Studies from the University of Sydney.

Amelia Jones

Amelia Jones is the Robert A. Day Professor of Art and Design and Vice Dean of Critical Studies at Roski School of Art and Design at the University of Southern California. She is known as a feminist art historian, a scholar of performance studies, and a curator. Professor Jones previously taught at McGill University (Montreal), University of Manchester (UK) and University of California, Riverside. Her recent publications include major essays on Marina Abramović and on new materialisms and contemporary art (in *TDR*), books and essays on feminist art and curating (including the edited volume *Feminism and Visual Culture Reader* (new edition 2010)), and on performance art histories. Her book, *Self Image: Technology, Representation, and the Contemporary Subject* (2006) was followed in 2012 by *Seeing Differently: A History and Theory of Identification and the Visual Arts* and her major volume, *Perform Repeat Record: Live Art in History,* co-edited with Adrian Heathfield and, in 2016, by *Otherwise: Imagining Queer Feminist Art Histories,* co-edited with Erin Silver. Her exhibition *Material Traces: Time and the Gesture in Contemporary Art* took place in Montreal (in 2013), as did the event *Trans-Montréal* (Performance Studies International, 2015). She curated *Live Artists Live,* which took place at USC in 2016. The latter two events included performances and lectures. Her edited special issue of *Performance Research* entitled "On Trans/Performance" was published in October 2016. Her new projects address the confluence of "queer," "feminist," and "performance" in relation to the visual arts.

Arjo Klamer

Arjo Klamer is Professor of Economics of Art and Culture at Erasmus University, Rotterdam, and holds the world's only chair in the field of cultural economics. Prior to that and after graduating with a PhD from Duke University, he taught at Wellesley College and George Washington University in the United States.

In 1984, he attracted attention with his book *Conversations with Economists*. In *Speaking of Economics*, he pursues themes that emerged from that book. He has collaborated with Deirdre McCloskey to promote the rhetorical perspective on economics. Klamer's articles have been published in a wide range of journals, including the *Journal of Cultural Economics*.

Currently, Klamer is working on a book titled *Doing the Right Thing*. In this book, Klamer will formulate a value-based approach to economics, which will lead to the reinterpretation of concepts such as richness and poverty.

His current research focuses on the cultural dimension of economic life and the values of art.

Brett Levine

Brett M. Levine is a doctoral candidate in the College of Arts, Society, and Education at James Cook University, Australia. A professional curator and museum educator for over two decades, he was previously the director of the Visual Arts Gallery of the University of Alabama at Birmingham, and Lopdell House Gallery, Auckland, as well as the Team Leader, Collection Programmes, at the Dowse Art Museum, Lower Hutt, New Zealand. His writings have appeared in numerous publications. His essay "The Slow Fire" was published in the Artspace Visual Arts Centre monograph *Brad Buckley*. His essay, "Princes Kept the View" appears in *Brad Buckley/John Conomos*, published by the Australian Centre for Photography. His exhibition reviews have appeared in *Art Papers, The New Zealand Journal of Photography, Art New Zealand, RealTime, Burnaway, Object, Urbis, monica,* and *log illustrated.* He is a regular contributor to *Burnaway*, and *B-Metro*. His current research focuses on curatorial intervention, reception theory, and curatorial mediation of the artist/audience exchange.

Ian McLean

Ian McLean is Hugh Ramsay Chair of Australian Art History at the University of Melbourne, and Senior Research Professor of Contemporary Art at the University of Wollongong. He has published extensively on Australian art, and particularly Aboriginal art, within a contemporary context. His books include *Rattling Spears A History of Indigenous Australian Art, Double Desire: Transculturation and Indigenous art, How Aborigines Invented the Idea of Contemporary Art* (Australia Council for the Arts, the Getty Foundation and the Nelson Meers Foundation, 2011), *White Aborigines: Identity Politics in Australian Art* (Cambridge University Press, 1998), and *The Art of Gordon Bennett* (with Gordon Bennett) (Craftsman House, 1997).

Jennifer A. McMahon

Jennifer A. McMahon is Professor of Philosophy at the University of Adelaide. She is the author of *Art and Ethics in a Material World: Kant's Pragmatist Legacy* (Routledge 2014) and *Aesthetics and Material Beauty: Aesthetics Naturalized* (Routledge 2007). She is the guest editor of the inaugural issue of the *Australasian Philosophical Review* on the "Pleasure of Art" (March 2017), Chief Investigator for the Australian Research Council funded project ArtSense: Taste and Community; and Executive Secretary of the Australasian Association of Philosophy.

Gregory Sholette

Gregory Sholette is a New York-based artist, writer and activist and an Associate Professor at Queens College, City University of New York. Where he teaches studio art and co-directs the new Social Practice Queens MFA concentration, and is an associate of the Art, Design and the Public Domain program of Harvard University's Graduate School of Design. Sholette holds a PhD in History and Memory Studies from the University of Amsterdam, The Netherlands (2017), he is a graduate of the Whitney Independent Study Program in Critical Theory (1996), Graduate of University of California Sand Diego (1995), and The Cooper Union School of Art (1979). His recent projects include the exhibition DARKER at Station Independent Projects NYC consisting of large ink wash drawings addressing current political conditions. He is active with Gulf Labor Coalition and was a co-founder of the collectives Political Art Documentation/Distribution (PAD/D: 1980-1988), and REPOhistory (1989-2000). A former Mellon Fellow at the CUNY Center for the Humanities he is on the editorial board of FIELD, a new online journal focused on socially-engaged art criticism, and his most recent publications include Delirium and *Resistance: Activist Art and the Crisis of Capitalism*, (Pluto/U. Chicago Press 2017), and *Dark Matter: Art and Politics in an Age of Enterprise Culture* (Pluto Press: 2010).

Stevphen Shukaitis

Stevphen Shukaitis is Senior Lecturer at the University of Essex, Centre for Work and Organization, and a member of the Autonomedia editorial collective. Since 2009 he has coordinated and edited Minor Compositions (www.minorcompositions.info). He is the author of *Imaginal Machines: Autonomy & Self-Organization in the Revolutions of Everyday Day* (2009), and *The Composition of Movements to Come: Aesthetics and Cultural Labor After the Avant-Garde* (2016), and co-editor of *Constituent Imagination: Militant Investigations // Collective Theorization* (2007). His research focuses on the emergence of collective imagination in social movements and the changing compositions of cultural and artistic labour.

John von Sturmer

John von Sturmer is an experimentalist and documentarian with a long engagement in Aboriginal affairs and a profound interest in the immediate life world. Alternating between academia (Universities of New England, Queensland, New South Wales, Sydney and others) and more practical spheres (consultant, Australia Council; acting director, Aboriginal Theatre Foundation; director, Project to Monitor the Social Impact of Uranium Mining in the Northern Territory; working to specific Aboriginal groups, e.g., PNG-Gladstone gas pipeline, Merepah Land Purchase, Wik Native Title Claim, Warburton Arts Project). Exhibiting artist and critic, with strong focus on performance and collaboration. Senior Fellow, Institute of Postcolonial Studies, North Melbourne, Australia.

John Welchman

John C. Welchman is Professor of Art History in the Visual Arts department at the University of California San Diego and a leader in the international arts community. He serves as chair of the Mike Kelley Foundation for the Arts (Los Angeles) and Advisor at the Rijksakademie van Beeldende Kunsten, Amsterdam. His books on art and visual culture include *Modernism Relocated: Towards a Cultural Studies of Visual Modernity* (Allen & Unwin, 1995), *Invisible Colours* (Yale, 1997), *Art After Appropriation: Essays on Art in the 1990s* (Routledge, 2001), *Vasco Araújo* (ADIAC, 2007), *Guillaume Bijl* (JRP|Ringier, 2016), *Paul McCarthy: Caribbean Pirates* (forthcoming, 2017). He is coauthor of *The Dada & Surrealist Word-Image* (MIT, 1989), *Mike Kelley* (Phaidon, 1999), *On the Beyond: A Conversation between Mike Kelley, Jim Shaw and John C. Welchman* (Springer, 2011), *Kwang Young Chun* (Skira Rizzoli, 2014), and *Joseph Kosuth: Re-Defining the Context of Art: 1968–2014;* The Second Investigation *and Public Media* (forthcoming, 2017); and editor of *Rethinking Borders* (Minnesota UP/Routledge, 1996) and *Sculpture and the Vitrine* (Ashgate, 2013). *Past Realization: Essays on Contemporary European Art* [XX to XXI vol. I] was published by Sternberg in 2016, the first of a six volume series of his collected writings.

Bibliography

Abbott-Smith, Nourma. *Ian Fairweather: Profile of a Painter*. St Lucia, Qld: University of Queensland Press, 1978.

Adorno, Theodor. *Prisms*. London: Neville Spearman, 1967.

———. "Reconciliation under Duress." In *Aesthetics and Politics*, 151-76. New York: Verso 1995.

Agamben, Giorgio. *Stanzas: Word and Phantasm in Western Culture*. Translated by Ronald L. Martinez. Theory and History of Literature. Vol. 69, Minneapolis: University of Minnesota Press, 1993.

———. *Homo Sacer: Sovereign Power and Bare Life*. Palo Alto: Stanford University Press, 1998.

Alloula, Malek. *The Colonial Harem*. Translated by Myrna Godzich and Wlad Godzich. Manchester: University of Manchester Press, 1986.

Althusser, Louis. *Lenin and Philosophy and Other Essays*. New York: Monthly Review Press, 1971.

Araeen, Rasheed. "New Internationalism, or the Multiculturalism of Global Bantustans." In *Global Visions: Towards a New Internationalism in the Visual Arts*, edited by Jean Fisher, 3-11. London: Kala Press in association with The Institute of International Visual Arts, 1994.

———. "Come What May: Beyond the Emperor's New Clothes." In *Complex Entanglements: Art, Globalisation and Cultural Difference*, edited by Nikos Papastergiadis, 135–55. London, 2003.

Aristotle. *The Ethics of Aristotle: The Nicomachean Ethics*. Translated by J. A. K. Thomson. New York: Barnes and Noble, 1953.

Ashford, Doug, Julie Ault, and Group Material. *Aids Timeline*. dOCUMENTA (13). Berlin: Hatje Cantz.

Ault, Julie, ed. *Show and Tell: A Chronicle of Group Material*. London: Four Corners Books, 2010.

Baume, Nicholas. "The Interpretation of Dreamings: The Australian Aboriginal Acrylic Movement." *Art & Text* 33 (Winter 1989): 110–20.

Bazoian, Kathy Phelps, and Steven Rhodes. *The Ponzi Book: A Legal Resource for Unraveling Ponzi Schemes.* New Providence: Matthew Bender LexisNexis, 2012.

Beier, Ulli. "Encouraging the Arts among Aboriginal Australians: A Report for the Australian Council of the Arts." In *Encounters with Aboriginal Australians*, edited by Ulli Beier, 1–42. Sydney: Ulli Beier, 1969.

Bell, H. R. *Storyman.* Cambridge: Cambridge University Press, 2009.

Benjamin, Walter. "The Author as Producer." In *Reflections* 220-38. New York: Harcourt Brace Jovanovich, 1978.

———. "The Task of the Translator." Translated by Harry Zohn. In *Walter Benjamin: Selected Writings Volume 1, 1913-1926*, edited by Marcus Bullock and Michael Jennings, 253-63. Cambridge, MA: Belknap Press of Harvard University Press, 2002.

Bennett, Gordon. "The Non-Sovereign Self (Diaspora Identities)." In *Global Visions: Towards a New Internationalism in the Visual Arts*, edited by Jean Fisher, 120-30. London: Kala Press in association with The Institute of International Visual Arts, 1994.

Berardi, Franco. *The Soul at Work: From Alienation to Autonomy.* Los Angeles: Semiotext(e), 2009.

Berger, John. *Ways of Seeing.* London: Penguin Books, 2008. 1972.

Bismarck, Beatrice. "Curating Curators." *Texte zur Kunst*, no. 86 (2012): 42-61.

Bloom, Brett. *Petro-Subjectivity: De-Industrializing Our Sense of Self.* Ft. Wayne: Breakdown Press, 2015.

Boltanski, Luc, and Eve Chiapello. *The New Spirit of Capitalism.* London: Verso, 2005.

Borges, Jorge Luis "The Library of Babel." In *Collected Fictions*, 112-18. New York Penguin Books, 1998.

Brenson, Michael. "The Curator's Moment." *Art Journal* 57, no. 4 (1998): 16-27.

Breton, André. "Preface." In *Dawn of Art: Painting and Sculpture of Australian Aborigines.* Sydney: Angus & Robertson, 1965.

Buckley, Brad, and John Conomos, eds. *Rethinking the Contemporary Art School: The Artist, the Phd and the Academy.* Halifax, Canada: NASCAD University Press, 2009.

Burnstein, Charles. *A Conversation with David Antin.* New York: Granary Books, 2002.

Buruma, Ian. *Theater of Cruelty: Art, Film, and the Shadows of War.* New York: New York Review of Books Inc, 2014.

Butler, Judith. *Giving an Account of Oneself.* New York: Fordham, 2005.

Butler, Sally. "Multiple Views: Pluralism as Curatorial Perspective." *Australian and New Zealand Journal of Art* 4, no. 1 (2003): 11–28.

Cavell, Stanley. *Must We Mean What We Say?.* Cambridge: Cambridge University Press, 2002.

Celant, Germano. "Haim Steinbach's Wild, Wild, Wild West." *Artforum International* (December 1987).

Cheng, Meiling. *Other Los Angeleses: Multicentric Performance Art.* Berkeley: University of California Press, 2002.

Christov-Bakargiev, Carolyn. dOCUMENTA (13): *Das Begleitbuch/the Guidebook*. Berlin: Hatje Cantz, 2012.

Cicero, Marcus Tullius. *Speeches*. Translated by Robert Gardner. Cambridge, MA: Harvard University Press, 1965. 1958.

Cocteau, Jean. *The Difficulty of Being*. Translated by Elizabeth Sprigge. Brooklyn: Melville House Publishing, 2013.

Connolly, Cyril. *Enemies of Promise*. Chicago: Chicago University Press, 2008. 1938.

Cox, Renée, and Jo Anna Isaak. *Renée Cox: American Family*. New York: Robert Miller Gallery, 2002.

Crouch, Colin. *Post-Democracy*. New York: Polity, 2004.

Danto, Arthur. "Narrative and Style." In *Beyond the Brillo Box: The Visual Arts in Post-Historical Perspective*, 233–48. New York: Farrar, Straus and Giroux, 1992.

Danto, Arthur C. "The Artworld." *The Journal of Philosophy* 61, no. 19 (1964): 571-84.

Davila, Juan. "Aboriginality: A Lugubrious Game?". *Art & Text* 23/4 (March–May 1987): 53–56.

De Certeau, Michel. *The Practice of Everyday Life*. Berkeley: University of California Press, 1984.

Dean, Carolyn. *The Self and Its Pleasures: Bataille, Lacan, and the History of the Decentered Subject*. Ithaca, NY: Cornell University Press, 1992.

Derrida, Jacques. *The Truth in Painting*. Translated by Geoff Bennington and Ian Mcleod. Chicago: Chicago University Press, 1987.

Dewdney, Andrew, David Dibosa, and Victoria Walsh. *Post-Critical Museology: Theory and Practice in the Art Museum*. London: Routledge, 2013.

Diaz, Eva. "Futures: Experiment and the Tests of Tomorrow." In *Curating Subjects*, 92-99. London and Amsterdam: Open Editions/de Appel, 2007.

Diepeveen, Leonard, and Timothy Van Laar. *Artworld Prestige: Arguing Cultural Value*. Oxford: Oxford University Press, 2013.

Doyle, Jennifer. "White Sex: Vaginal Davis Does Vanessa Beecroft." In *Sex Objects: Art, Sexuality, and the Dialectics of Desire* 121-44. Minneapolis: University of Minnesota Press, 2006.

Duncan, Carol. "Who Rules the Art World?". In *The Aesthetics of Power: Essays in Critical Art History*, edited by Carol Duncan, 169-88. Cambridge: Cambridge University Press, 1993.

Enwezor, Okwui. "Reframing the Black Subject: Ideology and Fantasy in Contemporary South African Representation." *Third Text* 40, no. Autumn (1997): 21-40.

———. "The Black Box." In *Documenta 11 Platform 5: Exhibition Catalogue*, 42–55. Ostfildern-Ruit: Hatje Cantz, 2002.

———. "The Postcolonial Constellation: Contemporary Art in a State of Permanent Transition." In *Antinomies of Art and Culture: Modernity, Postmodernity, Contemporaneity*, edited by Terry Smith, Okwui Enwezor and Nancy Condee, 207-34. Durham: Duke University Press, 2008.

Enwezor, Okwui, and Chika Okeke-Agulu. *Contemporary African Art since 1980*. Bologna: Damiani, 2009.

Evans, Mel. *Artwash: Big Oil and the Arts*. London: Pluto Books, 2015.

Fachinelli, Elvio. "Anal Money-Time." Translated by Tom Nairn. In *The Psychology of Gambling*, edited by Jon Halliday and Peter Fuller. New York: Harper and Row, 1974.

Fisher, Jean. "Fictional Histories: Magiciens De La Terre—the Invisible Labyrinth." In *Making Art Global (Part 2): 'Magiciens De La Terre' 1989*, edited by Lucy Steeds, 248-58. London: Afterall Books, 2013.

Flisbäck, Marita, and Anna Lund. "Artists' Autonomy and Professionalization in a New Cultural Policy Landscape." *Professions & Professionalism* 5, no. 2 (2015): 1-16.

Florida, Richard L. *The Rise of the Creative Class: And How It's Transforming Work, Leisure and Everyday Life*. New York: Basic Books, 2002.

Foster, Hal. "The "Primitive" Unconscious of Modern Art or White Skin Black Masks." In *Recodings*, 181–208. Seattle: Bay Press, 1985.

Fraser, Andrea. "From the Critique of Institutions to an Institution of Critique." *Artforum International* 44, no. 1 (September 2005): 278-83, 332.

Fry, Roger. *Vision and Design*. London: Chatto & Windus, 1920.

Fry, Tony, and Anne-Marie Willis. "Aboriginal Art: Symptom or Success?". *Art in America* 77, no. 7 (July 1989): 109–16, 59–60, 63.

Gablik, Suzi. "Report from Australia." *Art in America* (January 1981): 29-37.

Gadamer, Hans-Georg. *Truth and Method*. London: Bloomsbury Academic, 2014.

Geczy, Adam. "Display." In *Art: Histories, Theories and Exceptions*. London: Berg, 2008.

Geczy, Adam, and Vicki Karaminas. *Critical Fashion Practice: From Westwood to Van Beirendonck*. London: Bloomsbury, 2017.

Gielen, Pascal. *The Murmuring of the Artistic Multitude: Global Art, Memory and Post-Fordism*. Amsterdam: Valiz, 2010.

Gloor, Peter A. *Swarm Creativity: Competitive Advantage through Collaborative Innovation Networks*. Oxford: Oxford University Press, 2006.

Goldsmith, Kenneth, ed. *I'll Be Your Mirror: The Selected Andy Warhol Interviews*. New York: Da Capo Press, 2009.

Gómez-Peña, Guillermo. "From Art-Mageddon to Gringostroka: A Manifesto against Censorship." In *Mapping the Terrain: New Genre Public Art*, edited by Suzanne Lacy. Seattle: Washington: Bay Press, 1995.

Gottlieb, Roger S., ed. *An Anthology of Western Marxism: From Lukács and Gramsci to Socialist-Feminism*. Oxford: Oxford University Press, 1989.

Gover, K.E. "Christoph Büchel V Mass Moca: A Tilted Arc for the Twenty-First Century." *The Journal of Aesthetic Education* 46, no. 1 (2012): 46-58.

Graham, Beryl, and Sarah Cook. *Rethinking Curating: Art after New Media*. Cambridge, MA: MIT Press, 2010.

Green, Charles, and Anthony Gardner. *Biennials, Triennials, and Documenta*. Chichester: John Wiley and Sons, 2016.

Greenberg, Clement. "Avant-Garde and Kitsch." 6, no. 5 (1939): 34-49.

———. "Modernist Painting." In *The New Art: A Critical Anthology*, edited by Gregory Battcock, 66-77. New York: E.P Dutton, 1973.

Groys, Boris. "Moscow Romantic Conceptualism." *A - ja / Contemporary Russian art* 1 (1979): 3-11.

Guilbaut, Serge. *How New York Stole the Idea of Modern Art.* Chicago: University of Chicago Press, 1985.

Haacke, Hans. "Museums, Managers of Consciousness." *Art in America,* no. 72 (1984): 9-17.

Hall, Stuart. "The West and the Rest: Discourse and Power." In *The Formations of Modernity: Understanding Modern Societies an Introduction Book 1 (Introduction to Sociology),* edited by Stuart Hall and Bram Gieben, 276-89. Cambridge: Polity Press, 1992.

Hardt, Michael, and Antonio Negri. *Empire.* Cambridge, MA: Harvard University Press, 2000.

Harvey, David. *The Condition of Postmodernity: An Enquiry into the Origins of Cultural Change.* Oxford: Blackwell, 1990.

Heidegger, Martin. "The Origin of the Work of Art." In *Poetry, Language, Thought,* 17-87. New York: Harper and Row, 1971.

Heller-Roazan, Daniel. "Tradition's Destruction: On the Library of Alexandria." *October* 100 (Spring 2002): 133-53.

Henriques, Diana. *The Wizard of Lies: Bernie Madoff and the Death of Trust.* New York: Times Books, 2011.

Hof, Robert D., Gary McWilliams, and Gabrielle Saveri. "The Click Here Economy." *Business Week,* 22 June 1998, 122.

Hoffmann, Jens. "Overture." *The Exhibitionist* 1 (2010): 3-4.

Holdgaard, Nana, and Lisbeth Klastrup. "Between Control and Creativity: Challenging Co-Creation and Social Media Use in a Museum Context." *Digital Creativity* 25, no. 3 (2014): 190-202.

Holquist, Michael, and Vadim Liapunov, eds. *Art and Answerability: Early Philosophical Essays by M.M. Bakhtin.* Austin: University of Texas, 1990.

Holt, Elizabeth Gilmore. *The Triumph of Art for the Public, 1785-1848: The Emerging Role of Exhibitions and Critics* Princeton: Princeton University Press, 1984.

Hudek, Anthony. "From over – to Sub-Exposure: The Anamnesis of Les Immatéiaux." *Tate Papers,* no. 12 (1 October 2009).

Hunter, James Davison. *Culture Wars: The Struggle to Define America.* New York: Basic Books, 1992.

Huws, Ursula. *The Making of a Cybertariat: Virtual Work in a Real World.* New York: Monthly Review Press, 2003.

Ingarden, Roman. *Ontology of the Work of Art: The Musical Work, the Picture, the Architectural Work, the Film* Athens, OH: Ohio University Press, 1989.

Iser, Wolfgang. *The Implied Reader: Patterns of Communication in Prose Fiction from Bunyan to Beckett.* Baltimore: Johns Hopkins University Press, 1978.

Jameson, Fredric. "Postmodernism and Consumer Culture." In *The Anti-Aesthetic: Essays on Postmodern Culture,* edited by Hal Foster, 111-25. Seattle: Bay Press, 1983.

Janes, Robert R. *Museums in a Troubled World: Renewal, Irrelevance or Collapse?* London: Routledge, 2009.

Jauss, Hans Robert. *Aesthetic Experience and Literary Hermeneutics.* Minneapolis: The University of Minnesota Press, 1982.

———. *Toward an Aesthetics of Reception.* Minneapolis: The University of Minnesota Press, 1982.

Johnson, Vivien. "The Art of Decolonisation." In *Two Worlds Collide: Cultural Convergence in Aboriginal and White Australian Art.* Sydney: Artspace, 1985.

Jones, Amelia. "The 'Pollockian Performative' and the Revision of the Modernist Subject." Chap. 1 In *Body Art/Performing the Subject*, 53-102. Minneapolis: University of Minnesota Press, 1998.

———. ""The Contemporary Artist as Commodity Fetish," Art Becomes You! Parody, Pastiche and the Politics of Art." In *Materiality in a Post-Material Paradigm*, edited by Henry Rogers and Aaron Williamson, 132-50. Birmingham: Article Press, 2006.

Kantor, Sybil Gordon. *Alfred H. Barr, Jnr. And the Intellectual Origins of the Museum of Modern Art.* Cambridge, MA: MIT Press, 2002.

———. "The Multimedia Museum." In *Alfred H. Barr, Jnr. And the Intellectual Origins of the Museum of Modern Art*, 220-34. Cambridge, MA: MIT Press, 2002.

Kaprow, Allan. *Art as Life.* Los Angeles: Getty Publications, 2008.

Kelley, Mike. "Three Projects by Mike Kelley at the Renaissance Society at the University of Chicago: Half a Man; from My Institution to Yours; Pay for Your Pleasure." *Whitewalls*, no. 20 (Fall 1988).

Kester, Grant. "Crowds and Connoisseurs: Art and the Public Sphere in America." In *A Companion to Contemporary Art since 1945*, edited by Amelia Jones, 249-58. London: Wiley-Blackwell, 2006.

King, Peter. "Postmodernist Porn." *Philosophy Now*, no. 8 (1993/4). Published electronically Winter. http://philosophynow. org/issues/8/Postmodernist_Porn.

Klamer, Arjo. *Doing the Right Thing: A Value Based Economy.* Hilversum, NL: SEC, 2016.

Kostelanetz, Richard. *Soho: The Rise and Fall of an Artist's Colony.* London: Routledge, 2003.

Kosuth, Joseph. "The Artist as Anthropologist." In *Art after Philosophy and After: Collected Writings, 1969-1990*, edited by Gabriele Guercio, 107–28. Cambridge: MIT Press, 1993.

Kupka, Karel. *Dawn of Art: Painting and Sculpture of Australian Aborigines.* Sydney: Angus and Robertsoon, 1965.

Lacan, Jacques. *The Ethics of Psychoanalysis, 1959-1960: The Seminar of Jacques Lacan.* Translated by Dennis Porter. Vol. Book VII, London: W.W. Norton, 1997.

Langton, Marcia. *Well, I Heard It on the Radio and I Saw It on Television...* Sydney: Australian Film Commission, 1993.

Lapham, Lewis H. *Age of Folly.* London: Verso, 2016.

Lazzarato, Maurizio. "Immaterial Labour." In *Radical Thought in Italy: A Potential Politics*, edited by Paolo Virno and Michael Hardt, 133–51. Minneapolis: University of Minnesota Press, 1996.

Lefebvre, Henri. *The Production of Space*. Translated by Donald Nicholson-Smith. Oxford: Blackwell, 1991.

Léger, Marc James. "The Non-Productive Role of the Artist: The Creative Industries in Canada." *Third Text* 24, no. 5 (2010): 557–70.

Lewis, Michael. *Flash Boys*. New York: W.W. Norton & Co., 2014.

Lobsinger, Mary Lou. "Immaterial Labour." In *Labour Work Action*, edited by Michael Corris, Jasper Joseph-Lester and Sharon Kivland, 137-45. London: Artwords Press, 2014.

Lorey, Isabell. *State of Insecurity: Government of the Precarious*. Translated by Aileen Derieg. London: Verso, 2015.

Lukacs, Georg. "Realism in the Balance." In *Aesthetics and Politics: The Key Texts of the Classic Debate within German Marxism*, 28-59. New York: Verso, 1995.

Lyotard, Jean-François. *The Postmodern Condition: A Report on Knowledge*. Minneapolis: University of Minnesota Press, 1984. 1979.

―――. *Libidinal Economy*. Translated by Iain Hamilton Grant. London: The Athlone Press, 1993.

Mamdani, Mahmood. "Beyond Settler and Native as Political Identities: Overcoming the Political Legacy of Colonialism." In *The Short Century: Independence and Liberation Movements in Africa 1945-1994*, edited by Okwui Enwezor, 21-27. Munich: Prestel, 2001.

Marincola, Paula, ed. *Curating Now: Imaginative Practice, Public Responsibility*. Philadelphia: Philadelphia Exhibitions Initiative, 2001.

Marquis, Alice Goldfarb. *Alfred H. Barr, Jnr.: Missionary for the Modern*. Chicago: Contemporary Books, 1989.

Mauss, Marcel. *The Gift: Forms and Functions of Exchange in Archaic Societies* [Essai sur le don: forme et raison de l'échange dans les sociétés archaïques]. Translated by Ian Gunnison. London: Cohen & West, 1966. 1925.

McCarthy, Kevin F., Elizabeth H. Ondaatje, Laura Zakaras, and Arthur Brooks. *Gifts of the Muse: Reframing the Debate About the Benefits of the Arts*. Santa Monica: Rand Corporation, 2004.

McClellan, Andrew. *Inventing the Louvre: Art, Politics, and the Origins of the Modern Museum in Eighteenth-Century Paris*. Berkeley: California University Press, 1999. 1994.

McKee, Yates. *Strike Art: Contemporary Art and the Post-Occupy Condition*. London: Verso, 2016.

McLean, Ian. "Post-Western Poetics: Postmodern Appropriation Art in Australia." *Art History* 37, no. 4 (2014): 628-47.

McLean, Iain, and Jo Poulton. "Good Blood, Bad Blood, and the Market: The Gift Relationship Revisited." *Journal of Public Policy* 6, no. 4 (1986): 431-45.

McMahon, Jennifer A. *Art and Ethics in a Material World: Kant's Pragmatist Legacy*. London: Routledge, 2014.

―――. " Immediate Judgment and Non-Cognitive Ideas: The Pervasive and Persistent in the Misreading of Kant's Aesthetic Formalism." Chap. 18 In *The Palgrave*

Kant Handbook, edited by Matthew C. Altman. Basingstoke and New York: Palgrave Macmillan, 2017.

McRobbie, Angela. "'Everyone Is Creative': Artists as New Economy Pioneers." *OpenDemocracy* (2001). Published electronically 29 August. http://www.opendemocracy.net/node/652.

Michaels, Eric. *Bad Aboriginal Art: Tradition, Media and Technological Horizons.* St Leonards: Allen & Unwin, 1994.

Moore, Alan W. *Art Gangs: Protest and Counterculture in New York City.* Brooklyn: Autonomedia, 2011.

Moore, Jason W. *Capitalism in the Web of Life: Ecology and the Accumulation of Capital.* London: Verso, 2015.

Muñoz, José Esteban. "'The White to Be Angry': Vaginal Crème Davis's Terrorist Drag." In *Disidentifications: Queers of Color and the Performance of Politics*, 93-115. Minneapolis: University of Minnesota Press, 1999.

Murphy, Bernice. *Australian Perspecta 1981.* Sydney: Art Gallery of New South Wales, 1981.

Norment, Camille. "Balanse I Regnskapet, Balanse I Kunstnerskapet." *Billedkunst*, no. 7 (2016): 23-27.

O'Neill, Paul. "Curating Beyond the Canon." In *Curating Subjects*, edited by Peter O'Neill. London and Amsterdam: Open Editions/de Appel, 2011.

———. *The Culture of Curating and the Curating of Culture(S).* Cambridge, MA: MIT Press, 2012.

O'Neill, Paul, and Mick Wilson, eds. *Curating and the Educational Turn.* London and Amsterdam: Open Editions/de Appel, 2010.

Obrist, Hans Ulrich. "Interview with Harald Szeemann." In *A Brief History of Curating*, 79-91. Zürich: JRP/Ringier Verlag, 2008.

Obrist, Hans Ulrich, and Asad Raza. *Ways of Curating.* London: Penguin, 2014.

Oguibe, Olu. "New Internationalism." *Nka Journal of Contemporary African Art* 1, no. Fall/Winter (1994): 24-28.

———. "New Internationalism." In *Global Visions: Towards a New Internationalism in the Visual Arts*, edited by Jean Fisher, 50-59. London: Kala Press in association with The Institute of International Visual Arts, 1994.

Ortiz, Fernando. *Cuban Counterpoint: Tobacco and Sugar.* Translated by Harriet de Onís. New York: Alfred A. Knopf, 1947. 1940.

Ostrom, Elinor. *Governing the Commons: The Evolution of Institutions for Collective Action* Cambridge: Cambridge University Press, 1990.

Perlin, Ross. *Intern Nation: How to Earn Nothing and Learn Little in the Brave New Economy.* Brooklyn: Verso Books, 2011.

Peters, Michael A., and Ergin Bulut, eds. *Cognitive Capitalism, Education, and Digital Labor.* New York: Peter Lang, 2011.

Pietz, William. "The Problem of the Fetish, I." *Res* 9 (Spring 1985): 5-17.

———. "The Problem of the Fetish, Ii/ the Origin of the Fetish." *Res* 13 (Spring 1987): 23-45.

Pincus, Robert L. "The Invisible Town Square: Artists' Collaborations and Media Dramas in America's Biggest Border Town." In *But Is It Art?: The Spirit of Art as Activism*, edited by Nina Felshin, 31–49. Seattle: Washington Bay Press, 1995.

Pincus-Witten, Robert. "The Times Square Show Revisited." *Artforum International* 51, no. 4 (December 2012): 274-75.

Preziosi, Donald. "The Art of Art History." In *Museums in the Material World*, edited by Simon J. Knell, 110-17. London: Routledge, 2007.

Purves, Ted, ed. *What We Want Is Free: Generosity and Exchange in Recent Art*. Binghamton: SUNY Press, 2005.

Radok, Stephanie. "Focus: No Man Is an Island: A Two Part Reading." *Artlink* 21, no. 2 (2001): 9-12.

Rajchman, John. "The Postmodern Museum." *Art in America* (October 1985): 111-71.

Ranciere, Jacques. *The Politics of Aesthetics: Distribution of the Sensible*. Translated by Gabriel Rockhill. London: Continuum, 2004. 2000.

Roberts, John. "The Curator as Producer'." *Manifesta Journal*, no. 10 (2009).

———. "Art and the Problem of Immaterial Labour: Reflections on Its Recent History." In *Economy: Art, Production and the Subject of the 21st Century*, edited by Angela Dimitrakaki and Kirsten Lloyd, 68-82. Liverpool: Liverpool University Press, 2014.

Rosen, Evan. *The Culture of Collaboration*. San Francisco: Red Ape Publishing, 2009.

Rosenberg, Harold. "American Action Painters." *Art News* 51, no. 8 (December 1952): 22-23, 48-50.

Ross, Andrew. "The Geography of Work. Power to the Precarious?". *On Curating*, no. 16 (2013).

Rothenberg, Jerome, ed. *Technicians of the Sacred: A Range of Poetries from Africa, America, Asia, Europe & Oceania*. Berkeley: University of California Press, 1985.

Sartre, Jean-Paul. "Existentialism and Humanism." In *Art in Theory: 1900–1990*, edited by Charles Harrison, 587-89. New York: Blackwell Press, 1995.

Sawyer, Keith. *Group Genius: The Creative Power of Collaboration*. New York: Basic Books, 2008.

Scholz, Trebor. *Platform Cooperativism. Challenging the Corporate Sharing Economy*. Rosa-Luxemburg-Stiftung2016.

Schubert, Karsten. *The Curator's Egg: The Evolution of the Museum Concept from the French Revolution to the Present Day*. London: Ridgehouse, 2009. 2000.

Schwabsky, Barry. *The Perpetual Guest: Art in the Unfinished Present*. London: Verso, 2016.

Scotti, R.A. *Basilica: The Splendor and the Scandal: Building St. Peter's Basilica*. London: Penguin Books, 2007.

Shattuck, Roger. *The Banquet Years: The Origins of the Avant-Garde in France 1885- World War I*. New York: Vintage Books, 1968.

Sholette, Gregory. "A Collectography of Pad/D, Political Art Documentation and Distribution: A 1980's Activist Art and Networking." (2003). http://www.darkmatterarchives.net/wp-content/uploads/2011/01/2.2.Collectography.pdf.

———. *Dark Matter: Art and Politics in the Age of Enterprise Culture*. London: Pluto Press, 2011.

Shukaitis, Stevphen. *The Composition of Movements to Come: Aesthetics & Cultural Labor after the Avant-Garde*. London: Rowman & Littlefield International, 2016.

Smith, Bernard. *The Spectre of Truganini: 1980 Boyer Lectures*. Sydney: Australian Broadcasting Commission, 1980.

Smith, Terry. "The Provincialism Problem." *Artforum* 13, no. 1 (September 1974): 54–59.

Solomon-Godeau, Abigail. "The Legs of the Countess." *October* 39 (Winter 1986): 65-108.

Srnicek, Nick, and Alex Williams. *Inventing the Future: Postcapitalism and a World without Work*. London: Verso, 2015.

Stakemeier, Kerstin. "Art as Capital - Art as Service - Art as Industry: Timing Art in Capitalism." In *Timing: On the Temporal Dimension of Exhibiting*, edited by Beatrice von Bismarck, 15–38, 2014.

Standing, Guy. *The Precariat: The New Dangerous Class*. London: Bloomsbury, 2014.

Steinmetz, Julia. "Showing Us What's Wrong: Vanessa Beecroft and the Model's Body." *Signs: A Journal of Women in Culture: special issue on "New Feminist Theories of Visual Culture"* 31, no. 3 (Spring 2006): 753-84.

Steyerl, Hito. "The Institution of Critique." In *Art and Contemporary Critical Practice: Reinventing Institutional Critique*, edited by Gerald Raunig and Gene Ray, 13-21. London: MayFly Books, 2009.

———. "Politics of Art: Contemporary Art and the Transition to Post-Democracy." In *Are You Working Too Much?: Post-Fordism, Precarity, and the Labor of Art*, edited by Julieta Aranda, Brian Kuan Wood and Anton Vidokle, 30–39. Berlin: Sternberg Press, 2011.

Stiles, Kristine, and Peter Howard Selz. *Theories and Documents of Contemporary Art: A Sourcebook of Artist's Writings*. Berkeley: University of California Press, 1995.

Swenson, G. R. "What Is Pop Art? Answers from 8 Painters: Part 1." *Art News*, no. 62 (November 1963): 18.

Thompson, Margo. "The Times Square Show." *Streetnotes*, no. 20 (2010). http://people. lib.ucdavis.edu/~davidm/xcpUrbanFeel/thompson.html.

Throsby, David. "But Is It Art." *Art Monthly Australia* 105, no. November (1997): 32.

Thurman, Judith. "The Wolf at the Door: Vanessa Beecroft's Provocative Art Is Inextricably Tied to Her Obsession with Food." *The New Yorker*, 17 March 2003, 114-23.

Tillers, Imants. "Locality Fails." *Art & Text* 6, Winter (1982): 51–60.

———. "One Painting Cleaving (Triangle of Doubt)." In *Eureka! Artists from Australia*, edited by Sue Grayson and Sandy Nairne, 36. London: Institute of Contemporary art and the Arts Council of Great Britain, 1982.

———. "Metafisica Australe." *Art + Australia* 53, no. 2 (Issue One May 2017): 52-59.

Titmuss, Richard Morris. *The Gift Relationship: From Human Blood to Social Policy*. London: Allen & Unwin, 1970.

———. "What Is Social Policy?". In *Social Policy: An Introduction*, edited by Brian Abel-Smith and Kay Titmuss. London: Allen & Unwin, 1974.

Tokumitsu, Miya. *Do What You Love: And Other Lies About Success and Happiness* New York: Regan Arts, 2015.

Tuckson, J. A. "Aboriginal Art and the Western World." In *Australian Aboriginal Art*, edited by Ronald M. Berndt, 60–68. Sydney: Ure Smith, 1964.

van den Berg, Karen, and Ursula Pasero. "Large-Scale Art Fabrication and the Currency of Attention." In *Contemporary Art and Its Commercial Markets: A Report on Current Conditions and Future Scenarios*, edited by Maria Lind and Olav Velthuis, 153-81. Berlin: Sternberg Press, 2012.

Virno, Paolo. *A Grammar of the Multitude: For an Analysis of Contemporary Forms of Life.* Los Angeles: Semiotext(e), 2003.

Vischmidt, Marina. "The Aesthetic Subject and the Politics of Speculative Labor." In *The Routledge Companion to Art and Politics*, edited by Randy Martin, 25-37. London: Routledge, 2015.

Viveros-Fauné, Christian. "These 11 Artists Will Transform the Art World in 2017." *artnet news* (2017). Published electronically 2 January. https://news.artnet.com/exhibitions/11-contemporary-artists-for-2017-800375.

Waterlow, Nick. "1979 European Dialogue." In *Biennale of Sydney 2000*, edited by Ewen McDonald, 168–70. Sydney: Biennale of Sydney, 2000.

Welchman, John C. "Apropos: Tune in, Take Off." *Art/Text*, no. 57 (May–July 1997): 29–31.

———. "Public Art and the Spectacle of Money: On Art Rebate/Arte Reembolso." Chap. 5 In *Art after Appropriation: Essays on Art in the 1990s*, 165-82. London: Routledge, 2000.

Willis, Anne-Marie, and Tony Fry. "Art as Ethnocide: The Case of Australia." *Third Text* 5 (Winter 1989): 3–20.

Wimsatt, W. K., and Monroe Beardsley. "The Intentional Fallacy." In *Philosophy of Art and Aesthetics*, edited by S. M. Cahn and F. A. Tillman. New York: Harper & Row, 1969.

Witcomb, Andrea. "Understanding the Role of Affect in Producing a Critical Pedagogy for History Museums." *Museum Management and Curatorship* 28, no. 3 (2013): 255-71.

Wittkower, Rudolf, and Margot Wittkower. *Born under Saturn, the Character and Conduct of Artists. A Documented History from Antiquity to the French Revolution.* New York: WW Norton, 1963.

Žižek, Slavoj. *The Puppet and the Dwarf: The Perverse Core of Christianity.* Cambridge, MA: MIT Press, 2003.

Zuckoff, Mitchell. *Ponzi's Scheme: The True Story of a Financial Legend.* New York: Random House, 2006.

Index